Out of Inferno

Harry G. Carlson

———

OUT OF INFERNO

———

Strindberg's
Reawakening
as an Artist

A McLellan Book

UNIVERSITY OF WASHINGTON PRESS

SEATTLE & LONDON

This book is published with the assistance of a grant
from the McLellan Endowed Series Fund, established through the
generosity of Martha McCleary McLellan and Mary McLellan Williams.
Copyright © 1996 by the University of Washington Press
Printed in the United States of America
Designed by Audrey Meyer

Distributed in the United Kingdom and Europe by Reaktion
Books Ltd, 1-5 Midford Place, Tottenham Court Road, London
W1P 9HH.

Library of Congress Cataloging-in-Publication Data

Carlson, Harry Gilbert, 1930–
Out of Inferno : Strindberg's reawakening as an artist /
Harry G. Carlson.
p. cm.
"A McLellan book."
Includes bibliographical references and index.
ISBN 0-295-97503-2 (alk. paper)
ISBN 0-295-97564-4 (pbk.: alk. paper)
1. Strindberg, August, 1849–1912—Psychology. 2. Strindberg,
August, 1849–1912—Criticism and interpretation. 3. Authors as
artists—Sweden. I. Title.
ND793.S85C37 1996
839.72'6—dc20 95-35409
CIP

Contents

v

Contents

Contents

Illustrations

Acknowledgments

ONE BOOK SOMETIMES ENGENDERS ANOTHER. *STRINDBERG and the Poetry of Myth* (1982) was motivated by my desire to investigate how mythic images functioned as creative energy sources on Strindberg's plays. A National Endowment for the Humanities Fellowship in 1985 enabled me to broaden my research by studying the impact of other image sources on Strindberg's imagination. Of particular interest was the relationship between his visual and literary imaginations: his interests in painting, his genuine gifts as a painter, and the important roles played by visual imagery in his writings. Subsequent City University of New York PSC-CUNY Research Awards and Queens College Faculty-in-Residence and Presidential Research Fellowships between 1987 and 1990 provided the opportunities to explore in Strindberg's later writings the evidence of the artistic, spiritual, and cultural movements that fueled the Neoromantic revival in the arts in Berlin and Paris in the 1890s, a revival that did much to shape the evolution of modern drama and modern art in general.

My profound thanks go to the National Endowment for the Humanities, Queens College, the Swedish Royal Library, and the many people who generously offered advice about sections of this book: in the United States, Pat Berman, Haskell Block, Marian Burleigh-Motley, Marvin Carlson, Michelle Facos, and Gerald Rabkin; in Sweden, Margareta Brundin, Johan Cullberg, Lena Daun, Sven-Gustaf Edqvist, Sverker Ek, Hans-Göran Ekman, Claes-Göran Green, Inge Jonsson, Busk-Rut Jonsson, Agneta Lalander, Nils Leijer, Björn Meidal, Bertil Nolin, Anita Persson, Ann Sonnerman, and Birgitta Steene. The support and suggestions of my wife, Carolyn, were vital at every stage of composition.

This book was first published in Swedish in the spring of 1995, in slightly different form, as *Genom Inferno: Bildens magi och Strindbergs förnyelse*, and I am indebted to the cooperation and many wonderful suggestions of my translator, Gun R. Bengtsson.

Acknowledgments

At the University of Washington Press I am grateful to my editors Naomi Pascal, for her encouragement and interest, and Pamela J. Bruton, for her extraordinary courtesy, diligent eye, and many valuable comments.

Parts of this book have appeared in different forms in various publications, and I am grateful to the editors for permission to use them here: "Ambiguity and Archetypes in Strindberg's 'Romantic Organist,'" *Scandinavian Studies* 48 (autumn 1976): 256–71; "Strindberg och drömmen om Guldåldern," trans. into Swedish by Eva Sjöstrand, *Artes* 11, no. 4 (1985): 97–110; "Strindberg and the Carnival of History," *Scandinavian Studies* 62, no. 1 (winter 1990): 39–52; "Strindberg's Naturalism: Nature Malign and Benign and the Triumph of the Imagination," in *The Modern Breakthrough in Scandinavian Literature, 1870–1905*, ed. Bertil Nolin and Peter Forsgren, Skrifter utgivna av Litteraturvetenskapliga institutionen vid Göteborgs universitet, no. 17 (Gothenburg, Sweden, 1988), pp. 249–58; "Strindberg and the Visual Imagination," in *Strindberg and Genre*, ed. Michael Robinson (Norwich, England: Norvik Press, 1991), pp. 255–68; "Medieval Themes and Structures in Strindberg's Post-Inferno Drama," in *Strindberg's Post-Inferno Plays*, ed. Kela Kvam, lectures given at the Eleventh International Strindberg Conference, University of Copenhagen, Institute for Theatre Studies, 7–12 April 1992 (Copenhagen: Munksgaard/Rosinante, 1994), pp. 19–31.

Conventions

U NLESS OTHERWISE NOTED, ALL TRANSLATIONS ARE MY own. Quotations from *The Father, Miss Julie, The Dance of Death, A Dream Play,* and *The Ghost Sonata* are all from my *Strindberg: Five Plays* (Berkeley and Los Angeles: University of California Press, 1981; New York: New American Library, Signet Classic, 1983).

Quotations from Strindberg's collected works and letters are cited in the text with the abbreviations listed below followed by volume and page number.

Brev: *August Strindbergs brev,* ed. Torsten Eklund (vols. 1–15) and Björn Meidal (vols. 16–19) (Stockholm: Bonniers, 1948–).

ss: August Strindberg, *Samlade skrifter,* ed. John Landquist, 55 vols. (Stockholm: Bonniers, 1912–21).

sv: *August Strindbergs samlade verk,* ed. Lars Dahlbäck, 37 vols. to date (Stockholm: Almqvist & Wiksell, Norstedts, 1981–). This is a new, revised edition of the works and will not be completed until the early part of the twenty-first century.

The citations to the "Strindberg Library" throughout the book refer to the substantial private collection that Strindberg left at his death in 1912. At first the collection was moved from his apartment at 85 Drottningatan (Queens Street) in Stockholm and stored in the Nordic Museum. Subsequently, it was returned to the same Drottningatan building, in which the Strindberg Museum is now situated. Twice during Strindberg's life, in 1883 and 1892, he was forced to sell library collections. References in the book to these sources were taken from the two inventories reprinted in Hans Lindström's valuable bibliographical study *Strindberg och böckerna, Skrifter utgivna av svenska litteratursällskapet,* no. 36 (Uppsala, 1977).

In the notes, works that are listed in the Bibliography are cited only by author's last name and shortened title. Full bibliographi-

cal details can be found in the Bibliography. When more than one edition is listed in the Bibliography for a work, page references in the notes refer to the more recent edition.

Out of Inferno

Introduction

IN 1897, AUGUST STRINDBERG, ALMOST FIFTY YEARS OLD, embarked on one of the great comebacks in the history of literature. For six years he had lived as a peripatetic exile in Germany, Austria, and France, sometimes reduced to accepting the charity of friends. Though he had earlier earned a place in Scandinavian literature as an influential, radical pioneer, and two of his plays — *The Father* and *Miss Julie* — would guarantee him a place in an international context as an important modern dramatist, the general view in Sweden was that he was finished, his career over. Then, with the novel that described some of the most harrowing experiences of his exile years — *Inferno* — he returned swiftly to the center of Swedish literary life, which he had dominated as a promising young writer twenty years earlier.

This book explores a story that has up to now been only partly told and then just in isolated segments: how the coalescence of various forces in the fin de siècle climate of artistic renewal present in Berlin and Paris during Strindberg's exile years there powerfully influenced his own personal renewal by spurring him to discoveries about art and the power of the visual imagination that enabled him to restart his creative engine and begin anew. The results in plays like *To Damascus*, *A Dream Play*, *The Dance of Death*, *Erik XIV*, and *The Ghost Sonata* amounted to a vision of drama that helped change the course of the modern theatre by raising questions about the concept of a unified character, strict restrictions in the handling of time and space in dramatic action, the relationship between visual images and dramatic action, the uses of history and the historical process, the mingling of realism and the supernatural, and the purposes of myth.

In the total span of Strindberg's career (from the early 1870s to 1912), the last decade of the century was a vital turning point, climaxing a period of exciting, radical stylistic change — from realism/Naturalism to nonrealistic experiments that anticipated

3

the abstract art of the twentieth century. Strindberg negotiated the change more successfully than many of his contemporaries, and eventually he executed important works in nonrealistic as well as realistic styles. But the process of shifting stylistic gears took longer and was more painful for him than for many other artists. While part of him was an astute, politically conscious realist/Naturalist, anxious to imitate nature faithfully and objectively and careful to emphasize social relevance over entertainment in his art, the other part was a highly inventive dreamer, who, though suspicious of the seductive power of the imagination and its "visions," or "hallucinations," as he called them, nevertheless often instinctively trusted those "visions" over sociopolitical intentions. As the realist's social reforming ambitions inspired radically progressive thinking in a whole generation of Scandinavian writers and painters (understandably provoking revulsion and opposition in most conservative Swedish ruling circles at the same time), the dreamer's inventive storytelling stretched the imaginations of audiences, who, to his dismay, often blithely ignored his social message.

Not surprisingly, the tensions and contradictions between realist and dreamer, together with the frustrations that both suffered, ultimately helped precipitate the collapse of his career in the Inferno years. My argument is that only after he was able to reconcile these contradictions was he able to return to productive creative activity, and that the reconciliation was made possible because his faith in the imagination—particularly the visual imagination—and its Romantic legacy had been restored.

The route to reconciliation began with a fateful decision made early during his traumatic Inferno years. After having declared himself finished with drama and fiction, he turned, as he had done in the past when in need of fresh inspiration, to an old love, his painting (at which he was gifted, though untrained), and sought out the company of other painters and writers in avant-garde artistic and intellectual circles. In the extraordinary atmosphere of artistic ferment in Berlin and Paris, Strindberg's senses were bombarded with a variety of new ways of seeing and

new avenues of expressiveness for painters and writers. Paris, in particular, offered a virtual smorgasbord of artistic and philosophical choices, all of them impacting on the artist's perception and understanding of visual images. It was a time of many styles, from Impressionism to Symbolism to Synthetism; a time of revival of interest in the mystical arts of the occult, from alchemy to theosophy; and a time of feverish enthusiasm for Orientalism and medievalism. Strindberg's always sensitive visual imagination became recharged with energy, and the writer was inspired to return to work.

The cumulative force of these new stimuli, all hostile to positivist materialism and Naturalism, emboldened a generation of artists—playwrights like Strindberg and Maeterlinck and painters like Edvard Munch and Paul Gauguin (both of whom Strindberg knew well during the early 1890s)—to challenge the five-hundred-year domination of the arts by Renaissance perspective realism, which had demanded of painters that they produce illusions of three-dimensional spaces on flat canvas surfaces, and of dramatists that they create illusions of real action, performed in real, chronological time by real people, in real places. As old conventions were pushed aside, new freedoms opened up for painters in the treatment of color and line, and for dramatists in the handling of character and plot and of time and space.

A critical aspect of the challenge to perspective realism—particularly for my discussion—involved the conflict Strindberg endured between the artist's responsibilities to mimesis and to the imagination. How much should he imitate nature in a truly objective way (a necessary goal in an age of scientific realism), and how much should he allow his imagination to incorporate fantasy and the supernatural into his work? What Strindberg gradually assimilated in Paris was a new allegiance, which was to neither a simple, factual realism nor a high-flown fantasy, but to a hybrid, Natural Supernaturalism (the Romantics used the same term), that exalted the imagination in the creative process just as decisively as the Naturalists had earlier denigrated it.

The very concept of the imagination—its importance or unim-

portance—was the subject of lively controversy for much of the nineteenth century. In the early years the Romantics made it the engine of inspiration and invention—the "Creative Imagination." A half century later, the scientific Naturalists treated it as simply a mechanical function of the mind. Then, under the influence of Symbolists, mystics, and Occultists, attitudes turned positive again in the 1890s.

Strindberg recapitulated these changes in his own career. As a young man, he had an abiding faith in the imagination and was an admirer of the Danish Romantic poet-playwright Adam Oehlenschläger, who was himself an avid student of German Romanticism. In the late 1880s, he turned from aesthetic to political Romanticism, attempting to work in a rational, scientifically objective way to transform what he saw as an unjust society into a more just one by unmasking social privilege and hypocrisy. In this context, the realist in Strindberg professed to reject the imagination as a reactionary force. Yet the dreamer still found opportunities for imaginative expression to be irresistible. The realist aimed satirical attacks against the ruling class and against the aristocratic, empty, Romantic idealism that this Overclass—to use Strindberg's own terminology [1]—still used as justification for its oppression of the Underclass. But the dreamer was as Romantic and idealistic in his own way as the forces the realist attacked. "We who were nourished at the flower-bedecked trough of Romanticism," Strindberg confessed in 1884, have "so many 'ghosts' that we cannot root out of our minds. We are so gorged on adulterations (illusions and ideals) that it may take three generations for us to learn how to speak the truth" (ss 16:50). Looking back much later over the realism of his Naturalist period, he admitted, "I was an incurable Romantic, even when I dealt with social problems" (ss 53:556).

The conflict he suffered from was a common one among nineteenth-century artists. Though realism and Naturalism were politically, ethically, and aesthetically correct in an age of growing respect for scientific authority, artists never stopped being fascinated with the marvelous and the mythical. Alfred de Vigny described a sense of feeling divided between "a love of the true"

and "a love of the fabulous."[2] And Strindberg would surely have sympathized with Flaubert's confession that "in literary terms, there are two different fellows within me: one that is fond of ravings, lyricism, great eagle-flights, all the sonorities of the phrase and exaltations of the idea; another that searches for and digs out the truth as much as he can, that likes to point out the little facts as vigorously as the big ones, that wants to make the things he reproduces felt almost tangibly . . ."[3]

But a powerful imagination could also be a liability. More than once Strindberg was amazed by discrepancies in his works between the results achieved and the purposes he had originally intended. Finally, he despaired over the uselessness of any approach in art, realistic or fantastic. The realist saw that though his entertaining polemics enjoyed a certain popularity, especially among young radical intellectuals, they seemed to have little general political effect. And the dreamer was skeptical that he could ever find adequate artistic forms for communicating his visions. When art is impotent both politically and expressively, of what use is it? In this context it is not difficult to understand why his literary creativity dried up in the early 1890s. Another writer disillusioned by the political impotence of artists was Jean-Paul Sartre, who came to the realization that "for a long time, I took my pen for a sword" and confessed resignedly, "I now know we're powerless," but "I still write. What else can I do?"[4]

Strindberg's ambivalent feelings about the imagination were matched by ambivalent feelings about Romanticism, and they were reflected in his attitudes toward predecessors. He was a Romantic playwright but had little use for the kind of Romantic drama pioneered by Victor Hugo. Though he admired Hugo's novels, he regarded his plays Cromwell and Hernani as little more than warmed-over Shakespearean or Spanish Golden Age drama, "in other words a reversion to the past," Strindberg wrote in an 1889 essay, "which was the principal mission of Romanticism in every area" and resulted in "perhaps the beginning of the theatre's decline" (ss 17:284). His earliest important Romantic dramatic models (other than Shakespeare, that favorite of all

7

Romantics) were Goethe's *Götz von Berlichingen*, Schiller's *The Robbers* (*Die Räuber*), and Byron's *Manfred* and *Cain*. Like Byron, Strindberg does not fit neatly into any Romantic category. M. H. Abrams, in his influential study of Romanticism, *Natural Supernaturalism*, omits Byron from his discussion, "because in his greatest work he speaks with ironic counter-voice and deliberately opens a satirical perspective on the vatic stance of his Romantic contemporaries."[5] Similarly, Albert Nilsson's classic *Swedish Romanticism* (*Svensk romantik*),[6] which traces various Neoplatonic Romantic influences in Swedish literature from the mid–eighteenth through the end of the nineteenth century, includes the influential poet-novelist Viktor Rydberg but omits any reference to Rydberg's often equally Neoplatonic younger rival, perhaps because Nilsson felt that Strindberg, like Byron, spoke "with ironic counter-voice."

Nevertheless, Strindberg belongs to an identifiable strain in the Romantic tradition, to a particular way of seeing, an anti-aesthetic strain, apart from and even opposed to such *l'art pour l'art* movements as French Symbolism.[7] He belongs — to borrow Robert Rosenblum's label for a continuity of theme and purpose in painting — to the "Northern Romantic Tradition."[8] Rosenblum finds parallels in works by a procession of artists from Caspar David Friedrich through Turner, Blake, van Gogh, Mondrian, and Rothko. Their common goal, he asserts, was an abiding search for spiritual meaning in a world in which traditional religious values had been attenuated or lost.

The word "spiritual" poses problems in a critical discussion. During most of the period from the 1930s through the 1960s, it was a highly derogatory term in literary and art criticism, mostly because of the word's connections with religion, Occultism, mysticism, and even fascism.[9] In the last two decades, however, the word has taken on new importance as scholars and critics have directed particular attention to the spiritual tradition within Romanticism in general and to the spiritual interests of artists around the turn of the century in particular. "One cannot emphasize too heavily," says art critic Arthur C. Danto in connection

with Paul Klee, "the degree to which the early masters of Modernism were seized by spiritualistic preoccupations." [10]

If what is suggested by the words "spirit" or "spiritual" has made difficulties for American critics until only recently, in Sweden the situation has been even worse. Art critic Ulf Linde points out that since the Swedish word for spirit, *ande*, is used almost exclusively in a religious context and lacks the general connotations of the corresponding German *Geist* or the French *esprit*, it can tend to "smell of cheap religiosity." At the same time, Linde cautions that in order to understand the art and theory of an important modern artist like Kandinsky, "one must become accustomed to the word." [11] The same advice holds true for anyone interested in understanding Strindberg's art and theories about art. Spiritual concepts were meaningful to him in both a religious and a secular, political sense.

Though Rosenblum associates Strindberg with the Northern Romantic Tradition, it is only as a writer, noting that the themes in Strindberg's plays were similar to those in paintings by Strindberg's friend Edvard Munch. Rosenblum makes no mention of Strindberg's own paintings, nor have scholars generally devoted much attention to the relationship between Strindberg's ways of seeing as a painter and as a playwright. This is despite the esteem in which Strindberg, though an unschooled amateur, is held in Europe as a pioneering visual artist, and despite the impact he has had on such modern radical painters as the Germans Georg Baselitz and Anselm Kiefer and the Swede Max Book. [12] His paintings and plays contain the same urgent quest of the divine that Rosenblum writes about. Each art form was but a different means for furthering the quest. Even in the plays written during Strindberg's Naturalistic period—when he proclaimed himself an atheist—there is a search for the *deus absconditus*, the deity who seems to have abandoned the world and taken all meaning with him. And in that quest for the divine, especially after the Inferno period, image and word became intimate partners.

The separate emphases in the two parts of this study—the first

part devoted to Strindberg's ways of seeing as a realist or Naturalist during the 1870s and 1880s, the second to the new ways of seeing he developed in the 1890s—are summarized in the different ways he used a Swedish figurative word, a word connected with sight and seeing: *genomskåda*, "to see into, through, or beneath the surface." Although in both periods he viewed the role of the artist as an unmasker and discloser, there were different things to be unmasked. The realist/Naturalist discussed in Part I of the study—"The Making and Unmaking of the Artist"—was most interested in seeing through the delusionary façade of middle-class society to the lies, hypocrisy, and social wretchedness underneath, to reveal what he called in the late 1880s "life's nothingness" (ss 19:95).

For Strindberg in the last decade and a half of his life, *genomskåda* took on a transcendental dimension. Though still dedicated to exposing the contradictions in bourgeois society, he was now more concerned with demonstrating that it was possible to expose the contradictions in reality itself and was determined to pursue this goal by using apparently incompatible means: scientific investigation *and* spiritual revelation. As was true of many other nineteenth-century artists, he used as model the great eighteenth-century Swedish scientist-mystic Emanuel Swedenborg, who, he said, "disclosed [*genomskådade*] the harmony in the universe, the counterparts of the lower in the higher, the unity of opposites, and, like Pythagoras, perceived the lawgiver in the laws, the author in the work, and God in nature, history, and human life" (ss 46:30). Swedenborgian philosophy was only one of a number of sources of inspiration for Strindberg in the post-Inferno period, and Part II of the study—"The Remaking of the Artist"—is devoted to analyses of the ones I believe influenced him most in his investigation of new ways of seeing and in the recovery of his faith in the imagination.

Investigating Strindberg's renewal as an artist means exploring the evocative meanings called up by his "visions" both before and after the Inferno period, and in whatever context they occur: plays, stories, paintings, or letters. It means attempting to

define the way he saw and sensed things with his painter's eye and Romantic's conscience: the intimate relationship he perceived between human beings and nature; his instinct that history was not a static series of moments or tableaux but a continuous process, always to be questioned for its purpose; his awareness that language tended to remain dependent upon image and metaphor, to remain stubbornly figurative, despite his own forthright, "scientific" attempts to make it function otherwise; and finally, his abiding faith in the continuing power of that ancient image language—myth—the "inexhaustible mine of divine human symbols," as Goethe described Greek mythology in a passage marked in Strindberg's copy of Goethe's autobiography.[13]

I

THE MAKING
AND UNMAKING
OF THE ARTIST

1 / The Nature of the Artist: Romantic Legacies and Archetypal Images

This butcher, imagination, wastes not time with niceties: it clubs the fact over the head, quickly it slits its throat, and then with its bare hands, it pulls forth the guts. Soon the guts of facts are everywhere, the imagination is simply wading through them. By the time the imagination is finished with a fact, believe me, it bears no resemblance to a fact.
— Philip Roth, "This Butcher, Imagination"

"Pangs of Conscience": Precursor of The Father

STRINDBERG'S COMING OF AGE IN THE EARLY 1870S CO-incided with the launching of what has come to be called the Modern Breakthrough (Moderna genombrottet) in Scandinavian literature. Spearheaded by critics like Georg Brandes, who gave the movement its name, it encouraged a candid, trenchant, cosmopolitan realism in national literatures that had long been traditional, conservative, and parochial, and it spotlighted, for the first time, the often cruel, oppressed lives of ordinary people — workers and farmers — rather than of members of the privileged classes.

Among the foreign models that Brandes urged Scandinavians to emulate were the French Naturalists, especially Zola, and among those to avoid were Romantics of any national origin. The Naturalists were appropriately objective for the new scientific age; the Romantics, subjective and decadent. But contradictions soon appeared in this rationalistic argument. While Zola preached Naturalism, he suffered from the same fever that afflicted Strindberg and others, complaining of being "gangrened by Romanticism to the marrow."[1] And Brandes's anti-Romanticism was intellectual; emotionally, he felt otherwise. "It is good that no one knows," he

wrote to his parents in 1879, "that I, the official mortal enemy of Romanticism, am a thoroughgoing Romantic."[2]

The difficulties Strindberg had in shaking off the malady of Romanticism are nowhere clearer than in the long short story "Pangs of Conscience" (1884). It demonstrates how, despite his scientistic ambitions, he found it necessary in his art to resort to the figurative language from Romanticism's "flower-bedecked trough," to the images and literary devices that he purported to despise as frivolous, as mendacious "adulterations" (ss 16:50). His realistic, faithful observations of nature take on another dimension as they glide into metaphor and personification,[3] into mythic evocation and dream. In a letter to writer friend Jonas Lie after "Pangs of Conscience" was finished, he confessed, "Do you know what, Lie? I've discovered that I'm not a realist! I write best when I'm hallucinating! The whole [story] . . . is only visions!" (Brev 4: 180–81). It is with these "visions" and their implications in the full range of his art—his drama as well as his storytelling—that we begin our discussion. Though he sometimes regarded the writing of prose fiction as primarily a demeaning means to an end—a way of subsidizing his ambitions as a playwright—that same fiction often served as a seedbed for the plays and a laboratory for experimenting with aesthetic problems that had a bearing on his overall development as an artist. "The secret about all my stories, novels, and fairy tales," he wrote in 1907, "is that they are plays. When theatres were closed to me for long periods, I hit upon the idea of writing my plays in epic form—for use in the future" (Brev 16:11).

"Pangs of Conscience" signaled a momentary return of Strindberg's faith in imaginative writing after a period during which his confidence was shaken. Having persuasively established his literary credentials as a serious talent with the 1879 publication of the novel The Red Room and the premiere two years later of his first important play, Master Olof, he managed in 1882 to alienate most conservatives in the country with a stinging volume of polemical essays, The New Kingdom. In it, he ridiculed hypocrisy and corruption in almost every hallowed institution in Sweden from the monarchy to the church to big business to the Royal Dramatic

Theatre. By the fall of 1883, the hostility he had engendered persuaded him to take his family abroad on a journey that became a six-year exile.

While he was pleased with the story, it also surprised him. What had started as a straightforward, polemical, pacifist broadside in fictional form had turned into something quite different and was to cast long shadows on his subsequent writings, anticipating, in its handling of basic themes and images, plays as pivotal in his career as *The Father* (1887), *Miss Julie* (1888), *To Damascus* (1898), and *A Dream Play* (1901).

The story is set during the Franco-Prussian War in Marlotte, a small French village near the Fontainebleau Woods outside Paris, where a young German officer, Lieutenant Bleichroden, is stationed with his troops. Appalled by the horrors and injustices he witnesses, Bleichroden is torn by an inner conflict between his pacifist real self and the role of warrior that he has assumed only reluctantly. His most difficult test comes when he is given what he considers a terribly arbitrary and unjust order: the execution of three French snipers. Although the men had been captured wearing uniforms, they are to be denied the rights of prisoners of war because they were not officially registered in the French army. Bleichroden avoids witnessing the execution by assigning the task to a subordinate and then taking a special detail on a reconnoitering ride into the Fontainebleau Woods.

Returning to his quarters afterward, he cannot escape an acute sense of guilt. He tries reading but is startled by one of a series of visions: someone appears to be screaming and thrashing about in his bed. What he experiences is what the German Romantics had labeled the frequent result of severe personality conflict: a doppelgänger.[4] "He saw a body whose abdomen was constricted with cramps and whose chest was as tense as the coils of a spring, and he heard a strange, hollow voice screaming underneath the sheet. Why, it was his own body! Had he split in two, since he saw himself, heard himself, as if it were another person?" (SS 15: 195). Suffering a nervous collapse and loss of memory, he is sent to Switzerland to recuperate.

Later, in a hospital near Geneva, he is still so traumatized that he is unaware that his wife has come from Germany to be with him, and that she has just given birth to a daughter, their first child. His condition begins to improve when he is cheered by what he can see through the barred windows in his room. "He didn't know where he was, but it was too beautiful to be on earth. Was he dead and had arrived in another world? This couldn't be Europe! Perhaps he was dead!" (ss 15:204).

From this point on in the story, unfortunately, polemics begin to intrude on the poetry, a fact the author later acknowledged in an 1891 letter.[5] The purpose of "Pangs of Conscience," as the title of the volume in which it appears indicates — Utopias in Reality — was to demonstrate that a utopian society was not only possible but had already been realized in France (he had visited and been impressed initially by a workers' cooperative association — familistère — that he saw in Guise; SS 16:311–36) and was close to realization in Switzerland. Viewing Switzerland in a utopian context put Strindberg in good Romantic, even revolutionary, company. Through much of the eighteenth and nineteenth centuries, the country's neutrality, its harmonious, democratic mix of different peoples and languages, made it a haven for exiles who had suffered repression and a prototype for idealists who dreamed of a world government. Artists other than Strindberg found the glorious landscape irresistible and turned it into a setting for utopian visions. The Alps, says Peter Thorslev, "became a natural symbol for the English Romantics of the organic sublime: not only for Wordsworth and Coleridge, but also for Byron and Shelley. Indeed, one might almost say that had Mont Blanc and the Vale of Chamouni not existed, the Romantics would have had to invent them. Among the glaciers and eternal snows of the higher Alps they were inspired with a vision of a nature which is infinite, all-powerful, and remote from all mankind."[6] For the nature-loving Strindberg, Switzerland seemed, at least for a time, the Promised Land. A later, nostalgic letter records the first impressions it had made on him and his family when they visited from France. As their train descended through the Jura Mountains, he thought he

saw "cloud images of wondrous beauty, but—then the light made clear what they were: the Alps! 'It's heaven!' cried my children. And my wife broke into tears" (Brev 11:271–72).

It was surely no coincidence that Strindberg's last play, his farewell to art, the lyrical *Great Highway*, is set in a rugged Alpine terrain. In the early 1880s, however, Switzerland interested him primarily as living proof of the possibility of radical social reform. "Switzerland is Europe's better self, its conscience," he writes in an 1884 essay. "It survives on . . . a sufferance, bestowed by the universal sense of justice that is not yet alive" in the European conscience (SS 16:148). To arouse that conscience was his purpose with the stories in *Utopias*.

Bleichroden's fever soon disappears in this splendid environment, and he is permitted to leave his room to stroll about the grounds. Another vision, at the hospital chapel (to which we shall return later), restores his memory, and a reunion with his wife, coupled with the first sight of his baby daughter, completes his recovery.

The poet knew that he had accomplished more than propaganda. A May 1884 letter describes the story as "extraordinarily fine" and sees it marking a genuine reconciliation for him with belles lettres (Brev 4:151). Another letter rejoices that the story "is so beautiful that I felt ashamed afterward! Silly fool that I am I cried while writing it!" (156). But his satisfaction was short-lived. A pair of short-story collections published not long afterward, *Getting Married*, I and II, managed to antagonize critics on both the Right and the Left, dooming his prospects as a writer for some time to come. The first volume (a project concurrent with "Pangs of Conscience") infuriated conservatives with its candid realism, especially about sex, and with an allusion that suggested that Jesus was a political radical. The second volume alienated liberals and radicals by questioning and criticizing the tactics and goals of the incipient women's movement. Forced to stand trial on charges of blasphemy (for the allusion to Christ), he was acquitted, but everything was in ashes. Publishers turned their backs on him, and the resulting financial strain of trying to support a family

while traveling abroad contributed to the eventual breakup of his marriage. The trauma of the trial and its aftermath took a heavy toll: his faith in both politics and art was diminished.

Nothing was more relentlessly anti-Romantic than Strindberg's harsh and unjust attacks against those whom he considered his principal tormentors: advocates of the women's movement. His imagination worked feverishly to construct what he saw as a giant social conspiracy, begun centuries earlier in the age of chivalry, to turn woman into an idealized creature, free from blame. During the late 1880s, as earlier Strindberg scholars have documented thoroughly,[7] the conspiracy theory became an idée fixe, damaging his career, his marriage, and his life. His strident, often cruel, polemical attacks on organizations and individuals were among the more shameful activities in his life and in large measure responsible for the reputation as misogynist that he subsequently received.

Throughout Strindberg's life, he was never able to completely resolve painful inconsistencies in his relationships with women. When he recovered his creative powers in the late 1890s, he revealed his true colors: rather than hate women, he loved them all too much and not very wisely. On the one hand, as a progressive thinker on social issues (especially in the early 1880s) he regarded women as fellow partners in the struggle for equal rights for all social classes. On the other hand, he was as guilty of placing hopelessly idealistic demands on them as the conservative society he excoriated; when the idols acted like ordinary human beings, defending themselves against injustice and oppression, they became tainted in his eyes. But of course these inconsistencies were not uncommon in the period. "Virulent misogyny," says Bram Dijkstra in his *Idols of Perversity*, "infected all the arts to an extent understood by very few specialists in the cultural history of the turn of the century—perhaps precisely because it was so endemic and therefore so completely taken for granted by everyone."[8] To Strindberg's credit, he did sense incisively what is now recognized and acknowledged a century later: that resolving the many contradictions in the battle of the sexes was no simple task. And

there were no simple heroes or villains in the battle. Though a character like Laura in The Father behaves brutally toward her husband, it can be argued that she is simply a mother trying to hold on to her child and forced to use terrible means to accomplish this at a time when only men possessed civil rights.

The significance of The Father—the first Strindberg play to reach an international audience—is seen in a new light when we recognize that it came three years after "Pangs of Conscience," and that the same themes dealt with in the story are explored in darker, more tragic variations in the play. It may seem heresy to assert a connection between the two works. For almost a century The Father has been viewed narrowly as an accurate portrait of the playwright and his personal problems at the time he wrote it in 1887. Accordingly, when the hero begs his wife not to drive him insane, he is really the playwright, worried that his own wife will push him over the brink. (The latest edition of the standard Swedish work on Strindberg's plays, in a sample of extreme biographical criticism, labels The Father and Miss Julie "warning dramas" numbers two and three to his wife, Siri von Essen.)[9]

Whatever story and play reveal, separately or together, about Strindberg's private life, they contain striking similarities in character, plot, and even phrasing. The hero of the story is a lonely German cavalry lieutenant stationed in France; the hero of the play is an unhappy Swedish cavalry captain stationed in a dull provincial outpost. Each is a geologist (the first by profession, the second by avocation), is married, and has one child, a daughter. Each suffers internal stresses that lead to a mental breakdown. In the lieutenant's case, "all the operations of his soul lay as if ground to a pulp in a mortar. Thoughts tried to crystallize, but dissolved instead and floated away" (ss 15:187). In like manner the Captain complains: "my thoughts dissolve into mist, and my brain grinds emptiness until it catches fire!" (ss 23:93).

Even the different fates of the characters are illuminating. Although both men have breakdowns, the lieutenant recovers and the Captain suffers a crippling stroke. What restores Bleichroden is being reunited with his wife and seeing his daughter. What de-

stroys the Captain is his failing marriage and the suspicion that his daughter, Bertha, might not be his child. In story as well as play there is an echo of the Romantic nostalgia for a return to a sense of oneness in a world of painful contraries and dualities. The nature of the nostalgia is defined in Strindberg's autobiography, *The Son of a Servant Woman*, written between the story and play, in a passage describing how a young Overclass man will seek "a girl of his own class in order to feel complete. . . . [H]e sought in her the unconscious, with which he could experience a new version of the 'golden' time of childhood" (ss 19:130).

Before the lieutenant met his wife, he was a disillusioned idealist, ready to compromise with life and retreat from its demands. Afterward, he felt integrated: she had become his alter ego, "his old, emotional self"; "in her he found his complement and began to pull himself together." When they were separated by the war, "he felt as if he were missing one of his eyes, one of his lungs, one of his arms." The first sight of his new daughter reconciles Bleichroden with the whole human race. He felt "that he would not perish, even when he died, because his soul would continue to live in the child. He felt, in a word, that his soul was truly immortal" (ss 15:216, 217). In *The Father* a marital quarrel provokes from the Captain an expression of bitter disappointment: "When you and I became one," he tells his wife, Laura, "I thought I would become whole" (ss 23:66). His subsequent anxiety over Bertha—"she was my immortality" (63)—turns disappointment to despair, and the physical sense of loss he experiences is expressed in the same terms as Bleichroden's. "I grafted my right arm, half my brain, half my spinal cord onto another stem, because I believed they would grow together and unite into a single, more perfect tree. Then someone came along with a knife and cut below the graft. . . . Now I want to die" (85).

Each man comes to a realization that his struggles are with forces both external and internal, metaphysical as well as psychological. When Bleichroden walks alone in the Fontainebleau Woods, his thoughts are muddled by the execution about to take

place back in Marlotte: "memories, hopes, grudges, tender feelings, and a single, enormous hatred of all the perversity, which through some inexplicable natural power had come to govern the world, fused together in his brain" (ss 15:187–88). As the Captain in The Father lies dying, he asks: "What power rules over our lives?" Laura urges that he acknowledge biblical authority—"God alone rules"—but he argues that more archaic forces must be in control: "The God of strife then—or nowadays the Goddess! . . . Omphale! Omphale! You cunning woman who so loved peace you invented disarmament. Wake up, Hercules, before they take away your club!" (ss 23:93–94).

The world inhabited by the lieutenant and the Captain bears a strong family resemblance to the Gothic universe created by Romantics like Schiller and Byron, a universe, according to Peter Thorslev, that "represents a reversion to mythic ages more primitive than those represented by the great world religions . . . ; when the gods were presented . . . as capricious, vengeful, and only intermittently and often maliciously concerned with the plight of man." [10] More so than Bleichroden, the Captain repeats, in a new form, the defiant stance taken against a hostile and perplexing universe by Schiller's Karl Moor and Byron's Manfred, characters with whom Strindberg long identified. [11]

The Captain works in his spare time on experiments that he hopes will advance scientific knowledge into outer space, and he resists his brother-in-law's efforts to talk about religion, because he no longer believes in it. Like Bleichroden, however, he is torn between opposing feelings: on the one hand, an urge to reach for the stars and, on the other, a feeling that he is rooted to the earth, inextricably bound to a comforting but also suffocating matrix whose power he acknowledges but cannot quite comprehend. As in "Pangs of Conscience," there is also the suggestion of the emergence of a doppelgänger to express the protagonist's inner division. The Captain's daughter reports a strange experience she had in the house while her father was out riding, as if she heard the sounds of a child in need of its mother.

BERTHA: I heard someone singing up in the attic.
MARGARET: In the attic? At this time of night?
BERTHA: Yes, and it was so sad, the saddest song I ever heard. It sounded like it came from the storeroom, you know, to the left, where the cradle is. (SS 23:51)

At the end of the play, as the Captain lies dying in the arms of Margaret, his old nurse, he has indeed been reduced to a child, back in his surrogate mother's arms—Byron's Romantic hero transformed by Naturalism and late-nineteenth-century psychology.

Strindberg himself might have argued that the crucial difference between "Pangs of Conscience" and The Father was in intention. When he wrote the first work, he still had faith in social solutions to world problems; by the time he wrote the second, the loss of that faith turned his interests to psychological problems. The story was intended to serve rational, polemical purposes, while the play came about almost unconsciously, leading him to confess that he was not sure where it began and his own life left off (Brev 6:298).

Rousseau, "Natural Man," and the Doppelgänger

Rousseau's influence has been noted as the inspiration for Bleichroden's psychic problems, particularly in connection with the distinction Strindberg drew at this time between "cultural man" and "natural man." [12] Cultural man is incapable of fulfilling his natural destiny because of the encrustations and impediments of civilization. He is alienated in the profoundest sense of the word: from nature, from his fellow men, and from himself. Bleichroden's doppelgänger vision is only the inevitable result of the terrible schism between his natural and cultural sides.

There are implications in the story, however, that extend beyond the nature-culture conflict. Rousseau's discussion of the same dichotomy is so often oversimplified into the slogan "Back to nature!" that it is worthwhile remembering that he never actually coined it; [13] it obscures the subtlety of other distinctions he made. Rather than pose a simple solution, he described, more eloquently than anyone who preceded him, the complex charac-

ter of the problem. Man was tragically split, he insisted, not only between his natural instincts and his duty to society but between such elemental forces as reason and passion.[14] If Strindberg began "Pangs of Conscience" with "Back to nature" as his point of departure, he concluded by raising much more complicated questions about the dualities in human nature, thus drawing closer to the true implications of Rousseau's insight. It was a momentous step, for it led him eventually to challenge basic assumptions about the role of character in drama.

"La multiplicité du moi" was a popular theme in the late nineteenth century for psychologists and writers alike. Nietzsche wrote that the individual is "an assemblage of fragments artificially brought together by the mind, in a 'unity' which cannot stand up to examination."[15] In the same spirit, Strindberg widened his own exploration of character division to propose that human character is fatally fragmented, a crazy quilt of contradictions. "My souls (characters)," he writes in the preface to Miss Julie (1888), "are conglomerates of past and present cultural phases, bits from books and newspapers, scraps of humanity, pieces torn from fine clothes and become rags, patched together as is the human soul" (ss 23: 104). This concept of character as patchwork was some time in developing. Four years earlier, in a letter written just after finishing "Pangs of Conscience," Strindberg had described attempting to untangle his own "rat's nest of a soul—where tatters of Christianity, shreds of art-worshiping paganism, slivers of pessimism, [and] splinters of common cynicism lie helter-skelter. . . . I'm obsessed by all of them—asceticism, epicureanism, Pietism, and pessimism; it's as if I'd burst in two, and everything was spilling in one giant chaos" (Brev 4:144).

The landscape depicted is strikingly modern and apt: the artist's mind as littered with the flotsam and jetsam of Western civilization, cracked ideals and sundered icons. But, like the pack rat that the artist feels compelled to be, he has only half-abandoned them all—you never know when, or how, they might come in handy. This is one of the keys to Strindberg's art, an explanation of why in a play like Miss Julie, for example, he can mix, in almost equal

parts, Darwinian Naturalism, Swedish folklore, Schopenhauerian pessimism, 1880s' psychological and political theories, Old Testament judgments, and New Testament mysticism. The mix was heady and powerful enough to inspire Sartre (in No Exit) and Genet (in The Maids), and not until Beckett's Waiting for Godot do we find an equally audacious use of Western civilization's flotsam and jetsam anywhere else in modern drama.

The division and alienation involved in the concept of personality doubling imply a search for reconciliation, a search that is satisfied in "Pangs of Conscience." For the Captain and Miss Julie, however, it is too late. Though each is torn by a longing for reconciliation, neither has sufficient willpower to compete effectively in the struggle for survival. A decade after Miss Julie, Strindberg created his most comprehensive and revolutionary variations on the doppelgänger theme in To Damascus, variations that helped to launch German Expressionism. There, doubles serve as fragments of the central character that spin away from him at the beginning of the play, when he feels lost and alienated, and return again at the end, when he seeks an end to alienation. And once again, as in "Pangs of Conscience," the distraught hero, called simply "Den okände" ("The Stranger," but also literally the "Unknown One"), is undergoing a severe psychospiritual crisis the symptoms of which are feelings of personality fragmentation that are expressed in the same kinds of images of physical fragmentation and loss we see in both the story and The Father. "It seems to me," says the Stranger, "as if I lay chopped to pieces in Medea's cauldron and were being boiled slowly. I'll either turn into soup or rise up rejuvenated out of my own bouillon! It all depends on Medea's skill" (ss 29:23). Like Bleichroden, the Unknown One finds his way back to wholeness through reunion with a woman and the birth of a daughter.

Mal de Siècle and Weltschmerz

Through most of "Pangs of Conscience" we are given little information about the various internal forces Bleichroden feels are

pulling him apart. Only after his recovery do we learn, in any real
detail, about his past:

> Great-grandson of the French Revolution, grandson of the Holy Alli-
> ance, son of 1830, he was shipwrecked between the rocks of Revolution
> and Reaction. When he woke up to life at twenty, the veil fell from his
> eyes to reveal the web of [social] lies in which he was entangled, . . .
> [and] he felt as if . . . he were the only sane person confined in a mad-
> house. . . . [When he could see no way out,] he ceased to believe in
> anything, even in deliverance [from the madhouse], and threw himself
> into the opium dens of pessimism, which would at least deaden the
> pain for which there was no cure. Schopenhauer became his friend,
> and later he found in [Eduard] von Hartmann the most brutal truth-
> sayer the world has known. (ss 15:215–16)

It is tempting to read autobiographical revelation in the little
portrait. Strindberg, too, saw himself as an heir to the Revolution,
woke to despair over the world of lies in which he found himself,
and turned to Schopenhauer and von Hartmann for solace. But I
think it more important to view Bleichroden as an early sketch for
a prototypal central character to which Strindberg would return
many times in his career, from the Captain in *The Father* to the Stu-
dent in *The Ghost Sonata*. The character suffers from a malaise that is a
hybrid of two earlier Romantic strains: French *mal de siècle* and Ger-
man *Weltschmerz*. In each instance the afflicted individual endures
tensions that are difficult, perhaps impossible, to resolve or recon-
cile in this world. Musset expressed the anguish of the first in his
Confession d'un enfant du siècle (1836), depicting "his age as one with-
out faith or hope," one in which the past was "irretrievably gone,
the future nowhere near." [16] *Weltschmerz* found an eloquent advo-
cate in Heine, who stressed that "inner division" (*Zerrissenheit*) was
a necessity: "The world is torn in two, and as the poet's heart is the
center of the world, it must be torn pitiably in this present age." [17]

The opposing instincts that the Strindbergian Romantic hero
shares with his German kin are, on the one hand, a will to assert
a strong, skeptical, independent individuality and, on the other, a
longing to identify with some absolute vision, a longing (as Peter

Thorslev defines *Weltschmerz*) "for some intellectual and moral certainty, ranging from positive commitment to an orthodox creed, to a mystic conception of oneself as a part of a living organic universe." [18] Though Bleichroden had "ceased to believe in anything," it is significant that the immediate catalyst for his recovery is not a moment of intellectual enlightenment in democratic Switzerland but a spiritual experience in a churchlike setting. And though the Captain proclaims himself a nonbeliever ("I don't believe in it [Bertha's confirmation], but I have no intention of being a martyr for the sake of truth"; ss 23:16), he dies cradled in the arms of his old nurse, muttering the angel Gabriel's greeting to Mary (Luke 1:28): "Blessed art thou amongst women!" (ss 23:95).

With his French kin, the Strindbergian hero has in common what appear to be two hopelessly contradictory categories of interests: socialism and history on the one hand and religious mysticism and the revival of myth on the other. The interest in history is not in history as a static pattern but as an evolving search for justice in an unjust existence. Socialism becomes the end point of the process, the most practical means for redeeming history from injustice. Myth, often regarded as the diametrical opposite of history, a way of escaping from the demands of objective reality, became for Strindberg, as it did for many Romantics, a means of questioning the objectivity of that reality by returning to ancient insights that they felt transcended historical determinism. French Romantics, particularly, believed that history, no less than any other form of literature, rested on assumptions contained in mythic images, and that the artist's task included evoking those images. [19] This confluence of contradictory interests offers a partial explanation of how different kinds of Romantics throughout the nineteenth century could mingle—perhaps muddle, from a modern vantage point—religion and politics, how Jesus could become a socialist. Both the Germanic conflict between individual and Absolute and the French interpenetration of insights and disciplines are evident in Strindberg's handling of nature and natural events in "Pangs of Conscience."

Nature and the Naturalizing of Christ

No subject in Strindberg's works is as pervasive, as subsuming of his interests—artistic, political, psychological, and mythic—as nature. The polemical Strindberg may have emphasized the political meaning in "Back to nature"; the poet embraced all its implications. In art he professed to be nature's faithful imitator, whether working as a Naturalist or a Symbolist; in politics and psychology he championed nature and natural instincts over the constraints of the law or mere social convention; and in myth he sensed a tool for rendering nature more suggestive and poetic by blurring the lines separating the natural and the supernatural and by personifying the abstract concept of nature into the living being Nature. Implications involving all these interests—mimesis, ideology, psychology, personification, and myth—come into play in "Pangs of Conscience."

Like many of the Scandinavian writers and painters who went to France for inspiration in the 1870s and 1880s, Strindberg loved the countryside depicted in the story. References to a familiar feature in it appear in several of his writings: espaliered grapevines nailed up on trellises to grow in patterns suiting the grower's purposes. The tortured vines came to represent for him civilization's corruptive influence over nature. In a polemical essay, "The Universal Discontent: Its Causes and Cures," written the same year as "Pangs of Conscience," he asks, "When is the joy of life greatest for cultural man? Between the ages of fifteen and twenty-five, just as the sap is rising, and before society has had time to clip, trim, and espalier the young plant" (ss 16:94). In another story, "Relapse"—also part of the Utopias in Reality collection—a man visits vineyards in late winter. Vines nailed to dead walnut trees seem "like whole forests of Golgothas. To these dead stems, young vine runners, brimming with life, were 'married,' as the Romans called it. Within a month, these black, terrible, imprisoned corpses of old trees would be clad in fresh vine leaves" (ss 15:138).

In "Pangs of Conscience" similar allusions to Golgotha make

vine and Crucifixion imagery function together like a ground bass. At the opening, as Bleichroden sits at his desk writing to his wife, his eye is drawn to a curious sight in the garden outside:

A gnarled old grapevine was perched on the wall; lacking both leaves and grape clusters, it was like the skeleton of a mammal in a museum ... and hung as if crucified from the nails that attached it to the rotting espalier. As it reached out with its long, tenacious arms and fingers, it seemed ready to grab the sentry in an iron grip each time he passed it on his rounds. (SS 15:178)

When the lieutenant returns to Marlotte after the execution, it is with a sense of dread, that curious mixture of fear and fascination. He feels a strong desire "to see where 'it' happened" (SS 15: 190), and so he goes back to the same garden. What he encounters in the moonlight is another startling vision. The old grapevine has been transformed.

What's this? Two, three hours ago it was dead, leafless—just a gray carcass, twisting convulsively. Now, beautiful red clusters hung from it, and the vines themselves had turned green! He went closer to see if it was the same grapevine.
Near the wall he stepped in something sticky and sensed the suffocating, repulsive stench one finds in slaughterhouses. He could now see that it *was* the same vine, the very same one, and the stucco on the wall behind it was bullet-riddled and spattered with blood. So this is the place! This is where "it" happened! (191)

The personified vine that first implied Nature seeking revenge, France seeking revenge, now evokes a reminder of the Resurrection. And the lieutenant experiences these events as both internal and external; they take place as much in the landscape of his imagination as in the French countryside. In this dual setting images of Christ and Crucifixion continue to pursue him like hounding furies.

Fleeing to his quarters, he pulls off his bloodstained boots and finds his table set for dinner. Although hungry, he cannot eat; the red colors of the food—the lamb (another Crucifixion image), the

radishes, the wine—turn his stomach. When a servant woman stares at his feet, he realizes to his horror that though his boots are off, he has left red tracks across the floor. The long march he took that day had worn his stockings through and made his toes bleed (ss 15:192–93). Like another military man, Pontius Pilate, he cannot escape the sight and the sense of blood.

The sounds of two corporals talking about the execution in an adjoining room tempt him to eavesdrop. What he overhears seem like distorted echoes from the scene on Golgotha: "They were tough boys, the two short ones, but the tall one was frail. . . . He asked us to fasten him to the trellis so he could remain standing" (ss 15:193).

Christian Imagery versus Indic Imagery: Transformation, Metamorphosis, and Mythopoesis

When Strindberg at this point in the story has Bleichroden turn to a copy of Schopenhauer's *Parerga und Paralipomena* as a way of blotting out the terrible memory, the mythic pattern shifts modes. Up to now, although the lieutenant had long ago "ceased to believe in anything" (ss 15:216), references to Christ, though implicit rather than explicit, are unmistakable and ubiquitous. A passage cited from Schopenhauer abruptly veers the focus away from Christian optimism to Indic nihilism.

Birth and death are both parts of life. They counterbalance each other. The one presupposes the other. . . . This is precisely what the most profound of all mythologies, the Hindu, expressed through the symbol that is the attribute of Siva (the Destroyer): a necklace of death's-heads and the lingam, the organ and image of procreation. . . . Death is the painful unraveling of the knot that is tied in sensual pleasure at the moment of conception. It is the violent destruction of the fundamental error of our being; it is the removal from delusion. (194–95)[20]

The greening of the vine has apparently offered Bleichroden two profoundly contradictory meanings: a comforting hope evoked

by the Christian message of resurrection and reconciliation in the face of death and despair, and a somber resignation urged in the face of "the violent destruction of the fundamental error of our being." Implied, too, are the polar opposites of Strindberg's own religious philosophy. Time and again, throughout his career, he found himself pulled painfully between a stern, salvation-oriented, Christian faith, which had been imbued through his Pietistic upbringing, and a dark, innate, pessimistic skepticism reinforced by his readings in Schopenhauer and von Hartmann. Typically, the two viewpoints emerge in his art through references to the mythic traditions mentioned: faith through biblical allusions (especially to Christ), skepticism through references to Schopenhauer and to the Indic images found in what Schopenhauer described as "the most profound of all mythologies." The richest example of a blending of the two is *A Dream Play* (1901), where the descent to earth of the daughter of the Vedic god Indra is likened to Christ's, and her ascent to heaven to a removal from delusion.

Schopenhauer's preference for Indic images, evident throughout his philosophical writings, was a reflection of the profound impact on Western civilization of the "Oriental Renaissance," the grandiose term (coined by French Romantic Edgar Quinet in 1841) that described the surprise, delight, and respect felt by many Europeans at the first widespread appearance in translation of Asian literary, religious, and philosophical texts—it was like the discovery of the existence of the other half of the human imagination. Strindberg was one of the artists who passed this respect on to the twentieth century (Antonin Artaud would stage two of his plays with strong Eastern themes, *A Dream Play* and *The Ghost Sonata*), although in his own time, the critical climate was often hostile to this kind of cultural invasion. In 1875, for example, Danish critic Georg Brandes took British poet Robert Southey to task for "allowing his imagination to take the wildest oriental flights. . . . The oriental tendency is common to Romanticism [everywhere]."[21] By the mid-1890s, as we shall see, renewed ex-

posure to the imaginative power of the Oriental Renaissance was to play a key role in the gestation process that enabled Strindberg to recover his capacity to function as a creative artist.

Bleichroden's turning to Schopenhauer does not bring him the peace he seeks; indeed, it seems to heighten his anxiety and precipitate the appearance of the doppelgänger. In the hospital in Switzerland the mythic mode reverts again to Christianity: the ceiling of Bleichroden's room is painted to resemble a "trellis with vine leaves," and he imagines in his delirium that he is in prison awaiting execution for having "murdered a vineyard man under mysterious circumstances" (ss 15:201, 202).

The event that triggers the chain of associations leading from vine to Christian myth to Indic myth and back to Christian myth again is of course the fascinating transformation of the vine, nature's movement from one phase of life to another. These kinds of movements grab our attention because they immediately engage the imagination, as surely as the flames in a fire or the ripples in a brook. Kant, in his *Critique of Judgment*, had important insights into this process, as James Engell has summarized:

Whatever in nature is in process, in the act of moving, changing, evolving to another state, transforming and metamorphosing, whatever undergoes any kind of sea-change, draws the eye of the imaginative power to it. And then the imagination, as it produces poetry or art, not only imitates the object it sees but imitates the actual process of change, the force behind the change and the full context of it.[22]

No matter how strong Strindberg's political intentions were when he began writing the story, no matter how sincerely he saw his role as nature's objective, scientific observer, everything is made suddenly subordinate to the magisterial authority of his imagination. A decade later, his return to writing after a fallow time would follow the same course, as his imagination obeyed a process beyond mere surface observation, responding to the enchanting power of metamorphosis.

Some Romantics had what amounted to a reverence for the

response of the imagination to nature, defining a difference between *natura naturata*, the imitation of outer forms, and *natura naturans*, the imitation of "the inward, creative, and organizing spirit of nature." [23] Coleridge warned that "if the artist copies the mere nature *natura naturata*, what idle rivalry! . . . [He] must master the essence, the *natura naturans*, which presupposes a bond between nature in the highest sense and the soul of man." [24] This bond provides a coherence that is the key to the power of mythopoesis. "To think the world as a whole," says Karsten Harries, "is to engage in mythopoeic poetry." [25] Bleichroden may be a scientist, but he learns that his relationship with nature is not one of scientist to specimen, "I" to "It," but creature to fellow creature, "I" to "Thou." In mythopoesis human experience and natural phenomena, the mundane and the cosmic, the historical and the mythic, are not separate, independent elements but coexisting, interacting forces in one grand process, one continuous drama.

In the mythopoeic world of Strindberg's fiction and drama, everything has a role to play, whether animate or inanimate. When the lieutenant is hospitalized, the door to his room blends with the background, thereby "removing any thought the patient may have of finding an exit" (SS 15:202); similarly, the door to the Captain's room in *The Father* is covered with wallpaper, making it invisible. In each case there is the implication of a private prison fabricated by the imaginings of a sick man. Articles of clothing, too, perform special functions, not only in "Pangs of Conscience" and *The Father* but in *Miss Julie* as well. Bleichroden's uniform greatcoat is the badge of his cultural identity; when he dons it, he can issue the orders his natural self despises. The Captain's uniform tunic also represents ambivalent feelings, but different in kind from the lieutenant's: it is both the shield of masculinity that he feels is threatened and the life he has wasted in devotion to a dreary sense of duty. Both shield and devotion to duty become tragically ironic when he is tricked into putting on another garment by his old nurse: the straitjacket in which he dies. *Miss Julie* contains an example of a metaphorical straitjacket: the livery worn by Jean, as a

servant. When he changes from his street clothes into his livery in the final scene, he is unable to tell Julie what to do when it appears that her father will discover their tryst: "It's as if this coat makes it impossible for me to order you to do anything" (SS 23:185).

Strindberg knew he had accomplished unusual things in "Pangs of Conscience" but was only dimly aware of their implications. Careful nature observer that he was, it is hard to believe that he could have Bleichroden distinguish red grapes and green leaves by the light of the moon, which transforms all colors into grays and blacks. He was obviously carried away by his imagination, which he admits in the letter cited earlier. "The whole [story] . . . is only visions!" Whether a vision or not, however, the transformation of the vine is believable in the organic context of the story; nature's process is convincing.

The heart of that process is the metamorphic cycle of death in the midst of life and life in the midst of death that is indicated in the fates of the snipers and the resurrection of the vine, which in turn evokes the awesome symbolic power of the Passion. No single passage illustrates more clearly Strindberg's Romantic roots. With an ease and fluidity akin to changing keys in music, he moves through a full range of figural effects, from simile to metaphor to personification to mythopoeic resonance. And the figures are not imposed upon the material from without; they arise, as if from necessity, from within, as natural element and mythopoeic resonance become one.

Moreover, the distance from the mythopoeic to the mythic or mythological is short, as is made clear in the ease of connections made between Bleichroden's sense of guilt, the transformed vine, and Christ. Strindberg scholars and critics are agreed that he was keenly interested in myth throughout his life, sometimes to the point of apparent obsession; where they disagree is on its significance. Gunnar Brandell, for example, takes a dim view of it. In his important study of the playwright's traumatic Inferno period Brandell sees the interest in myth as reflecting psychological problems. "Whenever his situation seemed unbearable," says Brandell,

"Strindberg defended himself by resorting not to doctrines, but to mythological representations."[26] Ulf Boëthius, on the other hand, sees the choice of mythic references as determined by different political intentions. For example, at the time Strindberg wrote the history play *Master Olof*, says Boëthius, his liberal-radical sentiments led him to sympathize with the rebels in the ill-fated Paris Commune of 1871; thus the name of that arch-rebel of myth, Lucifer, figures prominently in the play. But when he wrote *The Father* fifteen years later, Strindberg had become a political conservative, and so the purposes of allusions in the play to Hercules and Omphale were "to twist weapons from the hands of the 1880's feminist movement and to defend the masculine society."[27]

Boëthius's reactions in particular are typical of the biographical-allegorical approach to Strindberg: finding meanings exclusively in the author's assumed personal motivations. No one can argue that biographical sources were not a vital part of his creative processes, but to make them the primary elements in interpretation—to the exclusion of other factors—is to strip his works of more subtle, even contradictory meanings. As Strindberg uses them, the mythic images are no more irrational or ornamental than metaphors, personifications, or "visions." They are, quite simply, literary choices: partly conscious, partly unconscious, almost always ambiguous responses by the artist's imagination to the demands of his central themes.

Another approach to Strindberg's use of myth has been archetypal, bringing to bear the insights of depth psychology to evoke a variety of modern meanings in ancient myth.[28] Swedish critic Horace Engdahl has argued that the metamorphic process at the heart of mythological thinking undermines the usefulness of an archetypal approach.

The crux of the problem lies in the mythological reading that insists on one story or ritual procedure as primary, thereby lifting it out of an endless chain of transformations and giving it the status of original source or model. . . . Structuralist theory has at least tried to make clear . . . that there is no first or "true" structure that stands outside the interplay of similarities and differences.[29]

Engdahl is quite right to protest the use of any *single model* in interpretation, whether that model is biographical-allegorical or archetypal. The play of contradictions between Christian and Indic myth in "Pangs of Conscience" must discourage any simplistic archetypal approach. In a story like "Pangs of Conscience" myth and metaphor are convincing, integral elements, because they seem to arise as natural, ambivalent responses by the protagonist to the confusing, fascinating, frightening metamorphic flux of life. "Mythology and poetry," said the German Romantic Friedrich Schlegel, "are one and inseparable. . . . Everything interpenetrates everything else, and everywhere there is one and the same spirit, only expressed differently."[30] That interpenetrating spirit dominates "Pangs of Conscience," relating man to nature, nature to society, society to the course of history, and the whole to language. Indeed, Strindberg's strongest instincts seem to lead him toward a new, experimental kind of amalgam, where the lines between the separate elements dissolve, and the richness created by the resulting contradictions is a richness not only of theme but of language and of language's possibilities, a richness of text.

History and Christian Typology

The implications of another of Strindberg's abiding interests—history—are only suggested in "Pangs of Conscience." A decade earlier, the obvious sympathy he showed in his history play *Master Olof* for radical social change, for revolution, had made him a hero to many like-minded intellectuals, but an anathema to the conservative establishment. By the time he wrote *Utopias in Reality* in 1884, he was skeptical about the possibility of revolution. But radical change was still a high priority for him, and he attempted to demonstrate in the stories about Switzerland both the necessity of change and the real prospects for such change taking place. Instead of any overt support for revolution, he reiterates its aims in another vision, this one experienced by Bleichroden as he lies ill in the hospital, tormented by the injustice of a world that forced

him to have the three snipers executed. A frenzied plan comes to mind to remedy the situation, save humanity, and redeem history:

"What's the purpose of all our earthly strivings?" he asked himself. "Why does the king reign, the priest preach, the writer create, the painter paint? To be able to procure nitrogen, of course. Nitrogen was the most expensive of all nutrients, which was why meat was the most expensive food. Nitrogen was intelligence, and so, rich people, who eat meat, are more intelligent than people who eat mostly carbohydrates. The world was running short of nitrogen, a situation that gave rise to wars, strikes, newspapers, Pietists, and state subsidies." A new source of nitrogen had to be discovered, and Bleichroden had discovered it. Finally, all men would be equal; freedom, equality, and brotherhood would become a reality on earth. This new, inexhaustible mine was the air, which contained 79 percent nitrogen. A way must now be discovered to enable lungs to transform nitrogen directly into nourishment for the body. . . . [If this problem could be solved,] agriculture and the raising of livestock would become superfluous and the Golden Age be restored on earth. (SS 15:202–3)[31]

Underscored is the difficulty of separating man's psychological problems from his social problems. Bleichroden's worries over his own sanity are intertwined with his concerns over a world where misery and want prevail. And as always, Strindberg's choice of images is crucial to his intentions. The French Revolution's "freedom, equality, and brotherhood" and the Golden Age of myth are made to harmonize with and complement the other references to Christ and the Christian message in the story. If this combination seems contradictory to modern readers, we need to understand Strindberg's approach in its historical context.

Perhaps because, as John Updike noted, ours "is a generation not raised on the Bible,"[32] critics and scholars are divided over how to interpret Strindberg's preoccupation with biblical imagery. He belonged to quite a different generation. The Bible was always a primary source for him of both spiritual and literary inspiration.[33] Politically inclined Strindberg scholars have tended to interpret this interest as a regrettable sign of the mystical (i.e., irrational) artist; religiously inclined scholars search for evidence

about Strindberg's own journey to the Cross. As we have seen in "Pangs of Conscience," however, it is impossible to secularize entirely his political interests or depoliticize entirely his spiritual interests.

For much of his life, Strindberg regarded the advocacy of social equality and justice as one of Christianity's primary goals. From the early 1870s to the mid-1880s, and once again after the turn of the century, socialism was the most valid political expression of Christ's mission for him.[34] In July 1884, for example, he promised his publisher, in a proposal for a "world-historical" trilogy of plays, that he would "quite simply treat Jesus of Nazareth as a respectable socialist, with no superfluous theological squabbling" (Brev 4:278).[35] By October of the same year, however, he found himself on trial for blasphemy for having referred to Christ as a "rabble-rouser" (uppviglare) in the story collection Getting Married. Although ultimately acquitted, he received a bad scare; some of the cocksureness he displayed in the mixing of political and religious elements disappeared. In a letter to a reader who had admired his work but deplored his carelessness with loaded terms, Strindberg responded defensively that his allusion was not irreverent: "'rabble-rouser' is a biblical word that I used ironically" (Brev 4:376).[36]

The portrait of a politically radical, even socialistic Christ was a popular Romantic figure during the first half of the nineteenth century. The precedent had been set in the early days of the French Revolution with references to "the 'sans-culotte' of Nazareth who chased the money-changers from the temple,"[37] and with sermons like that in 1791 by an English clergyman who cited Luke 4:18 to speak in support of the tumultuous changes taking place in France: "Jesus Christ was a Revolutionist; and the Revolution he came to effect was foretold in these words, 'He hath sent me to proclaim liberty to the captives.'"[38]

A reversal came about after the revolutions of 1848. The hope, ignited by the 1789 revolution, of an egalitarian society in which all classes participated was shattered when it collided with bourgeois ambitions. By midcentury in Sweden, says Strindberg, "the

middle class, who had helped [King] Gustav III create a royal revolution [in 1772], had long since been inducted into the Over-class" (SS 18:7). Socialist ideas came to be regarded as a direct threat to middle-class values and to be discouraged wherever they appeared, even in mythic images that only alluded to political ends. A representative of the middle class in Strindberg's uneven 1875 history play about the 1848 Stockholm Revolution, In the Year '48, urges that "the rabble must wear gray clothing so that the military know whom to shoot at when the revolution begins!" (SS 1:295).

Though mixing Christianity and socialism was a risky business, as Strindberg learned to his dismay, he persisted in doing so, deriving encouragement from an unlikely source: German theologian David Friedrich Strauss's Das Leben Jesu (1835). Strauss's intentions were entirely apolitical, but his work became one of the political and literary sensations of the century. Strindberg was exposed to Strauss's ideas secondhand, as a student, but they affected his thinking, in ways even he probably never realized, in three vital areas: myth, religion, and history.

Strauss, perhaps out of concern over the interest in non-European mythologies stimulated by the first translations of sacred books from the East in the late-eighteenth and early-nineteenth centuries, wanted to demonstrate that Jesus was a genuine historical figure, not simply another mythological character. Consequently, he strove to strip away all of what he regarded as fanciful inventions surrounding Christ. Unfortunately for Strauss, readers reacted far differently than he had expected: while the clergy and conservatives were appalled, young intellectuals felt encouraged to challenge church authorities on a wide variety of matters. Artists found a special lesson. Although the aim of Das Leben Jesu had been demythologization, many artists concluded that Strauss's evidence of a mythological aura surrounding Jesus simply made him another candidate in the international gallery of mythological heroes, another Hercules, Jason, or Buddha, to be used for literary purposes.

Strauss's method was to show that mythological inventions in the Gospels were devised to prove that Jesus was a legitimate suc-

cessor of the Old Testament prophets, that what had been promised in the Old Testament was fulfilled in the New. The effect of his argument was to take one of the venerable interpretive tools of his fellow theologians — "typological," or "figural," analysis — and turn it against them, an action that was to destroy his career as an academic.

The typologist's task was to link "types" in the Old Testament with "antitypes" in the New Testament. In this way the sacrifice of Isaac and the killing of Abel become the "types" that foreshadow the "antitype" of the Crucifixion, and all "types" culminate in the penultimate "antitype," Christ himself. Saint Augustine defined the reciprocal relationship: "In the Old Testament the New Testament is concealed; in the New Testament the Old Testament is revealed."

However useful it was as a didactic instrument for the church, typology's potential as an expressive vehicle for artists, particularly those working with historical materials, was extraordinary. In Strindberg's first important history play, Master Olof, typological images are used to give added import to a turning point in Swedish history, the early sixteenth century. Master Olof (Sweden's Luther) is urged by Gert Bookprinter, an Anabaptist radical, to defy conservative religious and political authorities and ally himself with radical changes taking place on the Continent. "Don't forget the great day of Pentecost," he tells the young clergyman.

Don't listen to the death cry that everything is fine, because then the millennium, the kingdom of freedom, will never come to pass, and that's exactly what's beginning now! . . .
. . . Don't you know that Thomas Münzer has set up a new spiritual kingdom in Mühlhausen? Don't you know that all Europe is in revolt? (SS 2:23, 166)

The connecting of Pentecost and the millennium sets up expectations: the first link is a Judaic covenant celebration adapted by Christians to herald a new covenant, a new contract between man and God; the second link is an apocalyptic vision of an immediate transformation of an evil world into a place of harmony and good. The horizontal line of history has suddenly been enriched

with a vertical dimension, as the present is charged with both an ancient promise and its future fulfillment. A moment of profane historical time, *chronos*, has been transformed into a moment of sacred time, *kairos*, pregnant with its evocation of the eschatological Final Days.[39] "The notion of fulfillment is essential," says Frank Kermode, for "the *kairos* transforms the past, validates Old Testament types and prophecies, establishes concord with origins as well as ends."[40]

Strindberg grasped quickly the dramatic advantages of typology's system of expectations and fulfillment, whether consciously or unconsciously, and he used it for plays set in contemporary as well as historical settings. In *Miss Julie*, for example, a historical moment is made both specific and timeless. On the one hand, there is the story of a seduction of an aristocratic woman by her father's valet, suggesting a transitional phase in history involving the fall of one privileged group and the rise of another. On the other hand, there are many references to the biblical Fall, with its lesson of the penalty for sin and disobedience. And there is also the double celebration of the summer solstice and the birth of John the Baptist, the latter evoking a hope of forgiveness and reconciliation, the preconditions necessary for restoration of the harmony between the mortal and the divine shattered by the Fall. The realism of the historical moment is foregrounded: specific *time* and *space* (in Mircea Eliade's words, "profane time and space") hold Julie and Jean captive, make them prisoners of history. In contrast, in *A Dream Play*, it is never absolutely clear which element is foregrounded: the realism of the moment or the dreamlike journey of Indra's Daughter, which seems to transcend historical limitations. In both instances, typology enriches the temporal by giving it greater scope and resonance.

Nature and the Grotesque

In the last important vision in "Pangs of Conscience," one that precipitates Bleichroden's recovery, Strindberg attempts an ambitious ritual-like ceremony in which humanity, God, nature, and

society are to be reconciled. Although polemical intentions make the reconciliation seem forced, the components of the setting obviously stirred Strindberg's imagination, because he was to return to them on a number of occasions, most notably seventeen years later in *A Dream Play*.

While wandering the hospital grounds, Bleichroden enters a building whose interior astonishes him.

[The hall] . . . resembled nothing he had ever seen before. It was neither a church nor a theatre auditorium nor a school nor a municipal hall but something of all of them. At the rear was an apse lit by three stained-glass windows. . . . Below the windows was a stalactite-formed arch, through which a little brook ran quietly and fell into a pool in which calla lilies were standing. . . . The pillars enclosing the apse were not of any recognizable style, and their trunks were clad right up to the ceiling with soft, brown hepatica. The lower wainscoting on the walls was covered with spruce twigs. Attached to large wall surfaces as ornaments were leaves of various evergreens—laurel, holly, mistletoe—but not in ways that could be traced to any particular style. Sometimes they seemed about to form letters of the alphabet, but then they scattered in soft, fantastic growing patterns, like the arabesques of Raphael. (ss 15:210)

After a short, syncretistic sermon in which a speaker talks of "how Christ thought of humanity as one, single people, but how man's evil nature worked against this great idea, how humanity divided itself into nations, sects, schools" (211–12), Bleichroden's memory returns. He discovers that his wife is waiting for him and they are reunited.

The strange hall is far more interesting than the rather mawkish epiphany staged in it. The interpenetration of man-made and natural elements there is so pervasive—walls and columns crawling with foliage, a cavelike stalactite arch surmounted by stained-glass windows—that the first question is not so much "where are we?" as "what is this?" In terms of decoration the answer, as the author himself indicates, is a suggestion of the highly foliated grotesque-arabesque tradition, made especially popular in the Renaissance by Raphael and his students in the Vatican loggias.

Raphael's inspiration was the discovery in Roman ruins of wall paintings in arched or underground chambers (Italian *grotta*, from the Latin *crypta*, "cave"—hence the word "grotesque"). What made this kind of ornamentation fascinating, says Mikhail Bakhtin in *Rabelais and His World*, was "the extremely fanciful, free, and playful treatment of plant, animal, and human forms. These forms seemed to be interwoven as if giving birth to each other. The borderlines that divide the kingdoms of nature in the usual picture of the world were boldly infringed."[41]

Throughout the story, the focus has been on Bleichroden's inner turmoil, made manifest in visions expressive of disharmony, of natural man being inhibited by cultural man, of human potential stifled by social oppression. Suddenly, in the hall, the lieutenant finds himself in a friendly environment, where humanity and nature are in mythopoeic harmony: the context of the grotesque, where the borderlines between organic and inorganic, even between flora and fauna, are "boldly infringed." In the grotesque, says Bakhtin, there was no "usual static presentation of reality. There was no longer the movement of finished forms, vegetable or animal, in a finished and stable world; instead the inner movement of being itself was expressed in the passing of one form into the other, in the ever incompleted character of being."[42]

It is difficult to overestimate the importance of Strindberg's instinct for the transmutable powers of the grotesque. It affected his approaches to setting and character in ways that recall German Romanticism,[43] especially E. T. A. Hoffmann, and anticipate German Expressionism. And it helps to explain not only his ideas about history but the strange quality of his humor.

In terms of character, the most obvious examples of Strindberg's instinct for the grotesque are from the last decade of his career, after his Inferno Crisis. They include the Captain in *Dance of Death* and an entire gallery of characters in *The Ghost Sonata*. Among modern directors who have best understood and appreciated the grotesque in Strindberg is Ingmar Bergman, who has staged *Ghost Sonata* no fewer than three times. While directing it the third time, in 1973, he stressed precisely the same personality conflict and

division that Strindberg developed in "Pangs of Conscience": between natural man and cultural or social man. "The moment the characters conduct themselves according to social patterns," he instructed his actors,

> they are grotesque, but the important thing is that . . . they oscillate between the grotesque and the deeply human. That's the whole point, that they behave grotesquely in certain situations. Society has commanded them to play these roles, and they have accepted them. If you turn to *Black Banners* [a Strindberg novel contemporaneous with the play], we have the same thing — veerings between something deeply human, desperate, reckless, and the wildly grotesque. I don't see it as a matter of making caricatures of them, but the whole time keeping the human aspect combined with the grotesque.[44]

The Captain in *Dance of Death* represents a more complex application of the grotesque to character, one that mixes the monstrous and the comic. Laurence Olivier was one of the first English-speaking actors to understand, instinctively, the nature of that mixture, as he demonstrated in his landmark 1967 portrayal of the grotesque Captain. I say instinctively because Kenneth Tynan once described to me how shocked Olivier was at first when audiences responded to the comedy. Intellectually, rationally, he had not realized its potential.[45] Perhaps what enabled him to make the comedy come alive was his background in Shakespeare and Shakespeare's own roots in medieval drama. It is in medieval drama that high seriousness, even stark terror, stands cheek by jowl with comedy and sometimes farce. "It must be recalled," says Mikhail Bakhtin,

> that the image of death in medieval and Renaissance grotesque (and in painting, also, as in Holbein's or Dürer's "dance of death") is a more or less funny monstrosity. In the ages that followed, especially in the nineteenth century, the public at large almost completely forgot the principle of laughter presented in macabre images. . . . The bourgeois nineteenth century respected only satirical laughter. . . . Merely amusing, meaningless, and harmless laughter was also tolerated, but the serious had to remain serious, that is, dull and monotonous.[46]

When the nature of the grotesque in Strindberg is incompletely understood, when the seriousness in a play like *Dance of Death* is only serious, the result is almost bound to be dull and monotonous.

Suggesting grotesque elements in the treatment of setting, as in the strange chapel sequence in "Pangs of Conscience," was to become something of a hallmark for Strindberg. As for the literary tradition of making a cave the location for important, even divine revelations, it begins at least as early as Plato's mythic references to shadows and illusion in *The Republic* and continues through Faust's request to a spirit to "lead me to the sheltered cavern, / and show me to myself, and then reveal / to me profundities within my breast,"[47] and the Demogorgon cave sequence in Shelley's *Prometheus Bound*. Strindberg's most comprehensive identification of the cave and church combination is in *A Dream Play*. There too, as in "Pangs of Conscience," we find a shifting sense of time and space. But whereas in the story the ambiguity of place is simultaneous — the hospital chapel "was neither a church nor a theatre auditorium nor a school nor a municipal hall but something of all of them" — in the play the ambiguity is consecutive and progressive: right before the audience's eyes a theatre alley transforms into the chancel of a church, in which, in turn, an organ transforms into a cave. Two scenes in *A Dream Play*, in fact, feature cave and organ, both involving Agnes, daughter of the god Indra, in an intimate encounter with a mortal man — first the Lawyer and then the Poet. In the first, according to the stage directions, the Daughter "*sits at the organ and plays a 'Kyrie,' but instead of organ tones, human voices are heard.*" The voices represent the children of man, calling out to a Father who seems to have forgotten them: "Eternal One, why are Thou so far from us?" After a blackout, the lights come up and transform the organ into Fingal's Cave (figs. 1–3), where "*the sea swells in between basalt pillars, producing a sound ensemble, a harmony of wind and waves.*"

LAWYER: Where are we, sister?
DAUGHTER: What do you hear?
. . .

LAWYER: Sighing . . . moaning . . . wailing . . .

DAUGHTER: The complaints of mortals have reached this far . . . but no further. (ss 36:250–52)

In the second Fingal's Cave scene, with the Poet, the Daughter perceives that mortals' complaints have a chance of reaching further, and she metaphorically transforms the cave into "the Ear of Indra." "Don't you see," she says to the Poet,

how the cave is shaped like a seashell? . . . Don't you realize that your ear is shaped like a seashell? . . . Didn't you ever as a child hold a seashell to your ear and listen . . . listen to the buzzing of your heart's blood, the murmur of thoughts in your brain, the bursting of thousands of tiny threads in the fabric of your body[?] . . . These things you could hear in a little shell; imagine what you'll hear in one this big! (ss 36:297)

After the Inferno Crisis, as we shall see, Strindberg's renewed feeling for the grotesque alerted him to the creative potential in the model so dear to the Romantics—the occult theory of correspondences, which, as in this scene, links elements on different planes, metaphysical and physical.

In "Pangs of Conscience" Bleichroden is moved by the sound of an organ playing music that "was neither Lutheran nor Catholic nor Calvinist nor Greek, and the sick man thought he could hear the words, and he found them comforting and full of hope" (ss 15:211). The source of music in the second Fingal's Cave scene in *A Dream Play* is no longer an organ but the mythic Aeolus, Nature's own cave composer, creating the "Lamentation of the Winds." The theme of the lament, however, is the same as in the story and in the first scene in the play: the suffering of humanity.

> Men breathed us in
> and taught us
> these songs of pain . . .
> In the sickroom, on the battlefield,
> but mostly in the nursery,
> where the newborn cry

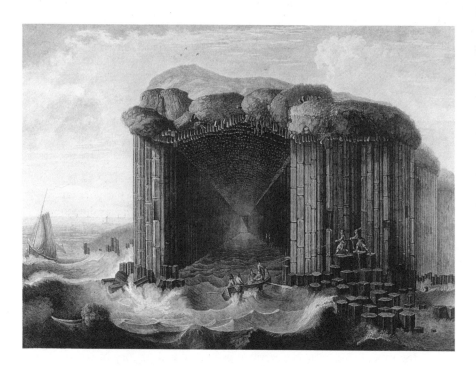

LAWYER: Where are we, sister?

 . . .

AGNES: The Ear of [the Indic god] Indra. . . . Don't you see how the cave is shaped like a seashell? . . . Didn't you ever . . . hold a seashell to your ear and listen? . . . imagine what you'll hear in one this big!

The Dream Play

Fig. 1. A 1795 copper engraving of Fingal's Cave by M. Pequenot, published in Paris during the French Revolution.

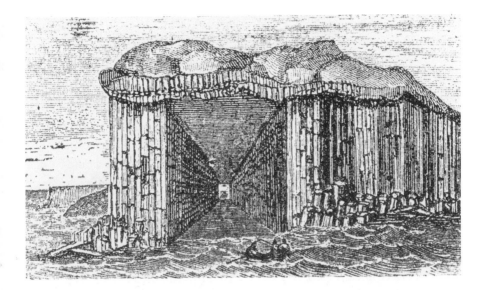

Fig. 2. An illustration of Fingal's Cave from Strindberg's *Blue Books* (ss 46:336). A similar illustration appears on the title page of the 1794 Swedish translation (called *Ossian*) of James Macpherson's great 1762 literary hoax, *Fingal, an Ancient Epic Poem, in Six Books*.

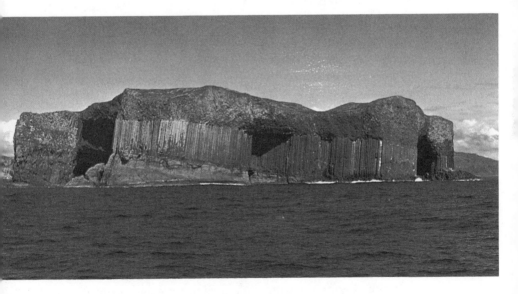

Fig. 3. A modern view of Staffa Island with Fingal's Cave.

and wail and scream

from the pain of being. (ss 36:299–300)

No single phrase comes closer to describing the central lament in all of Strindberg's works than the "wail and scream" of "the pain of being," sweeping like a wind through all the planes of being.

There was nothing unique about this metamorphic chain of associations culminating in Fingal's Cave; similar references to this grotto on Staffa Island in the Inner Hebrides appear in a number of Romantic contexts.[48] Mendelssohn wrote an overture in its honor, Turner painted it, and some of the same musical associations it had for Strindberg also inspired several poems on the subject by Wordsworth.[49] Strindberg never ceased to be fascinated by the image of the cave's most remarkable feature: the almost mathematically perfect six-sided basalt pillars of its walls, created by the sea's erosion upon a great volcanic lava mass. Packed tightly together as they are, some of them twenty feet high, the pillars' resemblance to banks of organ pipes was noted long before Strindberg's time.[50] His eagerness to demonstrate the literal resemblance between and theatrical potential of cave and organ later led him, in his late mystical, philosophical Blue Books (1907–12), to reproduce a print of the island (ss 46:336), in which the cave opening is drawn to resemble a Renaissance single-point perspective stage setting (see figs. 1–3).[51]

The important thing, however, is not the literal resemblance of cave to organ; it is the obviously galvanizing effect of the visual image on the machinery of Strindberg's imagination. Significantly, cave and sea images are primary subjects in several of Strindberg's paintings (see pls. 1–2), and Bengt Dahlbäck sees them constituting a metaphysical comment: "The recurrent motif of an ocean view seen through a cave entrance is connected with Plato's concept of this world as an imperfect reflection of the perfection of ideas."[52] But we might also argue that cave and ocean functioned together in his imagination more fundamentally, as a special kind of place, a catalytic location that set his creative processes in motion. Geoffrey Hartman, describing a similar imaginative

attachment to a place for Wordsworth, calls it an omphalos—a "haunting-and-haunted spot." [53]

"Pangs of Conscience" is significant in several ways as a microcosm of Strindberg's work. Behind the fiction writer is the incipient playwright, experimenting with problems he would later put to good use in a variety of dramatic forms. Character depiction, he realized, was not a matter of creating personalities with stable, central cores but of assembling clusters of passions that cling together only tenuously in an anxious modern age. Devising a proper stage for meaningful dramatic action meant not only conveying a palpably believable sense of time and place that was faithful to the concrete demands of realism but suggesting a platform where the natural and the supernatural, the realistic and the grotesque, could interact, as man's dreams and hopes did battle over the great issues of his destiny. Both the fiction writer and the playwright were essentially image makers, feeling trapped in an unusual love affair with the image-making capacity, the imagination. It is to a closer examination of that love affair as it affected the individual themes—nature, history, myth—that we now turn.

2 / Imitation and Imagination

It is in the contradiction between an eighteenth-century, almost
classical critical awareness and artistic self-consciousness, and this trust
in the miracle-producing resources of the individual imagination,
to which we owe the great achievements of modern art.
— Steven Spender, The Struggle of the Modern

The Aristotelian versus the Platonist

NONE OF THE VARIOUS ELEMENTS THAT LINK STRINDBERG
with the Romantic legacy created more vexing problems for
him as an artist than defining the nature and purpose of the role
of the imagination in the creative process. Though as a skeptical,
objective modern artist, he regarded it as a mechanical function
in the brain's biological activities, he was still instinctively drawn
to the same mysterious creative powers of the imagination that
the Romantics had found so intriguing. The Naturalistic writer in
him felt obliged to repress its urgings and limit himself to ratio-
nal, factual reportage, while the artist recognized that abrupt,
unplanned bursts of imaginative activity were among his greatest
strengths. In the 1870s and 1880s he struggled to define and rec-
oncile these conflicting demands.

Strindberg's dilemma was not a new one. From classical times
to the present, artists and critics have debated the proper purpose
of the imagination. In the period when Strindberg was formu-
lating and reformulating his literary values, the debate over this
purpose was led in Scandinavia by leaders of the "Modern Break-
through" movement toward greater realism in literature. Where
the Romantics had seen new viability in modes of the imagi-
nation that were looked upon with suspicion by the eighteenth
century—myth, fantasy, figurative language—realists and Natu-
ralists now questioned such devices as unscientific and artificial.
Some of his questioning was aesthetic, some of it philosophical,

and much of it political. There was a call for the abolition of all conventions in art; life itself would be the only gauge by which art would be measured. In the process, of course, new conventions were established, and the ancient concepts of imitation and imagination were redefined once more.

Many of Strindberg's polemical writings in the 1870s and 1880s describe the artist's proper stylistic goal as "realism" rather than "idealism." The "idealists" were the derivative artists and writers who served a conservative ruling class as purveyors of a sanitized, Christianized Romantic art and poetry. But Strindberg had difficulties clarifying the conflict within himself between idealism and realism. Like the iconoclast who attacks the icons of others but reveres his own, his target was a certain kind of idealism. Along with many other young European intellectuals after midcentury, he railed against ideals formulated during the Restoration period of 1814–30, when artists had turned their backs on the radical goals of the preceding generation. As a young journalist in 1874 he referred condescendingly to "the poetic dream life" that at the beginning of the Romantic period had taken hold "of the entire civilized world, which had been all too disturbed by the beneficial horrors of the Revolution."[1] In ancient times, Strindberg scoffed, artists had to have a special skill, the ability to imitate nature, and did not, as did contemporary artists, attempt to pass off a prettified substitute. To buttress his argument, he turned frequently to the classical definitions of art and imitation in Plato and Aristotle.

It is one thing to say that the artist's goal is imitation of nature, and quite another to specify exactly what that means. In antiquity *mimesis* was an ambiguous term almost from the start. Plato uses it in a number of different ways, the most famous of which (and one Strindberg cites often) is in the tenth book of *The Republic*, where he accords imitation little positive social value, just as he accords little value to the artist who practices it. The carpenter who makes a real bed imitates the idea of a bed, which has a divine origin. The artist who then paints a picture of the carpenter's bed is only making an imitation of an imitation, a copy of a copy, a semblance of a semblance.

Aristotle took a different approach. If Plato gives the word "imitation" an infinite series of gradations of meaning, Aristotle restricts it to a single literal meaning: imitation is of the actions of men.[2] It is a natural human instinct, and Aristotle answers Plato by arguing that positive social value in imitation comes from the pleasure to be derived from the artist's ability to render a realistic image.

The Platonic ideal and the Aristotelian real have served as points of departure, either explicitly or implicitly, for many arguments about art since antiquity. Coleridge is reported to have said that everyone is born either a Platonist or an Aristotelian.[3] It was Strindberg's fate to be a Platonist in his heart and an Aristotelian in his head. If the Aristotelian made him a realist who insisted that the basic model he imitated was nature, the Platonist never let him forget the ideal, making him search beyond simple imitation in an effort to extend the natural, as Coleridge put it, into the supernatural. Like Plato's horses, however, the ideal and real worked together in tandem only with difficulty for Strindberg. The Platonist was an image maker; the Aristotelian, an iconoclast. For long periods in his career an inability to reconcile these often conflicting demands caused him anguish. He was always proud, for example, to be called a Naturalist, but no matter how objectively he attempted to depict a social reality that was cruel, unjust, and corrupt, the depiction was haunted by images of a better world, one less cruel, less unjust, less corrupt, haunted by an ideal that informed the real.

The Platonist-Aristotelian conflict was both curse and blessing for Strindberg: a curse for the torment it caused him and a blessing for the richly ambiguous meanings it enabled him to evoke in his work. Only in the late 1890s did he rediscover a fundamental Romantic insight: that the real and the ideal were not opposite but complementary, linked together in polar tension. The basic instrument for linking them was the imagination, and here too there is ambiguity about the term, right from its points of origin in antiquity.

The Greek roots of "imagination" are *phantazein*, literally, "a making visible," such as to the mind, and *phantasia*, an "appearance" or "apparition." The Latin root is *imaginare*, "to form an image of," whether in one's own or another's mind. A related word in Latin is *imitari*, "to seek to reproduce the image of, to imitate."[4] And so, the concepts of imitation and of the imagination as the image-making faculty in the mind have been thought of as interrelated since classical times. The negative aspect of the faculty comes down to us through the word "fantasy"; fantasies are insubstantial, trivial—just castles in the air. In English a more serious side of "fantasy" was once suggested by the now obsolete use of the word "fancy,"[5] but it too was suspect, was associated with frivolity.[6] Today, the only serious word is "imagination."

In Swedish the ambiguity continues, first, through the fact that two words that are used for imagination—*fantasi*, from the Greek root, and *inbillning* (spelled by some early Swedish Romantics as *inbildning*), related to the Low German *inbilden* (German *einbilden*)— and, second, through the fact that both words can convey different values, depending on whether they are used in the singular or plural forms. In the singular forms, *fantasi* and *inbillning* are both serious, and almost interchangeable, although the first word is often used to indicate a capacity for giving life and color to something, as in *han har fantasi*, "he has imagination," and the second often suggests the image-making process itself, the root *bild*, as in German, denoting both image and picture, as in *fotografiska bilder*, "photographs." In their plural forms, however, *fantasier* and *inbillningar* denote the triviality of castles in the air. If I dwell at some length here on etymology and semantics, it is because the different ways that Strindberg defined the imagination at different times reflect clearly his feelings about art in general. Just as he had difficulties reconciling the ideal and the real, so was he torn with uncertainty and even guilt, as we have seen, about the value of his own gift for image making, that mysterious power for creating illusions that so aroused Plato's apprehensions. Socrates voices the apprehensions in the tenth book of *The Republic*: "Our minds are

clearly liable to all sorts of confusions . . . [because of] this natural weakness of ours that the scene-painter and conjurer and their fellows exploit with magical effect."[7]

The extraordinarily positive attitude that the Romantics took toward the image and the imagination was the result of more than a century of experimentation and speculation between 1660 and 1810 by psychologists, philosophers, critics, and poets, especially in England and Germany.[8] Step-by-step, the concept evolved from a belief held by British empiricists and association psychologists that the imagination was a fundamentally passive faculty in the mind, receiving and reordering sense perceptions, into the view formulated by the German Transcendentalists of an active, multi-leveled center, capable not only of storing and retrieving information and ideas but of functioning as a truly creative force, creative in the sense not only of combining already known data into new patterns but, as in imitation of the original Creator, of creating something ex nihilo.

This was the heart of the Romantic challenge to the classical concept of mimesis: that the reconciling power of the Creative Imagination constituted a bridge between the Aristotelian emphasis on the imitation of the real world of nature and the Platonic insistence that the only true realities were the original images in the realm of ideas. For German philosopher F. W. J. Schelling the power was Einbildungskraft (Swedish inbillningskraft) and the work of art was its instrument. "Through art," said Schelling, "divine creation is presented objectively. . . . The exquisite German word 'Einbildungskraft' actually means the power of forming into one, an act on which all creation is founded. It is the power through which an ideal is also something real."[9]

The German emphasis on the central role of the imagination in the poetic process had great impact in Scandinavia. In the 1790 poem described as the "morning star" of Swedish Romanticism,[10] Johan Henrik Kellgren's (1751–95) "The New Creation; or, The World of the Imagination," the poet took issue with the Enlightenment view that the imagination was an enemy of judgment since it produced only hallucinations and delusions that judg-

ment could tear to pieces. In Kellgren's poem "the imagination becomes akin to the divine power of creation." [11] But no Swedish Romantic placed a higher value on the imagination than P. D. A. Atterbom (1790–1855). In Atterbom's poetry—peopled with personifications of such airy essences as beauty, art, and poetry—all things in the finite world are representations in sensual images of things in the infinite world, the realm of ideas. For him the imagination, in its purest, "Ur" form, says Albert Nilsson, was akin to the gnostic, Neoplatonic "yearning that the divine forces, hidden in the womb of nature, felt for the heavenly world of light." [12]

A special power possessed by the imagination was the capacity to discover supersensual or metaphysical revelations in sensual or physical phenomena. Poetry was the recording of these revelations in symbolic form, "and the very essence of symbols," Atterbom declared, "is the Idea—shimmering through the prism of the mortal and the perishable—that we call Beauty." [13] The concept of art imitating reality had come a long way from Aristotle. By the late 1860s, when Strindberg was coming of age, the great Swedish Romantics were gone, leaving only colorless epigones to continue a stale tradition. It was clear to a growing number of young writers and intellectuals that the pendular swing in art from the real to the ideal had moved too far toward the Neoplatonic ideal. It was time for a change.

Brandes and the Realist Revolution

Change was in fact already under way at the University of Uppsala when Strindberg arrived there as a student in 1870. One of his professors, literary historian and critic Carl Rupert Nyblom (1832–1907), had begun publishing attacks on the subjective, abstract, conservative, sentimental qualities he found in Romanticism. His targets were the late Romantics, as well as the so-called Phosphorist group, named for the magazine Phosphoros, to which Atterbom had been an important contributor in the early 1800s. What Nyblom admired most was a liberal, humanistic tradition in literature in which idealism and realism were joined in perfect

harmony, and in which "a rich and vivid imagination was under the control of lucid reason." [14]

But clouds were gathering on the literary horizon. In 1870 another opponent of Romanticism, Georg Brandes, published his *Critics and Portraits*, which Strindberg said struck him "like a bolt of lightning . . . and cast a new light" (ss 18:376) on the idea of beauty in art. Over the next decade, Brandes's ideas, especially as formulated in the first four volumes of his *Main Currents in Nineteenth-Century Literature* (1872–90), had a profound effect, not only on Strindberg, but on a whole generation of Scandinavian writers.

Nyblom greeted the first volume of *Main Currents* positively in a review, praising Brandes's "ardent enthusiasm for truth and freedom." [15] His response to the second volume, however, was less positive; it was clear that he and Brandes subscribed to different varieties of anti-Romanticism. There was a gulf, says Gunnar Brandell, "between the liberal idealism that prevailed in Sweden and Brandes's anti-Christian position. A progressive, enlightened, liberal attitude was not unwelcome, but Brandes went too far when he turned materialistic, repudiated religion, and praised political revolution." [16]

Though Strindberg never acknowledged a debt to Nyblom as he did to Brandes, neither did he become as remorseless an enemy of idealism as Brandes was and as he himself professed to be. It was one of several points over which he and Brandes eventually separated company. The idealist and realist warred within Strindberg, just as the Romantic and Naturalist did.

A century later it may seem surprising that Georg Brandes once wielded enormous influence internationally as a critic. Although he is almost forgotten today outside Scandinavia, as late as 1914 a lecture he gave in New York on Shakespeare required police to hold the crowds in line, and more than a thousand people were turned away. [17] And in 1927 America's pioneering literary historian V. L. Parrington tacitly acknowledged Brandes as an example in the title of his own *Main Currents in American Thought*.

Brandes was continuing, and in some ways improving upon,

a French model, Hippolyte Taine (1828–93), whose own *Histoire de la littérature anglaise* appeared in 1864, less than a decade before Brandes became a sensation. The most important lesson Brandes learned from Taine was a particular kind of scientific determinism. The critic's task, according to Taine, was sociological and involved evaluating the three factors that decided an author's style: *race, milieu, moment.* His disciple took a different route. "Whereas a book had been an end-product to Taine," says Harry Levin, "to Brandes it was a continuing force, and the critic's added function was to chart its repercussions."[18] Where Taine was antipolitical, Brandes was resolutely political, encouraging artists to commit themselves to the promotion of the ideals of social justice advanced during the French Revolution.

Whatever impact Brandes once had, many of the judgments in his *Main Currents* have not held up well; in the light of modern criticism they seem naïve and shallow. As Bertil Nolin put it, he had "the deficient understanding of the positivist and the rationalist when it came to metaphysical speculations and dreamlike visions, when it came to poetry that tried to conquer new domains in the margins where reason cannot follow it."[19]

Brandes's preferences in his often racy history of nineteenth-century literature are for robust, "manly" writers ("criticism," he wrote in 1890, "is a particularly masculine activity"),[20] whose views were in harmony with his own, almost boundless, faith in the triumphal march of liberalism and progress. The liberal Byron is the hero, and Coleridge is the poet of "the Romanticism of superstition. . . . His philosophy is quite un-English . . . ; it is conservative, pious, and historical . . . ; it is a 'Schellingism.'"[21]

To appreciate Brandes's positive aspects as his contemporaries did, we have to examine, not the quality of his critical insights, but the message he brought to a generation of artists longing for change, the generation that was to effect the Modern Breakthrough. Instead of the harmonious synthesis of idealism and realism preached by Nyblom, Brandes attacked idealism for being rooted in the past and bloated with dead abstractions, emphasiz-

ing instead the importance of the concretely real and immediate. He believed that what writers should strive for in their art was, not beauty, but what a later generation would call social relevance. "In our day in Scandinavia," he wrote, "writing that has vitality must of necessity contain social criticism."[22] It must submit "problems to debate. . . . George Sand debates the problems of the relations between the sexes; Byron and Feuerbach, religion; Proudhon and John Stuart Mill, property; Turgenev, Spielhagen, and Émile Augier, social conditions."[23]

Addressing a generation that had seen the demythologization of Christianity by Strauss and Renan, Brandes labeled spiritual or religious issues inimical to free thought, the freedom of action, and the advancement of science. "Poetry, as I understand it," he asserted, "has two, different, fundamental forms. It has either the character of preaching — and in this aspect approaches religion — or it has the character of a physiological-psychological examination and presentation — in this aspect it approaches science."[24]

Perhaps the most important contribution made by Brandes's popular lectures and books was to make Europeans generally more aware of the richness of their national literatures. Nietzsche gave a fair assessment of his position when he called him "ein guter Europaër und Cultur-Missionär."[25] Thanks to Brandes, Scandinavian writers felt more a part of the European literary scene than they ever had done before. His knowledge of foreign languages, his wide familiarity with much of nineteenth-century literature, his audaciousness, and his articulation of dynamic social issues made him a critical eminence almost overnight. Together with his brother, Edvard, a capable editor who gave important encouragement to Strindberg, they dominated the progressive literary scene in Scandinavia for more than a decade.

The power of Brandes's message in Scandinavia can be measured in the extent to which he influenced its two most important literary figures: Ibsen and Strindberg. Before Ibsen read Brandes, he had written *Brand* and *Peer Gynt*. Afterward came the great realistic/Naturalistic plays like *Ghosts* and *Hedda Gabler*. Reading Brandes's lectures in 1872 caused Ibsen to confess to him in a letter that

a more dangerous book could never fall into the hands of a pregnant writer. It is one of those books that opens a gaping abyss between yesterday and today.... For me, it is like the California goldfields when they were first discovered; one either became a millionaire or one foundered in misery. Is our spiritual constitution in the north strong enough now? I don't know; but that does not matter. Whatever cannot accept these new ideas must fall.[26]

Brandes was an enthusiastic supporter of Ibsen, but his appreciation was limited to the realism in the plays; the "mystical" and "symbolistic" aspects of Ibsen were tolerated only because they were handled so skillfully. "It takes ... a great deal of art," Brandes wrote, "to make us believe in the symbol so completely that it does not seem only a symbol."[27]

Strindberg's early admiration for Oehlenschläger's Romantic plays disappeared after reading Brandes. He became committed to realism in his writing, and social satire became a favorite genre. An 1872 letter to a friend proclaims that Brandes must have "ascended Mount Everest . . . , because only from there would one be able to see as far as he does" (Brev 1:103). Three years later, he wrote to his editor to propose translating a volume of Brandes's essays (164). Brandes, in turn, recognized Strindberg's talent and responded warmly to him at first, passing his name along in 1887 to Nietzsche. A decade later, however, he wrote to a Swedish friend that he had long since lost his interest,[28] probably because Strindberg's work by then had moved sharply away from social satire and from the kind of realism of which Brandes approved.

Although Brandes's persuasive arguments in favor of liberal causes and objective, "scientific" realism had a liberating effect on artists like Ibsen and Strindberg, his narrow appreciation of symbolism may well have caused them to hobble the imaginative instincts that were important elements in each man's art. Certainly the disinterest Strindberg showed throughout his life in English Romanticism was due in part to Brandes's skewed views. A closer look at those views reveals ways in which they probably influenced Strindberg's objections to Romanticism in general and to the imagination in particular.

Although Brandes objected to heavy-handed didacticism (he advised one writer: "less debate, more psychology!"),[29] in the early volumes of Main Currents especially he placed a higher value on the expression of correct (i.e., liberal) ideas in a plausibly realistic style than on the use of evocative images. He finds, for example, the poem Der Camao, by the obscure German poet Moritz Hartmann, to be superior to Coleridge's The Ancient Mariner, not in terms of "virtuosity and originality in the matter of diction," but because Der Camao illustrates "the difference between a true poetic conception of a superstitious idea and a Romantic treatment of it."

[In Der Camao] the misfortune that comes to Vasco and his wife has a realistic, causal relationship with the killing of the bird, while [in The Ancient Mariner] the death of the whole ship's crew, as the result of the cruelty shown to the albatross, seems a kind of insanity. . . . Romantic affectation . . . preaches veneration for the marvelous and inexplicable as the sum and substance of all wisdom and of all poetry.[30]

The emphasis Brandes placed on social relevance is clearly reflected in Strindberg's early works. The young writer struggled to find a way to write that would enable him to both speak out against the social injustice and hypocrisy he saw in Swedish society and at the same time be thought of as interesting and socially acceptable enough to attract an audience to what he had to say. Satire was one of the weapons he chose to battle hypocrisy, and one of the individuals he singled out for ridicule came to play almost as important a role in shaping his career as Brandes did.

Wirsén and the Moralist Counterrevolution

A half decade before Strindberg arrived at the University of Uppsala, a popular lecturer, Lorentz Dietrichson (1834–1917), formed a group called the Nameless Society (Namnlösa sällskapet), of which Nyblom was a member. The group's purpose was to foster a view of poetry that departed from moribund Romanticism and to emphasize instead a blend of idealism and realism. One of the society members, however, developed a strongly antirealistic ap-

proach that was conservative, Christian, abstract, and sentimental: Carl David af Wirsén (1842–1912). For Wirsén the process of creation in the artist's mind was initiated by "divine, tranquil, chaste inspiration, which, in a miracle of transubstantiation, allows material to form itself, voluntarily, in accordance with images accepted by the soul in its heavenly receptivity."[31] Wirsén and several other members of the Nameless Society, including dramatist Edvard Bäckström (1841–86) and the only really gifted member of the society, poet Carl Snoilsky (1841–1903), became known as the Signatures,[32] and by the mid-1870s they personified for Strindberg everything reactionary and obsolete in the late Romantic tradition.

Wirsén went on to write literary criticism with a stringent, moral tone that found wide public acceptance and made him one of the most powerful—and certainly the most hated and feared—cultural authorities in Sweden, as well as one of Brandes's severest detractors. As first a member and then permanent secretary of the Swedish Academy from 1883 to 1912, he worked diligently to make sure that authors who leaned toward radical, vulgar realism in their art—such as Strindberg, Tolstoy, Chekhov, and Ibsen—would never be awarded the Nobel Prize for Literature.

Brandes and Wirsén, as cultural leaders of very different kinds of forces, represented respectively, for many young Scandinavian artists and intellectuals, the promise and the danger of seeking new, "scientific" artistic goals. If Brandes seemed to be urging a realism that might precipitate a social revolution, Wirsén was a self-appointed guardian of the established social institutions—the monarchy and the State Lutheran Church—guaranteed to resist that revolution. If Brandes was the liberal Aristotelian, advocating a faithfully realistic imitation of nature in literature in the service of political progressivism, Wirsén was the reactionary Platonist, proclaiming the preeminence of the ideal over any mere reality and faithfully echoing Plato's dictum in The Republic that "the only poetry that should be allowed in a state is hymns to the gods and paeans in praise of good men."[33] When Brandes provoked young radicals like Strindberg into pioneering new areas, Wirsén tried to make sure that they never got anywhere. Once Strindberg had

accepted Brandes's message, and then singled out Wirsén as a representative adversary worth attacking, his fate was sealed, for he proceeded to make many enemies. Although there was a growing audience in Scandinavia for the new realism among artists and young people, it was not as powerful as the old audience, which felt its values threatened.

But Brandes and Wirsén, for all their differences, had a great deal in common. In fact, they really represented different strains of the Romantic tradition. Both believed that art and literature should serve positive, optimistic ends, Brandes in a political and secular sense, Wirsén in a moral and Christian sense.[34] And both regarded the autonomous power of the Creative Imagination as a dangerous weapon in the wrong hands. For Brandes, Keats's poetry was deficient because it contained "no message of liberty, as in Shelley's and Byron's; it is pure art, owing its origin to nothing but the power of imagination [Indbildningskraften]."[35] Wirsén attacked Danish novelist Holger Drachmann's The Holy Fire (Den hellige Ild; 1899) because it seemed as if Drachmann's imagination (inbillningskraft) "was detached from the rest of his soul's capacities. It creates for its own sake, and it is remarkable how deprived Drachmann has become of a noble, positive view of life. . . . The flames of unrestrained freedom, of heartless sensuality gust forth from a spirit that seems to detest all bonds, even those forged by heavenly powers."[36]

Association Psychology and the Imagination

If Wirsén regarded his view of the imagination as justified morally and ethically, Brandes saw his interpretation, based on his readings in Hume and James Mill,[37] as justified scientifically and in harmony with the findings of association psychology. Association psychology was to affect Strindberg's development as an artist, if only indirectly. A basic principle of association psychology is that the mind is essentially a collector and organizer of sense perceptions. Remembering one experience, it was postulated, will often

call up an earlier one because they are associated in some way, through similarity perhaps or causality. The sight of a plant, for example, may call to mind an evocative image for a poet or the plant's species for a botanist.[38]

The implications of this tidy, rational approach to imaginative thinking were formidable for the artist. Where the Romantics revered the imagination as an almost mystical entity, an independent force, creative in its own right, and the very heart of the artistic process, the associationists assigned it a largely mechanical role. And so, even though the poet and botanist might react differently upon seeing a plant, their imaginations, as far as the associationist was concerned, functioned in the same way. Coleridge tried to check this reductive approach by assigning powers of association to what he called the "fancy," and creative ones to the imagination, but in England, at any rate, the associationist philosophy of the mind continued to dominate the psychology of the age.[39] One of the comprehensive approaches to it, James Mill's *Analysis of the Phenomena of the Human Mind*, was published in 1829. Four decades later, Brandes noted proudly that he had received a personal copy of the book from the author's son, John Stuart Mill, who assured him that it was "a masterpiece of the English school of this century."[40]

Associationist theory shaped Brandes's attitudes[41] toward literary criticism in general and the role of the imagination in particular, and for almost a century many Strindbergian scholars and critics have followed his example faithfully. As critic, Brandes preached a heavy-handed, psychologically oriented, biographical critical approach, in the spirit of Taine and Sainte-Beuve: "find the man behind the work." The artist was someone who could only render in his art rearranged versions of things that he had actually experienced; science had destroyed the myth of the inventive genius. Accordingly, E. T. A. Hoffmann's bizarre central characters, said Brandes, were "only rendered figures patterned upon himself."[42] And Shakespeare had no trouble transforming himself into Hamlet: "He could let the character drink of his own heart's blood; he could give him the pulse beating in his veins. Behind

[Hamlet's] forehead he could hide his own melancholy; [Hamlet's] tongue could speak with his own understanding; in [Hamlet's] eyes he could place a glint of the light and flash of his own soul."[43]

Brandes's associationist attitudes toward the imagination ranged from an almost reluctant admission. that it was a valuable tool for the artist to an open disdain for its primitive, "oriental" extravagances. At his most hostile, he speaks of the "empty ravings" (tomt Fantasteri)[44] of the German Romantics and is critical of the English Romantics for writing "page after page of hazy glorification of the imagination" (he uses the English word here), just "as Oehlenschläger and his school eulogized Fantasien."[45] As for Shelley, "many a time it was as if the visions that obtruded into his imagination [Indbildningskraft] would burst his brain. . . . Obviously, it took a strong will to keep a man with his delicate and fragile body from being destroyed by the dream images and deliriums that pursued him."[46]

Only when the imagination worked in the service of the liberal realism that Brandes thought best expressed the spirit of the age was he approving, as in the case of Balzac.[47] For the most part, however, he regarded it as something belonging to the past and now obsolete.

We Scandinavians have had pounded into us from our schooldays . . . that the one and only thing that matters in poetry is the imagination. We have accepted this definition as permanent and eternal, while it was only historical and applies only to a certain kind of poet and poetry: the Romantic. In our day it is not the gift for invention that we expect of a poet and search for in his works; it is a sense of reality.[48]

In polemical essays throughout the 1880s, Strindberg's attitudes toward the imagination echoed Brandes's:

[1882:] Once considered as creative, that is, capable of making something out of nothing, the imagination [fantasien] is only the gift for rearranging the greater or lesser treasures of impressions and experiences stored in the memory, [then] lining them up anew to illuminate the pathway of thought. (ss 17:193–94)

Imitation and Imagination

[1888:] By poet, I mean someone with imagination [*fantasien*], which is an ability to recombine phenomena, see connections, choose, and eliminate. (SS 17:193–94; 22:269)

Despite these kinds of confident assertions, Strindberg's feelings about the imagination continued to be mixed, a fact not as evident in his openly polemical essays as in an 1884 article sympathetic to his friend the painter Carl Larsson (1853–1919). Perhaps it was easier for him to express his feelings when ascribing them to someone else. He sensed that Larsson was torn, as he was himself, between Romantic instincts and realistic/Naturalistic intentions, and he described the painter as

typical of the interesting transitional period in which we are now living. On the one hand, there is his inherited love of the beautiful, the fantastic, and the "old ideals." On the other, there is his acquired, forward-looking, contemporary view of reality in all its infinite richness. He treasures the old as childhood memories, but the new embraces him in its strong arms. The logic of the new tries to bind his feelings, to win over his imagination [*fantasi*]. (SS 17:227)

The idea of the imagination struggling against "the logic of the new" is further developed in a description of how Larsson left Sweden to study and work in Paris:

Released from all the mundane pressures of his home, his imagination [*fantasi*], educated in a time now dead and gone, assumed an unrestrained freedom, and he began . . . to conjure up spirits from the shadowy unknown—to try to introduce riddles, allegories, and ideas into his paintings. (SS 17:225)

This "unrestrained freedom" of the imagination to "conjure up spirits from the shadowy unknown" is reminiscent of a line from an 1872 Strindberg essay about the "shadowy" world of myth, "where the imagination was allowed to play unrestrainedly" (SS 54:179). We are not far from the Romantic vision of the shadowy world of the unconscious as the artist's motor center. As for the condescending reference to "allegories," by the turn of the cen-

tury, as we shall see later, he did not hesitate to describe one of his own plays, To Damascus, as an "allegorizing pilgrim's journey" (SS 50:287).

The Obstinate Metaphor: "Above the Clouds" and the Literal versus the Figurative

Strindberg's ambivalence about the role of the imagination in creation is clearest in his fiction. In an 1885 story, "Above the Clouds," from Utopias in Reality, the same story collection that includes "Pangs of Conscience," two ailing and aging playwrights, Aristide and Henri, meet at a hotel in the Swiss Alps and argue over the transience and futility of art. A writer's imagery, says Aristide, is just a game with words; in the utopian future figurative language "will certainly be abolished as not only superfluous but worthless. Look at that snowy Alpine ridge there," he points out to Henri, "its foot enveloped in silvery-white clouds. . . . Let's make a poem about it. I'll try to liken it to something, for a poem is always a likeness. I'll liken it, for example, to a casket for a saint's relics, made of newly molten silver, and borne by a legion of angels, gliding along the earth" (SS 15:169). When Henri responds approvingly (perhaps inspired by the Romantic landscape), Aristide mocks his own image and says that it only "titillates the imagination [inbillningen]." Worse still, he insists, it is vulgar to degrade a mountain by comparing it to a human creation. Then, revealingly, Strindberg has him resort to a second image to describe the unfortunate effect produced by the first: "It cradles our comprehension in a state of numbness where reality and dreams are mixed" (SS 15:169–70).

Aristide's argument against metaphor is close to Aristotle's view in the Rhetoric: metaphor is a decorative addition to language. Clarity was achieved best through ordinary, nonmetaphorical language. Subsequently, Cicero, Quintilian, and others wrote of metaphor as something that undermined the "proper" meaning of words. By the seventeenth century, a rational materialist like Hobbes had so subordinated the significance of images and the

imagination that he viewed the faculty of "Judgement" as exercising the "controlling role in deciding what a poem was to be about, and then another faculty, Fancy, [assuming] the task of decorating the poem with suitable metaphors."[49] In Dr. Samuel Johnson's great eighteenth-century dictionary "there is the sense," says Terence Hawkes, "almost, of metaphor as an *abuse* of language."[50] If clarity should be a main purpose of language, ambiguity is a vice.

The Romantics challenged the classical and Neoclassical definitions of figurative language by proclaiming metaphor's organic relationship to language and by stressing its vital function as a vehicle of the imagination. For the Romantics, metaphor is not a fanciful "embroidery" of the facts. It is a way, as Hawkes has aptly described it, "of *experiencing* the facts. It is a way of thinking and of living, an imaginative projection of the truth."[51]

The same held for Strindberg: metaphoric language was his mother tongue.[52] Even when he thought he was being faithfully mimetic, he was often ebulliently figurative, as the example from "Above the Clouds" demonstrates. But—and this is the vital thing about his imagery—it is never gratuitously figurative in a decorative sense or simply hallucinatory or fanciful; it is almost always only a step or two removed from real experience, and it is organic. The tension between the mimetic and figurative is what makes his imagery so dynamic and vibrant. "I have always had a fear of flying," he wrote in 1894,

and wanted to feel the ground under my feet. . . . But even in my thinking I have had a need of standing on firm ground. First, a mass of raw material, observations, preferably my own, since I cannot trust those of others. Never grinding emptiness, but grist between stones. First physics, then metaphysics, as Aristotle said. Never metaphysics without physics. (Brev 10:206–7)

Goethe said something of the same thing in a different way, emphasizing the dependency of the writer on both spiritual stimulation for his imagination and material sustenance for his understanding. "The emptiest tale," he writes in his autobiography, "has

in itself a high charm for the imagination, and the smallest quantity of solid matter is thankfully received by the understanding." For both artists, an awareness of the validity of both the imaginative and the real accompanied them throughout their lives, linked, as Goethe put it, with an understanding of "the necessity of expressing [oneself] . . . figuratively and by comparisons."[53]

A century after Goethe, however, Strindberg felt obliged to be constant to the scientific spirit of Naturalism, and particularly during the 1880s, this sense of obligation led him on a collision course with his own instincts. While his conscience told him, as his character Aristide tells Henri, that metaphor is not truth but only a means of titillating the imagination, he is forced to advance his argument through metaphor in order to make the point. Perhaps he realized emotionally, as Nietzsche did intellectually, that language is too fundamentally figurative ever to be seriously considered literal. At the same time, in his own individual way he dreamed, as Vico and Leibniz did, of a universal language, free of the ambiguity of figuration. The Aristotelian and the Platonist in him thus engaged in a fierce war over the meaning and purpose of art, probably one of the reasons why, by the early 1890s, he found his creative talents drying up.

The Spiritual versus the Carnal: Development

One of the most interesting battles in this war occurs in an 1883 novella, Development (Utveckling), a reference to the "Development Hypothesis," the term used for the theory of evolution before Darwin. Strindberg's purpose was ironic: history evolves and develops in the novella, but Protestantism, the new order, is seen as no improvement over Catholicism. A lively, ironic, witty, and at times moving work, Development provides an important perspective on Strindberg's views of the contradictions in the artist's calling, of the inner struggle between different ways of seeing.

As in many of Strindberg's efforts in historical fiction and drama, the setting in Development is Sweden in the sixteenth cen-

tury, the period of dramatic transitions that he found so fruitful for exploration. And, like the other stories in the same collection, *Swedish Destinies and Adventures*, it was history intended to resonate with modern implications, written, according to the author, in "a Romantic style, with contemporary meanings and viewpoints" (ss 19:148). The protagonists are two young painters, Botvid and Giacomo, representing opposite points of view, the first man an ascetic, with his roots in the Middle Ages, the second a sensualist, trained in the heady artistic climate of High Renaissance Italy. Strindberg scholars have long recognized that the author identified with both artists, which is made evident in a letter Strindberg wrote to Jonas Lie: "There you have me in two parts" (Brev 4:194).

Botvid, an artist-monk, has been commissioned to do a painting for a monastery chapel in the little town of Mariefred outside Stockholm. The subject is the climactic moment of the Annunciation when Gabriel announces to Mary that she is with child: "*Ave, gratia plena*"—"The Lord is with thee: blessed art thou among women."[54] It does not take Botvid long to discover that the task of harmonizing the real and the ideal poses a terrible dilemma, for it means trying, on the one hand, "to retain the natural aspects of the episode and, on the other, to not forget the miraculous, or the supernatural aspects" (ss 11:199). Putting off the task of evoking the supernatural, he begins with the natural but can only manage a kind of awkward compromise.

It would not be proper in the same painting to represent a man alone with a virgin, especially when he had to carry out such a delicate mission. And so the angel was given that masculine-feminine appearance that characterizes angels. The face and as much of the arms and legs that could be discerned through the garments were those of a young man, while the breasts bulged slightly and the hips began to swell right below the waist. (200)

Worse still, he becomes much too preoccupied with the beauty of the gatekeeper's daughter, Maria, who sits as model for the Virgin. One night, while having a beer with the girl and her father, his

hand accidentally comes in contact with hers. He faints, waking up the next day with an anguished conscience for having gotten so drunk that he lost control of himself and removed his hair shirt.

Giacomo is imported from Italy to do the job properly. Breezily arrogant and unashamedly carnal, he brings a breath of fresh Renaissance air to the dusty medieval town and quickly finds fault with Botvid's work.

"What's this? . . . The angel Gabriel with a woman's breasts? Out they go! Gabriel has to look like an old rascal. After all, he was in the Old Testament and now has a role in the New. We'll give him a beard! On goes the lampblack! There!" He picked up a brush and stroked in a large goatee. (ss 11:211)

In short order, Maria becomes not only Giacomo's model but— to Botvid's dismay—his mistress as well.

The artists come to personify two conflicting aspects of the imagination: Botvid identified with otherworldly ideals, Giacomo with worldly, aesthetic ones, especially the concept of beauty. At night, they debate their ideas about faith and art.

"What do you really believe in, Giacomo?" [Botvid] began. . . .
"In everything my eye sees and my ear hears! Don't you believe that God created the world? Well then, He chose the world through which to reveal Himself to our eyes and ears!"
"But the world is sinful and corrupt!"
"That's a lie," said Giacomo. . . .
"And you're the one who's going to paint the Madonna?"
"Yes, and she's already revealed herself to me! What is the Madonna, anyway? The sweetheart of an itinerant carpenter who learns that she's in a family way! There's only one way for her to look. But in order to render that beautifully, you've got to have seen it, for the beautiful is the true!" (ss 11:215–17)

Botvid is alternately appalled by and drawn to Giacomo's worldly ways, but when he sees the completed painting, he is swept off his feet by the beauty of the Virgin.

Her round little white face and large, black child's eyes made an impression of innocence that clashed with the roguish play of her genially smiling, yet simultaneously wrathful, mouth. . . .

"It's beautiful," Botvid responded, somewhat perplexed, "but it's not the Madonna! What will the monks say?"

"The monks will be ecstatic, because they've never seen the archetypes."

"Are you sure about that?"

"Absolutely certain! They never go outside their walls, and the archetypes have never been inside those walls."

But Botvid is not having any of Giacomo's vulgarization of Plato's "archetypes" (urbilderna). "It seems to me," he says, "that this . . . looks more like a daughter who's been forced to confess some peccadillo to her father" (ss 11:228–29). He sees that Giacomo was no more capable than he was of harmonizing the natural and the supernatural, the real and the transcendental. He knows that the archetypes are not corporeal essences but ideals. Strindberg would return to this same metaphysical problem in more comprehensive ways in post-Inferno plays like A Dream Play, as we shall see, but early as well as late he was fascinated by the subject's implications for the artist, another clear example of which is in the 1879 novel The Red Room.

Though Strindberg's intention in The Red Room was a Dickensian satirical treatment of the wide-scale corruption in bourgeois society, the most interesting character is not the protagonist, writer Arvid Falk, a somewhat insensitive witness to the corruption, but a minor character—the bohemian sculptor, Olle Montanus, whose brooding over the philosophical difficulties of being an artist leads him to suicide. In notes found after his death, he relates how he had come to see a fatal contradiction in the artist's mission: "The ultimate design of earthly life is to liberate the idea from sensuality, but art actually tries to clothe the idea in sensual form in order to make it visible" (ss 5:359).

Although Olle felt his original motivation to be an artist was noble—seeking the freedom necessary to allow his soul to grow—

the means he was compelled to resort to in order to pursue the goal were ignoble. If the philosopher liberates the idea to its purest form, the artist imprisons it in material form. Plato was right all along, thinks Olle. He perceived "the nothingness of art, which is semblance of a semblance (= reality). This is why he eliminated the artist from his ideal state" (SS 5:358–59). Poor Olle was reduced to impossible alternatives. Manual labor stultified his soul, but he found meaningless the art that might have made him feel fulfilled.

The artists in *Development* represent other futile aspects of the artist's calling. Botvid's skepticism about the value of Giacomo's painting is confounded when the work is unveiled: the monks find it awesome. Giacomo can hardly contain the pride he feels over his victory. The monks did not realize that a local girl was the model, that the painter's inspiration was carnal, and his purpose aesthetic, not spiritual. "You see? You see?" Giacomo exults, "Beauty triumphs! What infinite self-deception! God help us if they knew! But they know nothing! Blessed are they who believe and cannot see!" (SS 11:230).

But Giacomo's exhilaration is short-lived. Maria is struck with plague, and he is so repulsed by the sight of her disease-ravaged body that he rushes to the chapel to refresh his memory of a time when her beauty was unspoiled. When he arrives, he finds his canvas vandalized: "The images had been scraped away with blunt knives and all that was visible was scratch after scratch." Protestant iconoclasts, carried away by the new Reformation spirit, have swept through the church and damaged not only Giacomo's painting but every other art image with artistic intentions. One object only was spared, a carved wooden crucifix that Giacomo had earlier criticized for its crudity: "the black Christ on the Cross, he with the flawed left knee and the squinting eyes. He had survived the devastation, ugly as he was, with the terrible wounds in his side and on his hands and feet and with his bloody forehead" (SS 11:246–47). Giacomo flees to Stockholm, leaving Maria to die in the arms of the faithful Botvid.

Through Giacomo's story, Strindberg managed to evoke a pano-

rama of the artist's triumphs and torments: of the fatal appeal of the imagination when it becomes isolated from human compassion and responsibility; of the power as well as the impotence of the artist's image; and of the search for, and the impossibility of, a reconciliation between the ideal and the real. He was to return often, especially in his later works, to the basic elements in the scene: an artist torn between his art and his beloved. In the *To Damascus* trilogy the artist is a writer; in *Crime and Crime*, a playwright.

The tensions set up in the novella between the religious and the secular, the spiritual and the sensual, are left unresolved. If Botvid can never keep the ideal from becoming contaminated by contact with the real, Giacomo cannot advance past the lure of the sensual to any higher level of understanding. If Botvid cannot flesh out the religious ideal sufficiently to make his work persuasive and appealing, Giacomo's lack of faith in anything beyond the transient leaves his work without a soul. If Botvid can never be down-to-earth enough, Giacomo can never soar. Significantly, after Giacomo's death, Botvid retreats into the ascetic world of a monastery, as Strindberg himself was to contemplate doing several times over the next quarter century.

Strindberg's Christian Iconography

Closely related for Strindberg to the conflict between the ideal and the real was a struggle that waged within him between a philosopher's impulse to smash all images that betray man's vain need to create idols and a writer's instinct to think in pictorial terms, in visual images that summarize contradictions so cogently: the transformed vine in "Pangs of Conscience," the homely Christ statue in *Development*. The fact that the focus in both examples is an image of Christ was not coincidental. One can speak of Strindberg's Christian iconography; pictorial references to Christ are common throughout his works. Sometimes they are explicit, as in the allusion to the Annunciation painting in *Development*; sometimes implicit, as in the final scene in *The Father*, where both An-

nunciation and pietà are evoked. We have already noted that as the Captain lies dying, he whispers the same angel's Annunciation greeting to Mary that is the subject of Botvid's painting: "Blessed art thou among women." At the same time, the Captain is being held by his old nurse in a pose that suggests Mary cradling the dead Christ, thus calling to mind both the beginning and the end. This is a familiar iconographic device—a dialogue of images in which one reference to a traditional motif associated with Christ's life is contrasted with another. But Strindberg's Christian iconography can be more subtle, as well. The most obvious example is in *Development*, where we have a distinction made between the simple spiritual honesty of the homely carved crucifix and the sensual materialism of Giacomo's elegant Annunciation. Clearly, Strindberg's preference was for the asceticism of a northern European emphasis in the depiction of Christ over the Raphaelesque elegance of the south. In the evolved Gothic style, says Kenneth Clark, "the emaciated body sags, the knees are bent and twisted: it is a hieroglyphic of pathos . . . [expressing] with irresistible force those impulses which turned mankind away from body-worshiping paganism." [55] Strindberg was haunted by that force— by images of the "Crucified One," as he often referred to it—especially during and right after his Inferno period.

On a deeper level, Strindberg's Christian iconography was but another aspect of his tendency toward typological thinking, which we discussed earlier (chapter 1) in connection with his vision of history. Just as he used Old Testament history as a model for his own history plays, he turned to New Testament imagery to contrast, for example, Christ's struggle on behalf of social justice with his own contemporaries' failure to continue the struggle.

Another pair of contrasting biblical images appears in *The Red Room*. The first is an important event in the lives of the artists who are the central characters: the unveiling of a commissioned painting of the Descent from the Cross, which is then mocked by the artists because of its stale and conventional treatment of the theme. The second image also involves a commissioned work,

and its story reads like a New Testament parable, projecting a meaning that transcends the details being related. An old wooden statue on the altar of a small country church has aroused the curiosity of an archeological scholar. It depicts a woman holding a cross, and local speculation held that she had once been joined by another figure, whose fragmentary remains are now preserved in two sacks. Experts are called in to examine the remnants in order to date them and possibly identify what the second statue represented. The matter soon escalates into a full-scale academic investigation, the kind of bureaucratic tempest in a teapot that Strindberg loved to treat satirically. For two years the sacks of wood fragments are shipped back and forth between the traditionally rival Swedish universities of Uppsala and Lund, and a bitter quarrel develops between a leading professor at each institution. Finally, a compromise interpretation is hit upon: "The broken figure represented Unbelief, while the whole one must represent Faith, as symbolized by the Cross" (ss 5:243).

Olle Montanus is commissioned to make a new statue of Unbelief, and appropriately, he uses a cynical actor friend as model. The finished work is greeted warmly by the congregation, but a further investigation discloses that there had originally been three statues, not two, and that they represented Faith, Hope, and Love. Faith and Love, it seems, were struck down by lightning in the 1810s, leaving only Hope sound and whole. Strindberg must have found images of broken symbols expressive: similar ones appear more than two decades later in the second Fingal's Cave scene in *A Dream Play*, where the Poet and Indra's Daughter see the figureheads of sunken ships about them. "And their names," she says, "Justice, Friendship, Golden Peace, Hope—this is all that's left of Hope . . . deceitful Hope!" (ss 36:301). Evoked in both contexts are the same images mentioned earlier of the flotsam and jetsam of the dreams and ideals of Western civilization, with seductive hope perhaps only a prelude to disillusion. On another level, the iconographic contrast in the novel makes an ironic comment on the fate of religion in a modern society, where church and state

authorities, in their eagerness to distinguish sharply between faith and unbelief, lose sight of a simpler, but perhaps more fundamental, truth: the importance of love.

The bold emphasis on eloquent graphic images in both *The Red Room* and *Development* was characteristic. Strindberg had an abiding interest in the dynamics of the visual imagination and its relation to literature. Another writer who felt strongly about the stimulation of visual imagery was Goethe, who went as far as to declare himself willing to abandon writing in favor of drawing. In drawing, he insisted, "the soul recounts a part of its essential being and it is precisely the deepest secrets of creation, those which rest basically on drawing and sculpture, that the soul reveals in this way."[56] Both Goethe and Strindberg possessed what the German Romantics called *Bildungstrieb*, or "divine impulse to form."[57] Göran Söderström has observed that "an image-making and form-giving impulse was not something Strindberg learned; it was a natural, integral part of his personality."[58]

The impact of Strindberg's visual imagination on his writing, his responses to forms in life and to the life of forms in art, are difficult to overemphasize. They helped make him the most versatile experimenter in drama in the last century. As I have noted elsewhere, "if Ibsen was the Rembrandt of modern drama, its master of psychological portraiture, Strindberg was its master of forms, its Picasso, its restless, inventive spirit, prodigious and prolific."[59] It was no coincidence that the periods when he did a lot of painting—the early 1870s and the early 1890s—were connected, either before or afterward, with periods when his imaginative writing flourished. In the late 1890s, as we shall see, that same visual imagination and his changing attitude toward nature—thinking it, seeing it, and feeling it as form—were the vital catalysts in the renewal of his art.

In the late 1880s, stimulated by his reading of psychological experiments being conducted in France, Strindberg's fascination with the imagination was focused more narrowly in his Naturalistic works on its pathological implications, on the bizarre and the

deviant. But before turning to that, one other important area of his imagination remains to be explored—his historical imagination, which is our next subject. There we will find clues to understanding the Naturalistic works, where the imagination is seen in an evolutionary context, as a vestigial activity in the human mind that must be suppressed in order to make way for the next phase in the historical process.

3 / Masters, Servants, and the Drama of History

*In your minds you must be the same as Christ Jesus:
His state was divine, yet he did not cling to his equality
with God but emptied himself to assume the
condition of a slave, and became as men are.*
—Philippians 2:5–7 (passage marked
in one of Strindberg's Bibles)

The Inveterate Historian

MUCH OF THE ATTENTION FOCUSED ON THE INFLUENCE of Strindberg's imaginative initiatives on modern drama has dealt with his efforts to stretch the bounds of realism: breaking the rules of time and space to find theatrical equivalents of dream states or atmospheres. Approaches to his interest in historical fiction and drama tend to take a different tack. Except for occasional references to expressionistic touches in some of the plays, most discussions have been limited either to praise for his interest in the role of the common people in history or to speculation about his use of anachronism or the extent to which he departed from traditional interpretations of the various historical figures he wrote about. As a result, the impressive range of his historical imagination tends to be overlooked or underrated. Though neither a historian nor a philosopher of history, he took a keen interest in contemporary definitions and evaluations of history's meaning and purpose, and that interest is reflected in the fact that almost half of the fifty-seven volumes in his collected works are concerned with the subject: twenty plays, four volumes of cultural history, four of short historical fiction, and six volumes of essays.

Unlike many nineteenth-century dramatists (the enormously popular and influential Eugène Scribe in Paris comes to mind),

Strindberg never viewed history as simply a source of exotic settings to be exploited for literary purposes. To be sure, the original motivation for his passion was not idealistic but practical. When he first began thinking of a writing career in the late 1860s, he knew that historical fiction and drama were the yardsticks by which he would be measured. Over time, however, a more compelling motivation emerged: the dynamics of history came to fascinate him. But instead of thinking of history as a grand pageant of romantic or patriotic intrigues—the fashion in the mid-nineteenth century—his focus was on its psychological and metaphysical dimensions and on the political lessons to be learned. Ultimately these concerns provided a structure for almost everything he wrote. Even his plays with contemporary settings have historical implications.

While *Miss Julie*, for example, is not designated a history play, the author makes us aware of a confrontation that is located not only at a specific point in chronological time but at an important crossroads: the end of one era and the dawn of a new one. The story of a titled woman's seduction by her father's valet is played out against a background of unique social tensions. Julie belongs to a dying class—the landed aristocracy—and Jean, the arriviste, to an emerging one. Like Hotspur in Shakespeare's *Henry IV*—another noble trapped in the maw of historical change—Julie evokes our sympathy even as we accept the inevitability of her destruction. Strindberg sounds very scientific and detached in his description of the historical necessity of Julie's tragedy: "When we become as strong as the first French revolutionaries, it will afford nothing but pleasure and relief to witness the thinning out in royal parks of overage, decaying trees that have long stood in the way of others equally entitled to their time in the sun" (SS 23: 101). But the playwright's sympathies are as much with Julie as with Jean. The death of the old moral and political order matters more to him than he lets on in his preface.

Not since Shakespeare had any dramatist explored more comprehensively the variations, problems, and contradictions of history, and the most important lessons Strindberg absorbed on the

subject, other than from Shakespeare, were from the Romantic tradition. Though the Romantics did not invent historical drama, they did bring it to its first flowering after Shakespeare, and through the theories of Herder and the novels of Sir Walter Scott, they made Europe conscious of historicism. What happened in the past was no longer to be depicted in a series of contrived tableaux, strung together with static narrative, but as the exciting revelations of an active, ongoing process, a means, says Renato Poggioli, of "comprehending the infinite metamorphoses of the Zeitgeist, but also an idolizing of history, the history not only of the past, but of the present and future, made into a divinity."[1] It is this Romantic sense of the high drama of history—"the infinite metamorphoses of the Zeitgeist"—that Strindberg absorbed and retained, even when he turned away from explicitly historical subjects for more than a decade in midcareer.

Strindberg's ideas about history have been analyzed, but except for Göran Printz-Påhlson in his useful essay "Allegories of Trivialization,"[2] most critics and scholars have taken the playwright too much at his word by reading literally and superficially the long, pedantic, often pretentious and misleading essay Strindberg wrote in 1904: "The Mysticism of World History" ("Världshistoriens mystik") (SS 54:337–401).[3] It presents a providential view in an argument that mixes Renaissance and Swedenborgian metaphysics: history as a giant chess game with God moving both the black and the white pieces. But this is really only one aspect of his philosophy of history. Strindberg the polemical essayist must always be read with a grain of salt; the artist was far more subtle and ambiguous. The polemicist was interested in reconciling contradictions with persuasive arguments; the artist, in reconciling contradictions with powerful images. It is to the images that we must often look for the most complete picture.

As it was for many Romantics, the root image in Strindberg's historical imagination was the French Revolution. Even though he never wrote a play specifically about it (despite plans to do so), its spirit either hovers over the action of many works, as in *Master Olof* (1872), a play set in the sixteenth century, or literally takes

place just offstage, as in *Gustav III* (1902), a play set in the early 1790s. Ironically, perhaps, his most complete dramatic realization of the theme is contained in a short story in the 1905 collection *Historical Miniatures*.

History and the Promise of Revolution

Historical Miniatures demonstrates a wide range of Strindberg's strengths and weaknesses as an interpreter of history. In a panorama of short scenes from world history, beginning with the discovery of the infant Moses and ending with the last day of the French Revolution, he sketches a record of the passing from culture to culture of the utopian, Promised Land aspects of the spirit of God's covenant with Abraham. At its best, the collection articulates his major themes clearly, sometimes eloquently. At its weakest, its historical veneer is so thin in places as to be nonexistent; drama, not epic, was Strindberg's forte. But the final story, "Days of Judgment" ("Domedagar"), is a minor triumph, a one-act play masquerading as a story, a distillation of many of his feelings about history's ultimate purpose and meaning.

The time is the seventh of November (or the eighteenth of Brumaire, according to the new calendar), 1799, the eve of the end of the Revolution. With a sure instinct for setting the right action in the right place at the right time, Strindberg places the scene in a watchman's tiny apartment in the north tower of Notre Dame Cathedral in Paris. The occupant has had little to do since the Revolution discredited traditional religion; the church lies in disuse. By night, he is a bookbinder and has assembled an impressive library. One wall is covered with prints that depict the whole ten-year history of the Revolution, from the Tennis Court Oath in June 1789 to the emergence of Napoleon and the executive council—the Directory—which, through a coup, has fallen into his hands on this very day. A proclamation of his appointment to the Consulate is awaited momentarily.

The old man is a centenarian out of the Old Testament, bearded like an apostle, and appropriately named Jacques (the pseudonym

adopted by so many revolutionaries). "The Revolution is over!" he shouts. "What are you saying?" answers a voice from behind a bookcase. "The Revolution is over! You can come out now, sir!" Grasping the bookcase and turning it like a door on its hinges, Jacques exposes a beautiful little room in the style of Louis XV. François, a pale young nobleman of thirty, steps out of his hiding place. Because he had once saved the old man from the guillotine, Jacques had smuggled him into the tower and saved his life. "Sir," says Jacques, "your time has come and mine is going out. The Revolution is over. . . . Tonight we are still brothers, but tomorrow you're the master and I'm the servant" (SS 42:314–15).

Despite the Revolution's excesses, Jacques believes that an ancient hope had been rekindled, and even, on one glorious day, realized: the Fête de la Fédération—14 July 1790, the first anniversary of the storming of the Bastille. Frenchmen of every class, from king to commoner, had turned out to help prepare the field, the Champs-de-Mars, where the grand celebration was to take place, and where today the Eiffel Tower stands. "It was," says Jacques,

the greatest leveling work human beings ever accomplished; the heights were evened out and the hollows filled. And at last the great theatre of freedom was ready. . . . The king . . . [as] "first citizen of the state" took an oath to uphold the constitution. Everything was forgotten, everything was forgiven. . . . We wept, we fell in each other's arms, we kissed. But we wept at the thought of how base we had been and how kind and good we were at that moment. Perhaps we also wept because we sensed how fragile it all was. Later, in the evening, all of Paris moved out into the streets and squares! Families had dinner on the sidewalks, . . . food and wine were distributed at the state's expense. It was a Feast of Tabernacles, in commemoration of the Exodus from the Egyptian slavery; it was a Saturnalia, the return of the Golden Age! (SS 42:318)

Jacques's reactions to the expectations raised in the early days of the Revolution mirror those of many intellectuals and artists at the time. The young Wordsworth, for example, arriving in Europe on Federation Day, wrote later in The Prelude of having seen

"France standing on the top of golden hours, / And human nature seeming born again."[4] Carlyle, a Romantic of the following generation, devotes much loving attention to the implications of the event in his *French Revolution*, a book Strindberg owned, and was probably inspired by, twenty years before he wrote *Historical Miniatures*.[5] In both works the same ecstatic atmosphere is evoked with the same metaphors. Carlyle talks of "a Hebrew Feast of Tabernacles," where there burst forth an "effulgence of Parisian enthusiasm, good-heartedness and brotherly love; such, if Chroniclers are trustworthy, as was not witnessed since the Age of Gold."[6]

The leveling work described in each instance implied a lot more than simple earthmoving. It was a profound political event set in a carnival atmosphere, reminiscent, as Strindberg says, of the annual Roman Saturnalia festival, where the world was briefly turned topsy-turvy as servants were permitted to change places with their masters.[7] Jacques says: "Animated by one spirit, the half million people assembled on the spot that day felt like brothers and sisters" (ss 42:318). Carlyle relates how all titles of nobility were abolished and, in

like manner, Livery, Servants, or rather the Livery of Servants. . . . In a word, Feudalism being dead these ten months, why should her empty trappings and scutcheons survive? The very Coats-of-arms will require to be obliterated. . . .

[It was a] true brethren's work; all distinctions confounded, abolished; as it was in the beginning, when Adam himself delved.[8]

Gracing the political intentions of Federation Day was its theatricality; the great Jacques-Louis David was in charge of the staging. Carlyle, in fact, insisted that the event should be remembered as "the highest recorded triumph of the Thespian Art: triumphant surely, since the whole Pit, which was of Twenty-five Millions, not only clap hands, but does itself spring on the boards and passionately set to playing there. . . . A whole Nation gone mumming."[9]

All the ingredients involved—the egalitarian ritual in a theatri-

cal setting, the undermining of authority as hierarchies are turned on their heads, the mingling of fantasy and reality—are integral parts of what Mikhail Bakhtin describes in *Rabelais and His World* as "carnivalization." And they are all elements in Strindberg's carnival view of history, a view with a broad range. Included is his little mock-medieval creation play, *Coram Populo*, the play-within-a-play in *Master Olof*, in which history is seen as a procession of cruel jokes God plays on humans, and Satan is a voice urging compassion and justice. A less obvious, but nonetheless important, Naturalistic example is *Miss Julie*, in which the end of a historical era—and the death of a social class—are the setting for a drama in which master and servant exchange roles.

It is impossible to understand this view of history without also understanding Strindberg's attitude toward the phenomenon that Bakhtin interprets as often synonymous with carnival: revolution. Sweden in the year Strindberg was born—1849—was, in Franklin Scott's words, a "rural backwater on the margin of the continent." [10] In the antiquated Parliament only four social groups, or Estates, were represented: nobles, clergy, merchants, and farmers. Some hesitant steps toward abolishing Estates had been made in 1809 and 1810, following the French revolutionary precedent, but not until the 1860s was there a serious attempt to reform a system of representation that had been in effect since Sweden separated from the Kalmar Union with Norway and Denmark in 1521.

Strindberg was a teenager when the Reform Act of 1865 raised high hopes for democratization, but the hopes proved illusory. Although the old Parliament was dissolved in favor of a more representative, bicameral body, the majority of the members of the new body were holdovers from the old one, and large segments of the people were still excluded from representation. As far as the radical elements in the younger generation were concerned— Strindberg among them—the Reform Act was a failed revolution, and they looked to the past for precedent, to "the mine exploded in '89 (ss 4:259), as Strindberg called it in 1872.

In his passion for history he viewed the French Revolution as many of the Romantics did: a secular equivalent of the Last

Judgment. "As long as the Romantics," says Paul Cantor, "viewed the French Revolution as a uniquely privileged moment in history—the beginning of the end of tyranny on earth—they had a fixed point around which to articulate their myths." [11] Swedish pre-Romantic poet Thomas Thorild (also a character in Strindberg's *Gustav III*) wrote in 1790 of how "this divine and greatest event on earth next to the Deluge, this rumble of Doomsday for tyrants—has made me meek as a lamb. I could depart in peace and die, except that I think it is really worth living at this time." [12] Coleridge put it most succinctly: "The present State of society. The French Revolution. Millennium. Universal Redemption. Conclusion." [13] Hovering over the action in many Strindberg works, either explicitly or implicitly, is a vision of apocalyptic social change, capable of redeeming the promise to Abraham and transforming the world of lies into the realm of truth: another Eden, a new Golden Age.

Although the novel *The Red Room* was based on Strindberg's experiences as a newspaperman in the years 1872–74, [14] one of the characters observes, as if parodying the French revolutionary calendar, that "we are now in our Year III, in Roman numerals, because this is the third year that our new Parliament is meeting, and we will soon see our hopes realized" (ss 5:9–10). Since the new Parliament first convened in January 1867, this would make it the autumn of 1870, an impression reinforced later in the novel by an allusion to "the workers' disturbances, which under the name of 'The Commune' are now devastating the French capital" (302).

The Red Room is thus not just a novel of social satire but a historical novel with a revolutionary theme, offering a view of the past to emphasize the shortcomings of the present. The references to the Commune and the Year III were obviously meant to draw the attention of Swedes to their own failed revolution. Olle Montanus, virtually Strindberg's alter ego, as we saw in the last chapter, is so disillusioned personally and politically that he commits suicide, leaving notes in which he complains of "the dreadful reaction that set in after 1865, the years of the death of hope, which demoralized the new generation then growing up" (ss 5:362). The

author, as a member of that generation, was radicalized by the experience, and it did much to shape his vision of his time as a period of crisis, a moment of transition, pregnant with possible change. Whatever hope he cherished of apocalyptic change was soured by the suspicion that no real change can ever take place, that one world of lies will simply be replaced with another.

Carnivals and Revolutions

The relationship of carnival to revolution is complex and, especially in Strindberg's case, ambiguous. On the one hand, carnival is a harmless fiction that can function as a means for avoiding revolution, a temporary transformation, a safety valve to dissipate social discontent. On the other, it is also regarded as potentially subversive, a possible rehearsal for the real thing. In 1559 Queen Elizabeth sanctioned a masque in which a masquerade of crows, asses, and wolves represented cardinals, bishops, and abbots. Five years later, however, the threat of serious conflict between Protestants and Catholics made her reluctant to permit such demonstrations, for fear that carnival's revolutionary spirit would ignite a real revolution.[15] In our time the egalitarian carnival spirit of the student demonstrations in Peking's Tiananmen Square was a reminder that the emotional power of "carnivalization," whether in fiction or reality, has lost little of its ability to alarm governments about the threat it poses of real revolution.

There are polar tensions in Strindberg's handling of the carnival theme, as there are in his handling of the failed revolution — a mixture of disillusion and hope. The fact that he never followed through with plans made on several occasions for a substantial work on the French Revolution is perhaps a good indication of how divided his feelings were on the subject. In his story "Days of Judgment" François's response to Jacques's glowing evocation of Federation Day is cynicism. Then, says the young man, "came Marat, Danton, and Robespierre . . . [and] the Golden Age went as it came." "But it'll come again," the old man responds. "Do you really believe in the return of the Golden Age?" the young man

asks. "Yes," says the old man, "like Thomas, I believe when I have seen. And I did see! That moment I just recalled, on the Champs-de-Mars, was such a time. And we could see the future. We were as certain as if we'd had a revelation of what was to come, but we weren't sure whether it would happen now, right away" (*ss* 42: 319). When their conversation is interrupted by the clanging of Paris church bells announcing Bonaparte's ascension to power, François sighs in gratitude, "The Revolution is over!" to which the old man replies, in a line suggesting the continuity of hope in the theme: "*That* revolution!" (321).

Underlying Jacques's confidence is a faith in the truth of the carnival spirit of Federation Day: a sense that the carnival spirit can—indeed, must—be more than a safety valve. This is in keeping, says Michael Holquist, with Mikhail Bakhtin's theory that carnival

is not only not an impediment to revolutionary change, it is revolution itself. Carnival must not be confused with mere holiday or, least of all, with self-serving festivals fostered by governments, secular or theocratic. The sanction for carnival derives ultimately not from a calendar prescribed by church or state, but from a force that preexists priests and kings and to whose superior power they are actually deferring when they appear to be licensing carnival.[16]

Underlying Bakhtin's faith in carnival is an almost mystical faith in the common man, and this marks a difference between his concept of carnivalization and Strindberg's. As Victor Hugo did, the young Strindberg invested much of his hopes for the future in "*le peuple*," "*folket*," but he came to fear them as well, as an unreliable and dangerous force. Whereas in 1872 he wrote that the artist's calling demanded that he serve not art but the people (*ss* 54:176), by 1887 he had become almost contemptuous of populist ideas, observing wryly, "The French Revolution was accomplished not by 'folket' but by noblemen, priests, and scholars, and in fact its effects were blocked by 'folket'" (*ss* 19:29). But the second statement was made in the antidemocratic middle years of his career, when he had become bitter because he felt his countrymen rejected his message of social reform. That faith was restored after

the turn of the century, evidence of which we see in Jacques's story of Federation Day.

Strindberg delivered his social message most clearly in his satirical poetry, short stories, and essays, using the corrosive power of laughter to expose what he called "Society's Secret." The nature of that secret was that society was a façade intended to conceal tyranny, "an invention of the Overclass to oppress the Underclass" (Brev 4:222). The artist's task was to penetrate the façade, strip away the mendacity, and demonstrate that everything stamped as official—festivities, court poets, noble titles, and so forth—was a fabrication by the Overclass to perpetuate its power. Bakhtin says that carnival laughter "builds its own world in opposition to the official world, its own church versus the official church, its own state versus the official state." [17] Rabelais's purpose, according to Bakhtin, had been to undermine "what his time 'said and imagined about itself'; he strove to disclose its true meaning for the people." [18]

Bakhtin sees reconciliation brought about by the carnival spirit: a process through which the sterile, abstract official world is purged, regenerated, and joined "with the essential aspects of being, with the organic system of popular-festive images." [19] The purging element is degradation, which in medieval grotesque realism is a positive force. It means, says Bakhtin,

coming down to earth, the contact with earth as an element that swallows up and gives birth at the same time. . . . To degrade . . . means to concern oneself with the lower stratum of the body, the life of the belly and the reproductive organs. . . . To degrade an object does not imply merely hurling it into the void of nonexistence, into absolute destruction, but to hurl it down to the reproductive lower stratum, the zone in which conception and a new birth take place. Grotesque realism knows no other lower level; it is the fruitful earth and the womb. It is always conceiving.[20]

Strindberg understood the power of this kind of degradation. Time and again, whether in choice of character or setting, he re-

turns, as to a source of strength and renewal, to earth images, to natural rhythms, to images of carnal desire. One notes how often the settings of his works are connected with the solar divisions of the year marked by Midsummer, Christmas, or Easter, or how eloquently, for example, he evokes the earthy, carnal power of an autumnal harvest scene in the 1887 novel *The People of Hemsö* (*Hemsöborna*). At the same time, the physical impulse downward was in conflict with a spiritual longing upward. Degradation may be necessary for regeneration, but its life-giving qualities were challenged, perhaps even negated, by its destructive capacity. In the preface to *Miss Julie*, as noted above, Strindberg appears to justify revolutionary violence. In the play proper, however, his sympathies are never this unequivocal. Indeed, *Miss Julie* serves as a model of the skill with which he used carnivalesque degradation to create a richly ambiguous interplay of meaning: social, historical, spiritual, and psychological.

Carnivalization and Drama

The main carnival aspect of *Miss Julie* is the festive Midsummer holiday atmosphere in which all class distinctions are temporarily suspended in a "*folklig*" celebration. Julie displays the appropriate condescension of a master to a servant when she tells Jean: "On a night like this we're all just ordinary people having fun, so we'll forget about rank" (SS 23:123). Thanks to the reversal of roles, she learns to empathize with the poor. But she senses from the start, even if only half-consciously, that carnival is more than a game; degradation is a process that threatens all values. In a recurrent dream she has of being trapped at the top of a high pillar she fears she will have no peace until she is down on the ground, but if she did get down, she would want to be under the earth (132).

After the seduction, her dream proves only too prophetic as Jean abuses her. "It hurts me," he says, "to find out that what I was striving for wasn't finer, more substantial. . . . It hurts like watching flowers beaten down by autumn rains and turned into mud"

(ss 23:154). In the tragic aspect of Strindberg's carnival vision, which is dominant, the longing for reconciliation of high and low, wealthy and poor, powerful and powerless is, to use Strindberg's own term, a "deceitful hope." The dream of something better or higher can only be debased when it comes in contact with the real world.

The biblical structure in *Miss Julie* of before and after the Fall is also present in the history play *Christina* (1901), with another futile promise of reconciliation, for carnivalization has turned to pure theatre. Once more a love affair is the focus of attention, this time between a nobleman and the controversial seventeenth-century Swedish monarch who startled her countrymen by abdicating and converting to Catholicism. An elaborate pageant is staged to celebrate the queen's love for nobleman Klas Tott, and both of them are at first mesmerized by the power of the make-believe. Her costume as Pandora causes him to wax mythological: "You don't know who you are or where you came from, any more than a child would know, any more than you can remember *all* the dreams you dreamt last night! When the gods sent you, their daughter, down here, they blotted out your memory" (ss 39:217).

Demonstrating just outside the castle, however, are Christina's subjects, angry because she has failed fundamentally in her royal duties, because she failed to understand the hunger for bread and justice of ordinary people. In a number of Strindberg's history plays and historical studies, with perhaps Carlyle's *French Revolution* as model,[21] the people often serve, like a Greek chorus, as a collective witness to the ugly truth of Society's Secret, a reminder that lies must eventually be penetrated.

In *Charles XII* an angry farmer says that the king's imperialistic ambitions have deafened him to the prayers and justified complaints of an entire people (ss 35:123). Those complaints come back to haunt Charles as he sits planning his final, fatal expedition to Norway. A stage direction reads: "*At the iron-grill gate people now gather. . . . They are silent, but frightful to look at.*" Similarly, in *Christina*, the queen, isolated from reality, is alarmed by sounds from outside the castle.

CHRISTINA: . . . Who's that?

HOLM: The little people!

CHRISTINA: (*trying to make light of it*) It doesn't sound like the voices of children.

HOLM: No, Your Majesty, it doesn't! (SS 39:194)

Later, the rumblings of rebellion spoil the party. As the queen claps her hands to signal a scene change,

. . . *the upstage drop rises. One sees instead of the expected* [mythological] *tableau a crowd of strange people, all motionless, silent, pale-faced.* . . .

CHRISTINA: Are they visions from Hell?

TOTT: I don't know! But I feel as though I were awakening from a long sleep! . . . In all these faces . . . I read a terrible judgment—of you!

The juxtaposition of grotesque, carnivalesque, theatrical, and political images approaches the level of metaphysical nightmare expressed in a Strindberg play with references to a goddess descending to earth: *A Dream Play* (1901). When Indra's Daughter returns to her celestial home at the end, "*the backdrop is illuminated by the burning castle and reveals a wall of human faces, questioning, grieving, despairing*" (SS 36:330). In contrast to Christina, however, Indra's Daughter has had compassion for ordinary people: "These poor people. I pity them" (229). In this instance the faces carry, not a judgment of her, but a message of pain and suffering that she will forward to a higher tribunal.

The tragic aspect of Strindberg's sense of carnival reflects the change that took place in the concept after the eighteenth century, when, says Bakhtin, "in its Romantic form the mask is torn away from the oneness of the folk carnival concept. It is stripped of its original richness and acquires other meanings alien to its primitive nature; now the mask hides something, keeps a secret, deceives."[22] Whatever egalitarian spirit motivates carnivalization, we are today perhaps more aware that the theatrical nature of the acts of donning masks and assuming temporary roles lends an aura of pathetic unreality to everything. An example of the pathos can be found in Rio de Janeiro's pre-Lenten carnival of Mardi Gras, a modern example of the carnival tradition, in which for a brief

time the *favelados* (the shantytown inhabitants) can dance proudly side by side in the streets with the rich and powerful. Tomorrow, however, the game of master and servant must be resumed. "The Romantic mask," says Bakhtin, "loses almost entirely its regenerating and renewing element and acquires a somber hue. A terrible vacuum, a nothingness lurks behind it."[23]

The unreality of carnival theatricalization is prominent in several of Strindberg's later history plays. In *Gustav III* the concept of masquerade, which is expressed as a sharply defined pageant in *Christina*, has become a controlling image that blurs the lines between fantasy and reality. The monarch credited with introducing a spirit of reform into the rigid Swedish class structure in the early 1790s, Gustav III, was also a lover of the arts and founded the Royal Dramatic Theatre. The final scene in the play takes place in a very charged theatrical atmosphere: the moments before the king's assassination at a masked ball (the same dramatic situation Verdi exploited for *Un ballo in maschera*). Ironically, as costumed, masked aristocrats chat about the latest news from the French Revolution, a real revolution threatens right under their noses. Nothing is real anymore or can deliver what it promised. One of the characters observes that the king and his advisers discuss revolution and counterrevolution as if they were talking about another play (ss 39:348). And another says bluntly, "We're all tired of this carnival" (379).

In *Erik XIV*, king and commoner, high and low, work in awkward concert in the odd partnership of Erik and his friend and confidant the powerful Göran Persson. Here it is a commoner, Göran Persson, who sets the carnival tone, not the aristocrat, as in *Miss Julie*. Nobleman Svante Sture, angry because his access to the king is denied by Göran, wonders how a clerk can stand between the king and a lord of the realm.

GÖRAN: There can only be one lord of the realm, and no noblemen shall stand between the king and the people. . . .
SVANTE STURE: Will you ask me to sit, or must I stand? . . .
GÖRAN: Stand or sit, my lord. I neither possess rank nor am subject to it. . . . (ss 31:319)

Sture knows trouble when he sees it: "Why, this is a revolution . . ." (320).

The carnival mood in *Erik XIV*, like the relationship between the king and his adviser, has an absurd and very modern quality. The contradictions we saw in *Miss Julie* in the game of master and servant exchanging places have been transferred from the personal to the public level, indicating that the curse of the Fall affects nations as well as men. Moreover, the changing of roles in both plays suggests that, if anything, a servant can become as great a tyrant as a master, which is exactly what happens in *The Ghost Sonata* (1907), where we find that Bengtsson's master, the monstrous Hummel, had once been his servant.

As Bakhtin himself noted, the positive, healthy aspects he detected in carnivalization have not survived well in the twentieth century. It is significant that he wrote his study in Russia during the terror of the Stalinist night, posing a challenge to the "official" view of who the "people" were with reminders of an older, organic populist tradition.

Strindberg's use of carnivalesque themes and devices began— in keeping with the older, positive tradition to which Bakhtin alludes—as an allegorical weapon in the battle against "official" lies, a tool for revealing Society's Secret, but he transformed its purpose during the last half of his career, making the egalitarianism more ambivalent and adding a modern dissonance. It is not simply that in a play like *Ghost Sonata* the façade of middle-class life found so attractive by the Student turns out to be just an illusion; life itself possesses the same uncertainty. Carnivalization, which served only purposes of social criticism in Strindberg's early works, is now also a means for expressing the metaphysical truth that the task of separating fantasy from reality is a slippery one. The plays written after the Inferno period, whether in a historical or contemporary setting, suggest a transposition of the carnivalization theme from the social and public level to an inner world of gnawing doubt, where make-believe and reality wear the same mask, so that a character like the Stranger in *To Damascus*, bewildered by the phantom shapes and events around him that seem to

be what they are not, can ask the Lady: "Tell me one thing: is this a carnival or are things really as they should be?" (ss 29:29).

Perhaps what attracted Strindberg to the carnival theme, despite his mixed feelings about it, was the opportunity to evoke the Romantic dream of reconciliation, a grand union of opposites that had political, psychological, and metaphysical implications. The type of dream he emphasized in a particular play depended on the style or genre he had chosen for the theme of descent. In the Naturalistic Miss Julie the mistress of the manor condescends to dance with her servants; in the history play Christina the monarch deigns to love someone beneath her station; and in the fantasy A Dream Play the daughter of a god marries a mortal. The model of action for all of them is the descent of a godhead, the metamorphosis of the divine into human form, and, by implication, the possibility of a meeting in which ordinary mortal and god, or servant and master, come to a closer understanding. But in these examples, the outcomes are tragic: Julie takes her own life; Christina and Tott are driven apart; and the Daughter returns to her heavenly home. Only in Miss Julie is there a moment of even partial reconciliation, an ameliorating comment on the vexing dichotomy of master versus servant, made possible by a Christian perspective fused to the carnival spirit. Julie's fall from high station is a kind of blessing, since she realizes that she is not just among the very last but "last of all" (ss 23:187), which echoes Christ's admonition to his apostles "If any man desire to be first, the same shall be last of all, and servant of all" (Mark 9:35).

Strindberg had traveled a great distance to arrive at the somber implications of Miss Julie, a distance measured by the evolution in his attitudes toward history from his journeyman 1872 history play, Master Olof, to his 1888 Naturalistic tragedy. Implied in the early play is a linear, purposeful view of history; in the later one, a cyclical, pessimistic view.

History and the Bible in Master Olof

The action in *Master Olof* has an Old Testament structure: a prophet appears at a time when the people are in spiritual need. The setting is a small Swedish town, Strängnäs, in the early sixteenth century, and the prophet is a Catholic clergyman about to defy Rome and become his nation's Luther. Clerical authorities, angry over tardy payments of tithes, have locked the doors of the cathedral on Pentecost—the very birthday of the church. Olof decides to hold services anyway, but not before being urged, even goaded into it, by an Anabaptist fanatic, Gert Bookprinter, an apocryphal figure and one of Strindberg's most imaginatively drawn early characters. Gert argues that not one but two authors of tyranny exist: the pope and the emperor, in the latter case young King Gustav Vasa. Before Gert and Olof are finished with their subversive activities, church authorities are up in arms and a rebellion is fomented against the king. When the rebellion is broken and Olof and Gert are captured, Olof recants and survives, while Gert goes unrepentant to the executioner's block.

Strindberg departs a bit from his biblical model by dividing the prophet's role between Olof and Gert, but the overall purpose was the same: a heroic figure appearing in a time of crisis to remind king, priests, and common people alike of the duties and responsibilities implied for all in the continuity of the covenant between God and Israel. In fact, the playwright was perhaps a bit too literal in his fidelity. The specific prophet alluded to is Jeremiah, and Strindberg constructs the kind of symmetry Northrop Frye has described as indicating "that historical content is being subordinated to mythical demands of design and form."[24]

In the play:	In the Bible:
1. When Olof says he is too young to preach reform, a friend reminds him of God's admonition to the prophet to "gird up thy loins" (ss 2:8).	1. When Jeremiah complains, "behold, I cannot speak: for I am a child" (Jer. 1:6), God tells him, "gird up thy loins" (Jer. 1:17).

2. Gert records in a book the injustices committed by the king against the people (ss 2:165).

2. Jeremiah prepares a scroll listing God's complaints against the king ("Doom for the man who founds his palace on anything but integrity" [Jer. 22:13]), priests, and prophets of Israel.

3. Olof rages against corrupt members of the clergy who frequent a tavern created in the wall of Stockholm's Great Church (ss 2:5).

3. Yahweh tells Jeremiah that "even prophet and priest are godless, / I have found their wickedness even in my own House" (Jer. 23:11).

4. Olof is stoned when he preaches (ss 2:78).

4. A legend holds that Jeremiah was stoned.[25]

5. Olof is punished for taking part in the conspiracy against the king by being put in the stocks (ss 2:176).

5. When Jeremiah's prophecies are unpopular, he is punished by being put in the stocks (Jer. 20:2).

Strindberg's mythopoeic imagination, which in so many of his works ties humans to nature and natural rhythms, here uses mythic elements, much as Carlyle did,[26] as *semes*, discrete units of meaning, reverberating with ancient import in a modern context and acquiring new significance in the process.

The dynamic energies in *Master Olof* inaugurated a new era in Swedish literary and theatrical history. Where conventional taste had expected a deferential treatment of some of the nation's most revered spiritual and political leaders, Strindberg presented human beings with all their contradictions. And instead of the kind of stilted, declamatory language that actors of the day were used to, he had given them pungent, realistic, conversational dialogue. Most important, however, was his superb intertwining of political and psychological themes, the public and the personal, and his subordinating of history as patriotic pageant to history as process. The same subordination was accomplished in Georg Büchner's Romantic *Danton's Death* (1834). Both were amazing accomplishments by playwrights only in their early twenties. *Danton's Death* was a work that might have inspired Strindberg, except that it was

virtually forgotten until Max Reinhardt staged memorable productions of it in 1916 and 1921, after Strindberg's death.

To be sure, some of the themes and dramatic devices Strindberg used were already standard items in Romantic drama: nostalgia for medievalism, anticlericalism, political intrigue, rapid alternation of scenes, and Gothic suspense in a cemetery at night. Even his emphasis on the individual presenting a challenge to tyrannical authority was a dominant Romantic theme in scores of nineteenth-century plays and operas. What was new in *Master Olof* was the nature of the challenge. In Goethe's *Götz von Berlichingen* (1773), for example (Strindberg's most immediate inspiration), the courtly, noble knight who is the hero defies a corrupt prince, but he is always careful to be faithful to the emperor, and so, the ultimate authority of the state is never challenged or threatened. Gert Bookprinter, in contrast, strikes out against that very authority.

Not surprisingly, theatres were reluctant to consider for production such a potentially controversial play, which led to almost a decade of frustrating and disillusioning attempts by Strindberg to come up with an acceptable draft. When the original prose version was finally produced in 1881, after a delay of almost a decade, his severest critic, Carl David af Wirsén, recognized immediately the size and implications of what had been achieved in the figure of Gert. Citing a study that asserted that Anabaptists were communists, Wirsén accused the playwright of sympathizing entirely too strongly with his character. "Herr Strindberg's temperament," Wirsén noted archly, "is extremely negative, and this is why he has depicted this spokesman for subversive movements with such marked partiality."[27]

Strindberg identifies Gert closely with the holiday which opens the action of the play, Pentecost, important in both the Old and New Testaments. In the first, it is the anniversary of the giving of the law to Moses, a renewal of the covenant. The very name of the second—New Testament—signaled a new covenant, which was established and a church founded when the Holy Spirit descended upon the disciples at Pentecost with the gift of tongues and prophecy. Throughout the play, Gert is fired up with the

energy and purpose of the holiday. "You can receive the Holy Spirit," he urges Olof. "I've received it because I believed it. God's spirit has come down to me; I feel it; that's why they locked me up as insane, but now I'm free" (ss 2:21).[28] His farewell to Olof before going off to a martyr's death at the end is another reminder of the day on which the action began: "Never forget the great day of Pentecost!" (180). Three decades later, in "Days of Judgment," Gert's reference to the revolutionary legacy of Pentecost echoes in the defiant answer old Jacques gives to the aristocrat's assertion that the Revolution is over: "*That* revolution!"

In true biblical tradition Gert is the prophet who seeks to remind his nation that God hates nothing more than oppression, and his most urgently pressed theme is the task of redeeming history from injustice. Though he would welcome divine help in the process, he is prepared to choose a drastic secular option: violent overthrow of tyranny. In the figure of Gert the spirit of revolution and the Holy Spirit are one and the same. Typologically (see chapters 1 and 2), another precursor has been identified for the Apocalypse—revolution—the ultimate moment when unjust history ends and transcendent justice begins. If Christ as prophet was the antitype of all the Old Testament prophets, who were his types, the revolutionary Gert is still another type in history's long line of development, pointing the way to the Final Days.

Joachism in Strindberg and Ibsen:
The Promise of a Third Age

The idea of connecting Holy Spirit and revolution did not of course originate with Strindberg; it evolved over a period of several centuries. The source was an unlikely one: the prophecies of a twelfth-century cleric, Joachim of Fiore, who influenced, directly or indirectly, almost every writer or philosopher involved with historical themes from that time to the present. Both Ibsen and Strindberg, although probably unaware of it, were Joachimites, and a comparison of their different approaches within the

Joachimite tradition goes to the heart of Strindberg's philosophy of history.

As an explanation of why the Second Coming and Millennium predicted in Revelation (20:1–10) had not materialized in A.D. 1000, Joachim declared that new mathematical calculations revealed the true date of those events to be 1260. At that time, a third age would ensue, changing history dramatically. The first age had been the "Age of the Father," the second was the "Age of the Son," and the third and last would be the "Age of the Holy Spirit." If Mosaic law dominated the first, and the Gospels and the church the second, the last would be a time when a more personal relationship was established between man and God, one without intermediaries. Where the first age, says Norman Cohn, "had been one of fear and servitude and the second age one of faith and filial submission, the third age would be one of love, joy and freedom, when the knowledge of God would be revealed directly in the hearts of all men."[29]

A tripartite view of history did not of course originate with Joachim; ancient apocalyptic literature, for example, often predicts that a time of hardship and injustice for the Jewish nation will be followed by the appearance of a brave Messiah and an age of warfare and will culminate in victory and the onset of an age of bliss. But much of the three-age historical thinking of philosophers subsequent to Joachim can be traced back to his paradigm: Hegel's thesis, antithesis, and synthesis; Auguste Comte's theological, metaphysical, and scientific phases; and Marx's stages of primitive communism, a class society, and a final communism in which there will be total freedom and a withering away of the state.[30]

Brian Johnston credits Hegel's tripartite concept of history with a direct influence on Ibsen, not only on the massive historical trilogy *The Emperor and the Galilean* but on the later Naturalistic prose plays as well.[31] Other scholars trace the tripartite influence on Ibsen back to Joachim.[32] The hero of the trilogy, the Roman emperor Julian, is torn between two ideologies, two phases of his-

tory: paganism and Christianity. In Ibsen's treatment, according to Johnston, they become thesis and antithesis, and the synthesis toward which Julian reaches, but never realizes, is a mystical "Third Kingdom." The movement toward that kingdom in Ibsen, says Johnston, is a Hegelian journey that depicts "the emergence of Spirit from the sub-ethical 'community of animals' and its ascent through various phases, manifested in history, up to the final phase of Spirit positing itself." [33] In many of Ibsen's plays, the most common image for Spirit's ascent is in perfect harmony with Joachim's third age of the Holy Spirit: a bird in flight, seeking freedom. Nora, for example, in *A Doll House*, is constantly referred to as a lark by her husband, and her dollhouse home is a cage, imprisoning her spirit. In the later play *Lady from the Sea*, Ellida Wangel has a longing for the boundless and the infinite in life, and she senses it as "black, soundless wings" [34] hovering over her.

In Strindberg's case we have already seen how closely Gert is identified with the Holy Spirit. The primary difference in the two playwrights' views of history lies in the connection Strindberg makes between Spirit and revolution and in the emphasis Ibsen puts on the psychological nature of Spirit's journey. Strindberg turned against democracy in the late 1880s, but earlier (when he wrote *Master Olof*) and later (after the turn of the century), he envisioned a third age of freedom as finding ultimate expression in political terms, in a transformation of society, whereas Ibsen throughout most of his life regarded the necessary revolutionary transformation as occurring not externally but internally.

The bumpy road each traveled in their lives to reach such conclusions was much the same as that covered by earlier Romantics: from a faith in radical social change, to disillusion, to skepticism, and, in some instances, to open hostility regarding any radical approach. They were repeating the journeys of English Romantics like Wordsworth, Coleridge, and Southey, whose hopes were dashed by the excesses of the French Revolution (and of Milton, whose millennial hopes in the English Revolution had similarly faded a century earlier). Strindberg, though opting briefly for anarchism, never completely lost his faith in a more conventional,

if necessarily violent, political solution. Ibsen, on the other hand, totally soured by all politics, was an enemy of all radical social change. "Liberty, equality, and fraternity," he wrote urgently to Georg Brandes in 1870, "are not the same things they were in the days of the blessed guillotine. This is what politicians refuse to understand, and that is why I hate them. These people want only special revolutions, external revolutions, in the political sphere, etc. But all that is nitpicking. What really matters is a revolution in the human spirit." [35] Strindberg, too, like so many Romantic artists who had preceded him, eventually discovered during his midlife Inferno Crisis the importance of inner change, but in contrast to Ibsen, for him, as we shall see, it meant spiritual *evolution* rather than *revolution*. And he never developed as bleak a view of liberal democracy as Ibsen did, who wrote in an 1872 letter to Brandes that "liberals are freedom's worst enemies. Spiritual and intellectual freedom thrive best under absolutism." [36]

Coram Populo: *Medieval Pastiche*

The Romantic interest in the French Revolution as a secular equivalent of the Last Judgment was balanced by a corollary interest in creation myths. While revolution centered on a radical solution to the problems of earthly life, creation myths speculated about the causes at the start—Genesis instead of Apocalypse. Strindberg, too, was fascinated by ends and beginnings. If *Master Olof* evokes an apocalyptic atmosphere of revolution, another work, a brief play-within-a-play he appended to *Master Olof* in an epilogue, is a dark cosmogony, his own modest Book of Genesis.

Coram Populo, as it was called in a later, French revision (full title: The Creation of the World and Its True Meaning [De Creatione et Sententia vera Mundi]), is a variation on a medieval chronicle play (see chapter 7). The setting for its performance is a town square, where Olof, now in his later years and grown fat, secure, and complaisant, is part of a crowd gathered for the event. The play opens with God deciding on a whim to create a world whose torments will amuse him and his angels. When his brother, Lucifer, objects

to this cruel injustice, he is cast into Hell as punishment. The rest of the short work depicts the history of the world as a kind of absurd game, with Lucifer trying to help, and God trying to torture, humanity. When Lucifer brings humanity hope of liberation through death, God determines that they will reproduce their kind before leaving. Lucifer counters by producing the Deluge. When the archangel Michael reports the bad news, God determines to retaliate, and the result is a chain reaction, a crescendo of apocalyptic events that blends the grisly with the comic.

> GOD: I have just saved two of the least enlightened ones, who will never understand the truth. Their ship has already landed on Mount Ararat and they have made burnt offerings.
>
> MICHAEL: But Lucifer has given them a plant called the vine, whose juice cures ignorance and confusion. One drop of wine and they see things as they really are.
>
> GOD: The fools! They don't know that I have endowed their plant with strange qualities: madness, sleep, and forgetfulness. With this plant, they will no longer remember what their eyes have seen.
>
> MICHAEL: But he has given them other, more lasting gifts, such as war, pestilence, hunger, storm, and fire. With those, they can always find liberation.
>
> GOD: Very well, I'll give them love for life.
>
> MICHAEL: Woe to us! What are they making now down there, those foolish earthlings?
>
> GOD: They're building a tower and trying to storm Heaven. Ha! Lucifer has taught them to question. So be it! I shall so affect their tongues that they will ask questions without answers. (SS 2:317–18)

The play ends in a virtual stalemate between the Creator and the Fallen Angel, and the crowd watching hoots its disapproval. As dutiful Christians, with a sanguine view of world history, they expected a happy ending. The theatre manager's response to his audience's complaints might well sum up Strindberg's own feelings when he was accused of interpreting earthly life too pessimistically: "Tell that to the author! I didn't invent the plot!" (319).

The sardonic humor of the little creation play is sometimes

explained as an outlet Strindberg found for the pent-up frustration he suffered during rewrites of *Master Olof.* But it was more than that. It is as if the controversial figure of Gert Bookprinter, who gradually disappeared in succeeding drafts of *Master Olof,* had reemerged in a distilled, symbolic form in the Lucifer of *Coram Populo,* as an eruption of a fundamental sense of rebellion. A key to the nature of that rebellion is the adversary relationship between God and Lucifer. Twenty years after writing *Coram Populo,* Strindberg revised the play and made it serve as prologue to the French version of his novel *Inferno,* the work with which he returned in earnest to belles lettres after a hiatus of six years. Among additions made were opening stage directions:

> *God is an old man with a stern, almost wicked mien. He has a long, white beard and small horns, like Michelangelo's Moses.*
> *Lucifer is young and handsome, with something about him of Prometheus, Apollo, and Christ. His facial complexion is white and luminous, his eyes blazing, his teeth bright. A halo hangs above his head.*[37]

Precedents in antiquity for such a negative treatment of the Creator go back to the world artificer in Plato's *Timaeus* and the Demiurge in Gnosticism, a lower-order deity responsible for the creation of the world and answerable, according to the Gnostics, to a higher-order deity, the Eternal One. The Romantic precedent for Strindberg's positive treatment of Lucifer is the Titan that he in fact specifies: Prometheus.[38]

For having defied Zeus's authority by bringing the gift of fire to humanity, Prometheus came to symbolize for the Romantics the prototypal rebel, with a mission to battle all forms of tyranny, political as well as spiritual. The symbolism had an enduring quality: Marx called him "the most noble of all martyrs in the annals of philosophy";[39] and Camus described his story as "the most perfect myth of the intelligence in revolt."[40] The Greek model for dramatic treatment of the subject was *Prometheus Bound,* the most influential classical play in the Romantic period, but the Romantics treated the hero much more sympathetically than Aes-

chylus had. Consequently, when Strindberg identified his Lucifer with Prometheus and Christ, he was following a well-established Romantic pattern. In Shelley's *Prometheus Unbound*, for example, the hero is clearly Christlike, and his punishment akin to the Crucifixion. But Strindberg knew little of Shelley. The most likely inspiration came from the two Byron plays whose protagonists are most Promethean: *Manfred* and *Cain*.

Byron and the Promethean Example

Strindberg first read the two most influential of Byron's plays in 1868, when he was nineteen, and they affected his thinking as a dramatist for the rest of his life. Although the total body of Byron's drama is today commonly classified as static closet drama, it is worth noting that it dominated the English stage from 1830 to 1870. Of course, Byron himself, the archetypal Romantic artist, was admired, even worshiped, as much for the valiant boldness of his life as for the quality of his work — the brilliant lyricist and dashing adventurer who died a martyr's death in the Grecian war for independence. In the 1870s, Strindberg's interest in the English Romantic was reinforced by Georg Brandes, the chief enthusiast for Byronism in Scandinavia.

Byron himself was at first skeptical about the worth of *Manfred*, which is clear in the brusque summary he sent to his publisher. He describes the protagonist, who lives a life of solitude in the Alps, as "a kind of magician, who is tormented by a species of remorse, the cause of which is left half unexplained. He wanders about invoking . . . Spirits, which appear to him, and are of no use . . . ; and in the third act, he is found by his attendants dying in a tower where he had studied his art." [41]

It was not the plot that attracted young intellectuals like Strindberg to the play; it was the expression given to a particular variety of *Weltschmerz*. Manfred is haunted by a sense of impotence. Though his mind, his imagination — "the Promethean spark," as he calls it — bids him soar, he is captive to earthly needs and earthly desires.

Beautiful!
How beautiful is all this visible world!

.

But we, who name ourselves its sovereigns, we,
Half dust, half deity, alike unfit
To sink or soar . . .

.

Contending with low wants and lofty will
Till our mortality predominates.[42]

When Strindberg first read the play, he said he felt as if he were renewing "his acquaintance with Karl Moor in another costume" (ss 18 : 285). The Romantic hero of Schiller's *The Robbers* voiced much the same complaint of having to live in a world where reality fell far short of the expectations of his imagination. Schiller's play so impressed the young Strindberg that he dreamed of being an actor and playing the central role. Cited at length in his autobiography, from one of Moor's famous speeches, are the sentiments and ideas he shared with the character: "I hate this age of scribblers, when I can pick up my Plutarch and read of great men. . . . The bright spark of Promethean fire is burnt out. All we have now is a flash of witch-meal—stage lightning, no flame enough to light a pipe of tobacco."[43]

Strindberg reread *Manfred* in the fall of 1872, after *Master Olof* had been rejected for production, and once more must have recognized his own situation in Manfred's expression of always feeling like an outsider:

From my youth upwards
My spirit walk'd not with the souls of men,

.

My joys, my griefs, my passions, and my powers,
Made me a stranger

.

My solitude is solitude no more,
But peopled with the Furies;

.

> I have had . . . earthly visions
> And noble aspirations in my youth,
> To make my own the mind of other men,
> The enlightener of nations.[44]

In a letter to a friend Strindberg wrote that *Manfred* "reconciled me somewhat with the past" (*Brev* 1:126). A quarter century later, in the first play he had written in six years, *To Damascus*, the hero is a writer, named only the Stranger (Den okände), who fears solitude "because there's always someone there" (SS 29:9). And he, too, is tormented by a vague unease.

> LADY: What are you waiting for?
> STRANGER: If I only knew. I've been waiting for something for forty years. I think it's called happiness—or maybe just the end of unhappiness. (7–8)

And he, too, tried to enlighten people.

> I couldn't watch people suffering, and said so. I wrote: free yourselves —I'll help you. I told the poor: don't let the rich steal you blind! I told women: don't let men subjugate you! Then—and this was the worst— I told children: don't obey your parents when they're unjust. The result?—well, it was unbelievable. They all turned against me at once, the rich and the poor, men and women, parents and children . . . (15)

In both plays the conventionally heroic Romantic image of the artist as a prophet with a mission is given a special twist. Injustices must be battled, political tyrannies must be overthrown, but these are not the only tyrannies the artist-prophet faces. He is tormented by an oppressive force that is as much metaphysical as physical. After *Manfred* (1817), Byron developed this theme further by going after bigger game in *Cain* (1821), the second Byron play that assumed an important role in Strindberg's development as a dramatist. The spirit of *Cain* rings through not only *Coram Populo* but most of Strindberg's history plays.

Though the force Manfred struggles against is nameless, the hubris he demonstrates in searching for the roots of his despair

(the "hidden knowledge")[45] helps us to identify it. One of the spirits he summons pronounces a somber judgment upon him:

> his aspirations
> Have been beyond the dwellers of the earth,
> And they have only taught him what we know —
> That knowledge is not happiness, and science
> But an exchange of ignorance for that
> Which is another kind of ignorance.[46]

If *Manfred* recalls the sin of hungering for the fruit of the Tree of Knowledge, *Cain* deals with the second Fall: the introduction of murder and death into the world. Now the oppressive force is not only implied, it is identified by name: a Jehovah who cruelly favors Abel over his equally deserving brother. Byron's Lucifer, like Strindberg's, complains about a Demiurge who is bored and has nothing better to do than to

> Sit on his vast and solitary throne,
> Creating worlds, to make eternity
> Less burthensome to his immense existence
> And unparticipated solitude. (I.i.146–53)[47]

Byron's Cain, contrary to conventional biblical interpretation, is the most admirable character in the piece, until the ending, of course, but even then, he is not entirely unsympathetic. Furious because his peaceful offering of fruit and grain is rejected in favor of Abel's bloody sacrifice of animals, Cain strikes his brother while trying to stop him from building altars to such an inequitable deity. Byron's intentions with the character are revealed in a letter in which he describes the cause of Cain's act as "not premeditation, or envy of *Abel* (which would have made him contemptible), but . . . the rage and fury against the inadequacy of his state to his conceptions."[48]

This same "rage and fury against the inadequacy of his state to his conceptions" seethes not only in Strindberg's history plays but in most of his works. In the histories especially, however, there is the sense that in a world ready to battle for justice the heroic

leader's choice of a rebellious role is proper and yet somehow futile. In *Erik XIV* (1899), for example, the mercurial son of Gustav Vasa wants to democratize his nation, but just as Cain turns as capricious as the deity he criticizes, Erik is finally guilty of the same ruthless injustices as the nobility who attempt to thwart his plans. In the end, his enemies closing in on him, he is left confounded by a world in which he meant to do good but somehow did evil. Byron's Cain ends much the same way, in Paul Cantor's words, "isolated, discontented, and destroying others to relieve his own frustration."[49]

Strindberg returned many times to the contradictions and ironies in the Prometheus theme, and it usually carried the same kinds of symbolic freight: the Titan as prototype either of the artist as rebel or of the rebel as artist. *Artist as rebel* dominates Goethe's poem on the subject and helped establish the precedent in Sweden.[50] A passage marked in Strindberg's copy of Goethe's autobiography describes how Goethe felt drawn to the story of the hero "who separated from the gods [and] peopled a world from his own workshop. I clearly felt that a creation of importance could be produced only when its author isolated himself. . . . The fable of Prometheus became living in me."[51] In Goethe's poem, the Titan/artist defies the Creator with his own creative spirit:

> Here do I sit, and frame
> Men after mine own image—
> A race that may be like unto myself,
> To suffer, weep; enjoy, and have delights,
> And take no heed of thee.
> As I do![52]

Brandes compared the poem to one by Byron on the same theme: "Goethe's is the creative and free Prometheus. . . . Byron's is the defiant and bound Prometheus."[53] The focus in Byron's ode was a tribute to the Titan who represents the *rebel as artist*:

> Thy godlike crime was to be kind,
>
>

And strengthen Man with his own mind;

.

A mighty lesson we inherit:
Thou art a symbol and a sign
To Mortals of their fate and force;
Like thee, Man is in part divine,
A troubled stream from a pure source. . . .[54]

Strindberg is closer to Byron in his handling of the theme: he too dramatizes man as "a troubled stream from a pure source." The most obvious example is near the end of *Development* (see chapter 2), in the death scene of Giacomo, the Italian painter and apostle of the cult of beauty. As he lies wounded on the floor of the monastery chapel, brought down by the father of the woman he abandoned, he is a fallen Titan, stubborn and eloquent:

"Now I'll get to know everything, Botvid, everything we weren't permitted to know. And I'll come down to you, one night when you're sitting in the cemetery, and I'll bring you the secret of Heaven. God, or Zeus, or whatever your name is, I'll wrench it from your Heaven, I'll steal it, like Prometheus stole fire, even if I'm stretched out over ten yokes of land and vultures pick at me!" (ss 11:260)

Botvid, Giacomo's double, is the artist as servant, accepting the shortcomings of life in the fallen world and despairing over the task of rendering the ideal in a sensual form because of the impossible gap between the ideal and the real. Giacomo, on the other hand, the *rebel as artist*, has not yet recovered from the injustice of the Fall; he has tasted the fruit of the Tree of Knowledge and it only whetted his appetite for more. What kind of a Creator, he wonders, would stimulate that appetite and then deny its satisfaction? The rebel challenges his adversary in a blasphemous invocation that rings with Byronic defiance:

"You give men instincts, strong as the river in spring! You lift up the floodgates and then say 'Stop!' to the river! What kind of joke is that? You give us flesh that trembles with the desire to live and you say to the flesh: 'Die!' Do you see any sense in that, Botvid?" (ss 11:260)

Less than two years after *Development*, in *Son of a Servant Woman*, Strindberg asked, "Was Prometheus only someone with a liver ailment who mistakenly located the cause of his pains outside himself? Not likely! Surely he became splenetic when he saw that the world was a madhouse, where the taunters ran free and kept guard over the only person in his right senses" (ss 19:44).

Rectilinear History versus Cyclical History

Master Olof (1872) and *Son of a Servant Woman* (1886) represent, respectively, the high- and low-water marks of Strindberg's faith in reading history for the meaning of life. The man who wrote the play was a young idealist who believed in revolution and the possibility of realizing millenarian dreams. The man who wrote the autobiography was an aging rebel who claimed he no longer harbored hope that Prometheus's sacrifice was worthwhile. When he looked at life "and especially the course of history, he found only circles and the reoccurrence of delusions" (ss 19:61). He says that even when he worked on his two-volume cultural history *The Swedish People* (1882),

difficulties became apparent when it came to finding a rational pattern [in which to arrange the material]. Skepticism arose—distractingly, confusingly—about whether a rational pattern existed. Had there been or could there be such a thing in history, he asked himself, even though he couldn't see it? Perhaps it was just a matter of "one thing after another," and not "as a result of." Wasn't history just a capricious jumble, an endless round? . . . Surely, those who earlier thought they saw a pattern were only perceiving their own mind's need to organize things into causal relationships, and when phenomena did not fit in, they were omitted. (180)

A similarly pessimistic view was suggested by Strindberg the preceding year in "Pangs of Conscience," where Bleichroden reads Schopenhauer's depiction of death as "the painful unraveling of the knot that is tied in sensual pleasure at the moment of conception" (ss 15:195). Implied is the Indic myth that depicts history as

endlessly cyclical rather than linear, and that all that exists only seems; everything is part of Māyā, the veil of illusion. In Schopenhauer's *The World as Will and Representation*, a vital source of inspiration for Strindberg, the flux of history is defined as "the transient complexities of a human world moving like clouds in the wind, which are often entirely transformed by the most trifling accident. From this point of view, the material of history appears to us as scarcely an object worthy of the serious and arduous consideration of the human mind." [55]

This grim cyclical interpretation of history had as great a hold on Strindberg's imagination as the opposing, linear view. While the linear view affirmed the idea of purpose in history, the cyclical view undermined that affirmation. In his works of the 1880s, the hope of reconciling opposites is often raised only to be frustrated. Giacomo voices a skepticism that mixes Schopenhauer and Darwin: "Eat and be eaten! There you have the answer to the riddles of life!" (ss 11:257). After the turn of the century, however, the two views often complement each other, as in *A Dream Play*, in which the daughter of Indra expresses both a Christian compassion for innocent suffering and an Indic resignation in the face of the realization that all is Mâyâ. Indra's daughter, who is enlightened,[56] understands that the riddle of life—its emptiness—is revealed when a mysterious door is opened, although the university deans assembled for the event are more confused than enlightened.

DEAN OF MEDICINE: But there's nothing.
DAUGHTER: That's it exactly!—But you haven't understood it.

In Buddhism, said Heinrich Zimmer, "the unenlightened behold only Mâyâ, the differentiated realm of delusory forms and notions, but by the enlightened ones all is experienced as the Void beyond differentiation." [57]

Giacomo was a harbinger of things to come: of the Captain, in *The Father*, who is thwarted in his search for signs of life on other planets, and of the Titan-like figures who people Strindberg's works after the Inferno Crisis and represent the artist with an un-

bounded zest for life, man prepared to defy the gods in his desire to solve the riddle. Note the pains Strindberg takes in the way Giacomo identifies himself at his first appearance in the novella: "I am Giacomo, born Jacob" (ss 11:208; emphasis added). Called to mind is another mythic figure who captivated the author's imagination: the biblical Jacob, who survived an all-night wrestling match with an angel. As in the case of Prometheus, Jacob's defiance earns the respect of Heaven, and eventually man and God are reconciled. This was a lesson Strindberg himself was to learn in the late 1890s.

In his search for truth, Strindberg, like Thomas Carlyle, was a reader of different texts: History, the Bible, and Nature. When he lost faith in one text, he turned, again like Carlyle,[58] to another. The carnival theme and the drama of history would reappear in his work after his Inferno period with a burst of incredible energy, adding a half-dozen masterpieces to the genre. In the process, he would become a major contributor to a revival of medievalism in drama (see chapter 7), which would profoundly affect later playwrights as different from each other as Bertolt Brecht and Arthur Miller. But in the late 1880s, Strindberg sensed that the time had come to abandon History and the Bible as fundamental sources of truth and to turn in earnest to the third text: Nature.

4 / Naturalism: Evolution and Devolution

[The character of Miss Julie] is too great an exception to feel sad over.
It is very good realism, but it is not reality. This brings us to the
touchstone. Is there nothing but sex, sex, sex to write about? . . .
Our age has been sex-mad, and Strindberg is a symptom.
—Review in The Dial (1913)

The human soul cannot be revealed except through its anomalies.
—Strindberg letter in 1910

Science and the Artist's Struggle for Survival

STRINDBERG'S PLAY TO DAMASCUS STARTLED SWEDISH READERS
and critics with its bold departure from the realistic style of
writing that they were accustomed to from him before he went
off to exile in the early 1890s. But his explanation of the play's
purpose in the Stockholm newspaper Svenska Dagbladet in March
1901 must have seemed equally startling: "I am what I have always
been: Naturalist. . . . People have said that To Damascus is dreams. It
certainly is, but completely Naturalistic."[1]

Why would he stress a stylistic relationship between To Damascus
and a play like Miss Julie, which he called "a Naturalistic tragedy,"
from a decade earlier? Miss Julie is a Naturalistic play according to
the rules: the unities of time and place are carefully observed;
there is an emphasis on the psychology of eroticism and psycho-
logical warfare; vulgar and shocking subjects are dealt with can-
didly; and the action is motivated by the tensions between the
forces of heredity and environment. To Damascus, in contrast, is a
sprawling, episodic piece: the continuities of time and place are
fractured and fragmented; the dialogue is evocative but ellipti-
cal; and instead of the kind of causally related stage action one

associates with realistic/Naturalistic drama, events seem driven by a dreamlike logic (the author later referred to it as his "earlier dream play"; *ss* 36:221).

It was not uncommon, of course, for Strindberg to make outrageous remarks in order to attract attention; he was as gifted as anyone in the game of *"épater le bourgeoisie."* But about his constancy as a Naturalist he was dead serious, and his Naturalism is an essential key to understanding his Supernaturalism. This chapter and those that follow in Part II deal with the ways in which these two apparently opposing styles were interrelated in his works, and with how a continuity of Romantic themes contributed to the evolution from Naturalism to Supernaturalism.

The high points in Strindberg's Naturalistic phase were in 1887 and 1888—a decade and a half after the brilliant promise demonstrated in *Master Olof*—with the works that brought Strindberg his first international recognition as a playwright: *The Father* and *Miss Julie*. Ironically, they were written when nothing seemed to be going right for the artist, personally or professionally. After the bitter victory of the *Getting Married* trial in 1884 (see chapters 1 and 5), Strindberg began increasingly to detect enmity everywhere, real and imaginary: from the Right and the Left, among competitors and colleagues, enemies and friends, strangers and family alike. He felt that all an ungrateful public wanted from him was entertaining tales, not his message of social and political reform. He had taken his lead from Dickens, and because he grasped the social commentary and criticism in Dickens, he assumed that his readers would absorb the same lessons in his works. An 1885 outline for a short story that was never written contains a picture of the dead end in which the artist as truthsayer felt he was trapped:

I am writing a satire about an English botanist who comes to the Redskins and because he cures one of the savages is compelled . . . to stay on as a medicine man! Finally, he becomes bored with the role, and one day announces to the beasts that he's not a magician; he's just an ordinary human being. First he gets garbage from the Overclass for

having "betrayed" them, then the Underclass threatens to pillory him if he doesn't continue with his hocus-pocussing. He just wants to give them medicine, without hocus-pocus, but hocus-pocus is the very thing they want. He flees! (Brev 5:58–59)

Strindberg proceeded to disavow all the ideals that had constituted the moral, ethical, and cultural core of his identity as an artist: utopianism, egalitarianism, Christian socialism, and especially his belief that a radical change of the existing political system could redeem the world from evil and suffering. In his 1886 autobiography his blunt answer to the question "What is life's goal?" was "Life itself! There can be no other purpose to life except survival. That is why we have the instinct for self-preservation" (SS 19:248). He abandoned the Romantic role of artist as biblical prophet reborn and strove to become an objective Naturalist—a detached vivisectionist and serious student of the dark pathways of human behavior. Accordingly, the central focus in his work shifted from a political emphasis on the dynamics of social interaction to what he termed the "battle of brains," an arena in which incessant psychological warfare disrupted and corrupted the relations within and between the sexes. In Hans Lindström's words, the social pathologist became a psychological pathologist.[2] Strindberg still held a Schopenhauerian view of the wretchedness of the world, but the solution he now proposed was a reform, not of external social chaos, but of internal psychic chaos, through a recognition of the weaknesses in men's and women's minds that put them at a disadvantage in the struggle for survival.

The stress produced by his feelings of disappointment, disillusion, and betrayal led to tragically contradictory results: his insights and instincts as an artist were sharpened to an intensity that matured his art but threatened to destroy his life. While he claimed to view the gift of visions and hallucinations as a kind of curse, his works indicate that it continued to be one of the artist's most effective weapons. The Father and Miss Julie remain masterpieces a century later, not primarily because of a frenzy that was autobiographically inspired (although this is unquestionably a factor), but

because in the final analysis the artist was faithful to his Romantic gifts, not his Naturalistic intentions. In both plays action takes on the concentration and evocativeness of the kind of vision in which the lines between waking and dreaming are blurred. Indeed, if we trust statements in his letters, the turbulence of the process of creation led to a nightmare experience that left the author unsure where reality left off and art began. "I don't know which is the fiction," he writes in 1887, "*The Father* or my life" (*Brev* 6:298).

Psychology was not stressed, however, to the neglect of the social dimension, or the sense of history. A generation later, in 1914, anarchist Emma Goldman was among the first critics to look beyond the obvious autobiographical references and note the skill with which Strindberg interpenetrated the psychological and the social. In her *Social Significance of Modern Drama* she describes *Miss Julie* as "a brutally frank portrayal of the most intimate thoughts of man and the age-long antagonism between classes. . . . Who in modern dramatic art is there to teach us that lesson with the insight of an August Strindberg?"[3] In the Naturalistic Strindberg, another kind of seer had replaced the biblical prophet, one more piercing, more disturbing, and definitely more modern.

Strindberg sought to be especially faithful in his writing to two of Naturalism's programmatic goals: first, a dedication to the scientific observation of nature and, second, a repudiation of everything that smacked of art or the artistic. He was reasonably successful on the first score and, like many Naturalists, faithful in his fashion to the second, but both goals were to play important roles in his evolution as an artist. Toward the first end, like many other writers and artists, he devoured the latest theories and case studies in the burgeoning new scientific area of psychopathology, taking special interest in what was interpreted as socially and sexually deviate behavior. Toward the second end, he loyally denounced everything in art that the Naturalists defined as artificial, constructed, or calculating, even as he continued to betray this principle in his own art.

Zola had articulated the aesthetic goals. "The old formulas, classical and Romantic," he proclaimed, "were based on the re-

arrangement and systematic amputation of the truth. They determined on principle that the truth is not good enough; they tried to draw out of it an essence, a 'poetry,' on the pretext that nature must be expurgated and magnified. . . . But today the Naturalistic thinkers are telling us that the truth does not need clothing; it can walk naked."[4] To "walk naked" meant getting rid not only of old conventions but of any conventions at all. The arbitrary barriers separating art and nature would come down. It was not just classical or Romantic rhetoric that was outmoded, it was any form of rhetoric. The presumption, says Harry Levin, was that "observation . . . would eliminate imagination and convert the art of fiction into a branch of scientific research."[5]

Of course, the Naturalists were no more successful than their predecessors had been in attempting to eliminate imagination and to formulate an objective, unambiguous picture of Nature—Zola and Strindberg least of all. In their works Nature is a presence whose mysterious immensity, power, and scope seem to compel the artist to go beyond simple, detached observation if he is to come up with anything resembling coherence. Plain, undecorated prose will not do. Back come all the despised literary trappings and devices that have been the age-old tools of the imagination: metaphor, personification, mythopoesis. Many old conventions were not abandoned, only transformed and dressed up in scientific language.

At the heart of Strindberg's Naturalism was a view of nature that was complex and riddled with inconsistencies, not surprising, perhaps, when one considers the diversity among the two most important groups of sources that influenced it. From the first group—Rousseau, Schopenhauer, Ovid, and Darwin—came ideas in the form of mythic images that energized his imagination. From the second group—Henry Thomas Buckle (a now virtually forgotten English historian) and French experimental psychologists—came theoretical concepts that challenged and stimulated his scientific ambitions.

While the Rousseauist in Strindberg regarded Nature as humanity's rightful home, a retreat from the evils and mendacity of

civilized culture, the Schopenhauerian saw it as the generator of a world of matter which was really a world of illusions, a prison from which the human spirit sought to be liberated. For the Rousseauist, the controlling mythic theme was the return of the Golden Age—a restoration of the harmony that existed between humanity and Nature before the disharmony of the present Iron Age. For the Schopenhauerian, harmony was out of the question; the dominant theme was the Fall of Man—that most expressive symbol of the origin of the disharmony of earthly existence.

Ovid's influence on Strindberg is much easier to explain than the ideas and images of Darwin. *Metamorphoses* was the only classic he liked while in school (ss 54:468), and during the Inferno years, his letters speak of reading all the secrets of the world there (Brev 11:295). As for the English scientist, most of the time it was only with "great reservations," as Strindberg put it in an 1886 letter (Brev 5:267), that he aligned himself with Darwin and the Darwinian evolutionists. He felt free to interpret *Origin of Species* in his own way, a common practice in the late nineteenth century. Whatever clear ideas we may have today about what Darwin intended, his contemporaries found many ambiguities in his text, and so did the author, as subsequent revisions made in succeeding editions demonstrate.[6] Strindberg's strongest objections to Darwin's ideas over the years involved those in *The Descent of Man*, not in *Origins*. Especially after his religious experiences at the end of the century, he could never forgive the English naturalist for attempting to "simianize" man. But, as might be expected from someone who admired Schopenhauer as much as Strindberg did, he was also hostile to Darwin's largely sanguine view of the course of the developmental process, which was made into an article of faith by Darwinian positivists. "The entire younger generation," Strindberg writes in 1884, "have become optimists [through Darwin's theory] and think that our present apparent development is a healthy one, forgetting that even an illness follows a developmental pattern, toward recovery or death!" (ss 16:141). During the early 1880s, his democratic inclinations made him hostile as well to the way Social Darwinists exploited Spencer's interpretation of

Darwin's theory as a demonstration of the "survival of the fittest," turning social or class differences into natural differences that justified rank and privilege as the natural consequence of evolutionary forces.

Hasn't the aristocrat . . . found support in this same theory, which teaches that the strongest (i.e., he who possesses the means to preserve himself and his family) is in the right, and that aristocrats, by being able to defend their clan through the ownership of landed property, entailed estates, and hereditary access to lucrative activities, have developed into a more perfect species? And haven't today's optimists found support in his theory for the heartless view that the weak should go under, that it is their duty to go under, and that it is unjust to protect them? Hasn't even a humanist like Spencer entangled himself in the sophism that those presently oppressed are the weakest? (141)

By the late 1880s, when he had turned away from democratic principles, he became only one of many who believed that there was as much chance of evolution being retrogressive and degenerate as progressive and generative. In fact the dangers of retrogression and degeneration are important themes in his Naturalistic works, although, as usual, Strindberg's polemical ambitions and artistic instincts often collide with each other. And so, while The Father was ostensibly written to demonstrate the dangers implied in a current theory by Paul Lafargue that the patriarchal system might be replaced by a reversion to matriarchy,[7] the play itself demonstrates no simple dogmatic thesis. The Captain is as much in danger from the chimeras in his own mind as he is from feminist or matriarchal intrigues. And although the author's preface to Miss Julie proclaims the inevitability of the decline of a degenerate aristocratic class, the play contains more sympathy for a representative of that class than the preface would indicate.

Ovid, Nature, and the Dream of the Golden Age

Ovid's Metamorphoses, inspirational to generations of artists, was also admired by natural scientists in the nineteenth century, and it

was not uncommon for scientists to cite other literary sources as influential in their thinking. I mention this because, though critics have regarded as eccentric Strindberg's habit of mingling mythic images with scientific concepts in his works, the practice was certainly not uncommon in his time. In fact, says Gillian Beer in her *Darwin's Plots*, because of the shared discourse that existed between science and literature, "not only *ideas* but metaphors, myths, and narrative patterns could move rapidly and freely to and fro between scientists and non-scientists."[8] Darwin, for example, found William Paley's *Natural Theology* of great educational value,[9] Milton's *Paradise Lost* was the only book that accompanied him on all his biological expeditions, and he always held Wordsworth and Coleridge in high regard.[10] Biologist Thomas Huxley also borrowed insights from literary sources. The opening paragraph of his essay "Man's Place in Nature" discusses how the "half-waking" dreams of myth anticipated scientific discoveries:

Ovid foreshadowed the discoveries of the geologist: the Atlantis was an imagination, but Columbus found a western world: and though the quaint forms of Centaurs and Satyrs have an existence only in the realms of Art, creatures approaching man more nearly than they in essential structure, and yet as thoroughly brutal as the goat's or horse's half of the mythical compound, are now not only known, but notorious.[11]

Geologist Charles Lyell also had great respect for Ovid and pointed to the following passage from the fifteenth book of *Metamorphoses* as a model in his accounts of protogeology:[12]

Nothing in the entire universe ever perishes, believe me, but the things vary, and adopt a new form. The phrase "being born" is used for beginning to be something different from what one was before, while "dying" means ceasing to be the same. Though this thing may pass into that, and that into this, yet the sum of things remains unchanged.[13]

Strindberg, too, accepted this metamorphic principle, particularly, as we shall see, during his Inferno years, and he admired Ovid, as he did Darwin, for being "a consistent transformist" (SS 27:243).

Naturalism

The ancient view represented in *Metamorphoses* of the mutability of natural history was paralleled by a similar view of the mutability of human history. In a passage following the one just cited, Ovid's narrator observes that "for my part, considering how the generations of men have passed from the Age of Gold to that of Iron, how often the fortunes of different places have been reversed, I should believe that nothing lasts long under the same form." [14] The two images stressed—Golden Age and transformation—appear and reappear in Strindberg's works from the beginning of his career to the end, and, as in Ovid, the concepts of History and Nature are linked indissolubly together.

The Golden Age was a time when people trusted each other. They felt safe in their homes and had no need for laws or cities or warfare. Nature was humanity's best friend, and eternal spring was the only season. Then came the Silver Age, when the year was split up into seasons. Natural shelters no longer sufficed and men were forced to build houses. In the third age, Bronze, men became more aggressive, without being warlike. Finally came the Age of Iron, when "all manner of crime broke out; modesty, truth, and loyalty fled. Treachery and trickery took their place, deceit and violence and criminal greed. . . . All proper affection lay vanquished and, last of the immortals, the maiden Justice left the blood-soaked earth." [15]

Only brief attention is given by Ovid to the second and third ages; the basic conflict is between the Ages of Gold and Iron. If the first epitomizes an ideal of earthly life, with humans in perfect harmony with Nature, the second is the cruel reality that humans inherit and still inhabit, alienated from Nature. Even the absences in the Golden Age are eloquent: with no laws or cities or wars, humanity and Nature are one and at peace. The Iron Age brings a distinction between *meum* and *tuum*, mine and thine, and disharmony replaces harmony as men battle over property. From Ovid's day to the present the expressive tension between these images has influenced people spiritually as well as politically. Early Christians and modern Marxists alike concluded that the concept of property in *meum* and *tuum* divided people into classes, and that often the

law existed only to perpetuate the division. The maiden goddess of justice, Astraea, had no choice but to abandon Earth for Heaven.

All the discrepancies implied between the Golden and Iron Ages are echoed in Rousseau's criticism of society, his urging men to abandon city life and to end their alienation from Nature. Fichte summed up Rousseau's contribution succinctly: "*Before* us lies what Rousseau, in the name of the state of nature, and every poet, under appellation of the Golden Age, have located *behind* us." [16] Before Rousseau's time, poets who dealt either implicitly or explicitly with the shortcomings of the Iron Age tended toward nostalgia, to sketch, in contrast to present misery, a pleasant, primitive Golden Age landscape: Arcadia, a timeless, pastoral vision of the harmony in Nature. Rousseau changed the focus, and another imaginative landscape took on new popularity: Utopia. If Arcadia is oriented toward the past, Utopia is oriented toward the future.

As we have seen (see chapter 1), Strindberg also cherished utopian ideals in the early 1880s, but as he lost faith in the possibility of perfecting the social order, that sense of loss was reflected in his changing attitudes toward Golden Age ideals. In 1882 he cited approvingly an eighteenth-century Swedish Rousseau disciple, Thomas Thorild, who proclaimed ambitious plans for a world republic: "New laws—the rights of nature! New customs, new ways of living—in freedom and joy. . . . In a word: the Golden Age realized—in a pure humanity" (cited in *ss* 8:371). A decade later an important character in the play *The Keys of Heaven* is that tireless champion of utopian ideals Don Quixote, but the champion's mission has been reinterpreted. In Cervantes's novel (with which Strindberg first became acquainted in his father's library) the Don says to Sancho Panza: "My friend, you must know that by the will of Heaven, I was born in this Iron Age of ours to revive the Age of Gold." [17] Strindberg's Don has given up his dream: "I abandoned all illusions about a heaven on earth, since I realized that life is hell" (*ss* 25:158). One can sense that over the years, both here and elsewhere in Strindberg's writings, but especially during the Naturalistic years, images of the grimness of the present Age of Iron, or its postlapsarian equivalent—Paradise Lost—are trans-

formed from Rousseauistic prescriptions for political change into resigned, Schopenhauerian, existential observations.

The stages from Golden Age to Iron Age are delineated in Strindberg's witty 1884 novella *The Isle of Bliss*, a variant on the Robinson Crusoe myth. It depicts Swedish colonists who are shipwrecked while bound for America in the 1600s. The island they land on is an Arcadian paradise where life is easy. In a discussion about how law and order are to be maintained, the colonists conclude that since no crime is likely to be committed in such a perfect place, there was no need for laws. The climate is mild and people need only the casual shelter Nature provides. The seasons differ from each other only in the availability of different fruits and vegetables. Envy and hate disappear. After some years, however, a volcano threatens to erupt and the colonists flee by boat. When they find land again, they must work hard to survive. The seasons succeed one another in their usual severity, necessitating the building of more-permanent shelters than were needed on the Isle of Bliss. Food must now be hunted or harvested. The Age of Gold has been replaced by the Age of Silver.

Soon there are quarrels, and class differences emerge. On the Isle of Bliss everyone was equal; now there are masters and servants. Step-by-step all the defects of the Iron Age are introduced in the new colony. Trade is established and along with it slavery. Taxes are levied and greed increases. Property becomes important and laws are passed regarding its ownership, disposition, and inheritance. *Mine* and *thine*, in other words, become the foremost considerations. For those found guilty of serious breaches of the law, the death penalty is instituted. An urban system appears, and people are once more alienated from Nature. And of course everything is done in the name of Progress. "Fear of hell vanished," the author tells us, "for people realized that hell already existed on Earth and things could not get any worse" (ss 12:96).

Fifteen years after he wrote *The Isle of Bliss* Strindberg made notes for a play that would depict earthly pain and injustice in terms that commingle Rousseauistic and Schopenhauerian imagery and that feature an Astraea figure—the goddess of justice—as the

central character. Under the heading "The Iron Age," he wrote: "Indra's daughter finds the earth to be a madhouse, a prison, and human beings a collection of treacherous scoundrels or hypocrites, treacherous, thievish, cruel, stupid." Later, in the drama that emerged from the notes, *A Dream Play*, Rousseau's warning to humanity from the *Second Discourse*—"you are lost if you forget that the fruits belong to all and the earth to no one!"—is echoed in the Riviera scene when the Daughter asks the Lawyer why everyone cannot swim there. He answers that the beaches are private.

DAUGHTER: But I mean outside town, in the country, where the land doesn't belong to anyone.
LAWYER: It all belongs to someone. . . .
DAUGHTER: Even the sea? The great, open . . .
LAWYER: Everything! If you're out on the sea in a boat, you can't even come ashore without getting permission and paying a fee. Beautiful, isn't it?
DAUGHTER: This is no paradise! (SS 36:293–94)

All Strindberg's Naturalistic treatments of the theme of the Golden Age are marked by a similar ambivalence: on the one hand, there is the denial of its viability, as in the Isle of Bliss novella; on the other, there is an implied affirmation of its justness and humaneness, its power to restore hope. Like the biblical image of Eden, the Golden Age is a lost ideal that galvanizes man into efforts to redeem it, to reverse the effects of the Fall, but it is also, as in *Miss Julie*, another "deceitful hope" that betrays. Part of Jean's seductive banter in the play is a promise to take Julie to the utopian Italian lakes of Switzerland, where there is "eternal summer—oranges growing everywhere, laurel trees, always green" (SS 23:144–45). Later, he admits that he lied: "Lake Como is a rainy hole, and I never saw any oranges outside the stores" (161). Images of Switzerland in Strindberg's works, so utopian in the early 1880s, had soured in the works of a decade later; the bright Rousseauistic idealism had been overshadowed by a dark Schopenhauerian skepticism.

Schopenhauer and the Fall of Man

Explicit or implicit references to the Fall of Man play different roles in Strindberg's works than references to the Ages of Gold or Iron. He found in the image, like many Romantics before him, a multivocal symbol, with social, political, moral, psychological, and metaphysical implications. "A fall of some sort or another," said Coleridge, "is the fundamental postulate of the moral history of man. Without this hypothesis, man is unintelligible; with it, every phenomenon is applicable. The mystery itself is too profound to human insight." [18]

A Rousseauistic Golden Age and an apocalyptic promise of revolution were the primary mythic models for Strindberg as social critic and portrayer of the drama of history, but the Fall of Man became the primary model for the Naturalistic Strindberg. And his shift of metaphors reflected the same kind of shift the Romantics had adopted, for much the same reason. Paul Cantor notes that in the first decades of the nineteenth century

the initial euphoria created by the American and French Revolutions made it at first look easy for modern man to bring on the apocalypse. But as the hoped-for paradise failed to materialize, Romantic mythmakers had to rethink the question of how man had fallen prey to tyranny in order to find a way of escaping it. In the logic of myth, Genesis necessarily precedes Exodus. [19]

Keats, in The Fall of Hyperion, says Cantor, demonstrates that fallenness is "the human condition itself and not just a stage in a grand historical development." [20]

Similarly, fallenness in Strindberg's Naturalistic works is not a state to be overcome but one to become resigned to. In Miss Julie there is momentary hope. Perhaps master and servant can exchange places, can understand each other, and thus make true equality possible. Then comes the dawn and the dismal recognition that the transformation was only temporary; the clear light of Midsummer Day reveals it to be an illusion. This tragic conclusion is reinforced throughout the play by various references

to descending and falling. Julie talks of "stepping down," condescending to associate with people beneath her station. Jean warns her that others will interpret this condescension negatively: "Don't step down, Miss Julie, take my advice. No one'll believe you stepped down voluntarily. People will always say you fell" (ss 23: 132). Like fish who live at different levels in the sea, Julie and Jean venture above or below their depths only at their peril.

The structure of Strindberg's dramatic universe, whether Naturalistic, historical, or Supernaturalistic, reflects a traditionally Christian four-tiered mythological universe:[21] Heaven, Eden, Earth, and Hell, with Eden a lost dream of harmony in nature, and the fallen Earth resembling a Hell in which humanity and Nature are estranged. In a variety of plays—Miss Julie, Creditors, Playing with Fire, To Damascus, A Dream Play, Christina, Crime and Crime, Dance of Death, and A Ghost Sonata—he found rich opportunities for the Fall theme in terms of character and plot, with each couple cast in the role of the first couple, and with the action exploring the different tensions in their relationships in the periods before and after they taste of the Tree of Knowledge, between the dream they experience of the possibility of Eden and the reality they come to know of an earthly hell.

To find the roots of Strindberg's interest in these tensions and their many implications, especially as they appear in a comprehensive, Naturalistic working of the image like Miss Julie, we have to begin by returning to the late 1870s and the work in which he first dealt explicitly with the Fall theme, the little creation play mentioned earlier (see chapter 3): Coram Populo. When the Lucifer of the play approaches Adam and Eve, he is appalled by God's capricious idea to create the world as a place of torment and offers the couple a way out.

As for that tree, as soon as you have eaten of it, you will know what good and evil are. You will know then that life is evil, that you are not gods, that Satan has struck you blind, and that you exist only to serve as the laughingstock of the gods. Eat of it, and you will possess the gift of liberation from anguish: the joy of death![22]

Lucifer's action infuriates God, who counters with an ambiguous gift of his own, the instinct to procreate: "Let there be love!"[23] In this gnostic perspective on the Fall it is Lucifer's or the Serpent's point of view that dominates.

The inspirations for such a view—regarding death as liberator and sexual love as a gratuitous prolongation of the agony of the world—were, as earlier Strindberg scholars have noted,[24] the ideas of Schopenhauer and his disciple Eduard von Hartmann. The same ideas help explain the transformation in Strindberg's works between *Master Olof*, in which the suggestion of revolution holds out the secular, linear promise of redemption from the effects of the Fall, and the Naturalistic works, in which the fallen world is a cyclical given, with every couple victims of forces beyond their understanding or power to control.

For Schopenhauer, too, the Fall was a key image, and his interpretation of it was both a reaction to and evolution of the treatment of the theme by his Romantic predecessors. Some Romantics had suggested hope in the image through a reinterpretation of Augustine's *"felix culpa!"* This was a "fortunate fall" for the early church father because he saw the expulsion of Adam and Eve as implying the consequent coming of the Redeemer. Milton's subsequent triadic pattern for interpreting the Fall positively—Paradise, Paradise Lost, and Paradise Regained—had been secularized by Rousseau, who suggested the possibility of a historical continuity between the first and second phases, between the innocent state of nature and the corrupt world that succeeded it, or, in Strindberg's words, the worlds of "natural man" and "cultural man." Rousseau preached, says Tom Driver, that "if history had brought about this result, . . . it might also, through education of the young, bring about the return to the former, superior state."[25] As we have seen, Strindberg's interpretation of positivist philosophy in the early 1880s suggested precisely this possibility. "I believe in Progress," he wrote in 1883, "but only as a disentangling of complicated social conditions, and I regard its mission in the future to be a return to something more primitive."[26] Schopen-

hauer rejected Rousseau's optimistic approach to the Fall, which he described as "the fundamental characteristic and 'first false step' of Rousseau's whole philosophy."[27] In the book by Schopenhauer that Strindberg had Bleichroden keeping by his bedside in "Pangs of Conscience" (see chapter 1), *Parerga und Paralipomena*, we find the story of the Fall regarded "as the sole metaphysical truth contained in [the Old Testament]. . . . For our existence resembles nothing so much as the consequence of a misdeed, punishment for a forbidden desire."[28] In Schopenhauer's diagnosis a root cause of the fallen world was the Will, which he defined as the powerful, unthinking, motor force of life. In a world where happiness was only a temporary cessation of suffering, he urged that the Will be replaced by Idea, "a lucid understanding purged of all self-deception."[29]

Hartmann transformed the Will into the Unconscious. In his *Philosophy of the Unconscious* (which Strindberg helped to translate into Swedish in 1877)[30] he went one nihilistic step beyond his teacher by defining the unconscious in part as a malevolent force primarily responsible for the endlessness and uselessness of the continuance of life on earth. A passage cited by Schopenhauer from Sophocles's *Oedipus at Colonus* could well sum up the nihilism to which both he and Hartmann subscribed (and which is reflected in Strindberg works from *Coram Populo* to *A Dream Play*): "Never to be born is far best; yet if a man lives, the next best thing is for him to return as quickly as possible to the place from which he came."[31]

Throughout the 1880s, Strindberg's thinking on psychological issues was affected by the nihilistic views of Schopenhauer and Hartmann, and nowhere are these views more expressive than in his handling of the Fall theme. Zola, too, was fascinated by the theme, and a comparison of the way each approached it, Zola in his novel *The Sin of Father Mouret* and Strindberg in *Miss Julie*, reveals much about what both men owed to their roots in the Romantic legacy.

Strindberg and Zola:
Miss Julie and The Sin of Father Mouret

Strindberg described *Mouret* in an 1882 letter as a "colossal prose poem" (*Brev* 9:53) and retained that favorable impression for the rest of his life.[32] One might question, however, whether it should be considered a representative Zola novel. The story of a priest who betrays his vows to go and live with a lovely young girl, *Mouret* lacks the obvious sociopolitical dimension present in a work like *Germinal*, where the spirit of the French Revolution lives on among a group of miners who are exploited by cruel mine-owners. Nevertheless, there is a consistency in the view of nature suggested in both works, a view ironically in conflict with Zola's most cherished scientific and objective intentions. Brandes was one of the first to note the discrepancy between the Naturalism that Zola "continually preaches as theorist and frequently exceeds in practice."[33] The point of departure in *The Sin of Father Mouret*, says Brandes, was not, as one might expect from the father of Naturalism, a carefully recorded slice-of-life observation but a "variation on the Paradise legend."[34] "In Zola," he wrote, we find "poorly digested Darwinism," just as in Tolstoy we find "irrationally regenerated primitive Christianity."[35]

Mouret is a parish priest who, against his will, falls desperately in love with Albine, a simple country girl. The setting for their affair is a huge, mysterious estate bounded by a high wall and appropriately named Paradou. There the young couple find a close parallel to Eden: there are not only lush gardens but four flowing streams. Alone in a world of their own, Albine and Serge (as Mouret is now known) consummate their love under a giant tree that is transformed by Zola into a biblical presence. It was "the dean of the garden, the father of the forest . . . , the friend of the sun. . . . Its sap was so powerful that it flowed through its bark, bathing the tree in a vapor of fertility, making it the very manhood of the earth."[36] Serge and Albine are Adam and Eve and they bed down under the Tree of Life. Brandes, discussing a similar

personification image in the novel, said: "We have come far from a rendering of reality; this is myth formation." [37]

But then the couple know shame and guilt and are confronted and ordered out of the garden, not by a cherub with a flaming sword, but by a reasonable facsimile thereof: a priest with a stick. For those who might miss the parallel, there is the priest's name: Brother Archangias. Serge returns to the church as Father Mouret and poor Albine commits suicide.

In Strindberg's variant of the Fall theme in Miss Julie, instead of a long affair between a priest and a peasant girl, there is a brief encounter between a valet and his master's daughter. And rather than an archangel-priest to discover the offending couple, there is Jean's mistress, Kristin. In the preface to the play Strindberg says that as author he avoided preaching morality: "this I left to the cook in the absence of a minister." There are other parallels as well between novel and play. As was the case with Lieutenant Bleichroden's military tunic in "Pangs of Conscience" (see chapter 1), an article of clothing in Miss Julie turns "natural man" into "cultural man." Though Jean can at least pretend for a time to be Miss Julie's equal, once he puts on his servant's livery, he is again the obedient subordinate. Similarly, in Mouret the abbé is able to respond to Albine's physical attractions when not wearing his cassock but, as Harry Levin says, is "inhumanly virtuous again when he is refrocked." [38]

In both novel and play the woman commits suicide and there are important references to a paradisal garden bounded by a wall. Jean speaks of the garden as he tries to make Julie aware of the class differences that separated them when they were children:

I grew up in a shack with seven brothers and sisters and a pig, in the middle of a wasteland, where there wasn't a single tree. But from our window I could see the tops of apple trees above the wall of your father's garden. That was the Garden of Eden, guarded by angry angels with flaming swords. (ss 23:137)

Jean says that when he stole into Eden as a boy and spied Julie for the first time, he was so overcome with hopeless, adoles-

cent desire that he determined to die rather than live without her—another parallel with the novel. In this case, however, one wonders whether Strindberg was not aiming at parody. Zola had chosen a rather exotic way for Albine to end her life. Filling her room with flowers of every variety from the gardens of her beloved Paradou, she suffocates under a cloud of the petals' fragrances. In the same way Jean says he wanted to

die beautifully and pleasantly, without any pain. And then I remembered that it was dangerous to sleep under an elder bush. We had a big one, and it was in full flower. I plundered its treasures and bedded down under them in the oat bin. . . . But I didn't die, as you can see. (139)

The contrast suggested seems clear: Strindberg points up the sentimentality of the Romantic gesture implied in Albine's death by demonstrating Jean's ability to use such a gesture to manipulate Julie's feelings.

Whether or not Strindberg was intent on parody here—he certainly had the talent for it—in the late 1880s he shared Zola's belief in making nature's main drama, the struggle for survival, the central theme in his plays. He also claimed that he viewed the struggle as dispassionately as a scientist observing a predator hunt down a prey, or a forester pruning dead wood. But he was never guilty of the kind of reductive determinism that the Naturalists so often practiced, a determinism easily traceable to Darwin. If Nature is a vast machine, as many Naturalists concluded after reading *Origin of the Species*, the implication is that men are not individuals possessed of freedom and originality but ordinary cogs in that machine. "Life," said Ortega y Gasset, "is reduced to mere matter, physiology to mechanics. . . . Darwin sweeps heroes off the face of the earth."[39] But while the characters in *Miss Julie*—often coarse and cowardly and cruel—are not conventional heroes, they are human beings, rendered compassionately, not dispassionately. They are victims forced to become pawns in some terrible game that they neither devised nor can comprehend. If Nature is not an actual enemy, she is a heartless games master. When Jean asks Julie

if she hates men, she says, "Yes!—Most of the time! But some-
times—when that weakness comes, when Nature burns! Oh God,
will the fire never die out?"[40]

Is Nature man's ally or antagonist? In both *Miss Julie* and *Sin
of Father Mouret* it is paradoxically both an alien and an intimate
force. Although Zola indicates that for a time the entire garden
participates in the joy of the love between Albine and Mouret—in
fact, it "shared the couple's orgasm in one last cry of passion"[41]—
Nature is less a friend than a betrayer. The tragic movement of
the story's plot has something of the inexorable thrust of a Greek
tragedy, but instead of Destiny, Nature is the motor force. "The
necessity of procreation surrounded them," we learn, "and they
yielded to the demands of the garden."[42] When Albine kills her-
self, says Sandy Petrey, it is because "the park tells her to die, be-
cause Nature teaches her that death is the consequence of love."[43]
The basic theme in the novel, says Petrey, is that "man is from
birth condemned to abject misery because he can neither reject
nature nor affirm it. The novel is not so much the story of man's
fall from grace as of a quest for grace which can never succeed."[44]

The same tension produced by a failure in the quest for grace
informs many of Strindberg's works. Olle Montanus, Strindberg's
alter ego in the 1879 *The Red Room*, sees in the Fall a symbol of
the fundamentally antagonistic relationship that exists, and per-
haps must exist, between the artist and nature. No matter how
much the artist insists that his works are but mirrors of nature,
the nature he constructs is in turn a mirror, distorted to reflect his
own feelings and ambitions. In the notes found on his body after
his suicide Montanus tries to justify, in the face of these contra-
dictions, his decision to become an artist and reflects Strindberg's
own inner conflict between the image maker and the iconoclast.

You who do not know what it is to work between sunrise and sun-
set, only to collapse afterwards, like an animal, into a coma, you have
evaded the curse of the Fall, for it is a curse to feel the soul stand still
in its growth as the body buries itself in the dust. . . . [I]n the summer,
when the earth is green, you enjoy nature as if it were an ennobling
and elevating drama. That is not the way nature is experienced by the

tiller of the soil; the field is food, the forest is firewood, the lake a washbasin, the meadow cheese and milk—everything is earth without a soul! When I first realized that half of humanity worked with their souls, and the other half with their bodies, I thought the world existed on two planes for two different kinds of people. Then came reason and rejected this. My soul rebelled, and I determined that I too would evade the curse of the Fall—so I became an artist. (ss 5:356)

But of course that curse is something he cannot evade, for reasons that transcend the hope raised throughout the novel that social problems can be solved by rational political means. A decade after *The Red Room*, Strindberg was able to articulate these reasons in his Naturalistic works. An 1891 letter to a prospective French translator recommends his novel *By the Open Sea* "because it is superior to the others, expressing most compellingly the contemporary despair over all the vain efforts to solve social problems, which perhaps should not or cannot be solved except through the interplay of unconscious natural forces."[45] The heart of the action in *Miss Julie* is precisely this "interplay of unconscious forces," especially those involved in the psychology of eroticism. But Julie's yielding to powerful natural instincts, which she regards as a weakness, is encouraged by another weakness: her Romantic imagination.

Strindberg explores the existential implications of both these "weaknesses"—sexual passion and the imagination—in a revealing scene that was intended for *Coram Populo* but does not appear in either the 1878 or the 1897 published versions. Confronting Lucifer (here called The Devil) in Hell, God is weary of the war going on between them.

GOD: How long will you struggle against me?
THE DEVIL: Till the wretches are free!
GOD: You gave them the gift of *death*. I gave them *love*, that they might live!
THE DEVIL: I gave them thought, when you struck them with the blindness of the imagination.[46]

This conflict between *thought* and *imagination* becomes a recurrent theme in Strindberg's works in the late 1880s, perhaps motivated,

at least in part, by his reading of von Hartmann's approach to unconscious forces like the imagination as malevolent. In a comment in Strindberg's autobiography on the current state of drama he asserts that

the decay of all the great European theatres suggests that interest in the art itself is declining. Educated people stay away; the uneducated cannot afford it. And while a sense of reality is evolving, the imagination, as a relic of the savage, is making a return. *Variété* theatre, which amuses without enlightening, seems the wave of the future, for it is play and relaxing. And all the significant writers choose other, more appropriate, forms for the treatment of important questions. Ibsen's plays have always made their impact in book form before they were staged. Once they are staged, interest focuses primarily on how they are performed—in other words on secondary matters. (ss 18:314)

In the preface to *Miss Julie* two years later Strindberg says there were signs that might encourage hope in the situation: "Rudimentary, undeveloped ways of thinking governed by the imagination seem to be evolving toward reflection, investigation, and analysis" (ss 23:99). This evolution toward a view that regarded thought as a superior function to the imagination was supported by experiments in the mid- and late 1880s in association psychology, particularly those of French associationists, whose studies were read avidly by Strindberg. Three of the works of Schopenhauerian disciple Théodule Ribot (1839–1916) were in his 1892 library,[47] one of which, *Diseases of the Personality* (*Les maladies de la personnalité*; 1885), undoubtedly played an influential role in Strindberg's experiments with the doppelgänger and other aspects of "*la multiplicité du moi.*"[48]

The Psychopathology of the Imagination: "For Payment," "A Witch," and The Romantic Organist on Rånö

Hostility toward the imagination was an accepted, widespread attitude in the last half of the nineteenth century, and not just among Naturalists or associationist psychologists. The ideas of

one of those identified with this attitude had already played an instrumental role in the development of Strindberg's philosophy of history: the English historian Henry Thomas Buckle (1821–62). Buckle's *History of Civilization in England* appeared in a Swedish translation in 1871–72, just as Strindberg was working on *Master Olof*, and struck the young Swede like a thunderbolt.[49] Buckle was a developmentalist like Darwin (who admired Buckle's work), and his *History* (1857) preceded Darwin's *Origin of Species* (1859); in fact, in Strindberg's mind many of Darwin's ideas were anticipated by the historian. Although Buckle's subject was specifically English history, the book was meant to be the beginning of a giant project (never continued because of the author's early death) to apply the scientific method to the examination of the place of human history in natural history by demonstrating the influence of nature (especially climate and geography) on the development of culture. Searching for the governing laws, the grand design in history, he asserted that historical truth was relative, not absolute, and that the progress of a culture to a higher level of civilization was dependent on whether the influence upon it of its geographical environment was positive or negative. He urged a skepticism in investigating history, making a special point of criticizing what he called "the protective spirit"—the tendency to defend established beliefs and values without serious questioning. The young radical Strindberg quickly seized upon these ideas as weapons in his battle against conservatism in Sweden.

Buckle assigned a special place in history for the imagination. "Under some aspects," he wrote in *History*, "nature is more prominent than man, under others man more than nature. In the former case the imagination is more stimulated than the understanding, and to this class all the earliest civilizations belong."[50] When the imagination is overstimulated by extremes in nature like earthquakes, volcanic eruptions, or even ordinary danger, understanding is overshadowed and impeded, thus retarding the progress of civilization. As an example of such a situation, Buckle contrasted the state of historical progress in India with Greece. The literature of ancient India demonstrated "the most remarkable

evidence of the uncontrolled ascendancy of the imagination. . . . [It] is no exaggeration to say, that . . . everything is calculated to set the reason of man at open defiance." [51] Greece, with a culture superior to India (in Buckle's view), enjoyed a markedly different climate and geography. "The works of nature, which in India are of startling magnitude, are in Greece far smaller, feebler, and in every way less threatening to man." The Greeks provided an example of a proper mental balance: "for the first time in the history of the world," said Buckle, the imagination "was, in some degree, tempered and confined by the understanding. Not that its strength was impaired, or its vitality diminished. It was broken in and tamed; its exuberance was checked, its follies were chastised." [52] That India was used as an example of an excessively imaginative, and therefore less civilized, culture must have come as welcome support to those in British ruling circles who saw the white man's burden as guaranteeing law and order among less developed members of the human species. Here was a clear justification for the use of harsh measures to put down such extreme outbreaks of the imagination as civil disorders and disobedience.

But what could these ideas have meant to Strindberg? Though he shared much of Schopenhauer's high regard for Indic religion and culture, he could hardly have been untouched by the obvious aversion by Buckle, Brandes, and others to things "oriental" (see chapter 2), an aversion connected with the conflict that ran through the entire nineteenth century between "Hellenism" and "Orientalism," and to which we will return in a later chapter. At the very least, the tendencies in the period to align reason and understanding with science, progress, and liberalism on the one hand, and imagination with irrationality and decadence on the other, must have added to Strindberg's own difficulties in sorting these concepts out in his art.

If Miss Julie is a victim of the fiery lure of Nature's Eros, she is also a victim of her own overstimulated imagination, exploited for Jean's own purposes by his skill as a seducer. Jean's persuasive picture of the dreary life he suffered as a poor boy arouses first her compassion, then her passion. Strindberg indicates that she

was brought up with a lot of wrongheaded Romantic ideas, but the terse action of the play gives him little opportunity to spell out what those ideas were. They are spelled out, however, in the 1885 story that could be regarded as an early sketch for the play: "For Payment" ("Mot betalning"), in the collection *Getting Married, II.*

The character of the general's daughter in "For Payment" was a model not only for Miss Julie but (and this seems to have escaped Strindberg's attention) possibly Ibsen's Hedda Gabler as well. Brought up sheltered and pampered with privilege by her widower father, Helène is a case study of an overly refined "cultural," as opposed to "natural," human being. Natural impulses, nature itself, intimidate and even appall her. Just as Julie watched in horror as her dog coupled with a mongrel, so Helène is disturbed by the sight of a stallion mounting her mare (and Hedda, by the way, is disgusted by the thought that she is pregnant). Withdrawing from natural demands, Helène finds sanctuary in the old family library, which had not been added to since her grandfather's time:

All the books were thus a generation behind the times, and Helène acquired antiquated ideals. . . . Dissatisfaction with the prose of life and the coarseness of nature had fired her imagination to build a dream world in which souls lived without bodies. . . . This is the gospel of the rich, the brain fever called Romanticism, which becomes absurdly pathetic when it filters down to the Underclass. (ss 14:307–8)

A new dimension is added to the struggle within Strindberg between the Romantic Platonist and the Naturalistic Aristotelian. Earlier, we noted (chapter 2) that the struggle focused on artistic issues, as Strindberg stated a preference for an Aristotelian imitation of nature over a Platonic imitation of abstract ideals. Now we see that the Neoplatonic "brain fever" called Romanticism has ominous political implications as well, poisoning the imaginations of the susceptible Underclass by raising painfully unrealistic hopes.

As Hans Lindström points out, some of the inspiration for this attitude toward the Romantic imagination came from the writings of French association psychologists.[53] Charles Richet's analysis of

hysteria in his *L'homme et l'intelligence*, though published after *Getting Married*, is an example of the kinds of elements blended in the associationist view of the imagination—the ideological as well as the psychological.

A young lady . . . , surrounded by . . . female companions from a better situation than hers, will become hysterical. . . . Disappointed dreams, vanished illusions, chimerical hopes, are some of the themes that are more or less capable of giving rise to hysteria. In Paris, for example, and other large cities, where young ladies from the lower and lower-middle classes receive an education superior to their social status, hysteria is very frequent. In fact, it is often very difficult for them to find the ideal husband they dreamt about. Marriage is thus not a cure for the shabbiness of daily problems, and stifling household anxieties can never provide sufficient sustenance for the vast aspirations of an excessive imagination [*une imagination déréglée*].[54]

Just as Buckle—in harmony with the developmental, evolutionary spirit that characterized so much research in different disciplines in the nineteenth century—creates a hierarchy in which an excess of imagination is characteristic of less developed (i.e., less civilized) societies, so Richet does the same thing to emphasize class distinctions within a society. Not surprisingly, many in the nineteenth century who used developmental theory for ideological purposes (a practice which the egalitarian Darwin adamantly opposed) came to similarly ethnic, racist, or sexist conclusions about the imagination. A properly controlled exercise of the imagination was seen as possible only in a highly developed society and, within that society, only in the most highly developed individuals. This control was most evident in a European, rather than an Asian, society, and within Europe the Overclass could better control imaginative activity than the Underclass, and the European male more effectively than the European female. In any case, the imagination was a dangerous instrument in the wrong hands.

Another example of a woman in a Strindberg work who suffers from an excessive imagination is Tekla, the central character in the 1890 story "A Witch," set in the seventeenth century. Daughter of

a humble jail guard, Tekla is encouraged by her parents to believe that she can improve her life with education, but she is discouraged by her schoolteachers, who urge her to become resigned to her humble station in life. She is encouraged again later, however, by her minister in confirmation class, when he preaches that rich and poor alike are all God's children. "Her imagination began to play," and she experienced "visions" (SS 12:186) of a better life for herself. Years later, an opportunity to improve her lot comes when she saves a rich girl, Ebba, from drowning, thus winning the victim's gratitude and an invitation to come stay with her on the family estate. During the visit, however, Tekla comes to fantasize that she has finally arrived in the world where she belongs and, although already married, falls in love with a court page. While in a self-induced trance, she uses a form of mental telepathy to lure the page from afar into a cave, where she is caught by her hostess trying to seduce him. Furious at this ingratitude and betrayal of her hospitality, Ebba orders her guest to leave, and Tekla is forced to walk the long distance back to Stockholm.

Humiliated, Tekla plots revenge against "the person who drove her out of Paradise" (SS 12:197). Soon she is arrested and charged with witchcraft and must face witnesses who testify about her "incredible ability to transform reality to her own purposes" (205). In a jail cell she continues to be plagued by her excessive imagination: "Solitude and the absence of sensations—which the four naked walls could not provide—began to create visions where there was nothing to see and illusions of sound where there was nothing to be heard" (210). Imagining that she is in a torture chamber, where she will be forced to confess to her crimes, she suffers a fatal attack: "the incredible power of the imagination . . . caused her to experience all the tortures as if they were really happening to her. Unable to bear them, she yielded to the pressure and fell, her body twisting in a half hitch, as if all the sensory fibers in her body were torn loose." A doctor called to determine the cause of death surmises "hysteria" (212).

Although Strindberg, provoked by his battles with the incipient feminist movement, was much preoccupied in the middle and late

1880s with demonstrating the natural inferiority of women, his interest in the psychopathology of the imagination was not limited to cases involving women. Several of the male protagonists in his important Naturalistic plays—for example, the Captain in *The Father* and Adolf in *Creditors*—are also susceptible to the siren call of fantasy. Nature, of course, finds individuals so afflicted to be unfit in the struggle for survival. The Captain says that he has awakened to the realization that he and others have lived their lives "as unconsciously as children, filled with fantasies, ideals, and illusions." Laura responds that he should have been a writer and advises that "if you have any more fantasies, save them until morning" (ss 23:68).

Adolf, in *Creditors*, dependent on the imagination as a painter, is particularly vulnerable. His wife warns him: "Keep a leash on your imagination, Adolf! That's the animal in man's soul" (ss 23: 231). Her first husband plays predator to Adolf's prey. A kind of Superego figure, he urges Adolf to abandon not only such esoteric aesthetic interests as the problems of form and imitation in his art but also the irrational emotional entanglements involved in the search for faith, love, and wholeness as a human being. It is Adolf's imagination that has kept alive these interests and entanglements, thus weakening his will for the struggle, and in a Naturalistic world the will is the only instinct that spares man from annihilation. Like the other Adolf—the Captain in *The Father*—he yearns to embrace Nature, interact with her, learn her secrets, a yearning he has less chance of satisfying successfully than, to borrow one of Strindberg's own analogies, a male black widow spider looking for love.

Although the male protagonists of *The Father* and *Creditors* are definite examples of the power of imagination to enfeeble the will to survive, Strindberg shared with many contemporary psychologists the belief that women—Tekla in "A Witch" is a good example—are more susceptible to the dangers of an "excessive imagination." But the most interesting example in his work in the late 1880s of an individual almost totally possessed by the imagination is a male: Alrik Lundstedt in *The Romantic Organist on Rånö*.

How ironic that though the imagination was regarded as a decadent feminine attribute, Strindberg had no difficulty identifying with it!

At the end of the novella the reader is left to puzzle a fascinating question: Just how negative a force is the imagination? Does it destroy Alrik or does it in fact enable him to survive? The only thing indisputable about the novella, written just a few months before both *Miss Julie* and *Creditors,* is that it constitutes Strindberg's most comprehensive investigation of the psychopathology of the imagination. Göran Printz-Påhlson suggests that *The Organist* and "A Witch" "can be regarded as psychological studies in the mechanism of regression. Both describe a return to a more primitive way of reacting and thinking."[55] But the novella is something more: the ambiguous nature of imagination that it evokes—positive *and* negative—makes the work an important bridge between Strindberg's Naturalism and Supernaturalism.

The Romantic Organist[56] occupies, like "Pangs of Conscience" (see chapter 1), an unusual place among Strindberg's works. Each turned out far differently than their author intended, transformed by imaginative outbursts that surprised even him. Whatever misgivings he had about the novella, he believed that while writing, "the fever had guided him correctly, even if later, upon sober reflection, he could see other alternatives. That is why I hardly ever alter, and when I have altered, I have ruined things. *Summa summarum:* what I have written is what I have written" (*Brev* 7:103). A sketch about an amusing fantast (Strindberg calls it an "idiotic idyll" in letters) became a rhapsody on the perils and the ecstasies of the creative imagination.

Most modern scholars and critics agree that *The Romantic Organist* is important: a flawed masterpiece. Martin Lamm maintained that "none of Strindberg's earlier works heralds his later symbolic writing as clearly" as it does.[57] But critics are divided over where it is flawed. Eric O. Johannesson, for example, says that "unfortunately there is a distinct falling off in the last three of the nine chapters,"[58] whereas Printz-Påhlson insists that "no matter which half of the story has greater artistic merit, it seems to me im-

possible to overlook the strong dynamic element in the second half."[59] Strindberg's own mixed feelings about the work are reflected in a letter he sent, along with a copy of the story collection of which it was part, *Men of the Skerries* (*Skärkarlsliv*), to Georg Brandes, advising him not to read it. It was just a "shit book," the kind of "publishers' literature" (*Brev* 7:127) he was forced to grind out in order to support the writing of Naturalistic plays (in fact, an advance for *Men of the Skerries* actually helped him to begin writing *Miss Julie*). Six years later, however, he called *The Romantic Organist* "the most splendid thing I have done, without a trace of tendentiousness" (*Brev* 10:203), and he regarded the novella as an important forerunner of anti-Naturalism in Swedish literature.[60] Significantly, even Strindberg's archenemy, critic Carl David af Wirsén, had praise for *The Romantic Organist* when it was first published, astutely singling out "the description of the organist's . . . fantasy life, in which the downright unreal and the imagined assume a touch of reality, while reality itself seems like a dream."[61]

The criticism most frequently made is that Strindberg unwisely injected somber, gratuitous elements into what is essentially a harmless tale about an eccentric young man. For six chapters of the story, set in Sweden in the 1850s, the reader follows the amusing adventures of Alrik Lundstedt as he leaves his job as a grocery clerk in a small town in the Stockholm archipelago to study music in the capital. He has a special talent for getting along in the world: an ability to "play," that is, to make reality more acceptable by transforming it in his imagination. Although he is forced by events to abandon his dreams of pursuing his education and becoming a professor, he is satisfied to accept a modest position as organist-sexton-schoolteacher back in his home parish. According to the narrator, he marries a lighthouse keeper's daughter and settles down to play games with "real toys": his own children. But this is not the only reading of the ending that can be made. Strindberg slyly suggests an alternative interpretation in the postscript to the story. After a description of the organist's new home and family, the narrator notes that this is

the way . . . the bewitched organist of Rånö used to tell his story when a yacht went astray in those remote waters and he had had a few drinks in exchange for pointing out where the perch were running. How much of it was true, one never knew, because every word he spoke was a lie and how he managed in solitude and poverty was not clear because he never showed anyone. (ss 21:258)

There have been various interpretations of this apparent disclaimer. Wirsén called it an "aesthetic fault" that left the reader uncertain "whether some of the circumstances in the protagonist's life were actually experienced by him, because one does not know if the man had been or become insane," thus providing "no firm grounds for a psychological analysis."[62] Subsequently, most critics have ignored the disclaimer or not taken it seriously, regarding it perhaps as just a final, ironic twist. Karl-Åke Kärnell, however, feels that it is so ambiguous "that one cannot state simply what the author's position is, whether he is defending the appropriateness of fantasy, play, free association, and dreams, or whether it is reality that is closest to his heart."[63] Printz-Påhlson sees the ending as paradoxical: "We have the author's word that no factual information in the story can be taken at face value. That is, with one exception: the fact that the organist used to tell his story. . . . Alrik-the-suffering-hero perhaps does not exist, but Alrik-the-storyteller does."[64]

Although Strindberg probably began with the goal of creating some fun at the expense of the organist-fantast, I believe that he came to identify with the fantast's plight—torn between the different appeals of reality and the imagination—more than he had meant to do. The realist/Naturalist may have intended nothing more than a playful mocking of the Romantic imagination (he seems to have attached the word "Romantic" to the novella's title almost as a whimsical afterthought),[65] but he ended as fascinated as Lundstedt was by its seductive charms. The secret of that fascination lies in the organist's gift for playing transformation games, which signaled in the author a new, heightened awareness of the power of the visual imagination, prompting him to experiment

in a much bolder fashion with images than he had in "Pangs of Conscience."

Right from the start, we learn that the games are Alrik's natural way of dealing with reality. As he watches from the window of his humble attic room, the inanimate, movable sections of chimney tops, swinging in a sea breeze in the moonlight, are transformed through fantasy into living beings.

First, the great metal cap took on the form of a witch wearing a black hood; then the snake-head of the weather vane poked out of the cowl, exposing its teeth and its outstretched stinger; then the balance beam swung its round disk forward and in profile became a safety valve on a steam engine; and then witches danced with dragons around the four-cornered pipe, from which smoke belched as if from an Easter Eve bonfire. (SS 21:193)

Lieutenant Bleichroden's imagination was similarly stimulated by moonlight in "Pangs of Conscience," and in each instance the shadowiness of perceptions evokes imaginative flights of meta-morphosis and personification. When Alrik turns his attention away from the window and back into his room, he sees, on one of the beds, "a carpetbag, packed, but still open, like a great toad that had choked on the dozen wool stockings and the roll of music sheets visible through its iron-sheathed jaws" (SS 21:194).

Most of Alrik's "playing" is used as a means of controlling his relationships with the most difficult people in his life: women. Congenitally shy and withdrawn anyway, he is virtually paralyzed when forced to deal with them. He finally gains some measure of confidence when he arrives in Stockholm to study at the music academy, where he discovers that he can satisfy his needs for self-expression in music, "through which he could tell his story without anyone else understanding what he said" (SS 21:246). On Sundays he assists the organist at Jacob's Church and passes the time by imagining a friendship with a family of strangers he sees in the congregation, in particular, a friendship with a beautiful girl.

Although it would not have been difficult to find out what her name was by looking at the placard attached to her pew, he thought it was more fun not to know it, and instead invented a beautiful name for her. He called her Angelika after the poem by [Romantic poet Bernard] Malmström. (222)

On succeeding Sundays he elaborates on his fiction, making up a military title for the man who might be her father, and the names Gurli and Fanny for two little girls who could be her sisters. Before long, he even windowshops at a jewelry shop and picks out engagement rings. And so, despite that he and Angelika have never met, she

was now his, and he was happy. He sang about her at the academy, sang to her in church, at the conservatory, at serenades, but he wanted to postpone the wedding until he had become great and powerful. Since he had saved almost a hundred riksdaler, he decided to take the director's examination and become a professor and be knighted. (ss 21:223)

Alrik never meets "Angelika," however, and never becomes a professor because he gallantly but foolishly invites his fisherman father to come to live with him. The old man quickly eats and drinks his way through his son's savings.

Before leaving Stockholm for the little parish in the archipelago, Alrik swallows his disappointment and resolves his relationship with Angelika in an interestingly theatrical fashion: He

did not say goodbye to his dreams. Now during the long church services he made believe that he had postponed marriage with Angelika indefinitely, perhaps until she became old and ugly and no one wanted her anymore and maybe then she would take him. And he sat and pictured how she would look when she was old: putting wrinkles around her mouth, coffee stains under her hairline, shadows under her eyes, just as he had learned in the supernumeraries' dressing room at the opera. (ss 21:231)

In compensation for his lost love, Alrik "transferred all his longing and desire to the [church] organ and in the flaming heat

of desire the instrument took on all the perfections usually possessed by his beloved" (ss 21:231). Thus, through a psychologically ominous transfer, the onanistic organist concludes what is apparently the first love affair in his life by shifting his affection from an imaginary girl to a real object, the organ, which is also the subject of one of the most complex and interesting transformation games he plays.

One of the first classes Alrik attends at the academy is conducted in Stockholm's Jacob's Church, where a professor introduces the students to its organ. Never having seen a church this big, let alone an instrument this magnificent, Alrik is overwhelmed, a situation certain to provoke his gift for playing. Wirsén, who thought he detected here the influence of Hugo's treatment of church architectural elements in The Hunchback of Notre Dame, had high, if also tempered, praise for the "apocalyptic life" the organ took on: "[J]ust as in other works he gave a ghostlike personal existence to coastal rocks or inanimate objects, so Strindberg here has the organ with all its pipes become for the young organist like a living creature, and the imaginativeness with which it is bewitched in this way into a kind of magical being has something captivating about it."[66]

When the music students are escorted to a point high in the church, where they can look down on the entire mechanism of the instrument, Alrik almost faints at the grandeur of the spectacle but is able to control his feelings by a series of transformations. Once again in a Strindberg work, the sight of a church with an organ triggers a rich chain of associations, blurring all distinctions between the inanimate and the animate, the man-made and the natural, the real and the imaginary. The church itself became

the forest primeval, in which heathens practiced human sacrifice, the pillars were trees, and the arches, branches, but the organ was the organ. It was like neither a plant nor an animal—unless perhaps coral —nor a building—unless perhaps a mass of overhanging towers on a feudal fortress, its turrets with façade pipes, of which a number had become mute but remained as vestiges from older periods, now no longer in use. Each nest of small pipes could pass for a syrinx, or panpipe, which surely was the original model, but the large ones

in the projecting hanging turrets were reminiscent of a weapon col-
lection, without actually resembling one, and the ornamentation in
gilded wood from the preceding century—with obliquely rolled snail
shells and spiral-shaped flowers—immediately interrupted this train of
thought, which was trying to tie together the different pathways in this
jumble of forms. A more cultivated taste than that of the young grocery
clerk could have read in it the entire history of the instrument, from
the reed flute of the pagan Latins, through the Celtic barbarian's bag-
pipe, the Byzantine water organ, with reminiscences along the way—
shadowy, to be sure—of the medieval empora, triforium, clock tower,
triptych, and tabernacle; of rococo porcelain from Saxony and a flavor
of Roman Empire weapons. (SS 21:219)

Later, we learn that one day he saw a picture in an encyclopedia of
Fingal's Cave on Staffa Island, and "from that day on, the [Jacob's
Church] organ was a great basalt grotto and the organ bellows
was Aeolus, King of the Winds" (232).

Strindberg had returned, as he had in "Pangs of Conscience"
and would again in A Dream Play, to the omphalos (see chapter 1),
the magic place, in which an enchanted cluster of associations
linked cave, church, and organ and acted as a powerful stimu-
lus to his imagination. In this passage—Kärnell calls it "a massive
poem of similarities and relationships"[67]—the Naturalist and the
Romantic merged, and we sense a joy in the metamorphic play
that has echoes of both Darwin and Ovid. The organ becomes
a kind of book of evolution in which the stages of life and the
progress of history can be read. There is even a metaphoric prefer-
ence that Strindberg inadvertently shared with Darwin. Although
Darwin is most famous for his image of the tree as pattern for the
evolutionary process, in his B Transmutation notebook he won-
dered whether "the tree of life should perhaps be called the coral
of life, base of branches dead: so that passages cannot be seen."[68]
Strindberg's organ also resembles coral, as he indicates, with cer-
tain parts, like extinct species, remaining as "vestiges from older
periods, now no longer in use." And everywhere in the meta-
morphic play, there is a searching for a pattern of coherence and
meaning, as Alrik's imagination attempts "to tie together the dif-

ferent pathways in this jumble of forms." Less than a decade later, the same kind of Ovidian searching would lead Strindberg to a new view of art and life.

Alrik has another chance to play a transformation game with an organ when he arrives to serve as organist-sexton-teacher on the island of Rånö. In reality, the church organ he finds there is a small, decrepit thing and his pupils sniveling brats, but for him the instrument becomes the great Jacob's Church organ and the schoolchildren characters out of James Fenimore Cooper's Leatherstocking Tales.

The last metamorphic game in the novella is one of the most delightful. The subject is the first meeting between Alrik and the woman who supposedly becomes his wife. As he rows out one day to deliver a letter from his pastor to the lighthouse keeper, he has a most unusual experience. In the passage describing it, Strindberg effects a discernible change of style—like a change of gears or transposition of musical keys—and the impression is given that Alrik's perception of reality has moved onto another plane. Throughout a dazzling, zigzag journey back and forth across the boundaries of reality and fantasy, a splendidly ironic, fairy-tale-like shimmer is paradoxically both enhanced and undermined by amusing traces of self-parody.

When Alrik first hears the girl's voice, "because of the distance and the attenuation of the air, the tones did not resound purely, but harmonized nevertheless, so that when they reached his ear they sounded vague, indistinct, as from an aeolian harp" (SS 21: 254). As he speculates on the kind of girl who could be making these sounds, "a broad smile spread over his face for the first time in eight days and his lips found the name: Angelika" (255).

For a time he had lost his gift of playing; now it returns as suddenly as it left. This new Angelika is a maiden imprisoned in a tower and he is a high lord, a coregent, heading a punitive expedition to rescue her. The letter in his pocket, instead of being a message from the pastor to the lighthouse keeper, "is a letter of safe conduct, containing a pardon or special dispensation from the pope to permit coregents to marry imprisoned princesses" (SS 21:

255). Alrik stands up in the boat and sings the seduction aria from act 1 of Mozart's *Don Giovanni*.[69] His invisible partner responds with a ballad from the obscure Finnish opera *The Hunt of King Charles XI*.

Alrik listened to it standing and with his hat in his hand, as one does when listening to the national anthem, and as he listened, his imagination began to play. The white lighthouse, slender on top and widening out toward the ground like a dress, became the mermaid with the fiery eye. The young maiden of the sea whose singing had lured him to her became tall Majken on Bernhardsberg, who blinked awkwardly—no, it must not be her! No, rather the maiden of the sea, that was much more beautiful, and he wanted to love her, embrace her, but at a distance, without seeing her and without her seeing him, in song, in harmony, under the rose-colored, gold-edged blanket of the summer night, and to accomplish the embrace Alrik began the first measures of the duet "Listen how the still wind sighs." After setting the key and listening, he heard the girl singing the song, and now he intoned the second part, and they entwined the notes, as one plaits favors. They kissed in the air, they embraced on the water, and when the last words—"song and love go from heaven, go to earth"—rang out, he saw the two final notes, like a pair of rosy-red doves, caress beaks. In that very instant a star fell from the zenith, painting itself like a note with its long tail, as if it had flown from the singer's mouth, and he opened his mouth to catch it between his lips, but the boat lurched suddenly, seating him upon the bait. And so he took hold of the oars, stuck out the blades like a pair of wings, and thus flew over to the lighthouse rock, where, quite literally, he met the lighthouse keeper's daughter with whom he had already sung a duet, and delivered the letter to her since her father was out on the sea, and he delivered the letter for two long hours, which were entirely too short, but nevertheless long enough to have coffee out on the porch with the singer's mother and, during a conversation about the big opera [house in Stockholm] and the Jacob's Church organ, win favor in a well-guarded heart and show the way to freedom for the imprisoned maiden. (255–56)

The elements in the passage are more extravagant than in any of Alrik's previous fantasies: absurdly Romantic arias and duets, sirenlike enticements, a lighthouse metamorphosing into a mermaid, a flying rowboat, musical notes that become falling stars.

Special energies are generated by this mélange, producing the same effect as similar energies in E. T. A. Hoffmann's tales.[70] A half year after finishing *The Romantic Organist* Strindberg wonders whether Hoffmann was not worthy of closer study; he had just discovered the works of another Romantic and Hoffmann disciple and, probably because of the metamorphic experiments and suggestive powers he found there, felt a strong affinity with him: Edgar Allan Poe (Brev 7:218).

Sven Rinman is surely correct in his criticism that the last section of the novella is rushed and undeveloped and that "the pity is that [the work] never became a full-length book."[71] In a sense, Strindberg never really finished it; he simply stopped writing. Perhaps this "trivial sketch," as he called it, sneaked up on him, drawing him to the brink of a confrontation for which he was not prepared and raising questions about Eros and identity, art and the imagination, that he was not ready to answer. In any case, this Naturalist's excursion into a full-blown, lushly imaginative Romanticism lasted only a short time. *The Romantic Organist*, says Lamm, "did not initiate a new phase in Strindberg's work. It was but a foreshadowing of a distant revolution, for it was followed by a relapse into Naturalism."[72] To be sure, the works written in the months following the novella—*Miss Julie* and *Creditors*—were intended by the playwright as Naturalistic tragedies, but in them, as we have noted, the dormant Romantic was stirring. It was not the first time in the 1880s that the intellectual intentions of Strindberg the Naturalist collided with the artistic instincts of Strindberg the Romantic over the role of the imagination in the creative process. At the same time, he was aware that times were changing. In a letter in late 1888 to Karl Otto Bonnier he wondered if the tide of Zolaism had not retreated. "It's not to be wondered at, therefore, that I am reluctant to ride in the baggage car when I am used to being in the van" (Brev 7:212). He had discovered Edgar Allan Poe and Paul Bourget and could see that new roads were opening up, beyond Naturalism toward Supernaturalism.

Times were indeed changing, but faster than Strindberg knew or was really prepared for. In France a revolution in attitudes

toward the role of the imagination in the creative process, led by people like Bourget, had been under way for almost a decade, and the first echoes of it resounded in Sweden a year after *Miss Julie* was written, with polemical pamphlets attacking Naturalism. By the time the storm cleared several years later, Strindberg found himself not only once again unwelcome in his native land but, what was even worse, regarded as a has-been. Almost a decade would pass before he would find his way back again to a productive creative life.

II

THE REMAKING
OF THE ARTIST

5 / The Visual Imagination and the Challenge of Nature

Perhaps the redemption of the imagination lies in accepting the fact that we create much of our world out of the dialogue between verbal and pictorial representations, and that our task is not to renounce this dialogue in favor of a direct assault on nature but to see that nature already informs both sides of the conversation.
— W. J. T. Mitchell, Iconology: Image, Text, Ideology

Dead End in Sweden

THE MOST PAINFUL AND DIFFICULT PERIOD, PERSONALLY and artistically, for Strindberg in his life — from 1889 to 1897 — was filled with ironies. Even as everything seemed to be coming apart — from his marriage to his career to his very sense of self — he was taking steps that would lead to renewal. The most important of these steps (although he probably did not realize it at the time) may well have been his return to an old love — painting. Personally, it helped restore his confidence in himself; artistically, it provided a framework that would help him develop a new view of the role of the visual imagination in the arts. The most obvious result of this new view was a challenge to the whole concept of a realistic, illusionistic imitation of nature as the artist's basic point of departure, and it altered his understanding of the aesthetic foundations of realism/Naturalism. Subsequent contacts with artists and writers in Berlin and Paris made him realize that others had already reached or were coming to the same conclusions. But it would take him until the late 1890s to develop the confidence that made possible the bold initiatives in the new direction that he took in plays like To Damascus and A Dream Play. If it took him longer to arrive at that point than many of his contemporaries, it was because he had to resolve many questions about where his

Fig. 4. Self-portrait of Strindberg, Berlin, 1893. *Photograph courtesy of Margareta Brundin, curator of the Strindberg Archives, Royal Library, Stockholm.*

Fig. 5. Portrait of Strindberg in his Stockholm apartment, 1902, by Herman Anderson. *Photograph courtesy of Margareta Brundin, curator of the Strindberg Archives, Royal Library, Stockholm.*

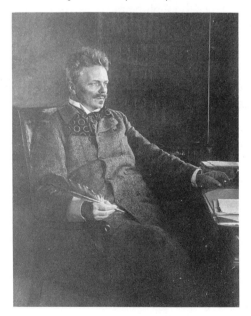

loyalties and commitment as an artist lay, and none was more difficult than his sense of identity as a Naturalist.

It would have been surprising if Strindberg had continued immediately to develop further the imaginative insights he acquired while working on the 1888 novella *The Romantic Organist on Rånö*, because a number of turbulent changes in his life caused him to go into a tailspin, as a writer and as a person. Ironically, they had their roots in an apparent triumph four years earlier: the 1884 acquittal on charges of blasphemy for the story collection *Getting Married*. He felt uneasy about the acquittal from the first, suspecting it was only a Pyrrhic victory, but he could not have foreseen that it would set in motion a series of events over the next decade that culminated in the worst crisis of his life. He may have been innocent in the eyes of the law, but the candid realism about marriage and sexuality in his stories made him guilty in the court of public opinion, and the trial and its aftermath eventually had a corrosive effect on everything in his life, personally and professionally. Already troubled by loss of faith in himself as an artist, he saw his chances of earning a living diminish rapidly. With the cultural climate poisoned against him in Sweden, he tried for some years to get by as a writer-in-exile, dragging his wife and three children with him through France, Switzerland, and Germany. But his financial difficulties were so pressing by as early as the spring of 1885 that he felt compelled to sell many personal belongings and manuscripts. Tensions in family life increased, and in 1887, only a few months after writing *The Father*—about a man's fear that his wife is driving him insane—Strindberg and Siri decided to seek a divorce.

Staying in Denmark during most of 1888 and 1889, he continued to be productive, writing *The Romantic Organist* and some of his most effective plays: *Miss Julie*, *Creditors*, and *The Stronger*. But the March 1889 world premiere of *Miss Julie* and *The Stronger* in Copenhagen was closed to the public by the censor, and the author found himself unwelcome in yet another Scandinavian country; one conservative Danish newspaper even demanded that he be deported for violating common standards of decency.[1] Return-

ing to Sweden in April 1889, he still found friends and admirers, but generally, as the scoundrel who wrote *Getting Married*, he was treated as virtually *persona non grata*.

Notice of the final divorce decree came in March 1891, giving custody of the children to their mother, which Strindberg took especially hard. After writing a series of one-act plays in the spring of 1892, including the masterly absurdist black comedy *Playing with Fire*, he stopped writing plays or fiction for half a decade; his next play, *To Damascus, I* (1898), would become a vital landmark in the history of modern drama. In between was a period of increasing poverty, humiliation, and degradation, seemingly a journey to the bottom circle of hell. In fact, Strindberg borrowed images from Dante in his description of the return from the journey in the novel *Inferno* in 1897.

He had experienced critical and public scorn before, from the Right as well as the Left, sometimes even thriving on it, but he had always taken strength from the warmth of family life and from his ability to earn a living with his pen. Now the warmth was gone and his career in jeopardy. To add to his problems, Naturalism had rapidly fallen into disfavor among younger writers, first in France in the mid-1880s, now in Sweden a half decade later. Though he had worn the label of Naturalist proudly, he was not unaware of the style's shortcomings, more than once voicing criticism of Zola's excesses, particularly the overemphasis on exhaustive descriptions of milieu. In an "interview" with himself in 1886,[2] while conceding Zola's authoritative position in contemporary European fiction, Strindberg questioned whether it was really necessary for the master, in the course of describing a seduction in an orangery, to relate the scientific names of all the plants at the scene (SS 18:456).

Nevertheless, Strindberg continued to be committed to Naturalism as the only style appropriate in a scientific age. Only Naturalism was in harmony with the frontiers of knowledge in all the sciences, from psychology to chemistry to physics to geology. Only Naturalism scoffed at the insistence that beauty was important in art. Only Naturalism was unblinking in its observations,

completely candid in its description of the most frightening forces in nature and the most sordid aspects of human behavior. Naturalistic truth alone was sufficient; it needed no assistance from sentimentality or supernaturalism, so frequently the products of an excessive imagination.

We have already seen (chapter 4) how these objective ideals were honored almost as much in the breach as in the observance by many Naturalists, not least of all by Strindberg. But this did not prevent him from resenting what he saw as unwarranted criticism of the style by nonbelievers or traitors to the cause. Consequently, when a polemical pamphlet, *Renaissance*, by poet-novelist Verner von Heidenstam appeared in Swedish bookstores in October 1889, he was appalled, even though it expressed some of his own reservations about Naturalism.

Heidenstam and Anti-Naturalism

Heidenstam's argument, though addressed to a Swedish audience, paralleled a similar attack against Zolaism in France—"le manifeste des Cinq"—two years earlier. It was couched in terms of a call for writers to bring forth something new but was quickly interpreted as a broadside directed against Naturalism. And though Strindberg was not attacked personally (Heidenstam described him as not really a Naturalist "in the strict meaning of the term"),[3] he reacted defensively for several reasons. For one thing he felt personally betrayed, having befriended and played the role of mentor to the younger writer two years earlier. For another thing, along with other realist/Naturalist artists, he felt Heidenstam had acted opportunistically by attempting to proclaim as a new truth the already growing awareness that Naturalism as a style had perhaps run its course. In a November 1889 letter he talks of "the kleptomaniac . . . , who snatched the whole cake we baked" (Brev 7:391).

Renaissance, after polite words of praise—"Naturalism's influence on prose writing must be considered extraordinarily salutary"[4]— proceeds to the attack. Realism was important, Heidenstam acknowledged, but it was time for literature to return to something

else as well. The more that it remained preoccupied "with insignificant and simply ordinary things, the easier for it to become dull, trivial, and empty, unless, as a counterbalance to the prosaic content, it is able to reveal a sufficient measure of idealism in the presentation."[5] Finally came the heart of his indictment, mitigated by a shrewd strategy: he called his argument a hypothetical parody of Naturalism. In this way, under the guise of pretense, he was able to be both respectful admirer and incisive critic:

Naturalism is the art of suffocating one's power of imagination and one's feelings, of never uttering a witticism, of never using an illuminating metaphor, in other words, of bringing some of the human mind's most splendid tools into disrepute. . . . [A]rtistic merit is dependent on something other than photographic fidelity. . . . Writers should therefore be wary of allowing their art to sink to the level of handicraft or soulless imitation—the kind of writing that earns the designation Shoemaker Realism.[6]

This opening barrage against the alleged unimaginativeness of "Shoemaker Realism" was followed the next year by another pamphlet, Pepita's Wedding, coauthored by Heidenstam and critic Oscar Levertin, and by an eloquent essay, "Naturalism and Romanticism," by poet Gustaf Fröding. More understanding and perhaps less opportunistic than Heidenstam and Levertin, Fröding praised Zola's "powerful imagination" but admitted that one can "hardly suppress a feeling of fatigue and aversion over the eternal repetition of the same impressions . . . and the endless lingering in 'milieu.'" Whether realistic or not, he insisted, style itself was not the essential thing. "It was, is, and always will be the creative imagination and the boldness of will that shape the artist, whether he is armed with the Naturalist's notebook or the Romantic's magic wand."[7]

Criticism of Heidenstam's Renaissance came from a number of realists and Naturalists who had begun their careers in the 1870s and 1880s. Nonetheless, it struck a responsive chord in younger writers and in the public at large, especially when it went on to call for less emphasis on social problems and for a more conge-

nially Swedish realism, as opposed to the "foreign" realism then prevailing in the nation's art. Heidenstam's coup succeeded, and within a short time Naturalism was discredited in Sweden. The controversy provoked by *Renaissance* helped make its author the nation's literary leader in the 1890s, and in turn he championed a Romantic nationalism that emphasized what he liked to call the uniquely "Swedish temperament" (*svenska lynnet*).

Exile in Berlin: Return to Painting

Strindberg gradually realized that he had been displaced; after late 1892, he played only a minor role in the national cultural scene until late in the decade. At the urging of expatriate writer Ola Hansson, who sympathized with his situation, he decided to join him in Berlin and try his luck in a literary market where some of his stories had already been published and two of his plays produced. He turned his back on everything that had meant so much to him, and he would not see his native land, except for brief visits, for another six years. Left behind, in addition to alienated family and friends, was something almost as precious: the unique beauty of Swedish nature, which he had depicted so sharply and warmly—the dark forests and the shining contrasts of sea, sky, and land. But it all remained locked in his memory, a source that would bring pain as well as comfort, and one that he would turn into a remarkable creative tool in the years ahead, when it was complemented by his extraordinary visual imagination.

Hope returned again for a time early in 1893 in Berlin when two of his one-act plays were staged there, and *Miss Julie* was performed in Paris at Antoine's important experimental Théâtre Libre. Though some of the French critics faulted Strindberg for lingering in Naturalism, the production paved the way for him to arrive in Paris the following summer as a celebrity: "*l'ennemi des femmes.*"[8] In Berlin he was lionized for a time in a largely Scandinavian circle of artists that included Edvard Munch and that gathered at a tavern Strindberg renamed the Black Pig (Schwarzen Ferkel). There, too, he met an ambitious young Austrian journal-

ist, Frida Uhl, who set her cap for the Swedish celebrity, and the following year they were married. Strindberg's first marriage had lasted longer than a decade; this one was even stormier, marked by frequent, extended separations, and ended in divorce in 1897.

Amid the setbacks and disappointments, Strindberg managed to find an outlet for some of his creative instincts. Almost twenty years earlier, frustrated and depressed when his *Master Olof* was rejected by theatre after theatre, he took up painting. Beginning again in 1892 in Sweden and continuing in Germany, Austria, and France over the next two years, he once more found solace in canvases and oils. At the same time, especially in Berlin and Paris, he associated constantly with painters and sculptors, Munch and Gauguin being only the most prominent, no doubt bringing back memories of happier days in the early 1880s when he had been intellectual leader in a group of talented young Swedish artists who subscribed as he did to many of the Naturalist goals. Now, artists were searching for departures from Naturalism. And there were other connections with painting, as well, for Strindberg. In the mid-1870s he had picked up enough insights into the visual arts from his readings and his own experience to be able to create what some experts believe was the first important art criticism in Sweden. He was the only critic of the time, according to Sixten Strömbom, "who gave the impression of *seeing* artistically, directly, and intensively."[9]

More than inspirational leader or critic, however, Strindberg was a gifted amateur painter in his own right. Unlike Goethe or Hugo, two other Romantic writers who were also serious graphic artists, he had little talent for (or perhaps patience with) draftsmanship. There is only a single human figure in all the 120 paintings he executed in his lifetime—*Golgotha* (1893)—and that one little more than a shadowy smudge, impossible to recognize without the painter's identification of it as a man. The main subject throughout is landscape, treated in typically Romantic fashion, showing Nature in her two most intense aspects: either dark, stormy, apocalyptic sea scenes or moments of great stillness—an arcadian island or a dazzling expanse of bright colors. As a land-

scapist, he admired both Turner and Constable [10] but was closer in mood and suggestive power, if not in accomplished technique, to Turner. During his only visit to England (an ill-fated honeymoon trip with Frida in 1893), he probably saw some Turners,[11] rekindling an enthusiasm for the man's work that he had had since first seeing reproductions in the 1870s.

Strindberg was an amateur painter in both the practical and the idealistic sense of the term. His technique was rudimentary—his trees tend to be simple clumps or stumps. "Like Kandinsky," says Göran Söderström, "he potentiates the expressiveness of colors and forms to such a degree that it is pointless to apply representational principles." [12] We see exactly what Strindberg is doing. Many of his paintings were executed with a palette knife, rather than a brush, and the passion expressed is unmistakable—here is raw power applied to the canvas as directly and physically as possible. But though there are no subtleties or nuances of line, he had a strikingly imaginative feel for color and a good instinct for design and structure. Some of his landscapes, for example, are uncommon in composition. Instead of horizontal views, they are vertical, thus creating unexpected and interesting linear tensions.[13] And while he disdained "*plein air*" painting, there is an authoritative immediacy in his work—not just the kind of immediacy of light, sea, and air one finds in Impressionism (a style he found puzzling when first exposed to it, then later came to approach in his own work), but the immediacy of the artist's feelings.

Scholars and critics have generally considered Strindberg's writing and his painting separately, almost as if they were individual, watertight compartments. Comparisons in most cases have been general, rather than specific, such as that he wrote "with a painter's eye." Biographer Michael Meyer, noting that Strindberg developed into "an interesting painter," says that during the first period (1872–74), "he was . . . painting vigorously, though as a relaxation rather than as a serious means of self-expression." [14] But it meant more than that to him. Sometimes painting was a vital way for the writer to get his creative juices flowing; at other times, an alternative form of expression when his writing efforts had been

rejected or failed to meet his own expectations. Perhaps he also found that painting was a more physically satisfying and organic activity than writing. W. J. T. Mitchell has observed that "if writing is the medium of absence and artifice, the image is the medium of presence and nature, sometimes cozening us with illusion, sometimes with powerful recollection and sensory immediacy." [15]

Strindberg comments in his autobiography that as a young neophyte writer he thought of painting as a catalyst. So intimidated did he feel by the challenge of expressing himself on paper that he felt, he said, a physical need to see his "hazy feelings" first take form on canvas,

perhaps also to find a concrete way of expressing them. His small, crabbed handwriting lay dead on the paper and was incapable of revealing as openly what he felt. He had no thought of becoming a painter, showing in an exhibition, selling paintings, or the like. Going to the easel was like sitting down to sing. (SS 19:8)

The adjective he uses to describe his feelings — "hazy" (simmiga) — is used again by him in an important context two decades later. In 1907 he sent to August Falck, the director of the Intima Teatern (the only theatre ever established to deal exclusively with Strindberg's work), a book of reproductions of paintings by Turner. Included with the book was a note: "This is how hazy [simmigt] I want the decor painted at the Intima Teatern, especially for *A Dream Play*." [16]

But painting could not satisfy all of the youthful Strindberg's expressive needs. While working as a young telegraphist on an island in the Stockholm archipelago in 1873, he enjoyed painting in his spare time and kept his eye open for likely subjects. One day, a shipwreck

occurred under especially picturesque circumstances. . . . The whole setting was so new and pictorial that he felt the desire to render it, but now brushes and paints were not adequate. He had to turn to the pen. And that is how he came to write several items for Stockholm's liberal morning newspaper. (SS 19:102)

Here is a telling indication of the intimate relationship between the painter and the writer: while groping for a way to express his feelings, painting offered him a more passionate, immediate outlet, but to articulate these feelings more clearly, with greater intensity, he had to turn from painting to writing.

Art critic Ulf Linde suggests that the relationship between Strindberg's literary and visual instincts is implied in the following passage from *The Son of a Servant Woman*, in which Strindberg defines the different ways that a botanist, a painter, and a poet interpret a visual experience:

Who saw what the forest really was? The botanist, perhaps, who found only a collection of phanerogams [seed plants] and cryptogams [spore plants], which convert dissolved minerals and gases in their inflorescences! The one who saw most superficially and falsely was surely the artist, who saw only surfaces, markings, and colors. But what had he seen as poet? He found his feelings revealed in the half-shadows and half-lights in the play of colors in the mosses, which aroused memories of some hazy place deep within him [*simmiga inre*], where the functions of his soul worked independently of his will. (ss 19:93)

The distinction made between artist and poet, says Linde, reveals that as an artist Strindberg wanted to control his subject matter in a subjectively practical way, "but as a poet he wanted to be controlled by the vision confronting him, to surrender totally." [17] The idea of "surrender" suggests someone who wants to lose himself in his work. But I think the importance Strindberg attached to different ways of seeing reveals instead a desire not to *lose* but to *find* himself in that work. The poet—that is, the true artist (whether he works with words or with lines and colors)—has an ulterior purpose in his fascination with the "play of colors" in the world around him. They become a way for him to explore his own feelings, to search for the truths contained in the "hazy place deep within him."

As early as his 1886 autobiography, Strindberg stressed the vital role the visual imagination had to play. Artistic forms must never be simply elegant expressions of natural forms, they must connect

those natural forms with his own feelings. His earlier experiences with painting taught him that

one should paint what is within, and not go about drawing logs and stones, which are insignificant in themselves and can only take on form by passing through the perceptive and sensitive smelter of the viewer. Therefore, one did not work out-of-doors, but painted at home, from memory, and with the imagination. (ss 19:9)

This kind of declaration may seem a contradiction in a writer who preached so insistently about the necessity of direct, personal observation and fidelity to nature, but of course he is talking here about expressing himself visually, not verbally. The visual artist, he felt, had greater license than the literary artist, a greater range of expressive opportunities. "There was no activity that so absorbed all thoughts, all feelings, as painting." While he felt obliged as a writer to copy directly from nature, as a painter he did not: "Sitting in front of nature did not work" (36).

Decades earlier, other Romantics expressed similar feelings about nature as model. The great German landscapist Caspar David Friedrich also distrusted painting directly from nature, relying instead on his own "inner light." [18] "Feeling can never be contrary to nature," he insisted, "it is always consistent with nature." [19] And another landscapist, John Constable, confessed: "For me, painting is only another word for feeling." [20] But of course for none of these Romantic artists did this imply that it was necessary, or even advisable, to place personal feelings over accurate attention to natural forms. Each was a passionate and dedicated observer of the details of nature; the important thing was that the design composed by the details be motivated and controlled by the artist's feelings. "Observe the form with precision," Friedrich advised, "the smallest as well as the largest, and don't make a distinction between the small and the large but between the important and the petty." [21] Strindberg echoed these sentiments in his early praise for Zola, "who, in the capacity of Naturalist, could never disdain the infinitely small as ingredient. On the other hand, he has never worshiped the trivial as great, . . . [but has] searched instead for

what was significant, and from the lesser reality has drawn the essence, shown the governing natural law" (ss 17:287).

A measure of the importance of the act of painting in the ebb and flow of Strindberg's creative impulses can be found in the fact that more than half of all his oils (68 out of 120) were executed in Germany, Austria, and France during the disturbing years 1892–94, when his literary career was at a standstill. Moreover, these works (especially those done in Dornach, Austria, in 1894) were some of his best.[22] In fact, he mustered enough confidence in what he was doing to submit two canvases for inclusion in the spring 1893 salon of the conservative Berliner Kunstausstellung. A friend and fellow Scandinavian who did the same was Edvard Munch. "Both artists," says Göran Söderström, "were refused . . . and their paintings were showpieces instead at the parallel *Salon des refusés*. Here, then, were Strindberg and Munch, major prophets of the later German expressionist movement, causing a stir as radical artists at odds with the conservative art establishment."[23]

The more striking of the works Strindberg submitted is one of a series of bright seascapes he did in which the only distinguishing feature in each is a single object or plant in the foreground. In his *Solitary Toadstool* (pl. 1) a clump of white-flecked, red *Amanita muscaria* is perched rather ominously in the lower right corner. The bright background, rendered in pale blue, white, and touches of pink, is in sharp contrast to the usual dark blues and greens that dominate in such Strindberg sea paintings as *The Wave VIII* (pl. 2). Although the mushroom is depicted realistically, the sand, sky, and sea behind it merge into each other without clear definitions. It is as if the plane on which the mushroom is located is the only one in focus, and all the others "hazy" (to borrow Strindberg's adjective) and out of focus. Reflected is a stylistic ambivalence that was to characterize Strindberg's post-Inferno writings as well. Even as the artist was reaching out beyond the real, toward the abstract, he felt the need to keep one foot planted firmly in the concrete here and now. It was another instance of the clash between two ways of seeing: he identified with both the botanist's and the poet's viewpoints. Though he shared the natural scientist's

need to see accurately and objectively, he had the poet's longing to penetrate Nature's deeper, transcendental secrets. In the 1880s and early 1890s he lacked the capacity to reconcile these conflicting impulses; in the mid-1890s, in the world of the occult in Paris, he would find a way.

On exhibit in Berlin, and thus accessible to him at the time he worked on The Solitary Toadstool, were paintings by Friedrich, including one that Strindberg might well have found inspiring: The Monk on the Beach (1808–10) (fig. 6).[24] Since he was associating at the time with Munch at the "Schwarzen Ferkel," and Munch was probably an admirer of Friedrich's work,[25] the chances that Strindberg would seek out the exhibit seem good. Though Friedrich's sand, sea, and sky are more somber and more sharply delineated than Strindberg's, here, too, are mysterious tensions created by a small figure isolated against the panorama of nature. Robert Rosenblum says The Monk on the Beach

suddenly corresponds to an experience familiar to the spectator in the modern world, an experience in which the individual is pitted against, or confronted by the overwhelming, incomprehensible immensity of the universe, as if the mysteries of religion had left the rituals of church and synagogue and had been relocated in the natural world. It has almost the quality of a personal confession, whereby the artist, projected into the lonely monk, explores his own relationship to the great unknowables, conveyed through the dwarfing infinities of nature.[26]

Friedrich and the post-Inferno Strindberg had much in common. Each attempted to locate a spiritual center in a chaotic universe in which man's faith in the solutions of orthodox religions to the eternal questions had been undermined. Each used references in his art to the continuing, if devalued, relevance of traditional symbols of Christ's mission and sought to evoke the spiritual equivalents of these symbols in nature. One Friedrich painting, Winter Landscape with Church (1811), manages to do both. It depicts a pilgrim resting in front of a giant wayside cross in a snow-covered forest glade, his crutches scattered on the ground nearby. Directly behind the cross are a pair of fir trees which both

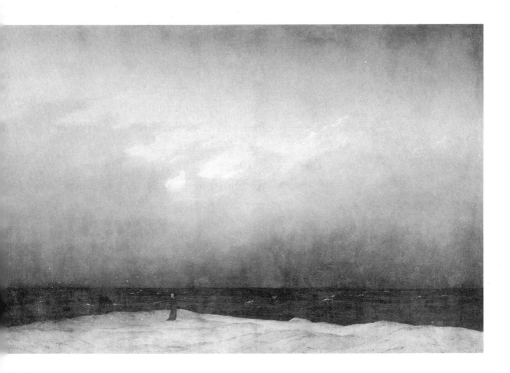

Fig. 6. Caspar David Friedrich, *The Monk on the Beach*
(Der Mönch am Meer), 1808–10, oil on canvas, 110 × 171.5 cm.
Nationalgalerie, Berlin, Staatlich Museen zu Berlin, Preussischer Kulturbesitz.

frame the cross and tower over it, suggesting that tree and symbol are one. To the left, on the distant, twilit horizon, the dim out-lines of a cathedral's spires rise majestically out of a mist, suggest-ing shadowy echoes of fir and cross and thus reinforcing further the intimate connection between nature and the divine. Goethe called Friedrich's hovering cathedral "the sublimely towering tree of God."[27]

It is doubtful if Strindberg ever saw this particular Friedrich painting, but if he had, he might have found it an apt expression of the difficult pilgrimage he himself began in November 1893, and at the end of which he, too, would turn to the Cross for comfort. The German literary experiment had soured, and he was both out of cash and in considerable debt to his publisher, who was not interested in the kinds of pretentious scientific manuscripts that Strindberg continued to submit instead of more popular pieces. To complicate matters, Frida was pregnant. Strindberg managed to find some peace of mind for a while with his wife's relatives in the small, quiet Austrian town of Dornach, where he continued painting. Without a real sense of mission, however, and with financial problems frequently erupting into marital squabbles, he was still in search of the missing center. One answer seemed to lie in his research in chemistry and botany, the sources of inspi-ration for his scientific writings. He hoped to make an important discovery and thus earn the renown he believed would restore him in the eyes of the world. Another answer was implicit in his paintings, their titles revealing spiritual or fanciful preoccupa-tions: *Golgotha, The Underworld, The Fairy-Tale Grotto, The Greening Island.*

Paris and the Appeal of Decadentism

By mid-1894, it was time for Strindberg to be on the move again, for several reasons. First, his new marriage, despite the birth of a daughter, was in deep trouble. Second, and most urgent, was the threat of another trial provoked by one of his books. The German version of his roman à clef, *A Madman's Defense (En dåres försvarstal)*, about his first marriage, was the target of charges of obscenity,

and a trial was scheduled in Berlin; Strindberg feared he would be ordered out of Austria. In late summer he suffered the first of a series of five psychotic episodes that occurred between 1894 and 1896. Many critics and scholars, focusing much attention on these attacks, have concluded that Strindberg was schizophrenic. In recent years more balanced interpretations by psychiatrists have questioned this as too simplistic, in view of the many factors contributing to what was obviously a particularly difficult mid-life crisis.[28]

Paris seemed a suitable haven, especially because Lugné-Poë's production of *Creditors* at the Théâtre de l'Oeuvre had just attracted attention and interest. Strindberg and Frida agreed that it would be wise to separate for a time; he arrived alone in France in mid-August. Given his particular needs and problems in 1894, it was a good time to be in Paris. It was the right place for someone searching for a lost center in his life: the city was filled with writers and artists motivated by the same intention. As musicologist and theosophist playwright Édouard Schuré described the period in his popular 1889 study *The Great Initiates* (*Les grands initiés: Esquisse de l'histoire secrèt des religions*), its mood resembled that of the earlier Romantic *mal de siècle*. Like Musset in 1836, who complained that his age was "without faith or hope," one in which the past was "irretrievably gone, the future nowhere near,"[29] Schuré spoke of "a dry generation, without ideals, without light and beliefs, neither believing in the soul nor God, neither the future of humanity nor in this life or the other, without energy of the will, doubting itself and human freedom."[30] Much of this spiritual malaise was a reaction against the voracious appetite for materialism that had been sustained by more than a half century of striking advances in science and technology. When Strindberg looked back at the period in his novel *The Gothic Rooms* in 1904, he wrote of natural science as "bankrupt," but that "the human spirit had awakened from its isolation and felt its powers cease when contact was broken with *Jenseits* [the Beyond]. This searching for a close bond with the incorporeal was a characteristic feature of the 1890s" (ss 40:112). And the searching went on well into the next century, especially

in the arts. In 1911 Wassily Kandinsky, writing of the necessity to satisfy the same kinds of needs, predicted the dawn of a new age: "der Epoche des Grossen Geistigen in der Kunst" (the Era of the Great Spiritual in Art).[31]

Strindberg was to be affected by two of the movements spawned in the 1880s by this crisis of faith: Decadentism and Occultism (to which we shall return in chapter 6). Decadentism diagnosed the situation with an antidemocratic pessimism that was drawn, as Strindberg's pessimism was, from the philosophy of Schopenhauer and von Hartmann and from ideas on "degeneration" advanced by German medical doctor and author Max Nordau. Nordau first became influential throughout Europe in the early 1880s through works like *Die konventionellen Lügen der Kulturmenscheit* (1883) and *Paradoxes psychologiques* (1885), published in Sweden in 1884 and 1885 respectively. For Strindberg, Nordau—who applied the concept of physical degeneration to European man's intellectual side —provided fresh evidence of the continuing relevance of Rousseau's ideas. The warnings made for so long about the dangers faced by cultural man when he becomes alienated completely from nature had finally come true: according to Nordau, Europe was on the brink of collapse. In *Son of a Servant Woman* Strindberg says he discovered that

everything that he [himself] had worked out in *The Red Room* and *The New Kingdom* in general principles . . . , Nordau had formulated in equations . . . : the confusion of degeneration with culture; the overfecundity of industrialization as an advance, not in a healthy, but in an unhealthy direction; the emancipation of women as only a relapse into idealism; the corrosive influence of urbanization on the land, and the need of a gradual return to a simplified life. It was all there. (ss 19:197)

Although Nordau had little use for the Decadents, they accepted his thesis that just as individual organisms and species age or evolve past the point where they can compete successfully in the struggle for survival, European man had advanced past maturity into senility and was therefore doomed to meet extinction at the hands of those who had remained closer to nature. The idea

of the Twilight of the West, of course, was not a philosophical insight limited to a select few — it was a popular image of the day. What the Decadents did was to make it into a credo, and they looked for models to emulate in other societies — ancient Rome and Byzantium — that had reached the point of decline and feared they were about to be laid waste by barbarians.

However much Strindberg may have agreed with the basic aspects of this diagnosis, he never arrived at the drastic solution the Decadents proposed: a total rejection of what they saw as a cruel, malign Nature and a withdrawal from reality into art. The Decadent most ardent and eloquent in his justification for such a choice was Oscar Wilde. In fact, in the different points of view that he and Strindberg represented on the relationships between art, nature, and reality lie two of the philosophical extremes in the international avant-garde at the turn of the century.

While Swedish anti-Naturalists like Heidenstam criticized an excessive emphasis among Naturalists on the mundane, they did not question the importance of realism per se. Wilde did, however, dismissing as irrelevant not only realism but Nature itself. The core of his argument is stated boldly in his essay in the form of a dialogue "The Decay of Lying." When "Cyril" asks "Vivian" to leave his reading and come outside and enjoy nature, "Vivian" replies:

Enjoy Nature! I am glad to say that I have entirely lost that faculty. . . . My own experience is that the more we study Art, the less we care for Nature. What Art really reveals to us is Nature's lack of design, her curious crudities, her extraordinary monotony, her absolutely unfinished condition. . . . When I look at a landscape I cannot help seeing all its defects. . . . Art is our spirited protest, our gallant attempt to teach Nature her proper place.[32]

Even allowing for possible Wildean hyperbole, it would be hard to find an artistic creed more opposed to everything Strindberg earlier had stood for as an artist. While Strindberg had spent his life battling to reconcile the conflict he felt between his Aristotelian sense of responsibility to imitate nature faithfully and the

pull toward Neoplatonic ideals that he could not abandon, Wilde simply denied any priority of importance to imitation. An 1891 Wilde letter declares that "a thing in Nature becomes much lovelier if it reminds us of a thing in Art, but a thing in Art gains no real beauty by reminding us of a thing in Nature. The primary aesthetic impression of a work of art borrows nothing from recognition or resemblance."[33]

The aesthetic war set in motion by these contradictory views has been an enduring one over the last century, dividing artists and writers over the question of where their real responsibilities lie. And in many instances in which the quarrel seemed over an obligation to science and scientific observation versus an obligation to self-expression, the basic issue was often really a restatement of Aristotelian and Platonistic themes: which should have a stronger claim on the artist's allegiance—the authority of nature and the natural phenomenon to be imitated or the authority of one's own imagination? Strindberg was to come down on each side of the argument at one time or another in his career—now Aristotelian, now Platonistic. What he discovered in the late 1890s, under the influence of the occult movement, was the necessity of acknowledging both positions, of feeling "kin with Plato *and* Aristotle" (ss 46:66; emphasis added), thus reconciling his conflicting interests in imaginative creation and the observation of nature.

Strindberg expressed hostility toward the literary ideals that Wilde personified, claiming that his work lacked "any indication of source or origin, like whipped-up froth; the starch without the fabric" (ss 47:650). Nevertheless, the man's imaginative verve fascinated as well as repelled him. This is clear in the way he described Wilde's writing, making him appear a precursor of Surrealism: "disturbing like holy candles or mirrors in a public building, in a labyrinth hall, with illusory lines and false panorama perspectives; it oozes through one's fingers like eggwhite or frog's roe" (ss 47:650).

In the early 1890s Strindberg was in a quandary over the role of the imagination in art. While he could no longer deny or resist

its urgings, as he had once done, neither could he accept the *l'art pour l'art* approach that tore the imagination free from any contact with, or responsibility to, reality.[34] Unlike Wilde or many of the Symbolists, he felt that the route toward the abstract or the supernatural must proceed via the natural. He was fortunate to discover in this period that Nature herself would show him the way by means of new creative impulses he received from his painting.

"Woodnymphism" and "The New Arts"

Between 1892 and 1894, Strindberg began to alter the way he defined the artist's responsibilities regarding the imitation of nature, granting greater authority to the imagination and moving progressively toward abstraction. Stages in the process of redefinition can be seen in an 1892 letter and an 1894 essay. In the letter, written to Richard Bergh before Strindberg left Sweden, he indicated that he was experimenting with a new style of painting: "I have a number of oil studies to show you, painted from the imagination. A 'new direction' that I discovered myself and call 'woodnymphism' [*skogssnufvism*]" (Brev 9:40). "Woodnymphism" referred to several discoveries he made about how chance participates in the creative process, and he described his findings two years later in the essay that is also an important document in art history: "The New Arts! The Role of Chance in Art." [35]

The first discovery came while he was working on a small, eight-inch-high, clay statuette, *The Crying Boy* (*Den gråtande gossen*) in 1892. It was intended as a historical study of an ancient Greek youth, his arms outstretched pleadingly, but according to the artist, he became discouraged with the outcome and let his hand fall on the statue's head. Suddenly, a miraculous change took place, "a metamorphosis Ovid could never have dreamt of." The statue's

Greek-style haircut had flattened into a Scottish tam-o'-shanter that covered his face; his head and neck had shrunk down between his shoulders, his arms had slid down so that his hands covered his eyes under the beret, his legs had bent, the knees had turned toward each

other. The whole thing had been transformed into a nine-year-old boy crying and hiding his tears with his hands.[36]

A few days later, says the author, this experience of the power of chance on the artist's imagination had emboldened him to improvise a theory of automatic art to a group of friends.

"You all remember the story in the folktale about the boy who is out in the woods and discovers a 'wood nymph.' She was as beautiful as the dawn, with emerald green hair, etc. As he approached her, she turned her back, and now looked like a tree stump.

"Naturally, the boy had only seen the stump—his lively imagination fabricated the rest."[37]

Two things are implied in the passages. First, there is a zest for and confidence in the imagination that Strindberg had seldom acknowledged as openly before. Depicted as a positive force, not something to be talked about in hushed or shy tones as the dark source of "hallucinations" or "visions," the imagination appears to have a capacity for not only permitting the whimsical intrusions of chance in its work but welcoming them, thus asserting its own authority in art, independent of the conscious intent or will of the artist. This marked a considerable change from the attitude implied in Strindberg's fiction a half decade earlier, where a lively or "excessive imagination" is regarded as suspect at best, psychopathological at worst (see chapter 4). In the story "A Witch" the "visions" conjured up by Tekla's imagination obviously constitute a prelude to madness. And though Strindberg's attitude is more ambivalent toward the "gift of playing" possessed by the hero of The Romantic Organist—he clearly is bemused by Alrik Lundstedt's tendency to see things that are not there—there is the strong suggestion in the novella that the gift may be a dangerous psychological symptom. In "The New Arts," on the other hand, a lively imagination is accepted as a natural, indeed vital, part of the artist's equipment.

Second, the character of the relationship between the artist and nature is revealed to be creative and subjective, rather than,

as in Naturalism, only scientific and objective, and this relationship is elaborated upon in some detail in "The New Arts." The author relates that he himself had experienced "woodnymphism" "many times."

One beautiful morning as I strolled in the woods, I came out onto an enclosed patch of cultivated land. My thoughts were elsewhere, but I spotted an unfamiliar, strange object lying on the ground.

The first moment it was a cow, the next a tree stump, the next— (I like it when sensations alternate in this way). . . . I felt the curtain of consciousness starting to rise—but I didn't want it to—What I now saw was some people eating breakfast alfresco—but the figures were motionless, as if seen through a panopticon—Oh, oh—it's all over— It was just an abandoned cart in which a farmer had thrown his coat and hung up his rucksack! That's all it was! There was nothing more to see. The joy was over![38]

The elements of reality that the artist perceives around him are not just things to be described or imitated, they are grist for the mill of his imagination, which is free to do almost anything, provided the artist is properly attuned to the messages emanating either from the sights and sounds of nature or from the whims of chance.

The emphasis on chance might appear to be an indication of an even more radical change in Strindberg's aesthetics than his new respect for the imagination. In the 1870s and 1880s, at least in part under the influence of Brandes, he set great store in what the artist intended, particularly what social message he intended. But if he now seemed to approach Wilde's position, giving the artist's muse primary authority over Nature in the creative process, the essay makes clear that the muse he finds inspiring is Nature herself. "They say that the Malays," he writes,

make holes in bamboo stems growing in the forests. Then the wind comes and the natives, stretched out on the ground, listen to the symphonies performed by these giant aeolian harps. The remarkable thing is that each person, thanks to the caprices of the wind, hears his own melody and harmony.[39]

An intimate partnership is implied between Nature, chance, and the artist's imagination. And the imitation that is done is no longer of nature as object but Nature as fellow maker and creator.

The narrator of Strindberg's essay speaks of visiting Marlotte in France—the same place Strindberg had used for the story that was the starting point of our discussion: "Pangs of Conscience." As in the story, Marlotte is still a setting conducive to transformations that excite the imagination. The narrator goes immediately to the dining room to look over and play a guessing game with the latest batch of impressionistic sketches:

What is this?—A leading question like this provides the first bit of pleasure. You must search, conquer; and there is nothing more agreeable than when the imagination is set in motion.

What is this? Painters call it "palette scrapings," which means: when the artist's work is done, he scrapes together the remnants of colors and, if he feels inclined, does a study of some kind. I stood enchanted in front of this one panel at Marlotte. There was a harmony in the colors—very understandable, of course, since they all came from the same painting. Once the artist felt free of the trouble of finding the right colors, he was induced to exert all his creative powers in the search for form. His hand guided the palette knife at random, and as he followed nature's model without trying to imitate it, the result revealed itself as a wonderful blending of the unconscious and the conscious. This is natural art—the artist working, in other words, like capricious Nature, without a prescribed goal.[40]

Years later, an almost identical description of a similar discovery was made by Wassily Kandinsky. Images created by chance on his palette stirred his imagination in unexpected ways.[41]

In the middle of the palette is a curious world of the remnants of colors already used. . . . Here is a world which, derived from . . . pictures already painted, was . . . determined and created through accidents, through the puzzling play of forces alien to the artist. And I owe much to these accidents: they have taught me more than any teacher or master. Many an hour I have studied them with love and admiration.[42]

The Visual Imagination and the Challenge of Nature

In Strindberg's essay the narrator concludes his discussion with advice to artists of the future that Strindberg as Zolaesque Naturalist would probably have questioned: "Imitate nature approximately; above all, emulate nature's way of creating!"[43] Strindberg had returned to a fundamental Romantic organic principle. "Ultimately, in the practice of art," said Goethe, "we can only vie with nature when we have at least to some extent learned from her the process that she pursues in the formation of her works."[44] Brought to mind are old terms that were revitalized by the Romantics: the distinction discussed earlier (chapter 1) between nature creating (natura naturans) and nature created (natura naturata), between "the essential creative power or act" and "the natural phenomena . . . in which nature is manifested."[45] Coleridge insisted that the artist "must master the essence, the natura naturans."[46] Centuries earlier Aquinas had defined natura naturans as "art imitates Nature in her manner of operation."[47]

Five years after Strindberg had written The Romantic Organist, it seems that he himself had acquired his fantast hero's gift of "playing": the gift of transforming reality according to imaginative "woodnymphistic" instincts. But though this new playfulness would eventually lead him back to a productive creative life, in his private life he continued to descend into the abyss. In late 1894 and early 1895 both his finances and his health worsened. He became an object of humiliating charity among Scandinavians both in France and back home. A second psychotic episode occurred in December 1894, and in January 1895 he was admitted for three weeks to the Hôpital de St. Louis for treatment of sores on his hands that have since been variously interpreted as either the results of alchemical experiments or a recurrence, because of all the stress, of psoriasis, from which he suffered during much of his life. The third psychotic episode took place at the end of 1895, and the following February he moved to the Hôtel Orfila, where he entered the last phase of his crisis, but where he also began to find the means of putting his life back together again.

CHAPTER 5

Experiments at the Hôtel Orfila:
Woodnymphism and Frottage

Strindberg's interest in experiments that encouraged a free play of
the imagination intensified after he moved into the Hôtel Orfila
in February 1896. Some of the experiments, in fact, were regarded
as very bizarre by his friends. He claimed to see images (one is
tempted to say "visions") in such commonplace objects as walnuts
and pillows—more parallels between himself and his Romantic
fantast Alrik Lundstedt. Just as Alrik saw in the metal cap of a
roof chimney "the form of a witch wearing a black hood" (SS 21:
193), Strindberg pokes a lump of coal out of his hotel room stove
and finds that it looks "like one of the demons who performed in
medieval witches' sabbaths. The next day I plucked out a superb
pair of drunken goblins dressed in billowing clothes and embrac-
ing each other. It was a masterpiece of primitive sculpture" (SS 28:
46). When he showed his lumps of coal to Munch, he says he was
pleased when Munch asked him, "Who made these?" (46) (fig. 7).
He found unusual resemblances between shelled walnuts and
brains, and sketched the walnuts to record his impressions (fig. 8).
And he became so fond of "reading" patterns in pillows that he
purposely tossed them about to examine the results, just as, to
borrow an image from Strindberg's essay on chance in art, weavers
might twist and turn kaleidoscopes to obtain new variations.

However bizarre these experiments might appear, they are not
unusual in art history. Surrealists in the 1920s found support
for their own experiments in statements by Leonardo da Vinci,
who advised painters to attempt the very kind of imaginative ex-
ercises that Strindberg engaged in: "Look upon a wall covered
with dirt, or the odd appearance of some streaked stones," to
discover "things like landscapes, battles, clouds, uncommon atti-
tudes, humorous faces, draperies, etc. Out of this confused mass
of objects, the mind will be furnished with an abundance of de-
signs and subjects perfectly new."[48] Strindberg was making simi-
lar discoveries and in the process was revivifying and reeducat-

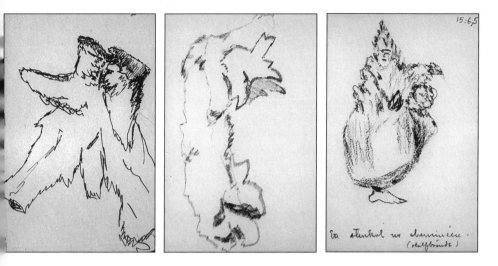

Fig. 7. In these three drawings of charcoal pieces, made by Strindberg in 1896, he detected human profiles. *Photograph courtesy of Margareta Brundin, curator of the Strindberg Archives, Royal Library, Stockholm.*

Fig. 8. In these 1896 drawings, from an appendix to Strindberg's 21 June 1896 letter to Torsten Hedlund, Strindberg detected a close morphological resemblance between a walnut and a human brain. *Courtesy of Barbro Ek, Bonniers förlag, Stockholm.*

ing his visual imagination. He was repeating, in a different way, and for different purposes, the lessons he had learned as a young writer when he had used painting to sharpen his eye for the details of nature. His good friend, the painter Richard Bergh, said Strindberg

saw in the same way we painters see. Fiery man of imagination and keen psychologist that he was, he never forgot for an instant the surroundings, the natural setting. . . . The secret must be that [he] never saw people and events isolated from each other. He saw them as parts of a whole, saw them against a specific background, in a certain light, at a particular time of day and time of year—exactly as we painters see them.[49]

Now, in the spring of 1896, Strindberg was learning to read the Book of Nature in a new way. Instead of just examining natural surroundings as a background for action, he was attempting to understand Nature's innermost process, and the results provide examples of how he anticipated future trends in art. Among the tools he used to record his observations, in addition to sketches, were charcoal rubbings of surfaces of objects (see fig. 9), such as the shell of a crab.[50] Thirty years later, Max Ernst, who coined the term "frottage" to describe such rubbings, was motivated by a similar woodnymphistic instinct to collaborate with Nature in the creating of an art object. Ernst described how a memory served as catalyst. As a boy, while ill in bed with a fever, he saw a mahogany panel across the room appear to change form, first resembling "a spinning top, then a nose, then the head of a bird, and so on. And later I consciously tried to recreate similar imaginings by looking at wooden panelling, clouds, wallpaper, unpapered walls, just to get my imagination working."[51] Years later, in August 1925, cooped up in a little hotel room on a rainy day, he was staring at the wooden floor when suddenly he noticed that the markings in the wood seemed to move, and he recalled the childhood incident.

Like my visions then, when I lay half-awake, half-asleep, the lines move and flow into pictures. And then, to keep my concentration going, I

Fig. 9. A frottage from Strindberg's *Occult Diary*, page marked 25, entry for 5 May 1897 (facsimile edition, Stockholm: Gidlunds, 1977). In the margin Strindberg speculates that the chevrons in the seal (unknown origin) can be interpreted in an occult numerological reading as signifying service stripes (seven years for each stripe) on a French army uniform, and he wonders if this message means that he will live twenty-one years beyond 1896. *Photograph courtesy of Margareta Brundin, curator of the Strindberg Archives, Royal Library, Stockholm.*

try to make a series of drawings from the boards. Quite haphazardly, I drop pieces of paper onto the floor and rub over them with a black pencil. I am astonished at the way suddenly my ability to look, to see, gets stronger.[52]

Ernst later wrote that "by widening in this way the active part of the mind's hallucinatory faculties I came to assist as *spectator* at the birth of all my works."[53] Although Strindberg's intention, unlike Ernst's, may have been scientific rather than specifically artistic, he, too, was widening his "mind's hallucinatory faculties" and improving his "ability to look, to see." He was demonstrating what Robert Rosenblum calls the "Romantic sense of regressing to a mysterious virgin nature, as yet untouched by the hand of man." This sense, says Rosenblum, "is nowhere more explicit than in Ernst's series of *frottage* drawings."[54] The same might be said for the whole range of Strindberg's woodnymphism experiments.

Though Strindberg's new heightened visual awareness of the resemblances he found in the world of forms around him helped prepare him for a new phase in his writing career, he still needed to find a metaphysical framework that would give his observations coherence and meaning, for spiritual as well as morphological reasons. This he would discover in the world of the occult, and with it would come yet another way of thinking about the imagination and its role in the creative process.

6 / The Romance of the Occult

If we want a clear picture of how our . . . rational culture [today]
has shrunk and constricted the definition of reality, at the same time
that it banished whatever does not fit the definition to a shadow world
of "psychic phenomena"—then we should turn to Strindberg,
especially the painter and the poet Strindberg.
—Ulf Linde, Efter hand

What is religion? . . . I say religion is Anschluß mit Jenseits, in our
language: contact with the transcendental; contact with the source of power.
—Strindberg, Black Banners

The Eye altering alters all.
—William Blake

Mysticism in Fin de Siècle Paris

THE RELATIONSHIP BETWEEN STRINDBERG'S INTERESTS
in occult ideas and phenomena and his later plays and novels
has been debated by scholars for more than half a century. On the
one hand, Martin Lamm[1] and Göran Stockenström[2] argued that
major concepts in Strindberg's post-Inferno art were patterned on
occult principles that were widely accepted by artists at the turn
of the century. On the other, Gunnar Brandell, taking an autobio-
graphical and psychoanalytical view, was skeptical. He concluded
that in Strindberg's case such exotic interests were motivated pri-
marily by personal, deep-seated psychological problems. "Perhaps
one should not take such fantasies as seriously as Lamm seems
to do," says Brandell, "when he surmises that the 'gods' and the
'powers'" that Strindberg wrote about were derived from occult
images. "The God and demons [he] . . . struggled against sprang . . .

from his own inner conflicts."[3] But Brandell's evaluation of the "powers" does not preclude the possibility that Strindberg's demons were both personal and in accord with occult models. To understand the appeal and importance of the occult, not only to Strindberg, but to a whole artistic generation, it is necessary to understand the heightened spiritual/religious atmosphere that pervaded Paris when he arrived for an extended stay in 1894. In this context his interests were not at all eccentric. For more than a decade the French capital had been a world center of revived interest in the occult. Many of the artists and intellectuals who migrated there to be exposed to the ancient, esoteric "secret wisdom" shared with Strindberg an enormous hunger for more evocative sources of inspiration than the positivist materialism of the day. In fact, by 1894, some in the occult movement were worried that it had become too fashionable—the esoteric was becoming exoteric. Papus, one of the leaders and editor of the most important of the occult journals, *L'Initiation* (to which Strindberg later contributed), decided that it was time for initiates "to leave the society folk to amuse one another and to retreat more than ever into the closed groups from which we were obliged to emerge in 1882 only to stop the propagation of doctrines that were leading the nation's intellectual life to destruction."[4] There were others, however, especially in the arts, who felt that the esoteric should become exoteric and that occult teachings should be broadcast to all. This would inaugurate the new age that Kandinsky described in 1911 as "the Era of the Great Spiritual in Art."

In Strindberg's 1904 novel *The Gothic Rooms* is a glowing description of the inspirational mood he says he found in 1890s Paris.

It was then that people discovered they were on the wrong path; at the next crossroads they veered in a new direction. They had collected facts and phenomena but could explain nothing. Explaining meant finding out what lay behind the phenomenon, and when people noticed that what lay behind it was on the "other side," they logically sought *Jenseits* [the Beyond]. This was called mysticism. And it was then that Swedenborg arose after a sleep of a hundred years in the grave. (SS 40:112)

Not everyone was impressed by the quality and character of the mystical climate. French literary critic Camille Mauclair reported that

the Salons bulged with Holy Women at the Sepulchre, Seas of Galilee, crucifixions, roads to Emmaus, pardons, and benedictions, all executed in the same leached-out tones and with the same magic lantern lighting effects. . . . An appalling and unending plethora of missals, chasubles, monstrances, and lilies. . . . All the external signs of faith were dragged in, and only faith itself was left out. . . . The theaters put on Passions in verse, or as tableaux vivants. Poems sagged beneath the weight of knights errant, palfreys, crenelations, and troubadours. The same label was used to cover Liberty fabrics, anemia, the Virgin Mary, stained glass, Edgar Poe, the Primitives, Sarah Bernhardt (in any role), braided hair, . . . slender waists, M. Péladan, waistless dresses, and M. Huysman's latest books. Such was the arsenal of mysticism: a jumble sale stall.[5]

Strindberg, however, participated very selectively in the mystical revival so exploited by Decadentism. He admired Poe, Péladan, and Huysmans but had no taste for the affected aestheticism that "dethroned life and put art in its place," as Jean Pierrot has described the phenomenon. But an artist did not have to be either a dedicated aesthete or a devout mystic to find aspects of the occult useful, as both Strindberg and Yeats discovered.

The Worlds of the Occult

By tradition, the occult has been not so much a single "wisdom" as a variety of "wisdoms" or "sciences," and during Strindberg's Inferno years he took at least some interest in all of them: alchemy, number symbolism, spiritism, the tarot, and the mystical systems of Theosophy, Gnosticism, and the Kabbalah. Occultists in the 1890s, following the lead of the French Romantics, absorbed even the study of comparative mythology into their philosophy as a primary source of esoteric knowledge. One result was that "no period in the history of French literature," says Pierrot, "witnessed such a ferment of legendary and mythic references."[6] In

1892 Édouard Schuré put the importance of myth and legend into what he thought was proper historical perspective: "Romanticism treated legends merely as themes to stimulate the imagination. Since then, we have come to understand that they are poetry itself, in its most essential form, manifesting itself in an intuitive state of the soul that we term the unconscious, and that sometimes resembles a higher consciousness."[7] If Schuré seemed to slight the Romantic perception of and commitment to myth—today sometimes described as "one of the distinguishing characteristics of Romantic writing"[8]—it only demonstrates the excitement and sense of wonder experienced by some fin de siècle intellectuals and artists at what they felt was their own discovery of the poetic power of myth. Whether primarily interested in myth or alchemy or Theosophy, however, all the different occult practitioners were motivated by a common goal: to do battle with materialism by finding a way to reconcile religion and science, and so, by implication, spirit and matter.

Although the occult movement was home to a number of charlatans and quacks, it enjoyed a certain respectability even in the scientific community. There appeared to many to be a natural progression from the psychological experiments of the 1870s and 1880s to the psychic experiments of the 1890s. It was a period when spiritistic séances were the subject of serious research by such eminences as William Crookes, president of the highly respected Royal Society, and Charles Richet, physiologist and later (1913) Nobel laureate. And so, when Strindberg's critics suggested that his own occult interests demonstrated that he was losing his balance, he could point to the authentic scientific credentials of the Occultists with whom he was associating (Brev 11:209). Papus, for example, was a physician and public health officer whose real name was Dr. Gérard Encausse; he began popularizing the occult in 1887 and continued both to practice medicine and to propagate occult ideas until his death in 1916. Another of the L'Initiation Occultists, Stanislas de Guaita ("the turn-of-the-century French occultist who was to have the greatest significance for Strindberg," says Brandel),[9] called his fellow Occultists "bold experimenters,

profound thinkers, who, by applying the very methods of positive science to the hyperphysical world, have laid down the unshakable foundation of a monumental synthesis of all human knowledge." [10]

If there was some interest in the occult among scientists, there was a great deal among artists. Guaita's hoped-for "monumental synthesis" was never achieved, of course, leaving science and faith as distant from each other as before, but the very striving toward such a goal had a profound effect on artists. Over the next quarter century, the occult revival proved an important creative stimulus to writers like Strindberg, Yeats, Maeterlinck, Jarry, Apollinaire, D. H. Lawrence, and Thomas Mann; painters like Munch (thanks at least in part to Strindberg's example), Gauguin (see chapter 8), the Nabis (the group that included Bonnard, Vuilliard, and Maillol), Kandinsky, Mondrian, and Duchamp; and composers like Scriabin and Stravinsky. [11]

Strindberg's work for *L'Initiation* did not mark his first acquaintance with the world of the occult. Records of the Royal Library in Stockholm show that he borrowed books on the subject as early as 1876, [12] and knowledgeable references to alchemical ideas, experiments, and potions figure prominently in his 1883 novella *Development* (SS 11:219–25). Hans Lindström has shown that Strindberg's interest in occult subjects was continuous in the late 1880s and was renewed in Berlin in 1892, [13] where his regular drinking companions at the Schwarzen Ferkel tavern included fellow Occultists Edvard Munch and Polish playwright Stanislaw Przybyszewski. He appears always, however, to have pursued his explorations in the "secret wisdom" warily and even reluctantly, partly because of his innate skepticism but mostly because of his Pietistic religious background. Though the occult had ties to orthodox religion, it also had ties to satanism. Indeed, Przybyszewski was the most prominent Polish satanist of the turn of the century, practicing black magic and devil worship. [14] At one point, Strindberg feared that Przybyszewski suspected him of having had an affair with his wife and would seek revenge with supernatural means.

Two occult philosophical camps in fin de siècle Europe vied

with each other for power and influence, disagreeing about the sources they regarded as most authoritative. The focal point of the dominant camp in Paris was the Groupe indépendent d'études ésotériques, founded as a publicity and information center by Papus, the editor of *L'Initiation*. The subject matter of essays in *L'Initiation* was very eclectic: philosophy, science, Occultist initiation, Gnosticism, and literature. Strindberg contributed several items, as we shall see, on the theory of correspondences. Though the proclaimed goal of the magazine was to appeal to people from all branches of Occultism, Western and Eastern, by rejecting "both positivist materialism and the claims of the Roman Catholic Church," [15] the dominant tone was Western and many occult enthusiasts still identified strongly with their roots in Roman Catholicism. Significantly, when interest in traditional occult subjects died out after the turn of the century, a number of these people returned to the church. The other camp consisted of those associated with the Theosophical movement, which, while not neglecting Western sources entirely, emphasized Eastern Occultism, particularly the esoteric teachings of Eastern religions. Less popular and influential in France than Western-oriented Occultism, Theosophy nevertheless attracted a number of important artists throughout Europe. Yeats in Ireland and Mondrian in Holland, for example, became members of their respective national branches of the Theosophical Society and contributed articles to Theosophical journals.[16]

Strindberg allied himself openly with the first camp, not only writing for *L'Initiation* but corresponding at length with several of its leaders. In a letter he indicated that he preferred "the scientific occultism in *L'Initiation*" (Brev 11:134) to Theosophy. As in so many things, however, he was really an eclectic when it came to the occult. Like the Theosophists, he drew on both Eastern and Western sources, but his attitude toward Theosophy as a spiritual movement had been negative ever since 1884, when attendance at several séances in Stockholm made him suspect that it was a fraud. Only after reading Allan Kardec's *The Book of the Spirits* (*Le livre des esprits*) in 1897 did his attitude become more sympathetic.[17]

During his most fervent antifeminist period, he included the Theosophical Society among the dangers posed by the women's movement. An 1886 outburst, part of a preface intended for, but never used in, the second volume of *Getting Married* stories, declares that "there are at present two mystical movements in Europe led and exploited by women: spiritism and theosophy" (ss 54:250). One of the exploiters he referred to was the founder and leader of the Theosophical Society, the dynamic and controversial Mme. Helena P. Blavatsky. Given Strindberg's usual distaste for strong, aggressive women, it is not surprising that she met with his disapproval.[18] A decade later, however, he became aware of the power of her ideas through Kardec's book, which he found saturated with "Swedenborg and above all Blavatsky, and when I see my own 'case' represented everywhere, I cannot conceal from myself that I am a spiritist. I, a spiritist!" (ss 28:319).

There were also personal and philosophical obstacles that prevented Strindberg from becoming a full-fledged member of either philosophical camp. First, he was simply by nature not a joiner. Second, he could not accept the attacks on Naturalism that issued from all quarters of the occult movement. In Theosophist Schuré's influential *Great Initiates*, for example, Naturalism is regarded as having degraded "the beautiful name of Nature, for Naturalism is the systematic negation of the soul and the spirit."[19] What Strindberg defended so stubbornly in Naturalism, long after the style was regarded as outmoded, was what he feared would be lost if the style was discredited entirely: the hard-won right of artists to depict all aspects of life—the pleasant and the unpleasant, the tender and the cruel, the politically acceptable and the politically unacceptable—no matter how much they might offend conventional standards of propriety or of beauty in art.

Though he continued to attack Theosophy in his letters, there were several reasons why Strindberg found himself drawn more and more to its program during his Inferno years. Its Eastern orientation stirred the interest of someone who had been fascinated by images and ideas from the East for more than twenty years (see chapters 1, 7, and 8), and this fascination was now revived during

a long and important exchange of ideas conducted in 1895–96 with a Swedish Theosophist, Torsten Hedlund, who also gave him financial assistance. At the start of their correspondence, Strindberg admitted: "As for theosophy, I take a wait-and-see attitude. It is said to be derived from Buddha, and I was educated by three Buddhists: Schopenhauer, v. Hartmann, and finally Nietzsche. Maybe this is why we share common viewpoints" (Brev 11:99).

Equally important to him was Theosophy's syncretic effort to demonstrate the common spiritual roots and antimaterialistic heritage shared by all the world's religions. Schuré proclaimed in *The Great Initiates* (subtitled *A Study of the Secret History of Religions*) that when "humanity is about to sink deeper and deeper into the worship of matter," it "will thirst . . . for redeemers and sons of God as it realizes its decadence more keenly." [20] In the motley group of redeemers whom he singles out for attention are Krishna, Hermes, Moses, Orpheus, Pythagoras, Plato, and Jesus.

Syncretism was a concept Strindberg long had found appealing. Earlier (chapter 1), we mentioned the vital chapel transformation scene in the 1884 story "Pangs of Conscience," during which Lieutenant Bleichroden regains his memory. The catalyst is a sermon he hears about "how Christ thought of humanity as one, single people, but how man's evil nature worked against this great idea, how humanity divided itself into nations, sects, schools" (SS 15:211–12). Though there is no evidence that Strindberg read Schuré, holdings in his 1892 and 1912 libraries demonstrate that he was exposed to the syncretic message contained in a broad range of Theosophist literature and theory,[21] including works by Mme. Blavatsky, Annie Besant (Blavatsky's most important disciple), and Rudolf Steiner, who broke with Besant to found his own movement, Anthroposophy. In Besant's *Ancient Wisdom* (a well-marked copy of which Strindberg owned)[22] the author speaks of a "Brotherhood of great spiritual Teachers" who "acted as the instructors and guides of the child humanity of our planet, imparting to its races and nations in turn the fundamental truths of religion in the form most adapted to the idiosyncrasies of the recipients. . . . [T]hese books contain teachings about God, man,

and the universe identical in substance under much variety of outer appearance."[23]

Rendering Visible the Invisible World: The "Magic Wand of Analogy"

The primary artistic boon that many writers and painters derived from Theosophy and other aspects of the occult was an ancient cosmology that had striking implications for the way they thought about their art. For dramatists like Strindberg it meant new choices in the handling of character and the conventions of time and space that challenged the dominant realism of the contemporary theatre and anticipated the development of Surrealism and Expressionism. For painters like Kandinsky and Mondrian it meant new freedom in the handling of subject matter that challenged the dominant figurative tradition in the visual arts and initiated an interest in abstractionism.

Three basic premises of occult cosmology must have seemed especially appealing and useful to Strindberg, premises shared by both occult camps, Western and Eastern. The first was that the universe was divided into two worlds, one visible and terrestrial, the other invisible and spiritual, and that it was up to the artist to reveal the relationships between them. The second premise identified potential tools of expression for the artist: the correspondences or analogies that existed and created bonds both within and between the worlds, such as the analogy that views a human being as a microcosm, or diminutive mirror image of "the greater being," the universe as macrocosm. The third premise posited the existence of an intermediate state of being or world between matter and spirit, termed the "astral light" by Papus's group and the "astral plane" by the Theosophists.

The idea of an invisible world beyond the one we see was a Platonic concept (some critics, in fact, rename the occult tradition the Platonic tradition)[24] that had also been vital to the earlier Romantics. Carlyle cited German idealistic philosopher Johann Fichte's allusion to "the divine idea of the world" that lies "at the

bottom of appearance" and asserted that "all appearance, from the starry sky to the grass of the field, but especially the appearance of man and his work, is but the *vesture*, the embodiment that renders it visible."[25]

The second premise entailed preparing to see in a new way, becoming an "initiate" uniquely equipped to detect the correspondences between appearance and what was "at the bottom of appearance." Once again, the Romantics had led the way. Novalis, in a passage underlined and accentuated in the margin of Strindberg's copy of his works, stressed the necessity of learning "to use the Magic Wand of Analogy."[26] Affirming analogies or correspondences—through axioms like "as above, so below" and "as within, so without"—created bonds between all elements and phenomena in the universe, making the artist's mission, as William Blake described it,

> To see a World in a Grain of Sand
> And a Heaven in a Wild Flower
> Hold Infinity in the palm of your hand
> And Eternity in an hour[27]

Strindberg's Occultist mentors and colleagues worked diligently to revalidate the traditional "law of universal analogy." Papus wrote in his *L'Occultisme* that "analogy permits, given one sole phenomenon, to deduce with certainty one general law applicable to all phenomena, even those of a totally different order."[28] And Guaita asserted that it was by virtue of analogies "that the mollusk secretes the mother-of-pearl and the human heart love"; "the same law rules the communion of the sexes and gravitation of the suns."[29] The analogies drawn were not simply curiosities: they were evidence of humanity's intimate relationship with every part of the natural order. For Strindberg they became, as they had been for the Romantics, a means of making the universe organic again. Just as the Romantics reacted against eighteenth-century mechanistic rationalism, Strindberg and other fin de siècle Occultist enthusiasts reacted against positivist materialism.

Neither Papus nor Guaita, however, received primary credit

from Strindberg for demonstrating to him the spiritual and poetic power of analogy—that he gave to eighteenth-century mystics Emanuel Swedenborg and Louis-Claude de Saint-Martin (Brev 12: 315), also popular with the Theosophists. Swedenborg, the first to apply the terminology of correspondences to the older theory of universal analogy,[30] was the model and inspiration for generations of Romantic artists from Blake through Balzac, Baudelaire, and Yeats. And Saint-Martin, a philosopher and friend of Rousseau, was much admired by both the German and French Romantics. Like Swedenborg, he too emphasized an analogical view of the universe that moved toward a restoration of material and spiritual harmony. Both Saint-Martin (called the "Luther of Occultism") and Swedenborg probably offered Strindberg what he felt was lacking in other occult theorists: a way of appreciating the ancient wisdom within an orthodox religious tradition, untainted by high-powered aestheticism, magic, or satanism. While Saint-Martin criticized the superstitious practices of the mystical Illuminist tradition, Swedenborg stressed a Christian interpretation of Occultist principles. More importantly, they provided Strindberg, as they had provided the Romantics before him, with a new rationale for the artist as a poet-seer who possesses, as Sainte-Beuve put it, "the key to the symbols and the knowledge of the figures, for whom what to others seems incoherent and contradictory is only a harmonic contrast, a chord on the universal lyre."[31]

In 1896 Strindberg experimented with the poetic potential in the law of universal analogy in essays for *L'Initiation*, experiments that would later be put to good use in his post-Inferno drama. In one of these essays, the author reveals his Neoplatonic purpose in using correspondences with an epigraph credited to the Talmud: "If you want to know the invisible, look carefully at the visible" (SS 27:357). Another essay, "A Look into Space," relates the results of a test the author said he conducted on himself to investigate the mysteries of "primordial light" ("urljuset"). In it we find the same perceptive, self-proclaimed Naturalist who had written so eloquently about Swedish nature a decade earlier. But now, his visual acuity sharpened by his painting and his imagi-

nation reawakened, he is no longer concerned about the dangers of "hallucinations." Without hesitation, he pursues his objective observations beyond the natural, using analogy and correspondence to create bonds between the images flashing on his own retina and the spectacular energies of outer space. The imaginative "woodnymphistic" improvisations he practiced as a painter (see chapter 5) had become scientific and occult:

When I press against my eyeballs in the dark, I see first a chaos of light, stars, and sparks, which gradually condense and collect into a shining, rotating disk. This disk then begins to throw out sheaves of red light, imitating the sun's faculae, but also resembling the vortex of a sunspot or the spiral nebulae in the constellation Virgo or Orion. . . . When the pain provoked by the pressure is at its maximum, the sun disappears, and a single, dazzling star remains. As the pressure diminishes, the light phenomenon ceases, and a play of colors begins. In the center a *Scabiosa* purple depression appears, surrounded by soft sulfur yellow, and resembling a sunspot in design. Is this, then, what the astronomer renders in words and pictures—the interior of the eye . . . ? Where does the self begin, and where does it end? Did the eye conform to the sun? Or is the eye the creative phenomenon we call the sun? (SS 27:354)

The implications of the questions raised were discussed approvingly in an "amendment" to the article signed by "Buddhist Guymiot," who mingles images from East and West: "The eye is a reduction of Brahma's egg. . . . Everything that takes place in our solar system is analogous with what takes place in one of our eyes. . . . In the play of light in our eyes we can study the play of light in the cosmos. . . . One must take seriously the expression macrocosm and microcosm in order to arrive at a knowledge of nature. There is nothing outside man which is not also inside man and in other forms of existence" (SS 27:355-57).

Strindberg had at last found a way to regain a center of meaning in his life. He was beginning to discover, in his own words, "the infinite coherence" in "the great chaos" (Brev 11:153) of existence, echoing probably unknowingly similar feelings expressed by French Romantic Gérard Nerval forty years earlier in his novel *Aurélia*:

How can I have existed so long, I said to myself, outside Nature without identifying myself with her? Everything lives, everything acts, everything corresponds; the magnetic rays emanating from myself or others traverse unimpeded the infinite chain of created things; it is a transparent network which covers the world, and its fine threads communicate from one to another to the planets and the stars. I am now a captive on the earth, but I converse with choiring stars, who share my joys and sorrows! [32]

Astral Bodies in the Astral Plane

Correspondences provided Strindberg with a new way of understanding man's relationships with the temporal and spatial aspects of nature, whereas the third occult premise—the existence of the astral plane or light—gave him a new view of the movements of the human soul, a new perspective on the dimensions of human character. The nature and configurations of the astral plane were described differently by two authors whose work Strindberg knew: Occultist Éliphas Lévi and Theosophist Annie Besant. For Lévi, says Arthur E. Waite, "astral light" was "at once a substance and movement, a fluid and perpetual vibration," moving "in virtue of an inherent force which is called Magnetism." [33] In contrast, Theosophist Annie Besant envisioned seven planes of humanity: three lower—physical, astral, and mental—and four higher planes of a spiritual order. She said the three lower planes fit together like "concentric interpenetrating spheres, not separated from each other by distance but by difference of constitution. . . . The astral world is above us, below us, on every side of us, through us; we live and move in it, but it is intangible, invisible, inaudible, imperceptible, because the prison of the physical body shuts us away from it." [34] In the astral world each person (as well as each animal, plant, and mineral) has an "astral body," [35] which can "function independently of the physical" [36] body. Clearly a densely populated, pliable region—Lévi calls the astral light a "plastic medium" ("médiateur plastique") [37]—it is crowded with a variety of bodies, images, reflections, and spirits, including spirits of the dead in transit to one of the four higher planes. Its plasticity makes

it instantly responsive to the whims of human thought and imagination, so that the life within it, according to Besant, is "swiftly remolding the form to give itself new expression." [38]

The astral plane or astral light, it would seem, is not only a canvas upon which the imagination paints. Its very existence suggests that the imagination, as an independent, almost divine creative force, is its master. Lévi writes in his *Key of the Mysteries* that the soul, by acting on the medium "through its volitions, can dissolve it or coagulate it, project it or withdraw it. It is the mirror of the imagination and of dreams. . . . It can take all the forms evoked by thought, and, in the transitory coagulations of its radiant particles, appear to the eyes." [39]

Disparaged for so long by association psychologists as mechanical and then by the Naturalists as obsolete, the imagination had begun a new rise to eminence. Baudelaire was among those who paved the way for the renaissance with his description of "the queen of the faculties" in his "Salon de 1859": "The visible universe is only a store of images and signs to which imagination gives place and relative value; it is a kind of fodder that the imagination must digest and transform." [40]

The concept of astral bodies was interpreted and used by artists in different ways; astral bodies were often considered to be separate beings. Yeats accepted Mme. Blavatsky's identification of the astral plane as synonymous with the *anima mundi*, or world mind or soul. For him, some of the astral bodies dwelling in the astral plane were the spirits of Irish folklore. The fairies, he wrote in 1892,

are the lesser spiritual moods of that universal mind, wherein every mood is a soul and every thought a body. Their world is very different from ours, and they can but appear in forms borrowed from our limited consciousness, but nevertheless, every form they take and every action they go through has its significance and can be read by the mind trained in the correspondence of sensuous form and supersensuous meaning. [41]

Psychic presences capable of both moving through and shaping another plane of existence provided the Occultist Strindberg

with a new term to describe what the Naturalistic Strindberg, stu-
dent of 1880s psychology, had labeled "the battle of brains." He
had no great difficulty making the transition from a focus on the
psychological power of suggestion to telekinetic thought travel
by astral bodies on the astral plane, and found ample support in
occult writings for his new faith in its presence. Stanislas de Guaita
asserted that during astral travel the astral body retains contact
with the physical body through a kind of umbilical cord.[42] And
Papus said that "to know the astral body thoroughly is to pos-
sess the most important of the doctrine's keys";[43] he claimed to
have located the body's physiological seat in the sympathetic ner-
vous system. One of the most important guides here, for Guaita,
Papus, and Strindberg (as well as for Rimbaud and Villiers earlier),
was the occult theorist mentioned above, Éliphas Lévi (1810–75),
a friend of Baudelaire and a dedicated student of Swedenborg. A
Strindberg note, scrawled on the title page of his Occult Diary, a
notebook of observations he kept from 1896 to 1908, asserts that
"the explanation of this diary, including all signs and symbols,
can be found in Eliphas Levi [sic]: La Clef des Grands Mystères, Paris,
1861." It is not necessary to take the generosity of this endorse-
ment very seriously (other sources, too, were identified as the
explanations)[44] in order to conclude that Lévi's ideas were prob-
ably vital links in a chain of Occultist-Theosophist revelations that
helped Strindberg find his way, both personally and artistically,
out of his crisis. An example of such an idea is in the following
passage from Key of the Mysteries, describing how astral bodies act
upon each other:

[T]he essence of the astral light is a double movement of attraction and
repulsion; just as human bodies attract and repel one another, [astral
bodies] can also absorb themselves, extend one into another, and make
exchanges; the ideas or imaginations of one can influence the form of
the other, and subsequently react upon the exterior body.[45]

The kind of stimulus Strindberg may have found in observations
like this is revealed in an essay on "The Doppelgänger" from his
1907 Blue Book collection:

When a man falls in love with a woman, he goes into a trance, becoming a writer and artist. From her malleable, unindividualized astral matter he molds a thought-form [tankeform], into which he deposits everything precious within him. He thus creates a homunculus,[46] which she adopts as her *double*,[47] and it is this that she lets the man occupy himself with. . . . [W]hen she has murdered her doppelgänger, love is ended, leaving only endlessly dry hate behind. (SS 46:250–51)

The passage is revealing in several ways. First, it is an eloquent picture of the functioning of the imagination in an artist's life, both in his interpersonal relations and in his art, threatening to poison the first even as it enriches the second. Second, it demonstrates how easily he accepted the dynamics and evocative artistic potential of the activities of astral forces in an astral plane. Third, the influence of Theosophy is implied in his use of the uncommon Swedish word tankeform (thought-form), ordinarily used only as a philosophical term for the way that an idea is presented or as a literary term for the way that a character's thoughts are presented in fiction. Thought-forms in Annie Besant's vocabulary allude to astral presences. In her *Ancient Wisdom*, much attention is devoted to thought-forms, which are constantly being shaped and reshaped by the imaginations of the senders and literally colored by their emotions. An outburst of anger, for instance, will produce a thought-form consisting of "a very definitely outlined and powerful flash of red."[48]

"Thought-Forms" and Correspondences in Legends, To Damascus, *and* The Ghost Sonata

In a separate study of thought-forms by Besant and C. W. Leadbeater, the universe itself is referred to as "a mighty thought-form called into existence by the LOGOS."[49] Research by Sixten Ringbom has demonstrated that the study came to play a role in the development of Kandinsky's ideas on abstraction in art by solving a frustrating problem for him.[50] In Kandinsky's "Reminiscences"

("Rückblicke") is an account of how the artist was surprised as he returned to his studio one day at dusk:

[S]uddenly I saw an indescribably beautiful picture drenched with an inner glowing. At first I hesitated, then I rushed toward this mysterious picture, of which I saw nothing but forms and colors, and whose content was incomprehensible. Immediately I found the key to the puzzle: it was a picture I had painted, leaning against the wall, standing on its side. The next day I attempted to get the same effect by daylight. I was only half-successful: even on its side I always recognized the objects, and the fine finish of dusk was missing. Now I knew for certain that the object harmed my paintings.

A frightening depth of questions, weighted with responsibility, confronted me. And the most important: what should replace the missing object? [51]

According to Ringbom, Kandinsky found the answer to his question in Theosophy. If the existence of thought-forms indicated, as Theosophy maintained, "a world of form and color independent of material objects, then such forms could be exploited artistically and provide the content replacing the object." [52]

Kandinsky's experience with the mysterious painting in his studio resembles the Strindberg story about the boy who thought he saw a wood nymph: "he had only seen [a] stump—his lively imagination fabricated the rest." [53] In each instance the artist was referring to having one's imagination stirred in a surprising way by seeing an image that was at first perplexing or unrecognizable. (In fact, Strindberg even recommended in an 1894 letter to Littmansson that a group of his paintings should be viewed in dim light, "preferably by strong firelight or in a half-shadowy room"— Brev 10:177.) [54] A blurring or obscuring of the viewer's sensual perception would make exact identification of an object difficult or impossible. As a result, the visual imagination was freed from what W. J. T. Mitchell in another context calls "the tyranny of the picture" [55] and was permitted to generate its own interpretations. And both artists—Kandinsky in painting, Strindberg in drama and theatre—became sufficiently encouraged by their experiences to

transcend conventional ideas about what constituted "realism" in art. Here, too, was an echo of the Romantics, who, said Paul de Man, were "the first modern writers to have put into question, in the language of poetry, the ontological priority of the sensory object." [56]

The "tyranny of the picture" began with the systematization after 1435 of the theory of artificial perspective, thanks to which people learned for the first time to calculate and record on flat surfaces spatial distances and the relative scale of objects, small and large. A measurable world could now be reproduced mechanically. When mapmakers applied these procedures to their charts, long-distance travel was made easier and a revolution in exploration took place. When painters applied them to their canvases, a revolution in illusionistic realism took place. Never mind that in both instances two-dimensional surfaces distorted a three-dimensional reality. An entire civilization became convinced that it had hit upon an infallible approach for depicting the real world in images created through a process in harmony with the Renaissance scientific spirit.

The tyranny in the case of painters and dramatists lay in the assumption that because almost anything could be measured, everything should be measured in this concrete fashion. For painters machines were devised to enable them to conform strictly to the rules governing the depiction of three-dimensional space on a two-dimensional surface. Dramatists were then expected to learn to write plays for stage settings that these same painters created by constructing plots that conformed to a narrow Renaissance reading of Aristotle's "unities," which demanded a measured action set in a measured time and measured space. Even today, Mitchell suggests, "no amount of counterdemonstration from artists that there are other ways of picturing what 'we really see' has been able to shake the conviction that these pictures have a kind of identity with natural human vision and objective external space." [57]

Just as thought-forms provided Kandinsky with replacements for the object and a new method of presenting what "we really see," they provided Strindberg with a way of continuing his cam-

paign against a narrow view of character as a simple, unified entity, a campaign begun a decade earlier in fiction like "Pangs of Conscience" and plays like *Miss Julie*. References to "elementals" (another term for thought-forms in Theosophy) appear in a number of his 1896 letters to his Theosophist correspondent Torsten Hedlund, and he seems to regard them as forces better known by more traditional names. "Fairy tales speak of trolls," he writes in July; "we say elementals and think we don't believe in trolls" (*Brev* 11:269). In August he praises the old Romantic concept of the doppelgänger, suggesting that it might be used to explain

the mysterious things in our existence, our double lives, obsessions, our nightly existence, our bad conscience, our momentary groundless (?) fears, our persecution mania, which is perhaps not a mania but real persecution—by what you and the occultists call elementals or lower beings, which envy us our existence, drive us to suicide in order to occupy what you call our Astral Bodies. (*Brev* 11:293)

The landscape of Strindberg's post-Inferno drama and fiction is rife with these phenomena—"mysterious things," "double lives," and "groundless fears"—and the lessons he had to teach about their use were later absorbed by playwrights from the German Expressionists to Pinter, Albee, and Sam Shepard.

Implicit in the letter to Hedlund is a faith in an extraordinary power possessed by the imagination, a power Strindberg explained in an unpublished article written in November 1897. "The Occultists believe," he said, "that the human soul has the creative power to project its passions into semibeings which they name elementals, elementary spirits, and so forth, and that a bad conscience spontaneously generates punishing spirits, spirits that can be expelled only by the patient himself through repentance and reformed behavior."[58] What Strindberg once worried about—the psychopathological dangers of the hallucinations and visions produced by an excessive imagination (see chapter 4)—could now be interpreted more positively, with the apparent support of philosophical and even scientific evidence. An artist's creation, far from being merely what he once called an insignificant "imitation of

an imitation" (see chapter 2), had an existence of its own: it was a "semibeing." (Besant and Leadbeater talk of a thought-form becoming "a kind of living creature.")[59] Strindberg had come to believe, like Keats and Nerval before him,[60] in the literal truth of what his imagination invented, although the degree of that belief is difficult to quantify. Perhaps because the skepticism he had about the value of the imagination through most of the 1870s and 1880s still lingered with him, he had difficulty defining the relationship between what was imagined and what was real and material. "The imagination's creations," he wrote in the narrative Legends in 1898, "have no reality, but visions, hallucinations, possess a kind of materiality. In the same way, one distinguishes in optics between virtual and real images; the latter can be projected on a screen or fixed upon a sufficiently sensitive photographic plate" (ss 28:272). Several pages later, however, he asserts bluntly that "the poet's fantasies [fantasier], so despised by narrow-minded souls, are realities" (280). If the creations of the imagination are not real beings, they are at the very least semibeings.

Strindberg began experimenting with these semibeings early in his post-Inferno writings, as we see in another passage from Legends. Described are impressions of a late-night visit to a Parisian tavern:

Rather than an atmosphere of high spirits, a quiet narcosis hangs over everything. It is like walking into a kingdom of shades, where a ghost-like half-reality reigns. . . . I saw people drinking champagne who seemed to be princes and princesses in disguise, and could not be sure whether these apparitions were real people or the "astral bodies" of sleepers who come to hallucinate the sleepy people sitting here. (ss 28:378)

A similar atmosphere prevails in the asylum scene in To Damascus, written in the same period (1897–98). The protagonist, the Stranger, is confronted by a group of figures who resemble people he knows without really being those people—he has wandered onto the astral plane. When he asks the Abbess taking care of him whether the strange people are genuine, she replies:

THE ABBESS: If you mean real, then they're terrifyingly real. If they look strange to you, it may mean you're still feverish, or . . . something else.

THE STRANGER: They all look so familiar! But it's as if I see them in a mirror, and they're only pretending to be eating. . . . Is this some sort of play they're performing? . . . That couple there—they resemble my parents, but only in passing.

I've never been scared of anything before, because life meant nothing to me, but now I'm getting scared. (SS 29:91)

The scene is anticipated earlier in the play when the Stranger makes clear that he is accustomed to encountering such figures, and the images he uses suggest the half-reality of the astral world:

It's not death I fear but solitude, because there's always someone there. I don't know whether it's someone else I'm sensing or myself, but you're never alone in solitude. The air gets denser, it germinates, and creatures begin to grow. They're invisible, but they're alive and you can sense them. (9–10)

The asylum figures themselves are mute and play only minor roles in the drama. It is quite a different matter in *The Ghost Sonata*, written almost a decade later, where some of the most important characters are either full-time or part-time residents of the astral plane. By choosing to locate the action of the play on this plane—one level higher than the physical plane—Strindberg knew that he might be taking a risky step. He assured his German translator in March 1907 that he was not abandoning the conventions of realistic drama entirely: "When you've written me your impression of *The Ghost Sonata*, I'll send you [another of the chamber plays, *The Burned Site*] . . . , which is full (lower) reality, or a splendid Philistine play" (Brev 15:354). That he intended for *The Ghost Sonata* to take place on the astral plane is evident in the play's working title—*Kama-Loka: A Buddhist Drama*—drawn directly from Theosophist terminology.[61]

Kamaloka (in Sanskrit, the "realm of desire"), according to Annie Besant, is the name for the purgatorial region of the astral plane that contains "human beings who have lost their physical

bodies by the stroke of death, and have to undergo certain puri-
fying changes before they can pass on to the happy and peaceful
life which belongs to the man proper, to the human soul."[62] The
description she gives of the situation in Kamaloka could well be
part of the stage directions for the house in which the action takes
place in *Ghost Sonata*: "gloomy, heavy, dreary. . . . It seems to reek
with all the influences most inimical to good, as in truth it does,
being caused by the persons whose evil passions have led them to
this dreary place."[63]

The most evil of the characters led to this dreary place is Hum-
mel, a ruthless real estate speculator who was once the lover of
several of the women who live in the house and is now likened
to a vampire. Other characters include two ghostly semibeings:
a recently deceased Consul and a mysterious Milkmaid, who we
learn was murdered years earlier by Hummel. Most of the time,
the semibeings are visible only to the audience and to the Student,
who says he is a Sunday child and gifted with visions. According
to Besant, astral beings are visible only to clairvoyants.[64] Hummel
is terrified when he learns from the Student that the Milkmaid is
in the vicinity; Besant says that "a man may be seen constantly
followed by his murdered victim, never able to escape from [its]
haunting presence, which hunts him with a dull persistency, try
he never so eagerly to escape."[65]

The Consul and the Milkmaid are not the only unusual charac-
ters in the play. Sitting alone in the dark in a closet of the top-floor
apartment where the other grotesque residents of the building
gather for their "ghost supper" is a woman whose name is Amalia
but who is called the Mummy and squawks like a parrot. Former
mistress of Hummel, this marvelous figure, one of Strindberg's
most imaginative and evocative creations, seems to live in a zone
of the astral plane somewhere between the literal and metaphori-
cal, or perhaps, as both Mummy *and* parrot, mixed-metaphorical.

Theosophical imagery also informs the powerful scene in the
play in which Hummel's attempts to tyrannize the residents of
the house are finally thwarted. Besant says that the conditions in

Kamaloka correspond to those "existing in the various hells, pur-
gatories, and intermediate states, one or other of which is alleged
by all the great religions to be the temporary dwelling-place of
man after he leaves the body."[66] The Mummy, provoked by Hum-
mel's viciousness, halts his vengeance with a simple, almost magi-
cally effective action: she stops the pendulum of the clock. No
longer parrotlike, she speaks in a normal voice: "I can stop time
in its course. I can wipe out the past, undo what has been done.
Not with bribes, not with threats—but through suffering and re-
pentance" (ss 45:192). The Mummy's time in purgatory is nearing
its end.

Although *The Ghost Sonata* represents Strindberg's most com-
prehensive use of Occultist-Theosophist astral-plane imagery, the
imagery's influence appears in other works as well, most con-
spicuously, perhaps, in the character of the clairvoyant Eleonora
in *Easter* (1900), whose astral body travels at night to share the feel-
ings and problems of relatives in America (ss 33:61–62). In these
concepts of astral bodies and the planes of existence, Strindberg
found new ways of suggesting multiple levels of being, expressed
in an almost cubistic approach to character. "The theosophists
speak," he says in a *Blue Book* essay written the same year as *Ghost
Sonata*,

of the seven planes of Kama-Loka, the state following death. I must
admit that during certain relationships in my life I have lived on sev-
eral planes at the same time, which has been difficult for me to under-
stand, and even more difficult for my enemies. These contradictions
in existence I have tried to explain through character fragmentation or
multiple personality. (ss 46:248)

It was probably Strindberg's earlier experimenting with the
doppelgänger principle in works like "Pangs of Conscience" that
prepared him to be receptive to Occultist ideas on character frag-
mentation. The occult concept of correspondences strengthened
and developed further the mythopoeic spirit he also demonstrated
in "Pangs." The result was a broader and deeper view of nature.

One of the essays he wrote for *L'Initiation*, "The Sunflower," sub-
titled "Analogies = Correspondences = Harmonies," contains an
inventory of correspondences that link vegetative imagery with
the solar system:

Plants, the daughters of the sun, conform to their mother, and strive to
resemble her. None has succeeded better in this striving than the sun-
flower, which embodies her image in its disk and ray flowers, follows
her movements, and completes its growth within a year, the time of
the sun's journey through the twelve houses of the zodiac. (SS 27:357)

Enumerating the useful purposes to which the sunflower is put—
from fuel to oil for cooking to fodder for cattle—the author
points out that "since the beneficial sun has incarnated itself in
this flower, more stately than beautiful, she has deposited in her
all the good things that are indispensable to living things" (360).

Viewing flowers—especially sunflowers—as microcosms was
a practice Strindberg shared with a number of nineteenth-century
artists. Robert Rosenblum says that "van Gogh's ability to empa-
thize with the life of flowers and to find in them some mysterious
metaphor of the supernatural in nature is nowhere more emphatic
than in his many studies of sunflowers." [67] And the same ability,
says Rosenblum, had been present in many Romantic poets and
artists: it was "a way to find the mysteries of the supernatural in
the smallest of nature's manifestations." [68] Paul Klee, for example,
using concepts that could have been borrowed from theosophical
imagery, wrote of wishing to make a cosmos of forms "so similar
to the Creation that a breath is sufficient to turn an expression of
feelings, or religion, into reality." [69] In this way, says Rosenblum,
Klee was searching for visual metaphors that translated "[Caspar
David] Friedrich and [Philipp Otto] Runge's scrutiny of the pal-
pitant, God-given life of trees and flowers into the more overtly
symbolic language of twentieth-century organic abstraction." [70]

Strindberg the Naturalistic artist had emphasized accuracy of
detail in description that mingled sensual metaphors and horti-
cultural details, as in this much-admired portrait of a garden from
the 1884 story "Relapse":

The Romance of the Occult

Lofty tea and perpetual roses stood in long ranks and in full bloom, arranged according to their colors. The back rank was made up of Maréchal Niel, with their huge yellow bowls stained with faint orange-red shimmers like the afterglows of sunsets; then, the small, tight balls of Gloire de Dijons, yellow like raw silk dipped in Madeira and with a fragrance like a song; the sulfur-yellow of Safrans, which stung the eyes; then, a platoon of white Boules de Neige, as white as their name. . . . It was sensually intoxicating to see and feel the fragrance of this forest of roses. It aroused all sensations simultaneously; as powerfully as by well-prepared food, as intoxicatingly as by wine, as bewitchingly as by the presence of a woman, as innocently as by a child's caresses or stories about angels; like a blend of meat newly butchered and burning Madeira, rouge and angel's wings, a woman's breast and children's kisses, sulfur and auroral blush, blood and milk, violet and linen. (ss 15:99–100)

After the Inferno period, Strindberg retains the sensuousness and scientific accuracy, but harmonizes them poetically through correspondences, and the effect produced is often a curiously ambiguous one, simultaneously concrete and abstract, material and spiritual. When the Student in The Ghost Sonata speaks to the Young Lady of the love he has for the hyacinth, "the flower of [her] soul," he finds echoes of that love in the universe in a passage conspicuous for its Eastern imagery:

STUDENT: I love it above all others — its virginal figure rising so slim and straight from the bulb, floating on the water and sending its pure white roots down into the colorless fluid. . . . But first its meaning. The bulb, whether floating on water or buried in soil, is our Earth. The stalk shoots up, straight as the axis of the world, and above, with its six-pointed flowers, is the globe of heaven.

YOUNG LADY: Above Earth, the stars! How wonderful! Where did you learn to see things this way?

STUDENT: Let me think! — In your eyes! — And so this flower is a replica of the universe. . . . That's why the Buddha sits brooding over the bulb of Earth in his lap, watching it grow outward and upward, transforming itself into a heaven. — This wretched Earth aspires to become heaven! That's what the Buddha is waiting for! (ss 45:196–97)

Alchemy, Monism, and Metamorphosis

Strindberg's alchemical experiments were another occult source that made him better attuned to the mysteries in nature. Though their scientific value is easily discredited today, Gunnar Brandell asserts that both Strindberg's published and unpublished "laboratory protocols should be regarded not as the results of what is now defined as scientific research, but as expressions of a particular attitude toward natural philosophy."[71] The core of that attitude lay in the nature of alchemy, from the Arabic *al-kimiya'*, the art of transmutation.

A preoccupation with transmutation in the mid-1890s was the next stage in a process for Strindberg that had begun with a fascination in the transformative aspects of evolution more than a decade earlier. The transformist of the 1880s became the transmutationist of the 1890s, perhaps in part under the influence of the theosophist view that Darwin's theory was flawed because it regarded matter rather than spirit as the motivating force in the universe.[72] An important factor in this change was the relationship between alchemical transmutation—transformation carried to a higher plane of development—and the revival of interest in Monism. A June 1894 Strindberg letter to Brandes reports that "in Paris, and even in Berlin, modern chemistry is evolving toward 'Alchemy,' in other words, Monism (= Aristotle)" (Brev 10:110).

Monism was an effort on the part of scientists like zoologist Ernst Haeckel (1834–1919)—whose ideas intrigued Strindberg in this period—to apply the implications of Darwinian theory to a theory of matter, suggesting, for example, that the basic elements were as subject to the laws of evolution as living organisms. In Strindberg's 1904 novel *The Gothic Rooms* he writes that the most succinct definition of the difference between alchemy and chemistry is that "alchemy believed in the capacity of the basic elements to transform into each other (transmutation), but the newer chemistry did not" (ss 40:113). The Monistic idea that all of matter, whether organic or inorganic, was composed of a single substance, capable of growth and transformation, was in har-

mony with occult principles: it lent new validity to the alchemist's dream of turning baser metals to gold, and Strindberg took heart. He saw it confirming the significance of his own experiments in chemistry and botany. What seems to have escaped his attention, notes Evert Sprinchorn, was that Haeckel's essentially materialistic approach was incompatible with Strindberg's own spiritual emphasis.[73] He was too eager, perhaps, to be thought of as in the vanguard of scientific thinking to worry about such contradictions: "I am a transformist like Darwin and a Monist like Spencer and Haeckel," he proclaimed in 1896 (SS 27:298). But though Strindberg liked to cite scientists as sources of inspiration, occult images were more important to him than scientific concepts. "No reputable scientist," says Northrop Frye, "has had the influence on the poetry of the last century that Swedenborg or Blavatsky has had."[74]

As a Naturalist, Strindberg dealt with the psychopathological implications of an excessive imagination and with the degenerative implications of Darwinian evolution (see chapter 4). As an Occultist Naturalist (he said he aspired to be the "Zola of the occult"; Brev 11:307), his focus shifts radically: evolution is now examined for its spiritual implications, particularly the implications of metamorphosis and transmutation, and the imagination is the tool that will enable him to read transcendental meaning in those implications. If Naturalism was necessary as an objective way to read Nature's outer forms—the visible world—the imagination opened a door to the supernaturalism of the invisible world, helping him to accomplish what he called "*Anschluß mit Jenseits*" ("union with the Beyond"; Brev 15:354).

Artists have always been attracted to the parallels between Nature's transformative powers and their own, and during Strindberg's Inferno period he came to regard such parallels as virtual divine revelations. An instinctive morphologist, like his models Aristotle and Ovid, he eagerly studied the life of forms, whether in art or in the real world. Swedenborg, too, was absorbed in morphological transformation, as a passage marked in Strindberg's copy of a German translation of Ralph Waldo Emerson's essays indicates: "Swedenborg, of all men in the recent ages,

stands eminently for the translator of nature into thought. . . . Before him the metamorphosis continually plays."[75] Perhaps the most telling generalization we can make about the post-Inferno Strindberg, to borrow from Emerson, is that "before him the metamorphosis continually plays." Strindberg's enthusiasm for metamorphosis may have spilled over and become central in an inappropriate area, his scientific writings with Monistic ambitions, but in the art of his post-Inferno writings it was entirely fitting, playing an energizing role in a time of renewal and revitalization. Thanks to the influence of the occult, he was able to read the metamorphic play of forms in new ways, and even on different planes. If his primary focus before the Inferno had been on *what* Nature creates—*natura naturata*—afterward, it was on *how* Nature creates—*natura naturans*. And the bond between nature and man's soul in *natura naturans* emphasizes the *invisible* rather than the *visible*, the internal processes in the life of forms instead of the external aspects. By suggesting to him how the imagination could provide a new, comprehensive, and, above all, spiritual view of the meaning in Nature's churning, metamorphic process, the occult had helped set the stage for him to return with a new sense of purpose to some of the other Romantic themes that have been the center of our discussion from the first: history, myth, and art. Before this return could take place, though, he had to assume once again the artist's calling that he had abandoned a half decade earlier, and for a time, this seemed an impossible commitment to make.

New Beginnings: Inferno

In late 1897, weighted down with guilt and feelings of anxiety over the broken dreams of the past and the realization that his scientific career was going nowhere, Strindberg sought to unload some of his burdens in a roman à clef, *Inferno*, published in both French and Swedish. His purpose was not to resume a literary career, but to undertake a painful journey of expiation through the wasteland of the last three difficult years. "I can't write plays and novels

anymore," he wrote from Paris to fellow author Gustaf af Geijer-
stam in Sweden; "I've lost interest and therefore the ability" (Brev
12:243).

Inferno depicts a hell of poverty, degradation, and humiliation
which the author slowly comes to accept as a necessary means of
chastisement for his sins. The novel is a candid, even ruthless, in-
ventory taken by a man who at first sees himself as spiritually and
financially bankrupt. Only gradually does he realize that the gruel-
ing experiences of the past half decade have provided him with
an abundance of assets that may help him turn his life around by
restoring to him a sense of calling and purpose. What is achieved
finally is more than an interesting autobiographical analysis. It is a
moving and revealing work of fiction, the first full-scale effort of
its kind that Strindberg had attempted in more than five years. Page
by page, we sense that even as the man is regaining his confidence,
the artist is beginning to see the creative potential in his new as-
sets. Like a painter experimenting with colors from a new palette,
Strindberg blends onto his canvas touches of occultism, Theoso-
phy, Swedenborgianism, and a syncretic approach to mythology.

All is spontaneous and yet all is calculated. When a case is pre-
sented for the existence of doppelgängers, a person turns up in
the narrator's life to relate a personal experience that clinches the
case; when the Theosophists are credited with advancing the pos-
sibility of psychic travel on the astral plane, the author discovers
that Swedenborg had already certified the validity of such jour-
neys a century before. Though the events described are based on
real-life experiences and told with the ring of simple truth, they
are also artfully arranged, altered, and even distorted to serve the
artist's intention of producing the maximum impact on the reader.

As always in a Strindberg work, there are contradictions. Even
as he continues his attacks on Theosophy as an outmoded, "un-
scientific" discipline, he is compelled to return, time and again,
to the evocative imagery he found in Theosophical sources. A let-
ter to Geijerstam shortly after Inferno was published in Swedish
in November 1897 urgently requests a copy of a new novel that

depicts a journey to the astral plane (*Brev* 12:201). *Legends*, another narrative account of the events of the past few years, followed *Inferno* several months later and is largely a continuation of the first book, with more evidence to reinforce the argument about the existence of astral forces. When Geijerstam examines the new manuscript and apparently suggests that certain of the scenes containing this evidence be cut, Strindberg replies that their purpose is to render "that semireal state which is neither vision nor hallucination but corresponds to what Swedenborg calls being conveyed by the spirit" (212). The "semireal state" ("which the Theosophists call the astral plane"; *SS* 28:289) is further defined in a passage taken directly from Swedenborg's *Arcana Coelestia* and cited in both the letter and *Legends*: "Man is put in a state that is midway between sleep and waking; and when he is in this state, he is unaware that he is anything but completely awake. This is the state in which it is said that one is transported out of the body, and that one does not know whether one is in the body or outside the body"; one is "carried away to another place" (*Brev* 12:213; *SS* 28:289). The astral plane had become a model, certified by both the Theosophists and Swedenborgians, that Strindberg would follow for the handling of time and space in a number of his post-Inferno plays. The concepts of astral bodies and thought-forms inspired him to experiment with characters as semibeings, and the astral plane suggested a condition of time and space somewhere between dream and reality—what the Romantics liked to call the waking dream. In a March 1898 letter Strindberg calls *To Damascus* "a fiction with a terrifying half-reality behind it" (*Brev* 12:279). And in *A Dream Play* the entire earthly journey of the Daughter of Indra takes place in that special atmosphere, the same atmosphere described by another student of Theosophy and the astral plane, Yeats, in "Under Ben Bulben":

> Where everything that meets the eye,
> Flowers and grass and cloudless sky,
> Resemble forms that are or seem
> When sleepers wake and yet still dream,

And when it's vanished still declare,
With only bed and bedstead there,
That heavens had opened.[76]

Wherever the narrator of *Inferno* turns, he sees support for his belief that a new age is dawning when matter will once again be reconciled with spirit. In a study in comparative mythology by Viktor Rydberg, *Germanic Mythology*, he finds images that demonstrate anew the endless coherence in the great chaos. In the visions of hell in Swedenborg's 1744 book of dreams he finds reminders, not only of ancient mythology, but of the visions he himself is experiencing in his own hell. He reports in a letter to Geijerstam that he asked Marcel Réja, the French translator of *Inferno* and someone familiar with Swedenborg's visions, what he thought the Swedish mystic intended with them. Réja, who, Strindberg notes, was "initiated in occultism . . . , answered elegantly: 'They were not visions; Swedenborg found himself on the astral plane.' This phrase means: in contact with the invisible world" (*Brev* 12:202). In *Inferno* correspondences provide the narrator with an answer to how such visions (that are not really visions) fit together with the other assets that he had accumulated during the Inferno years.

Where has Swedenborg seen these hells and these heavens? Are they visions, intuitions, inspirations? I don't know, but the analogies between his hell and those of Dante and those in the mythologies of the Greco-Romans and Germans lead me to believe that the Powers, in order to realize their purposes, have always availed themselves of closely analogous means. (*ss* 28:188)

Strindberg's frequent use of the term "Powers" in this period has been a subject of speculation on the part of scholars and critics. Martin Lamm suggested that the idea was probably borrowed in 1896 from the Occultists, who spoke of "*les puissances invisibles*" and "*les puissances de l'invisible.*"[77] Gunnar Brandell regards "the Powers" as an intentionally vague term invented to fit a number of different contexts. And both Brandell and Göran Stockenström believe that Strindberg first used it in the spring of 1897, Brandell

because that was when Strindberg began "seriously attempting a moral interpretation of his experiences,"[78] and Stockenström because that was when Strindberg started reading Swedenborg.[79] The Powers, in many of the contexts in which they are mentioned, also appear to be the name that Strindberg devised for the particular species of astral semibeings who seemed to be playing special roles in his life. He defines them in Inferno in much the same way that he earlier defined elementals and thought-forms, not as simple fictions but as psychic presences with a reality of their own. He says he created them through "the power of the imagination" as "disciplinary spirits" in order to punish himself (ss 28:95). This is reminiscent of the August 1896 letter to Hedlund in which he talks of the possibility of really being persecuted, not just suffering from persecution mania, "by what you and the Occultists call elementals or lower beings, which envy us our existence, drive us to suicide . . ." (Brev 11:293). To skeptical readers of Inferno who may doubt the existence of Powers, the author suggests an experiment: "Walk into your room at night alone and you'll find that someone else has arrived ahead of you. You can't see him, but you sense his presence. Go to a psychiatrist in a hospital for advice and he'll tell you all kinds of things about neurasthenia, paranoia, angina pectoris, and so forth, but he'll never cure you" (192). In To Damascus, which followed Inferno in the spring of 1898, the Stranger insists, as we noted earlier, that it is not death he fears "but solitude, because there's always someone there" (ss 29:9).

Not neglected in the novel are signs of Strindberg's recently rejuvenated faith in the transformative powers of the visual imagination. He records observing images shaped like human hands in prayer in walnut embryos (ss 28:38), grotesque animal and demon shapes in lumps of coal (45), Michelangelesque heads in pillows (58), landscapes created by the dried deposits of salts that evaporated during chemical experiments (77), and the likeness of a Gothic window trefoil in a piece of rock (105). (Cf. figs. 7–8.)

The most significant visual reference is in a scene which underscores the continuing influence of the woodnymphistic experiences he first wrote about in 1892. One day, while visiting the

studio of a friend (interesting how many of these dramatic events take place in a friend's studio), he is struck by the beauty of line in a pencil drawing hanging on a wall.

"What was the inspiration? A Madonna?"
"Yes, a Madonna in Versailles. It's a drawing of floating weeds in the pièce d'Eau des Suisses there."
A new art discovered, right from Nature! A natural clairvoyance! Why then scorn Naturalism, when it inaugurates a new phase in art, rich with the potential of growth and development? The gods are returning to us, and the battle cry raised by writers and artists alike, "To Pan!" has reverberated so vigorously that Nature has reawakened after centuries of slumber! Nothing happens in the world without the consent of the Powers, and so Naturalism appeared. Then let there be Naturalism, let there be a rebirth of the harmony between matter and spirit! (ss 28:59–60)

The passage is an inventory of what Strindberg had absorbed in his Inferno years: in the reference to the pantheistic fever of the time, reinforcement for his faith in Naturalism and inspiration for a new way to reconcile art and nature through the imagination; in the reference to Powers, a sign of the influences of the occult, Theosophy, and Swedenborgianism; and in the references to the Madonna of the floating weeds and the "new art, right from Nature," a reminder of the stimulus he first found in his wood-nymphistic experiments in 1892 as well as a suggestion of the new authority he conceded to the visual imagination. Strindberg the man may have believed intellectually that he was no longer able to write plays and novels, but the artist knew emotionally that he was ready. On 19 January 1898 he noted in his *Occult Diary*: "Caught the theatre bug again," and on 8 March he sent the newly completed *To Damascus* to Geijerstam, hoping to get it produced. An accompanying note read:

Enclosed is a play; whether it has merit, I have no idea.
If you find it good, give it to the theatre.
If you find it impossible, hide it in the safe at Gernandts [publishers].

But the manuscript must remain my property. It is my only annuity. (Brev 12:272)

The forward movement of the journey in *Inferno* is a rising trajectory, if not toward salvation, then toward the hope of salvation, a journey during which the Powers seem bent on compelling the narrator to return to the Christian faith of his fathers. Suggestions of another religious mode, however, constantly complicate the progress of that return. During the summer of 1895, the narrator says he discovered that

a kind of religion had evolved within me, difficult to describe clearly — a spiritual state rather than a viewpoint grounded in theories, a diverse mixture of impressions which more or less condensed into ideas.

I bought an old Roman Catholic missal, which I read carefully and meditatively. The Old Testament both comforted me and chastened me in some vague way, while the New Testament left me cold. A Buddhist work, however, made a stronger impression on me than all the other holy books, because it placed a more positive value on suffering than on abstinence. (ss 28:33–34)

References to the narrator's continuing interest in Buddhism recur throughout the book (Balzac's term "the Scandinavian Buddha" is used to describe Swedenborg; ss 28:184). The most elaborate reference is contained in the description of the doctor's home in southern Sweden where Strindberg stayed briefly for treatment for depression in the summer of 1896. Although, as Walter Berendsohn observed, "a photograph of the building . . . shows an ordinary, tiled-roof . . . house and grounds,"[80] Strindberg redecorated it in Asian splendor:

[M]y doctor's home had the appearance of a Buddhist monastery. The four one-storied wings of the house enclosed a quadrangular courtyard, in the middle of which stood an outbuilding in the shape of a cupola in imitation of Tamburlaine's tomb in Samarkand. The roof's shape and its covering of Chinese tiles were reminiscent of the Far East. An apathetic tortoise crawled along the paving stones and was swallowed up among the weeds in a state of Nirvana that stretched into

eternity. . . . In the midst of a flower garden was a pagodalike pavilion covered with clematis. (ss 28:106)

The narrator's impression of his host quickly makes clear the purpose of all this Orientalization. The doctor had a "deep familiarity with the worthlessness of everything, including one's own self. This man's entrance onto the stage of my life was so unexpected that I am tempted to regard it as an example of a theatrical *deus ex machina*" (106). The reader is tempted to add: Precisely! The elaborate and blatantly theatrical preparations are meant to set the stage properly for a crucial lesson the narrator was to learn on how to approach the restoration of his psychic well-being. After spending several terror-filled nights at the house and enduring cold-water therapy, he is given advice by the doctor, who held "to the fundamental Mohammedan principle of never praying for anything except to be able to bear the burdens of existence with resignation" (111).

Strindberg was only one of a number of artists in fin de siècle France for whom allusions to the Near East or Far East were never simply, as one might conclude at first from the example of the doctor's house, attempts to embellish reality with exotic details (see chapters 7 and 8). They reflected a deeply felt response to a philosophical worldview, an effort to identify with a spiritual integrity and perfection that they felt were lacking in the West, even if this meant resorting to a naïve Orientalism that a later society, more sophisticated about cultural development, might regard as awkward or in bad taste. Van Gogh, for instance, wrote to his brother that in one of his best self-portraits he had "aimed at the character of *bonze* [a monk], as a simple worshiper of the Eternal Buddha. . . . I have made the eyes slightly slanting like the Japanese."[81]

The Eastern images in Strindberg's 1884 story "Pangs of Conscience" (see chapter 1) were also sincere responses to a different philosophical worldview. In that story and elsewhere in his work the images frequently serve as a counterbalance to a Christian worldview, and the resulting tension between the two is richly evocative. That same tension reappears in the post-Inferno works,

of which *Inferno* is only the first example, and renewed interest in the imagery and mythologies of both traditions, Christianity and Eastern philosophy, was inspirational artistically and spiritually.

Christian imagery committed Strindberg to a reexamination of the meaning of salvation, especially in a medieval context, and in Eastern imagery was a reminder of the importance of resignation and an awareness of the interpenetration of nature and art. Together, the two traditions supplied energizing jolts that brought his creative batteries up to full charge, as he was caught up in the enthusiasm for Orientalism and medievalism that had vitalized European art and literature from the Romantics onward. The implications of those themes for Strindberg's art are the subjects of the next chapter.

7 / Oriental Renaissance
and Medieval Nostalgia

The East is lighting up in the distance, the past is being restored,
and India shall, even in the very North, flower with joy for the Beloved.
—Novalis, *Geistliche Lieder*

Would we not have a higher and broader view of the modern age by
studying the Middle Ages, and of the ancient world by studying the Orient?
—Victor Hugo, preface to *Les Orientales*

Within the narrow confines of our boards
you must traverse the circle of creation
and move along in measured haste
from heaven through the world to Hell.
—Goethe, Prologue in the Theatre, *Faust*

Fresh Water from Old Springs

OF THE FOUR MAJOR SOURCES THAT QUICKENED STRIND-berg's dormant imagination in the 1890s—his return to painting, and his interests in the occult, Orientalism, and medievalism—the last two were perhaps most crucial. While painting helped give him the confidence to rely on the play of unconscious forces in the creative process, theosophy and the occult (complemented by a Swedenborgian Christian perspective) indicated metaphysical structures within which these forces might operate. What still remained as a problem, however, was the debilitating conflict within him that has been the central subject of this study: between his ambitions as an objective realist and his instincts as a subjective dreamer. While the realist was an angry, righteous, "scientific" smasher of images, the dreamer was an iconophile, whose fiery imagination generated images spontaneously. In Orientalism

and medievalism he would find a passion for images and a respect for the imagination that showed how he might reconcile these differences. Together they would provide justifications for a new view of art and its purpose and new ways of working as an artist.

Two documents from the period illustrate the kinds of impressions they made. The first is a Strindberg letter from March 1896: "Today I finished reading a book about India and I no longer know where I am. I feel as if the author . . . [of all my books] were someone else and that someone was a Hindu" (Brev 11:151). Since he was inclined to overstatement, we might question how seriously to take the declaration. In this instance, particularly, he had a good incentive to appear enthusiastic and persuasive. Down and out in Paris, he was writing to someone who was helping him financially, Torsten Hedlund, a Theosophist absorbed in Indic religion and philosophy. It would not have been out of character for Strindberg to flatter his benefactor's interest, but not this time. The enthusiasm was genuine, even if he overstated the influence of the source on his work. Indic culture had first appealed to his imagination in the late 1870s and early 1880s and is evident in his story "Pangs of Conscience" (see chapter 1), with its references to Indic mythic images in Schopenhauer's philosophy. Now, in the 1890s, Strindberg took a direct interest in Eastern philosophy and mythology, and the result was a fascination that influenced his thinking and, above all, his ways of *seeing* as an artist.

The second document is a statement from *Jacob Wrestles*, the 1898 sequel to *Inferno*. It describes the 1890s fashion for the medieval: "The Middle Ages—the era of faith and conviction—is once again approaching in France. . . . The beautiful Middle Ages, when people knew how to experience pleasure and suffering, when strength and love, beauty in color, line, and harmony were revealed for the last time before they were stifled and cut down by the renaissance of paganism called Protestantism" (ss 28:346, 347). Returning to medieval themes stoked an old fire for Strindberg. An 1883 letter describes a character in one of his history plays as "a Romantic with one foot in the Middle Ages and the other in

the Renaissance, just like the author of *The Red Room*, etc." (Brev 3: 168). But his enthusiasm in 1898 was different in kind from the past. Though the emphasis on faith and conviction was an echo of earlier days, the respect for "beauty in color, line, and harmony" was not. Absent is the hostile iconoclastic spirit of the Naturalistic Strindberg, always suspicious of beauty as an end in art. And this new respect was to remain with him through the last decade of his life.

How can we explain Strindberg's interests in two such apparently disparate traditions as the cultures of the East and the Middle Ages? The fact is that not only did they attract much attention in fin de siècle Paris, but they were linked together in unusual ways. If this seems odd today, it posed no problem for Strindberg and his contemporaries, for they had clear precedents to follow. To Romantics more than a half century before them, especially in Germany and France, a linkage between Asia and medieval Europe was natural and right. Victor Hugo, in the preface to his *Les Orientales* in 1818, explained that he turned to the East for inspiration because he "seemed to see in it, shining from afar, a great poetry. . . . There, in effect, everything was great, rich, fruitful, as in the Middle Ages, that other sea of poetry."[1]

The idea of comparing the two cultures originated in Germany, the first European country to translate and publish sacred books from the East in the early 1770s. So powerful was the imaginative stimulus provided there by what became known as the Oriental Renaissance that it prompted Friedrich Schlegel's call to action: "We must seek the supreme romanticism in the Orient."[2] Much of the appeal undoubtedly came from the fact that the richness of oriental culture, its primitif qualities, seemed an apt weapon against the authority of French classicism. Primitif was an adjective with multiple meanings for nineteenth-century Europeans. As a descriptive term, says Kirk Varnedoe, it could refer both "to foreign peoples and to that which is most deeply innate within oneself. . . . [I]ts connotations were more consonant with those of the terms 'rustic' or 'archaic' than would be the case today."[3] This

is why Western medieval art as well as non-European art were both regarded as *primitif*; they seemed simpler, less sophisticated, and somehow more genuine than the materialistic culture of the age of progress in Europe. And so, medieval paintings, Japanese prints, Polynesian carvings, and ancient mythologies were regarded as equally authentic examples of the *primitif*. Indeed, some artists—Gauguin and Strindberg, for example, as we shall see in the final chapter—saw no inconsistency in borrowing from several such sources at once.

German Romantics found in *primitif* Orientalism an appropriate weapon with which to end the humiliation that their nation had long suffered under the yoke of French cultural dominance. The wealth of treasures uncovered by the Oriental Renaissance justified and reinforced the fervor they felt for the richness of their own Middle Ages. In the 1820s a Schlegel disciple and influential Orientalist, Baron Ferdinand d'Eckstein, spread the same anticlassical message in France, inviting French poets, says Raymond Schwab, "to imbibe 'unexpected inspirations' from 'two prolific springs'—the Orient and the Middle Ages," a combination that "enabled Romanticism to dismiss the centuries of Augustus and Louis XIV."[4] By 1838, French Romantic Edgar Quinet, in a burst of multicultural enthusiasm, could comment while in Heidelberg that "the Hindu epics are for the Indians what the Homeric poems are for the Greeks; they correspond to the age of the Nibelungen for the Germans."[5]

The renewed attraction of both "prolific springs" in the 1890s was heightened by studies in comparative religion like Édouard Schuré's popular *The Great Initiates*, which "launched a trend" with its "mixture of Eastern and Western religious notions."[6] Earlier artists like Balzac were inspired directly, through new translations of original works. In his novel *Louis Lambert* (which Strindberg admired), there is a focus on India as the root source of a universalist, syncretic approach to spiritual imagery. Reflected were the author's own readings in the new translations of classic Indic texts that were widely popular among educated Europeans in the 1820s. Lambert, Balzac's autobiographical hero,

thought that the mythology of the Greeks was borrowed from the Hebrew Scriptures and from the sacred Books of India, adapted after their own fashion by the beauty-loving Hellenes.

"It is impossible," said he, "to doubt the priority of the Asiatic Scriptures; they are earlier than our sacred books. . . . In the Hindus . . . the spectacle of the rapid recoveries of the natural world, and the prodigious effects of sunshine, which they were the first to recognize, gave rise to happy images of blissful love, to the worship of Fire and of the endless personifications of reproductive force. These fine fancies are lacking in the Book of the Hebrews."[7]

In December 1896, in one of a series of Strindberg letters to his estranged wife, Frida, but addressed to their infant daughter, he recommends that the child's mother read both *Seraphita* and *Louis Lambert*: "There she will meet herself and August-Poppa too" (Brev 12:28). Scholars have noted the importance to him at this time of Balzac's *Seraphita* as well as *Louis Lambert*, primarily because the novels inspired him to examine Swedenborg's philosophy.[8] But Swedenborg too was interested in comparative religion, detecting Christian meaning in a variety of foreign sources, Asian among them.[9]

Orientalism and medievalism satisfied interconnected needs in Strindberg's post-Inferno art. In the first were ways to reconcile the idealistic and the sensual, and to see that the artist's mission was honorable rather than base. In the art and philosophy of the Middle Ages, he discovered not only spiritual comfort and certainty but opportunities for renewing the contemporary theatre through older, less realistic ways of staging dramatic action. He was remaking himself as an artist, and we sense in his letters and his works from the late 1890s a Phoenix rising from its own ashes.

Orientalism versus Hellenism

Whatever fascination there was with Eastern art and philosophy among artists in fin de siècle Paris, throughout Europe during most of the preceding half century sharp differences were expressed, cultural and aesthetic, over the value and importance of

such foreign influences. For many Europeans during the period, Orientalism represented everything in the human spirit that was irrational—all extremes of emotional, artistic, and imaginative expression. Its polar opposite, representing reason, order, and balance, was Hellenism. "Oriental" was a pejorative used frequently by Georg Brandes to criticize Romanticism and Romantic artists. And, as we saw (chapter 4), influential historian Henry Buckle, in contrast to Balzac, ranked Greece, where the imagination "was broken in and tamed; its exuberance . . . checked, its follies . . . chastised," [10] above India, where the imagination, "luxuriant even to disease, runs riot on every occasion." [11]

But such antagonistic views were not shared by early Romantic artists. The very impression—whether accurate or not—of a culture in which the imagination was free to "run riot" was what made the East seem so exciting in the first place. The mystery and charms of lands where the spirit could soar and the senses be bombarded with exotic colors, sounds, and smells seemed irresistible to those who were bored with Enlightenment rationalism or appalled by the monotony and dehumanizing mechanization of the Industrial Revolution. But it was not just this provocative, escapist dream that was appealing, it was the exciting discoveries made about Eastern culture in the late eighteenth and early nineteenth centuries. When linguistic research identified Sanskrit as the probable root of all European languages, it undermined the linguistic authority of Eurocentrism and encouraged a more tolerant attitude toward different societies and cultures. With the subsequent establishment of institutions of Asian studies, says Raymond Schwab, "an entirely new meaning was introduced for the word 'mankind.' . . . Suddenly the partial humanism of the classics became the integral humanism that today seems natural to us." [12] French historian Jules Michelet rhapsodized over the Indic *Ramayana* and *Mahabharata* as "two gigantic pyramids beside which all our petty Western works must stand humbly and respectfully." [13]

For Rousseauistic Romantics, man's relationship with nature in the East was markedly superior to that in the West. Delacroix noted in his journal during an 1832 visit to the Middle East (regarded by

Europeans as a synthesis of East and West) that the people there "are closer to nature in a thousand ways, in their dress, in the shape of their shoes. And so beauty merges into whatever they do. We, in our stays, our narrow shoes, our ridiculous corsets, how pitiful we are." [14] Eastern culture not only seemed more artistic, it was more natural, more organic, than Western culture, and artists discovered integrating correspondences to support the idea. In a note Goethe made on "Primordial Elements of Oriental Poetry" in his *West-östlicher Divan* he evokes a mythopoeic view of a world in which man and nature are one. In the Arabic language

all the things which man expresses freely and naturally are life relations; . . . the Arab is as intimately connected with camel and horse as is body with soul; nothing can happen to him which does not at the same time affect these creatures and vitally connect their existence and their activity with his own. . . . If we proceed to consider everything else visible: mountain and desert, cliff and plain, trees, herbs, flowers, river and sea and the starry heavens, we find that, to the Oriental, all things suggest all things. [15]

The positive Western attitude toward the East gradually turned hostile for a variety of reasons — aesthetic, cultural/political, and religious. Increased contacts with the East began to undermine the often naïve Western idealism, and the positive attitude clashed with growing European imperialist ambitions. New theories of social evolution encouraged the racist assumption that Asian and African civilizations were lower on the evolutionary scale than Western civilization. Artists and intellectuals took sides in a clash of attitudes that continues more than a century later. The difference is that today terms like "Orientalism" and "Hellenism" have been replaced by "multiculturalism" and "Eurocentrism," expressing the conflict between those who advocate a greater emphasis on the diversity of contributions to human culture and those eager to protect the integrity of uniquely European traditions from this perceived threat.

In 1891 Oscar Wilde outlined an aesthetic case for Orientalism in his own idiosyncratic way, with the implication that the imagi-

nation was superior to the imitation of nature: "The whole history of [the decorative arts] in Europe is the struggle between Orientalism, with its frank rejection of imitation, its love of artistic convention, its dislike to the actual representation of any object in Nature, and our own imitative spirit." [16] Support for Hellenism was voiced in Sweden by poet-novelist Viktor Rydberg, although his liberal idealism led him to try to reconcile classical humanism with Christianity. He declared that both "science and art are by nature Helenes. . . . They honor the olive of Golgotha, but the laurel of Parnassus is the symbol of their struggles or victories." [17] But Rydberg also revealed some of the political and even racist overtones of the issue. The preface to his popular 1859 novel The Last Athenian describes the principal feature of the "Oriental type" as "a pious submissiveness to external authority. . . . The forces of reaction want to make mankind happy by returning it to its childhood. Hellenism wants mankind to mature . . . and sees true happiness in the fulfillment of that goal." [18] Of course, Rydberg was only expressing in politically idealistic terms what was basically an arrogant, widely accepted attitude about the right—even responsibility ("the white man's burden")—of Caucasians to dominate Asians. The same decade The Last Athenian was published, Chinese immigrant workers in the United States were brutally exploited in the building of the first railroad to span the continent.

Strindberg could not have supported either Wilde's or Rydberg's argument. Though he was learning to stretch his definition of the artist's mission, this would never have included a complete rejection of the importance of an imitation of nature. And though politically he leaned toward the liberal position in Sweden for which Rydberg was a major spokesman, Hellenism was abhorrent to him—not because he had a more tolerant attitude on racial or ethnic issues than Rydberg; it was not a tolerant time. Though Jews like the Brandes brothers, for example, won respect in intellectual and artistic circles, anti-Semitism was rife in Scandinavia, and cruel anti-Semitic and racist remarks appear in a number of Strindberg's letters. [19]

Hellenism for Strindberg represented the negative aspects of

classicism, an idealistic aestheticism that he had opposed ever since he was a young man: the kind of cool, austere, antiseptic, rationalistic style that the great German art historian Johann Winckelmann in the eighteenth century interpreted as the apex of Greek art. According to Winckelmann, in order to appreciate a statue from antiquity like the Apollo Belvedere, one had to understand that "here there is nothing mortal, nothing subject to human needs. This body, marked by no vein, moved by no nerve, is animated by a celestial spirit which courses like a sweet vapor through every part."[20] In the 1880s, Strindberg rejected this kind of aestheticism, emphasizing instead the natural over the idealistic or artificial. And even in the 1890s, when he had come to accept beauty as an artistic goal, his definition of beautiful included the coarse, the brutal, and the grotesque, and excluded delicacy and refinement. It was a view closer to Nietzsche's conception of Greek art in Birth of Tragedy: as an intimate dialogue in which dark Dionysian passion is every bit as significant as bright Apollonian order.

With Strindberg's long, though limited, history of exposure to Eastern culture and philosophy, he was ready in the 1890s—like other Neoromantics—to be seduced by its imagery. As a young man, he had learned a smattering of Chinese and Japanese for his cataloguing duties at the Royal Library. The early readings in Schopenhauer that had introduced him to aspects of Indic religion and philosophy were now amplified by Theosophy's emphasis on the same sources, as well as by information and ideas he absorbed about Indic art and literature in Parisian artistic circles.

Indic Revelations: Chevrillon and the Benares Vase

Clear evidence of Strindberg's increasing passion for things Asian (perhaps influenced by Gauguin—see chapter 8) is his enthusiastic reaction in March 1896 to the book about India mentioned earlier: a travel journal by André Chevrillon,[21] who was associated with the French Symbolists.[22] It became another in the long series of discoveries he made after resuming painting again in 1892, discoveries that stretched and extended his ways of seeing as an

artist. It made no difference that in this case the evocative force of images was communicated through words. The book's special value was that it seemed to suggest to him a way of bridging the gap between the natural and the supernatural without obliging him (as he felt Symbolism obliged many artists) to retreat into abstraction and thus betray his Naturalistic roots as an artist. Here was a way of seeing and working as an artist that he instinctively sensed as his own, making him feel, as he said, that the author of all his writings was "someone else and that someone was a Hindu" (Brev 11:151). Echoed in his remark was an insight voiced in an earlier Romantic's youthful reaction to an exposure to Eastern culture. Schwab says "Goethe's discovery of the Hindu seemed to produce the shock of recognition that one hemisphere of his thought was decidedly Oriental." [23]

Chevrillon's travel book included a description of a building and a street scene in the holy city of Benares, and Strindberg cites from it approvingly in his letter:

In the walls, over the doors, niches protect malformed gods — monsters with the heads of elephants, their androgynous bodies entwined with arms. Here and there are wells from which the stinking odor of rotting flowers arise. . . . One slips on a dunghill of flowers, one advances over a mire of refuse; sacred jasmines rot in the waters of the Ganges, which is then sprinkled on altars. . . . In the midst of a throng of people . . . cows wander freely, eating flowers. (Brev 11:151)

Contradictions in the description may have puzzled most Western readers, but they clearly fascinated Strindberg: a place where flowers are holy and yet trampled underfoot, where living growths are revered at the same time that dead and rotting ones are used to anoint altars, where cows are as sacred as flowers. In this profusion of images is a tumultuous, metamorphic play of forces in which there are no sharp lines of demarcation between the aesthetic and the organic, the spiritual and the sensual. Implied was a view of humanity's relationships with art, religion, and nature that was at odds with Western tradition, and it set Strindberg's imagination going. Two months after the Benares let-

ter, he wrote to Hedlund from Frida's family home in Austria: "It's very windy here, very occult, and life resembles in its great chaos the famous Benares Vase and Indic spiritual life. Everything is incalculable, capricious; every ten minutes something new; and it has its charm" (*Brev* 11:308).

Chevrillon (in Strindberg's excerpt) evoked in his picture of Indic culture the same "endless personifications of reproductive force" that Balzac's Louis Lambert had found in Indic scriptures, a lively amalgam of constant transformations and correspondences:

Brahmins worship these living forces in nature. . . . [The gods] Indra, Varuna, Agni, Surya, are nature spirits, not frozen or fixed in definite attributes, not comprehended as separate persons and unalterable, but floating, billowing, transforming themselves one into the other—The rosy dawn is also the sun; the sun is fire as well; fire is lightning, which is storm and rain. (*Brev* 11:151)

The transformist we saw in the Naturalistic Strindberg stirred to life in a new way. The fluid forms of the Indic gods—first one identity, then another, now anthropomorphic figure, now nature spirit—were in sharp contrast to the fixed forms of Greek mythological divinities and must have seemed especially attractive to a playwright with a long history of exploring multiple dimensions in the portrayal of character. The most conspicuous result of this attraction is in *A Dream Play*, in which the protagonist is the daughter of the god Indra and plays a variety of roles during the course of her journey on earth.[24] Her very name, Agnes, evokes several identities. When she descends to earth to share the sufferings of mortals in Christlike fashion, she is *agnus dei*, the Lamb of God. When she ascends again at the end of her journey through the agency of sacrificial fire, intending to carry the message of that suffering to the gods, she is a female version of Agni, who in Vedantic Buddhism is the divine messenger, the god of fire, and, along with Indra, one of the two most prominent deities in the sacred hymns of the *Rig-veda*, a marked copy of which was part of Strindberg's library.

Two of the critics who argue against regarding Oriental sources

as important in Strindberg's post-Inferno drama, Örjan Lindberger and Gunnar Ollén, point out that in Indic mythology the god Indra had no daughter.[25] Surely the metamorphic and androgynous powers of Indic gods, described clearly by Chevrillon and underscored by Strindberg, provided more than enough justification for assuming the liberty of giving Indra a daughter, had not poetic license already sanctioned it.

In what is probably the most important passage cited from the travel book—in terms of its potential impact on Strindberg's changing ideas about art—Chevrillon describes his reactions to decorations that were "chased," or hammered, onto the surface of a Benares copper vase:

What do these chasings represent? At first one knows nothing: one sees only a thicket of entwined lines, twisted together at random. Gradually, the skein untangles and shadowy figures emerge: gods, genies, fish, dogs, gazelles, flowers, herbs, not grouped around a motif, but tossed, pell-mell, and one glimpses in the formless mass, as in a lump of clay dragged from the bottom of the sea, a claw, a shell, a fin. . . .

Involuntarily, through a special talent in [the souls of the Indians], the things of the outer world seem infinitely enmeshed to them. (Brev 11:151–52)[26]

To understand how this description could rouse Strindberg's imagination, we must imagine that in a flash art and nature became one. Not only do the vase decorations imitate faithfully the interconnectedness in the flow of life and the enmeshed correspondences in the universe, but the total effect created can be viewed as a model for the way that art in general can be read and interpreted. Like life, art too can seem "only a thicket of entwined lines," which gradually, with the aid of the imagination, untangles, allowing "shadowy figures" to emerge. This was precisely one of the points Strindberg had made two years earlier in his 1894 essay on the role of chance in art. Now he found apparent support for it in Indic art. In a section of the 1894 essay dealing with examples of modern art that a Philistine public found inexplicable, the narrator says that at first one notices

nothing more than a chaos of colors. Then it begins to look like something, it resembles—no, it doesn't resemble anything. All at once there is a fixed point, like the nucleus in a cell; it grows; colors group themselves around it, accumulate; beams radiate outward, sprouting branches and twigs, as ice crystals do on windowpanes. . . . A pattern appears to the observer, who has himself assisted in the act of creation. More importantly, the painting is continually new; changing with the light, never tiring, ever reviving, endowed with the gift of life.[27]

The reading of the Chevrillon book was one more element alerting Strindberg to the cumulative significance of his occult experiences and the visual imagination experiments he had been conducting since 1892: the "wood-nymph" revelations, the creative patterns discovered in pillows, walnuts, and painters' palettes. In the same May 1896 letter to Hedlund from Austria cited earlier the austere country landscape he finds there becomes a canvas upon which he is free to project his visions, and he is pleased to learn that it similarly inspired earlier visitors to the area: "Beethoven had his revelations here . . . [and] even the lesser Mozart saw these landscapes, which are so unlike all others" (*Brev* 11:309).

What had been evolving in his mind before the Benares Vase episode was a new view of the dynamics of the creative process. He had long sensed, not without some apprehension, that the best in his art was made possible by a bold and unrestrained imagination, operating through improvisations, hallucinations, visions, and dreams. Chevrillon must have reinforced this sense by suggesting that such a freedom was an established part of artistic tradition in Asian culture—this is probably why Strindberg felt that his own works were Indic in origin. He was arriving at insights made earlier by the Romantics, such as Alphonse de Lamartine's proclamation in 1853 that "India is the key to everything."[28] And just as Strindberg talks of a painting being "continually new," Asian enthusiast Friedrich Schlegel defined Romantic poetry as "still in the process of becoming; this indeed is its very essence, that it is eternally evolving, never completed. . . . It alone is infinite, just as it alone is free."[29]

The Artist as "Second Jove"

Three months after the travel book induced Strindberg to pursue further his readings in Indic culture, he called Hedlund's attention to the ability of Buddhist priests to evoke incarnations of the Indic god Vishnu:

> The priest sticks his hand down into a wide sack and with quick movements of his fingers creates a fish, a turtle, a wild boar, a cart, a snare, a garland, etc.
>
> 108 figures.
>
> Where does his hand get this monstrous artistic creative power from? (Brev 11:226)

Strindberg answers his own question by declaring that anyone can produce similar effects: "Examine your pillow in semidarkness in the morning after you've slept, *without thinking about* what you're going to see! and without deliberately shaping the pillow. I've shown mine to artists, and I'm going to photograph them later!" (226).

Thanks to his growing awareness that the "monstrous artistic creative power" that everyone possessed was a very positive force indeed, Strindberg was able to begin repudiating his deeply rooted belief that the artist's mission was futile. Here was apparent philosophical validation for the inventive freedom he had long treasured (but also felt uneasy about) in his fantastic visions. We can follow the virtually feverish stages in his awareness of this validation in a series of letters to Torsten Hedlund during a hectic, psychologically turbulent month: July 1896.

> [6 July:] God, in the occultists' version of Creation, is an artist, working long, sketching and discarding abortive, half-finished drafts; that is why the species are so random, sometimes without transitions between them, sometimes with. And why not? (Brev 11:240)

> [18 July:] Imagine if everything were really "made" by hand by a Creator-Artist who with practice carried perfection ever farther even as he evolved himself. (272)

[20 July: After carefully observing the animals in Paris's Botanical Gardens (Jardin des Plantes),] I have found full confirmation for my opinion that they were created by hand by a great Artist who sketched, discarded, and began again, evolving himself and his skills as He worked. He reveals himself as so completely free that He disdains all laws, all adherence to rules, demonstrating that the Great Artist is "whimsical," which is the expression of the highest independence and freedom from restraint. (282)

The idea of God as the archetypal creative artist suited several needs for Strindberg, polemic and artistic. Polemically, it provided the transformist-creationist with a useful weapon against Darwinians, who searched for humanity's simian ancestors. He could argue that God needed no transitions like apes or other "missing links" to advance life through stages from simple-celled creatures to people: he just improvised new forms as the mood suited him. Artistically, he had found further support for a concept as popular with occultists in the 1890s as it had been with Romantics almost a century earlier: if God was the divine creative artist, then the human artist was his mortal counterpart. Éliphas Lévi in *Key of the Mysteries* explains the concept in terms that parallel Strindberg's: "God creates Himself eternally, and the infinite which He fills with His works is an incessant and infinite creation. . . . The great week of creation has been imitated by human genius, divining the forms of nature."[30] And in Coleridge's two-tiered structure for the imagination—primary and secondary— the second tier approached the divine in function. The first tier was simply the agent of perception, lacking in originality and fitting Plato's conception of the limitations of the imagination: strictly mimetic, capable of producing only copies of nature. The secondary imagination, on the other hand, was creatively original, permitting the poet to be (in a popular Romantic image) a Second Maker under Jove, creating a new world. As we shall see (chapter 8), the idea of creating a new world in drama became a basic goal for Strindberg after 1898.

For the sculptor Olle Montanus in Strindberg's 1879 novel *The Red Room*, the artist blasphemed when he attempted in his work to

play God. And such a pretentious goal was equally absurd to the Naturalistic Strindberg of the 1880s, who saw the act of creation as a scientific activity and the imagination as a mechanical tool "for rearranging the greater or lesser treasures of impressions and experiences stored in the memory" (SS 17:193–94). By 1896, however, the artist's imagination had become for him a productive partner with Nature, interacting in the act of creation, as a letter to Hedlund implies:

Hallucinations, fantasies, dreams seem to me to possess a high degree of reality. And if I see my pillow take on human forms, then these forms are there, and when someone tells me that they are only (!) taking shape in my imagination, I answer:

You say only?—What my inner eye sees means more to me! And what I see on my pillow—created by birds' feathers, which once bore life, and by flax, whose fibers contained life's energy—is soul, is the power to create life, and it is *real*, because I can draw these figures and show them to others. (Brev 11:268)

For Strindberg the Naturalistic artist, the primary thing was a faithful depiction of the facts of nature: the bird's feathers and the flax fibers. Whatever the artist's imagination did to "rearrange" the facts in his depiction was secondary. For Strindberg the occultist artist, the emphasis shifted to a profound, imaginative response to the pulse of life present in the facts; the facts themselves became only raw materials to be deployed by the artist's transformative powers. In the "Author's Note" to A Dream Play he says that "upon an insignificant background of real-life events the imagination spins and weaves new patterns: a blend of memories, experiences, pure inventions, absurdities, and improvisations" (SS 36:215). In ancient India, according to a passage marked in Strindberg's copy of a popular Swedish survey of world literature, the magical force of the Indic imagination "split itself . . . into a thousand forms" and floated "out into the infinite and the incomprehensible." [31] The same image is echoed in the "Author's Note," in which we learn that "the characters break up, double, redouble, evaporate, condense, fragment, cohere" (SS 36:215). In addition, Strindberg was

echoing Coleridge's assertion, made almost a century earlier, that the secondary imagination "'dissolves, diffuses, and dissipates' what has been perceived 'in order to recreate,' 'to idealize and to unify.'"[32]

Asian Images and Western Words

Strindberg's fascination with Indic philosophical and mythological concepts continued for some time, as extensive markings in some of his books demonstrate,[33] but over a period of several years the intensity of the fascination waned as he sensed himself more comfortable with Christian concepts. He felt no obligation to endorse all the assumptions of the Oriental Renaissance. For someone raised in a monotheistic culture, the multitude of Indic gods and the variety of forms each could assume were apparently artistically stimulating but spiritually questionable and unnerving. Strindberg described his skepticism in a 1907 Blue Book essay:

When Buddhism became fashionable in 1890, all the apostates plunged in and tried to fill their religious void. Six thousand new gods were acclaimed immediately; the new trinity, Brahma–Vishnu–Siva, met no objections; spirits, ghosts, genies, fairies were natural phenomena. . . . Those who had recently disputed the Resurrection now found reincarnation self-evident.

All this was acceptable! The trinity Brahma–Vishnu–Siva was acceptable, but the Father–Son–Holy Spirit was not acceptable! Krishna was all right, but Christ wasn't!

Ridiculous! (ss 46:179)

Schwab concludes in his study of the Oriental Renaissance that in the early nineteenth century one reason for the eventual dissatisfaction with Orientalism felt by the same Romantics who had once been so enthusiastic was the crucial difference between an emphasis in the postmedieval West on the *word* and in the East on the *image*. The Asian

read his plastic arts as if from an open book. . . . Christianity had . . . lost the faculty of reading bibles of stone, those signs having been sup-

planted by the monopoly of the book. If India abounded in people unable to read the written word, the West had a prodigious number who were illiterate when it came to images, incapable of spontaneously deciphering architecture and drawing edification from it.[34]

There are several reasons why oriental images continue to appear in Strindberg's works even after he expressed cultural/religious doubts about Eastern religion. For one thing, they provided the skeptical streak in his nature with a counterbalance to the optimistic emphasis of Christian imagery. In *Ghost Sonata*, for example, as we shall see in the last chapter, while Christian images of resurrection and redemption are evoked in the second scene, somber references to Buddha and the importance of resignation in the face of the mystery of existence dominate in the last one. As Strindberg had always done, he was enriching the texture of his work by playing assonances and dissonances off against each other in his mythic allusions.

In terms of his development as an artist, there was a more compelling reason why he turned to Eastern images to satisfy his expressive needs: they galvanized his imagination. Although his instincts and greatest strengths would continue to be as a writer over the next decade, the visual artist in him, reawakened during the Inferno years, was reordering the priorities of the workings of his imagination. This might seem contradicted by the fact that in his reactions to the Chevrillon book he never mentions any pictures or prints of the locations described. But words alone, apparently, were enough to stir up his imagination. In fact, it may have been the very absence of the actual images that was so provocative. The visual power of his imagination enabled him to conjure up their presence and force.

American director Robert Wilson has discussed similar imagination-expanding experiences. As a child, he says he loved silent films and radio drama for separate but related qualities that he found uniquely stimulating:

If we think of a silent movie, the edges of the visual screen are boundless in the sense that we are free to imagine the audio book. If we think

of a radio drama, the edges of the visual screen are boundless in the sense that we are free to imagine the visual book. . . . Perhaps it's easier to hear than to see. See the text and hear the text and hear the pictures and see the pictures.[35]

What Strindberg and Wilson both describe is an old Romantic favorite: a synesthesia, where one sensation stimulates another, such as a visual sensation arousing an aural one. A clear example appears in "Pangs of Conscience," the story where we began our discussion of Strindberg and the imagination. Located at the rear of the curious Swiss hospital chapel where the depressed Bleichroden regains some of his hope for the future,

was an apse lit by three stained-glass windows, but in soft, harmonious colors, as if a great color artist had composed them, and the light coming in was broken up into a grand, harmonic major chord. It created the same impression on the sick man as the C-major chord with which Haydn disperses the darkness of chaos in his *Creation*: after the chorus finishes its long, painful work disentangling the anarchic powers of nature, the Creator finally shouts: "Let there be light," and cherubim and seraphim concur. (SS 15:210)

Strindberg must have had a similar synesthetic experience when he read the Chevrillon book. To use Wilson's image, he was "seeing the text" and expanding his own creative potential. The perspective opened on Eastern culture pushed him to envision new and different ways of experiencing and eventually communicating the shifting forms of reality. He could have commented as Matisse did late in life when reminiscing about the beginning of his career: like Delacroix before him, Matisse had been struck by what he saw on visits as a young man to Morocco, confessing that "revelation thus came to me from the Orient."[36]

Medievalism in Fin de Siècle Paris

Throughout his life, Strindberg was both drawn to and repelled by medieval culture. It was an ambivalent response shared with a number of Romantic predecessors: Goethe, Schiller, Sir Walter

Scott, and Victor Hugo. Each of them showed a preference for setting the action of plays and novels during the exciting transitional period between the Middle Ages and the Renaissance. But even as they depicted positively the vitality of new ideas battling the stultifying weight of the past, they continued to show sympathy for the values of the older world.

When Strindberg arrived in Paris in 1894 and found a medieval revival in full swing, he had strong reasons for identifying with that revival. The first was personal—he was searching for a spiritual center to give his life meaning after a long period of emptiness and frustration. The second had to do with making a fresh start. The many new ideas churning in the artistic circles he encountered in Berlin and Paris in the early 1890s must have suggested to him the possibility of reviving his dormant career. Among many fin de siècle avant-garde writers and painters there was a growing conviction that after decades of laboring under the oppressive domination of positivist materialism, it was time to seek a new direction in the arts. Kandinsky reflected the conviction in his 1911 proclamation that a new age was dawning— "the Era of the Great Spiritual in Art"—and medieval images and themes were among the sources he turned to for inspiration. What Strindberg found in medieval drama and theatre—powerful themes and a stage on which they could be realized—not only returned him to full effectiveness as a playwright but cast a long shadow over the subsequent development of modern drama.

Over the years since Strindberg's death, a number of critics have called attention to the obvious presence of the same image in To Damascus and the medieval morality play Everyman: life as a journey of tests, temptations, and a search for redemption. Other scholars—Birgitta Steene, Margareta Wirmark, Barry Jacobs[37]— have found medieval elements in individual plays. But the larger implications of such elements have not been pursued much beyond tentative generalizations. The same is true of the religious allusions in his post-Inferno plays that were rooted in medieval traditions. They are discussed in very restricted contexts, either as symptoms of the spiritual and psychological turmoil in Strind-

berg's life at the time or simply as indications of a longing to reaffirm the faith of his youth. Hans-Göran Ekman, for example, in his notes and commentary for *Advent* and *Crime and Crime*, observes that the two plays "illustrate clearly Strindberg's striving toward a [dramatic form] that mirrors his religious experiences" (*SV* 40:255). Ekman cites as evidence for his conclusion a conversation between Strindberg and Gustaf Uddgren, who said the playwright declared that *Advent* would be the "beginning of a religious drama, just as the [medieval] mysteries ushered in the great era of English drama. Strindberg hoped that the time was not far off when a religious theatre would be realized."[38]

Though Strindberg's search for new forms at this time was certainly driven by personal hopes and ambitions, we must be wary of focusing too narrowly on the man struggling with his private demons. We risk losing sight of the artist struggling to regain his creative powers. At the turn of the century, his vision of a modern drama arising out of medieval tradition was neither unique nor eccentric; it was shared by a number of contemporaries.

Perhaps it is to be expected, though, that such plans have not been taken very seriously as artistic initiatives by most Strindberg scholars. After all, medieval plays themselves were not regarded as mature, significant forms of drama, even by scholars and critics of medieval drama, for much of the last century and a half. They were too rudimentary, too close to religious liturgy. In Gustaf Ljunggren's 1864 survey of the history of Swedish drama (which Strindberg owned in 1882), the author declared that "the value of the [medieval mystery play] as a work of art is not particularly great. It lacks the first requirement of dramatic art: unity and organic division."[39]

Similar attitudes persisted throughout Europe and the United States and continued to dominate research about medieval drama into the mid-1960s. Only then, thanks to pioneering scholars like O. B. Hardison, did attitudes begin to change. Hardison not only addressed the artistic consequences of drama in the Middle Ages but disputed the earlier prevailing view that it "originated in spite of Christianity, not because of it. In addition to distorting the

understanding of medieval drama . . . , this view encourages emphasis on . . . a reading of Shakespeare which ignores or actively denies the religious elements in his plays."[40]

Similarly, many Strindberg scholars, unless specifically interested in his spiritual life, have ignored the religious elements in his plays, perhaps regarding them as unimportant in his development as an artist. Hardison long ago suggested that there is an important continuity of ritual form in European drama, patterned upon religious ceremonies in the Middle Ages and extending into our day, and that it was time to explore further its implications. Strindberg made vital contributions to that continuity, and to appreciate them, we need to understand his familiarity with and use of medieval dramatic conventions.

In 1918, Pär Lagerkvist, another Swedish artist interested in medieval forms, was among the first to recognize Strindberg's connections with the drama of the Middle Ages. Although uncertain whether his predecessor consciously used those forms as models, Lagerkvist cited the medieval echoes he found in the plays. They were "in the freedom with which dramatic themes are handled, in the apparent casualness, the apparently chance juxtaposition of scenes that one senses while reading but is not noticeable in the theatre, and in the immediacy and richness of plot invention."[41] Twenty years later, Walter Benjamin, writing about Brecht and the epic theatre, described the continuity of medieval form in modern drama as an "important but poorly marked road, which . . . went via Roswitha and the mystery plays in the Middle Ages, via Gryphius and Calderón in the Baroque age; . . . and finally . . . Strindberg."[42]

The poorly marked road that Strindberg followed is perhaps seen more clearly when he is contrasted with Ibsen. While both playwrights share the distinction of being the artists who did most to shape the subsequent direction of modern drama, each affected it very differently. Ibsen was also influenced by medieval tradition through the example of Goethe's *Faust* (especially evident in *Brand* and *Peer Gynt*), but he was primarily a renewer of Greek tradition, of Sophoclean drama. Strindberg, in contrast, was a major

renewer of the ritual drama of the Middle Ages. In Sophoclean drama the focus of attention is a double journey, moving simultaneously forward and backward in time. As the future unrolls, the past is revealed, and the climax is the intersection of the two lines. Ibsen's heroes, like Sophocles' Oedipus, move inexorably toward virtually predetermined rendezvous with dark truths buried in the past, despite often desperate struggles to ignore them. Peer Gynt, Nora, Mrs. Alving, Hedda Gabler, and Rebecca West must all face such truths at a final crossroad.

Of course, Strindberg too dealt with the demands of Sophoclean form, such as making the climax of a play's action heavily dependent on revelations about the past. In *The Father*, for example, the most telling blow for the Captain is learning that his worst fear—that he may not be Bertha's father—has been confirmed. But *The Father* is subject as well to the rhythms of ritual drama, in which a revelation about the past takes place differently than in most Ibsen plays. Instead of the future intersecting with the past at a final crossroad, they commingle, as the dividing line between them becomes unstable. What is called to mind in the Captain's final delirium, as he relives the serene moments of the early days of his marriage, is the final scene in what might be called a pre-Sophoclean Ibsen play—*Peer Gynt*—in which Peer returns to the dream of love of his youth, Solveig. In both instances there is the suggestion of a pietà—a solemn mother-son reunion that transports the scene to a timeless realm.

While Ibsen favored the use of a lengthy review of events from the past, underscoring the strict causal aspects of time and space relationships, Strindberg moved in a different direction by interpenetrating realism and myth in ways that suggest an existential condition of ambiguous simultaneity. The Captain in *The Father* and the unlucky couple in *Miss Julie* and the Stranger in *To Damascus* and Indra's Daughter in *A Dream Play* are all like sacrificial victims. Instead of suffering because of dark truths that they refused to acknowledge, they are fated to repeat, willy-nilly, ancient patterns of action that have their roots in the larger mysteries of human destiny.

Mysteries, Moralities, and the Typological Dimension

Strindberg's ritual challenge to the Sophoclean-influenced logic of the well-made play was anchored in the renewal begun by the Romantics of a two-pronged medieval tradition. First, his histories are heirs to the chronicle or mystery plays, where reminders of the past, particularly the biblical past, are not presences suggesting secrets to be revealed but typological truths that turn individual episodes into parts of a greater metaphysical pattern, thus joining beginnings to ends and the fates of individual rulers or nations to the will of historical forces. Second, his "pilgrimage dramas," as he called them—To Damascus and A Dream Play—add a secular dimension as they build on the medieval morality play and anticipate an expressionistic drama of interior psychological landscapes.

In the Middle Ages the different dramatic forms served complementary didactic purposes. While mysteries were parts of cycles of dramatized biblical episodes from Genesis to Revelation, moralities typically restricted the action. "Where the cycles take their form," says Robert Potter, "in fulfilling the totality of human history and defining its crucial rhythms, the morality play takes its shape from a different figure and pattern—the life of the individual human being."[43]

Strindberg's post-Inferno plays—and many of his earlier works as well—follow the same kind of order. His histories attempt an examination of the crucial rhythms of human history, while his plays in contemporary settings highlight microcosmic versions of the larger purposes by focusing on the lives of individuals. Implied in the balance and totality of his historical vision—with its coupling of the specificity of the historical and the universality of the metaphysical—is the kind of thinking that was characteristic of the functioning of typological patterns in medieval drama. When diverse scenes in the course of history were viewed typologically, said Erich Auerbach, they became parts of "the same context: of one great drama whose beginning is God's creation of the world, whose climax is Christ's Incarnation and Passion, and

whose expected conclusion will be Christ's second coming and the Last Judgment."[44]

In a Gothic cathedral, which Strindberg described in *A Blue Book* as "the loveliest artwork that exists" (SS 46:322), different parts of the building reiterated the lesson of the typological balance and totality in the great drama. Parallel biblical events were represented in stone, wood, and stained glass, with a scene from the Old Testament, called a type (e.g., the sacrifice of Isaac or the murder of Abel), flanking a scene from the New Testament (e.g., the Crucifixion), called the antitype. While the types foreshadowed the antitype, the antitype fulfilled and affirmed the promise of the foreshadowing.

To further assist clergymen in making clear the important lesson of typology to the illiterate in the congregation, large picture books were made available, illustrating the same mystical connections between the Testaments. The most important of these books to come down to us was called the *Biblia pauperum*. It is interesting that in the opening of the preface to *Miss Julie* Strindberg says that the theatre, indeed, all of art, seemed to him to be "a *Biblia pauperum*, a Bible in pictures for those who can't read what is written or printed; and the playwright, a lay preacher hawking the ideas of the day in popular form" (SS 23:99). Present in the play proper, in harmony with the typological spirit of the *Biblia pauperum*, are Old Testament allusions to the Garden of Eden and to Joseph and Potiphar's wife, along with New Testament allusions to the beheading of John the Baptist and the parables of Christ.[45]

But religious didacticism was not the only function served by mysteries and moralities in the Middle Ages. During the religious festivals when they were staged, they served as extraordinarily popular forms of entertainment for common people, gathered before open-air performances in streets and marketplaces, much like the crowd gathered to witness the mystery *Coram Populo* at the end of Strindberg's verse version of *Master Olof*. It was a popularity that lasted from the end of the tenth to the middle of the sixteenth century. Indeed, in England medieval drama gave way to forms of secular drama only a generation or two before Shake-

speare was born. He grew up on and was educated by the echoes
of mysteries and moralities that still resounded in the develop-
ing secular drama, as evidence in many of his plays demonstrates.
Just as the age of mysteries and moralities had, in Strindberg's
words, "ushered in the great era of English drama," so did he
and many others hope the same would happen again in the late
1890s. No Shakespeare appeared, of course, after the turn-of-the-
century revival of mysteries and moralities, but the continuity of
ritual form that Hardison described was preserved and still ener-
gizes Western drama.

The medieval theatre appealed to its audience with a disparate
but somehow harmonious mixture of contradictory elements: the
popular and the sacred, the comic and the serious, the ridiculous
and the sublime. For Romantics from Goethe to Strindberg that
mixture seemed to possess a special kind of organicism, a guaran-
tee that everything in life—and art—had a natural, justified place.
This is understandable in a century that experienced a constant
fragmenting of social values and overturning of traditional be-
liefs. Life in the Middle Ages seemed a desirable paradigm of an
integrated whole, when man and society, man and Nature, and
man and God were in more perfect harmony.

William Morris—an English Romantic artist admired in Swe-
den in Strindberg's day for his championing of a return to native
craft traditions[46]—went even further in his enthusiasm for medi-
evalism. He insisted, says Northrop Frye, that the conventional
view of medieval culture was distorted: "the genuine creators . . .
[of that culture] were the builders and painters and romancers,
not the warriors or the priests."[47] When Strindberg wrote in
Jacob Wrestles that the Middle Ages was a time of appreciation for
"beauty in color, line, and harmony" (ss 28:347), he was speak-
ing not only as someone who identified with that legacy but as a
dramatist whose very instincts were medieval-Romantic.

The revival of interest in medieval drama and theatre that
Strindberg found in Paris in the mid-1890s was not limited to
France. Elinor Fuchs has pointed out the appearance in a number

of European countries of what she calls the "Mysterium": "a hardy lineal descendent, often a creative fusion, of the religious dramatic forms of the Middle Ages, the Biblical mystery play and the morality with its allegorical method."[48] In addition, she says, "new plays were written that were referred to as mysteries, ranging in form from [Charles] van Lerberghe's mysterious, atmospheric Les flaireurs to Claudel's comparatively realistic La jeune fille Violaine."[49] And these were only part of the medievalist phenomenon.

Return to a Medieval Stage

Some of the theatre directors who were drawn to mysteries and moralities took initiatives that had far-reaching consequences. In the late 1890s in England William Poel's Elizabethan Stage Society pursued the revolutionary aim of abandoning the then prevailing realistic, illusionistic approach to the staging of Shakespeare's plays. For productions of medieval as well as Elizabethan plays Poel returned to the same idea of staging that Shakespeare and his contemporaries had inherited from the theatre of the Middle Ages: simple platforms, generally unrealistic settings with realistic costumes and properties, and often surrounded on three sides by the audience. Though Poel's productions were modest and outside the mainstream of the commercial theatre, they had an enormous impact. His 1901 production in London of the morality play Everyman, says Martin Stevens,

strongly influenced the drama of William Butler Yeats, George Bernard Shaw,[50] T. S. Eliot, . . . Hugo von Hofmannsthal and [possibly] . . . Max Reinhardt, who may have used it to help inspire Hofmannsthal's version of Jedermann at Salzburg. . . . The medieval stage thus becomes a formative influence in the development of the modern theater, one that extends even to the design of Bertolt Brecht's epic theater and his theory of Verfremdung.[51]

It should be noted that following the production of Jedermann, Max Reinhardt became one of the first directors of stature outside

Sweden to attract attention with a staging of a Strindberg play—
A Dream Play—whose journey plot structure owes much to medieval drama.

Between 1902 and 1907 in Russia, in a development parallel to that initiated by Poel, Meyerhold fired off a series of broadsides against the tired realism in the theatre of his day and called instead for a return to the basic principles of past eras of greatness. He charged that "the stage has become estranged from its communal-religious origins; it has alienated the spectator by its objectivity. . . . The two forms of public performance, the [communal-religious] mystery and the theatrical entertainment, have become totally divorced from each other."[52] Meyerhold subsequently experimented with medieval, commedia dell'arte, and Asian staging practices, attempting to restore a ritual power to the theatre by returning it to its origins. In the late 1960s the boldly innovative productions of Jerzy Grotowski and the Polish Laboratory Theatre continued, in the spirit of Meyerhold, to attempt to re-create a communal-spiritual atmosphere, eventually influencing a variety of groups throughout Europe and the United States—from Joseph Chaikin's Open Theater in America to Eugenio Barba's Odin Theatre in Denmark.

Though Strindberg's experimental efforts in the same direction were not as radical as those of Poel and Meyerhold, he was familiar with the new movement and refers to it in his *Open Letters to the Intimate Theatre* (1908). Without mentioning Poel by name, he speaks of the idea of an open-air theatre, which "transplanted in Germany . . . and England began the simplification of scenery that is now upon us" (ss 50:284).

Long before Meyerhold and Poel, Strindberg had demonstrated an awareness of both the evocative poetic power of medieval themes and the expressive, flexible nature of medieval staging. As early as 1872 he added as a prologue to the opening of *Master Olof* an excerpt from the oldest, most complete Swedish medieval chronicle play extant, *Tobiae comedia*.[53] The people of Israel in this little biblical play complain about suffering oppression during the Babylonian captivity, just as in the play proper Strindberg

has ordinary Swedes of the 1520s complain about suffering under the oppressive double yoke of an insensitive monarch and a corrupt Catholic Church. The Sweden of Gustav Vasa and Master Olof is thus given a typological dimension that pairs the nation with ancient Israel in a traditionally medieval panorama of world history; Vasa becomes the equivalent of a biblical king and Olof of a biblical prophet who warns against the evils of injustice.

The epilogue to the verse version added in 1877–78 of *Master Olof, Coram Populo* (see chapters 3 and 4), is an elaboration upon still another sixteenth-century mystery, and it serves, together with the prologue, as a historical frame. If the prologue was a way of going from biblical world history to Swedish history, the epilogue returned the play to the larger context, thus broadening the perspective and generalizing the themes. *Coram Populo* appears again in 1897, this time as prologue to the work with which Strindberg returned to belles lettres: *Inferno.* The grim theme of the little creation play—demonstrating that mortals serve as playthings for the gods—becomes a kind of typological foreshadowing of similar sentiments in the novel itself.

Strindberg's familiarity with staging practices in the medieval theatre[54] is evident in a chapter on religion in his ethnohistorical two-volume *The Swedish People,* published in the early 1880s. Described are what the author believed were the two main types of theatrical presentation: "Sometimes, the stage was built with three levels, the top one representing heaven, the middle one the earth, and the bottom one hell. More often it was set up like a circus arena" (ss 7:256). Accompanying the description is an illustration of an arena arrangement: a floor plan of a cathedral, with small settings (the *mansions* of the medieval theatre) positioned along each side of the total length of the nave from the cathedral entrance to the altar, and representing twenty-two separate locations in the panorama of Christ's Passion, from the herb garden in Gethsemane, the Mount of Olives, and Pilate's house, to heaven and hell.

Though most modern scholars identify the stationary arrangement of the kind illustrated—with many locations represented

simultaneously—as one of the two dominant medieval staging forms, the other was not the three-tiered structure Strindberg described. Instead, in England, *mansions* were mounted on wagons and drawn through the streets of the cities or towns to make performance stops at designated places. But then where did Strindberg get his strong impression of a three-tiered stage, which is also described in the stage directions for *Coram Populo?* More importantly, what significance did that impression have on Strindberg's dramaturgy?

His most immediate source of information on the medieval theatre in general and the three-tiered stage in particular was probably the one mentioned earlier: Ljunggren's 1864 survey *Swedish Drama until the End of the Eighteenth Century* (*Svenska dramat intill slutet af sjuttonde århundradet*). Ljunggren described the unlikely possibility (given what we know today of the period) of a medieval stage reaching as high as nine levels. The exact choice of number, according to Ljunggren, depended on where the stage was temporarily erected. If it "was set up at the end of a street— which was regarded as especially convenient, since the windows of nearby houses could function as loges—then it was necessary to use height and to construct several levels above one another. . . . [Though many levels might be used,] the most common number was three. . . ." [55]

But Strindberg was probably equally influenced by another source as well. The clue to its identity lies in *Open Letters* statements made thirty years after he wrote *The Swedish People:*

Some time ago (1840?), I think it was Devrient who found a way to present the entire of [Goethe's] *Faust.* His point of departure was the idea that the audience wanted to see everything: Faust's study when he was a student, Margareta's room, the Well, Blocksberg, and so forth. To do this without cutting the text, he hit upon simultaneous settings, with every scene set up once and then not changed. And so he constructed a tabernacle on stage, like a triptych . . . , which, with its three levels, imitated a medieval stage for mystery plays: Heaven, Earth, and the Underworld. . . . The advantages gained were a medieval atmosphere, a stillness on stage [because of the absence of the sounds of

scenery being moved], and, above all, both the rescue of the text and the retaining of the pleasures of spectacle. (ss 50:283–84)

Strindberg's obvious approval of the simplicity of a staging that rescued the text reveals a common concern in a period when the slow, cumbersome machinery necessary to change elaborate, illusionistic settings often motivated theatre managers to cut texts drastically in order to shorten performance time. Strindberg points out that contemporary revivals of medieval drama like Oberammergau's Easter Passion staging ("about which there are no complaints!") demonstrated the practical theatrical advantages in adopting alternatives like Devrient's: "In other words, it works" (284).

It is interesting that Strindberg remembered a great deal about the setting but was unsure of the year the play was staged. The director, Otto Devrient, an actor, director, and member of a distinguished German theatre family, did indeed direct *Faust* as a medieval mystery on a stage with three levels, but not in the 1840s, as Strindberg guessed. The production took place at the Weimar Court Theatre in 1876, just a year before Strindberg added *Coram Populo*, with its Heaven-Earth-Hell stage, to *Master Olof*. The important thing here is not that Strindberg may have borrowed the idea after reading or hearing about Devrient's production, which is of course possible. It is that he still remembered so vividly in 1908 the idea of flexibility that the stage implied. In fact, however, the theory of a three-level stage, in which he continued to place so much faith, had by then been rejected as unsound by scholars. He should have known this because the rejection was emphasized in a historical survey that Björn Meidal concludes Strindberg used extensively during his post-Inferno years: Herman Ring's 1898 *Teaterns historia*.[56] But Ring emphasized as well another aspect of medieval staging of which Strindberg undoubtedly approved: the practicality of a simplified approach to scenery. Contrary, says Ring, to the modern realistic theatre with its demands for illusionism, the earlier theatre satisfied expectations in more-modest ways. Medieval audiences "only needed meager support for their

imaginations, which, mobile and lively, filled in what was missing and assisted the director in a more powerful way than modern mechanical and artistic tools can do. It was the best stage imaginable for a drama with the form and disposition of the mystery play." [57]

The importance Ring attached to the imagination fit in nicely with Strindberg's own feelings at the time. From 1892 on, and especially after the mid-1890s when Strindberg was absorbed in occult and theosophical ideas, his increasingly positive view of the imagination and its role in the creative process included the audience's as well as the artist's imaginations. How this changed attitude might have affected his ideas about staging is reflected in another statement from *Open Letters*:

Twenty years ago (see the Preface to *Miss Julie*), Naturalism was the fashion, striving in accordance with the materialism of the day toward a faithfulness to reality. . . . By the turn of the century, however, the taste of audiences had changed, their imaginations were roused to action, the intangible became more interesting than the tangible, [and] the spoken word became the important thing on stage. (ss 50:284)

This is a cogent summary not only of his new approach to staging but of the fundamental transformation in his ideas of art that occurred during his Inferno years. With audiences' imaginations roused to action and the intangible becoming more important than the tangible, Strindberg felt confident about shifting from a virtually exclusive emphasis on creating believable illusions of a concrete reality to a form of theatre that focused more on what it suggested than what it represented, a form that expected the audience to play a more active role in the creative process of performance than it had in the past. But something else was needed to go with the suggestiveness of simplified and flexible staging: appropriate dramatic forms.

The Search for New Dramatic Forms:
The Renewal of Allegory

The goal of finding new forms was an old artistic problem for Strindberg. In the 1870s and 1880s it had been one of the clarion calls for young Swedish artists. Some of the new forms recommended in the preface to *Miss Julie* involved a greater use of concrete objects from real life in the theatre. "Even if the walls must be of canvas," he wrote, "it is surely time to stop painting shelves and kitchen utensils on them" (SS 23:112). But more complex problems arose when it came to finding new dramatic forms:

People have believed it possible to create a new drama by filling old forms with new contents; but . . . new forms have not been found for the new contents, so that the new wine has burst the old bottles.

In the following play, instead of trying to do anything new—which is impossible—I have simply modernized the form in accordance with demands I think contemporary audiences make upon this art. (SS 23: 99–100)

Evident in the argument is Strindberg's skeptical and pragmatic nature as an artist, probing for ways to reach spectators effectively, even as he stretched their imaginations. But behind his observation that the search for new forms had yet to produce satisfactory results is the suspicion that a search for new forms as an end in itself may be fruitless. By the turn of the century, the suspicion had turned into a conviction, which we can read in the remarks on art in a posthumous note that is reminiscent of Olle Montanus's posthumous note in *The Red Room* discussed earlier (see chapter 2). This one is left by Smartman, the writer Zachris's secretary, in the 1907 novel *Black Banners*, and like the *Open Letters* statement, it can serve to summarize the phases in Strindberg's evolution as an artist over the preceding thirty years:

It was the purpose of the time to raze old forms; I concurred, and felt I was justified. . . . When the [resulting] void and despair reached its

height, I wanted to fill the void, but found no contents. The new hadn't finished fermenting and couldn't be tapped; and you know the new is not at home in old bottles. . . . The subject you deal with will provide its own form. . . . (ss 41:289–90)[58]

From a search for new forms he had progressed to the belief that such a search must be pursued organically: "the subject . . . will provide its own form."

Strindberg's gravitation toward medieval dramatic forms for his return to belles lettres did indeed have an organic appropriateness about it. The painful decade of trials and tribulations that culminated in the Inferno Crisis took shape in his imagination as an extended journey. By 1898 he was ready to dramatize portions of that journey in his plays, and what could be more natural as a choice of form than the journey structure of mysteries and moralities? Readings at the time in Dante's *Inferno* obviously encouraged his decision, but the journey image came easily to him; he had always identified with biblical and mythical wanderers. From his earliest poem, "The Visit," in 1868, long before his exile wanderings began, to *The Son of a Servant Woman* almost twenty years later, to the last play in 1909, *The Great Highway,* he saw himself as an Ishmael, the son of the servant woman Hagar and the patriarch Abraham and described in Genesis as a "wild ass of a man," whose hand was "against every man and every man's hand against him" (16:12), and who was driven into exile. Other wanderers he identified with included Cain and Ahasuerus (the Wandering Jew), and the fates of both are evoked in *To Damascus.*[59] In *Open Letters* in 1908 he refers to *Damascus,* based so closely on some of his own Inferno years' experiences, as an "allegorizing pilgrim's journey" (*allegoriserande pilgrimsvandringen;* ss 50:287).

Defining what Strindberg might have meant by "allegory" or "allegorizing" not only helps give a clear picture of his indebtedness to medieval drama but is also crucial to a fundamental understanding of his art, especially after the Inferno period. When he was younger, he tended to use the word in its specifically analogical sense, as indicating the simultaneous presence in an artwork

of two patterns of events or ideas, with the background pattern suggested in and through the foreground pattern. In an 1872 book review, for example, he describes how poet Wilhelmina Stålberg followed contemporary taste when, "using a fashionable allegory with a classical apparatus, she provided a horoscope of her future."[60]

Implicit here is a characteristic of all allegories in the arts. "As they go along," says Angus Fletcher in his important study of the mode, "they are usually saying one thing in order to mean something beyond that one thing." While the allegory can be read on one level—the literal—somehow the literal surface "suggests a peculiar doubleness of intention, and while it can, as it were, get along without interpretation, it becomes much richer and more interesting if given interpretation."[61] The evocative idea of a "doubleness of intention," like a shadow behind the literal surface, explains the importance to Strindberg of a discovery he made about allegory when reading Swedenborg in the late 1890s. In a passage in the 1910 Tal till Svenska nationen he recommends that readers interpret Swedenborg's philosophy not literally but freely, as freely as Swedenborg himself interpreted the Bible: "allegorically, symbolically, or translating it in one's own way" (ss 43:269).

Strindberg's use of "allegorizing" to describe the purpose of To Damascus rather than the tamer "allegorical" suggests a continuous dynamic activity and indicates how vital it was for him to mix in his works, either consciously or unconsciously, patterns of allusions that included the mythological, the biblical, the historical, and the autobiographical. To discern only one of these patterns and overlook others, as some scholars do, may mean missing an entire dimension.

His allegorical approach is almost always complex. He rejected the kind of one-dimensional allegory that involved simple personification of abstractions like madness or injustice, calling it "old-fashioned" and "bad" (ss 53:94). And so, although the allegorical elements in To Damascus include allusions to folkloric forms like changelings and horses frightened by the nightmare spirit (ss 29:11, 106), the two dominant image patterns in the play are

biblical and autobiographical. The Stranger wanders by landscape features strikingly similar to those Strindberg himself observed when visiting his wife's relatives in Austria, but they also compose a landscape of biblical allusions. The Stranger is the Wandering Jew or Ishmael in the desert as well as Strindberg in Austria.

Given Strindberg's reliance on medieval forms, it is not surprising that he preferred to use allegory within typological contexts. Frequently resounding, for example, behind the particular historical event that he depicted was its biblical counterpart or counterparts, so that in Erik XIV, for example, the king's spiteful decision to send into battle the fiancé of the woman he desires (ss 31:324) is likened to King David's action against the husband of Bathsheba. A sentence underlined in a passage in one of the numerous Bibles Strindberg owned points to a New Testament justification for such analogies, for recognizing the power and importance of typological continuities. Christ, appearing to his disciples in a vision after the Resurrection, advises them that they can find the meaning of his destiny foretold in the Old Testament: "'This is what I meant when I said, while I was still with you, that everything written about me in the Law of Moses, in the Prophets, and in the Psalms has to be fulfilled.' He then opened their minds to understand the Scriptures" (Strindberg's emphasis).[62]

Strindberg's instincts for the dramatic potential of the ritual structure of the morality play were just as traditional as his reliance on allegory and typology. That structure has been described by Robert Potter, in his English Morality Play, as a sequence of innocence, Fall, repentance, and redemption.[63] The prototypal fall from innocence is of course Adam and Eve's loss of Paradise, one of Strindberg's favorite mythic images, as is demonstrated in plays as diverse as Miss Julie and To Damascus. Jean says that when he was a boy he regarded the garden of Julie's family estate as Eden (see chapter 4); and Julie's fate in the play repeats the full sequence of the morality play pattern. Her dream about her greatest fear— falling, with all its sexual, class, and metaphysical implications— is followed inexorably by her actual fall, remorse, and desire for redemption. For Strindberg, as for earlier Romantics and even

Naturalists (see chapter 4), the state of fallenness was the most comprehensive metaphor imaginable for the human state.

To Damascus, written twenty years after *Miss Julie*, turns quickly to the theme of the Fall. The Stranger, deciding to go off with the Lady, will start a new world with her: "I've only a vague idea of what your real name is. I'll give you one myself. Let me think—what should it be? Of course, your name will be Eve" (ss 29:13). The subsequent allegorical action of this play, too, follows the morality play sequence, from innocence to search for redemption. *To Damascus*, in fact, is really a hybrid and exemplifies the flexible use to which Strindberg was able to put the two forms of medieval drama. Elinor Fuchs describes the play as containing "a mystery within a morality. . . . Within [its] . . . progress or journey form . . . lies the imprint of another medieval dramatic structure, the Passion play."[64]

The new life and vitality that Strindberg was to give to these forms in his own work is at the core of his contributions to the modern theatre. The power of the example he set was clear almost immediately following his death. In the years just before World War I, the appeal of his plays—particularly those in which the medieval ritual journey structure was either explicit or implicit: *To Damascus, A Dream Play*, and *The Ghost Sonata*—made him "the most frequently performed playwright on the German and Austrian stage"[65] and the most influential precursor of Expressionism in the theatre.

Whatever Strindberg's primary motivation for adopting mysteries and moralities as examples—whether it was the general fashion at the time for the "mysterium" or the memories of his own extensive reliance in the past on biblical mythic patterns—he found in them eloquent vehicles for giving shape to his Inferno years' insights. The powerful medieval image of the road toward redemption fit completely his own predicament. The subject found its own form.

By 1897, Strindberg's Inferno period experiences—his painting, his visual experiments in "seeing" beneath and beyond the surface

of things, his contacts with and research into the occult, Theosophy, Orientalism, and medievalism—had provided him with all the expressive insights and tools he would need to begin his revolutionary return to playwriting. Though he had always been aware of the importance of his instincts as a painter to his instincts as a writer, he now understood more profoundly the sensitive, continuing interaction between the visual and the verbal imagination in an artist's work. Most importantly, perhaps, he was confident that the artist's first responsibility was not to some simplistic Naturalistic imitation of nature but to an imaginative re-creation of nature's inner processes. This meant following carefully and revealing faithfully the turbulent, metamorphic flow in life and art between the natural and the supernatural, the sensual and the spiritual, the profane and the sacred, the historical and the metaphysical. What remains to be discussed is the subject of the final chapter: how he devised the strategies necessary to put all the insights together, and how these strategies are evident in some of his most important post-Inferno plays.

8 / The New Seer:
Putting It All Together

In devising a story, therefore, the first thing
that comes to my mind is an image.
—Italo Calvino, 1985

The world that one sees is an invention of the visual brain.
—The Scientific American, 1992

The Artist as Autotherapist

N O LESSON STRINDBERG ABSORBED DURING HIS INFERNO
years was more important to his post-Inferno writings than
the trust he developed in the catalyzing energies of visual images.
Indeed, they became virtual collaborators in his work. But the re-
sults of this collaboration are not always easy to evaluate. How,
for instance, do we separate his visual experiments and fantasies
with potential artistic implications from those that were possible
symptoms of mental illness? For eighty years, Strindberg scholars
have debated whether that line is best drawn by psychoanalysts
examining the state of the man's mind or literary critics evaluat-
ing the quality of the artist's work.

Answering questions about art and illness is complicated by the
fact that Strindberg's renewal as a productive, creative artist after
1898 was preceded by a period marked by a simultaneous artis-
tic ascent and personal descent. Even as he acquired new levels of
insight and perspective in the richly energizing worlds of art and
the occult in fin de siècle Paris, he sank into a serious psychotic
crisis whose climax—a breakdown in the fall of 1896 [1]—would
have destroyed or crippled many other artists.

Not surprisingly, perhaps, the paradox of this rise-fall has often
prompted sharply diametrical interpretations of many of the writ-

ings of the post-Inferno period. While for some critics, the writings were the noteworthy achievements of a deranged genius, for others, they were the strikingly original works of an artist who was probably only feigning madness. For the first group, visual experiments like Strindberg's woodnymphistic exercises, in which he searched for meaningful images in pillows or walnuts, might signify, "Now he's going off the deep end"; for the second group, "Now he's experimenting purposefully with artistic abstraction." A number of psychologists and psychoanalysts have come down on the first side. Karl Jaspers's 1921 study of Strindberg and van Gogh begins with the bald assumption: "Strindberg was mad" ("Strindberg war geisteskrank").[2] In contrast, more recent literary studies by Olof Lagercrantz and Evert Sprinchorn have tended to regard much of Strindberg's alleged madness as an experimental pose or even a ruse—a kind of theatrical gesture by a highly conscious, deliberate artist.[3]

More preferable may be the kind of prudent middle course suggested by psychiatrist Johan Cullberg, especially regarding the events and works of the Inferno years. Though he believes that Strindberg did indeed suffer a serious breakdown, it occurred only when his "occult approach" gradually turned "into a more uncritical, anguish-filled experiencing of the world around him as magically threatening and altered. At this point it becomes plausible to speak in terms of illness."[4] Cullberg further suggests that it is difficult, maybe impossible, to divide the elements of Strindberg's life and work in the period into such absolute categories as signs of madness or signs of artistic experiment, even those during the severe crisis period from mid-1894 until mid-1897. Instead, they should be seen as points along a graduated spectrum the climax of which was Strindberg's personal and psychic recovery. The wisest interpretative course may be to give the artist the benefit of the doubt. "The more profoundly we come to know and understand the person in question," says Cullberg, "the farther ahead we must shift the demarcation line between what we would call expressionistic fiction and psychic illness."[5] What emerges in his portrait of Strindberg is an example of the artist as autotherapist,

whose writing provided him with "the important resting point where he could let his ambivalent self-images take form and encounter each other."[6] When, in the early 1890s, "this safety valve ceased to operate and the pressure slowly began to rise,"[7] Strindberg's serious troubles began, psychically and artistically.

This interpretation suggests that we can closely examine individual Inferno years' works and experiences as providing a double perspective: views into the healing processes of both the artist and the man, as the slow process of reintegration undid a long period of disintegration. He was finding a center in his life again, a center that had been shattered by a painful series of events, beginning with the separation from Siri and the children in 1891, the divorce a year later, and the apparent end of his writing career in Sweden, with its attendant loss of regular income and even self-identity. A subsequent new marriage in Berlin and minor triumphs in German and French theatres, bringing in little or no income, were only temporary respites from the steady psychic decline. Worst of all, perhaps, was the absence in his life, despite the fitful sojourns into science, of any sustained, meaningful, creative activity. But Paris offered hope. He was not alone in his search for a new creative center in his life, and many of the other writers and artists embarked on a similar quest had the same motivation: inner renewal, psychically and artistically. It is significant that in the months before Strindberg's breakdown in mid-1896, as he became intensely preoccupied with interpreting visual impressions of all kinds, one image appears repeatedly in his letters and essays: cocoons transforming into butterflies. He reported that what he found most encouraging while investigating and dissecting cocoons was the certainty that despite all the signs he found of apparent death, new, beautiful life would eventually emerge; out of death would come resurrection. He writes repeatedly of the death-like state of "necrobiosis" as a natural phase in the life process, a preparation for new growth (Brev 11:114, 126, 129). Even as he was steadily losing a firm contact with reality, it would seem, he was preparing himself for rebirth. Two years earlier, in one of his first letters to Theosophist Torsten Hedlund, he had written of sensing

that he was on the brink of an important new phase in his life, and feeling as "nervous as a crab, changing its shell" (Brev 10:208).

Image as Revelation

Strindberg's Inferno years' obsession with the imaginative power of visual images, whether stimulated by his own painting or by various occult sources, reached a special intensity in the spring of 1897 when he deepened his familiarity with Swedenborg's philosophy (see chapter 6) and made a discovery about its inspirational power that coincided with (and some scholars[8] believe led to) the final abatement of his Inferno Crisis. A note made after March 1897 suggests an inspiration for the novel with which he would end his Inferno years: "Inferno: the Vase of Benares, the Creation of the World."[9] Chevrillon's travel-book description of the vase, which Strindberg read the previous year, concluded that the vase demonstrated how "involuntarily, through a special talent in [the souls of the Indians], the things of the outer world seem infinitely enmeshed to them" (Brev 11:152). It sounds remarkably similar to Swedenborg's ideas about the correspondences that tie all elements in the universe together, spiritual as well as material. Strindberg's long history of enduring what he considered the dubious gift of visions—healthy and unhealthy—was now made meaningful, and Swedenborg's philosophy became a key reference guide to that meaning. Göran Stockenström has noted that Strindberg's Occult Diary in the spring and summer of 1897 is filled with visual observations that the writer considered significant and attempted to interpret with Swedenborg's help.[10]

In a Swedenborgian context the most important function of images is to serve as symbolic links in the theory of universal correspondences. When the philosopher first presented his theory in a 1742 essay, the essay's title underscored the significance of the visual: A Hieroglyphic Key to Natural and Spiritual Arcana by way of Representations and Correspondences. Its thesis, says Inge Jonsson, was that "there is nothing in nature that is not an image of a spiritual

prototype," and the goal of Swedenborg's reasoning "is to arrive at the ancient Egyptian wisdom which, he believed, embraced a similar theory of correspondence: these correspondences were designated with 'hieroglyphic characters' of different kinds . . ." [11]

Heavily marked passages in a book on Swedenborg in Strindberg's library detail how the philosopher applied for research funds from the Swedish Academy of Science to study Egyptian hieroglyphics because, he said, "they were correspondences for spiritual and natural things." [12] Here was further evidence for Strindberg of the unifying links between visual images, verbal images, and the natural and spiritual worlds they represented. [13] Every new graphic image he saw became an invitation to probe the visible for the deeper meanings of the invisible. He was in good Romantic company. After the deciphering of the Rosetta Stone in 1820, Egyptian hieroglyphics—a writing system of images drawn from the visible world—became a source of inspiration to artists and poets. "Hieroglyphic," says James Engell,

became a word representing a medium of pure imagination, of pure images, much in the way Chinese ideograms later appealed to Ezra Pound. Not only Coleridge but Wolff, Hazlitt, Keats, Goethe, and Schelling used "hieroglyphic" as an image for the concrete power of imagination carried into a symbolic world where man and nature are united in poetic language. [14]

Implicit in Strindberg's faith in images was the belief that they had the power to reveal truths that mere words could not convey. A passage describing this kind of revelatory power is marked in his copy of a work by another admirer of Swedenborg, the Romantic P. D. A. Atterbom: *Swedish Seers and Poets* (*Svenska siare och skalder;* 1841–55). In a luminous catalogue of Platonic-Christian correspondences that could well summarize the insights that Strindberg himself acquired during the Inferno years, Atterbom uses the preeminence of the image over the word to set up correspondences between the divine imagination and human imagination, between divine symbolism and mythological symbolism:

The closest resemblance to the way in which human beings . . . communicate their innermost thoughts to each other is that of the heavenly intelligences. These actually speak to each other through figurative representations (*repraesentations vivas, per imagines*), or . . . living pictures, which are simultaneously real and expressive, and from which meaning sparkles with unbounded clarity. . . . [T]hese . . . figurative representations, which can express several . . . things at once, have correspondences in our world, within us as well as outside: within us in our imagination, outside in the natural world. [Both heavenly and earthly forms of communication] are languages, each equally rich, equally lively—languages not of words but of images. The first and the richest thought-creation in our soul is always an *image*, and always signifies *more* than we can speak during the course of an entire day. We can thus assert that the word—oral or written—is a mere expedient.[15]

The reference to images as "thought-creations" (Atterbom also writes about "Swedenborg's Theosophy")[16] is a reminder of Strindberg's own post-Inferno use of the Theosophical term "thought-forms" (see chapter 6)—those examples of the capacity of the imagination to create virtually autonomous, semireal beings or entities.

Atterbom's analysis of the superiority of images over words in the communication of subtle meanings on many levels was motivated by the conviction that there was "a symbolism in nature and in the imagination, which, correctly understood, offers entry to the truths of the heavenly spiritual world."[17] This Swedenborgian dual emphasis on nature *and* the imagination, rather than on the one at the expense of the other, is echoed in Strindberg's post-Inferno works. But it was also, as we have seen throughout our discussion, a practice that he had followed periodically from the beginning of his career; he was returning to an old friend. For example, in between detailed, Naturalistic descriptions of nature in the 1884 story "Pangs of Conscience" (see chapter 1) are moments like the protagonist's discovery of the sudden, mysterious blossoming of the grapevine, which is transformed in his imagination into a reminder of the Crucifixion. This, too, was an example of the symbolism linking nature and the imagination.

How did the enhanced importance given to images affect Strindberg's thinking as a dramatist? The answer is suggested in a remarkable metaphor in the later *Blue Book* essay collections:

Note how in cinematography many light images must be shown in succession in order to indicate a single movement, and yet the images flutter. In each fluttering an intermediate step is missing. If a thousand separate images are necessary to produce an arm movement, how many myriad would not be necessary in order to depict a movement of the soul[?] A writer's character depictions are therefore only abbreviations, contour sketches, all incomplete and all half false. (ss 47:788) [18]

So vital have visual images and visual media become to Strindberg that the very process of character creation is described in terms of image making!

The virtually autonomous authority Strindberg often allowed images and the imagination in his post-Inferno works has led some critics to categorize him as a Symbolist, but the label is questionable, for several reasons. First of all, he resisted programmatic labels of all kinds. Even as a self-proclaimed Naturalist, he remained fiercely independent. Second, as Haskell Block has pointed out, Strindberg's "conscious efforts to approximate symbolist ideas are far less important than his plays marked by mixed dramatic styles, wherein symbolist elements are but one part of the playwright's intricate orchestration." [19] As an old realist, Strindberg was too much of a skeptic to subscribe faithfully to the Symbolist program, too trusting in Nature's own authority to allow the dreamer in him full sway in the creative process, and too interested in man's social and political identities to think of art as somehow superior to life. Nevertheless, he had come a long way from the young man who had denigrated the imagination two decades earlier as only a "gift for rearranging" memories (ss 17:193).

The special respect that the imagination had earned in Strindberg's mind during the Inferno and post-Inferno periods is reflected in a number of ways. For one thing, rather than finding science and the imagination to be incompatible, as he had done

in the 1880s, he now underscores the vital connection between them. An 1896 letter to Hedlund speaks of Strindberg's respect for the great botanist Linnaeus, who "had imagination, which is now lacking and therefore blunts the intellect of an entire generation or two" (Brev 11:346). A statement by another natural scientist, John Tyndall, is cited approvingly in the postscript to Strindberg's 1896 collection of mystical-scientific observations Jardin des plantes: "Without imagination, we cannot take a step beyond the animal world, perhaps not even approach the boundary line of the animal world" (ss 27:299). But finally, of course, it is in Strindberg's art that his new respect for the imagination is most clearly and dramatically reflected. In a passage from his 1907 novel Black Banners, Count Max (significantly, a character seriously dedicated to studying Theosophy) defines the imagination's capacity for creating images. He warns against any disparaging of the imagination, for

fantasy has a role to play in all [storytelling], so you should understand the concept before you thoughtlessly try to belittle it. First, it is the ability to create an image, then it is the image itself. When you remember something, it is not the thing you recall but its image. The divine gift of memory thus operates with fantasies; therefore, speak respectfully of fantasy and not disparagingly, for then you blaspheme. (ss 41:145)

A poignant suspicion voiced by another Strindberg character many years earlier makes an interesting contrast to Count Max's declaration. The sculptor Olle Montanus in the 1879 novel The Red Room (see chapter 2) thinks it is the artist who blasphemes because he must use images that cannot possibly communicate higher values: "The ultimate design of earthly life is to liberate the idea from sensuality, but art actually tries to clothe the idea in sensual form in order to make it visible" (ss 5:359). For the post-Inferno Strindberg, it was the very sensuality of images that made the ideas they represented resonant, that made concretely clear the correspondences between all the planes of being. In the old battle within him between the maker and the breaker of images, the maker was winning out, and the Aristotelian had come to terms with the Platonist.

Pl. 1. August Strindberg, *The Solitary Toadstool*
(*Den ensamma giftsvampen*), Berlin, 1893, oil. Private collection.
Courtesy of Agneta Lalander, director of the Strindberg Museum, Stockholm.

Pl. 2. August Strindberg, *The Wave VIII* (*Vågen VIII*),
Stockholm, 1901–2, oil. *The Nordiska Museet*, Stockholm.

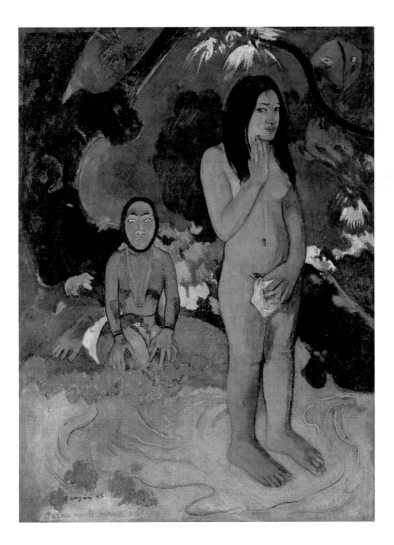

"In your paradise there dwells an Eve who is not my ideal. . . ."
(From a Strindberg letter to Gauguin)

Pl. 3. Paul Gauguin, *Words of the Devil* (*Parau na te varua ino*), 1892,
oil on canvas, $36\frac{1}{8}$ × 27 inches. *The National Gallery of Art, Washington, D.C.,
gift of the W. Averell Harriman Foundation in memory of Marie N. Harriman.*

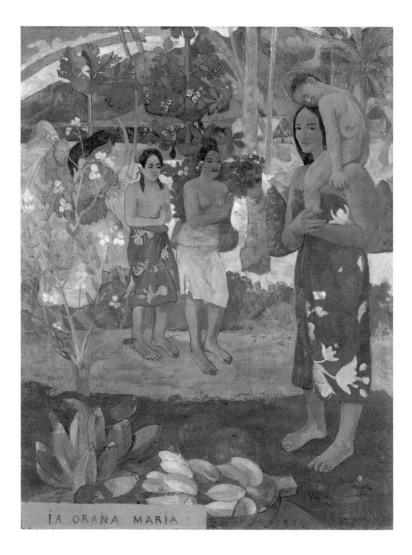

Pl. 4. Paul Gauguin, *Ia Orana Maria*, 1891, oil on canvas, $44\frac{3}{4} \times 34\frac{1}{2}$ inches. The Metropolitan Museum of Art, bequest of Sam A. Lewisohn, 1951 (51.112.2).

New Visions from New Visionaries

For all the fascination that Strindberg found personally in the revelatory, rather than representative, power of images, he was only part of a generation of artists who made similar discoveries. In the choices of strategies he later adopted to exploit this power he was almost certainly influenced by his close acquaintance with two other artists who mixed representation and revelation in their art: Edvard Munch and Paul Gauguin, two of the seminal image makers in modern art. These were encounters with dramatic implications: on the one hand, a Swedish playwright in the midst of gestating a new approach to his art that would profoundly affect its practice for the next century and, on the other hand, two painters who had already discovered their new approaches, which would similarly affect painting for the next century. Since all three were given to philosophical speculation about their work, intense exchanges probably occurred between Strindberg and Munch and Strindberg and Gauguin about art and the artist's goals. Indeed, such exchanges are implied in Strindberg's writings about their paintings, as we shall discover.

Though working in different art forms or styles, Strindberg, Munch, and Gauguin shared a number of artistic goals and problems. First, to a greater or lesser degree, they had all played the role of artistic provocateur in their respective societies, challenging a variety of bourgeois values and standards. Second, each had begun his career motivated by realistic/Naturalistic objectives, Strindberg and Munch from a radical political point of departure, Gauguin from an apolitical point. Finally, in concert with the antimaterialism of the last decades of the nineteenth century, each artist evolved different ways to depart from Naturalism without rejecting it entirely by experimenting with separate approaches to Natural Supernaturalism. This involved flirting with theosophical ideas —Munch in Berlin,[20] Gauguin during the time in the early 1890s that he was closely associated with his disciples among the Nabis,[21] and Strindberg (as we have seen in chapter 6) in Paris in the mid-1890s. It also involved a leaning toward mysticism, Strindberg

CHAPTER 8

within an identifiably Christian context, and Munch and Gauguin within a more general or eclectic approach. Earlier (chapter 5), we discussed German Romantic Caspar David Friedrich's efforts to evoke God's presence in his landscapes. Munch, who may well have been influenced by Friedrich, had a different aim: the evocation of a vaguely spiritual, rather than specifically religious, mood. He wanted people, when confronted with his paintings, to "understand the holy quality about them and bare their heads before them as if in church."[22] A similar spiritual quality was found by G.-Albert Aurier, Symbolist poet and critic, in Gauguin, whom he described as one of those sublime seers, who could exclaim with Swedenborg, "that inspired hallucinator," that "the eyes of the inner man were opened: they were made fit to look into the heavens, into the world of ideas and into the nether regions!"[23]

Distinctions between the three artists in their approaches to spiritual themes say much about the art they produced. Spiritual resonances in Strindberg and Munch at their best (Strindberg can be mawkish at times) are intimately connected with the conviction both held that the only justified form of art was one rooted in and relevant to life. They belong to the continuity Robert Rosenblum has labeled the Northern Romantic Tradition, in which artists seemed to work "not in the art-for-art's-sake ambience of Paris but in the art-for-life's-sake ambience of a private world in which the making of art was a means of communicating with the kinds of mystery that, before the Romantics, were located within the public confines of religion."[24] Spiritual themes in Gauguin, however, are matters of controversy among critics. William Rubin, for one, sees Gauguin's interests in Eastern religious practices as motivated as much by Rousseauistic cultural considerations as spiritual ones, and that the painter's "willfully anachronistic vision of Tahitian society provided him an ideal alternative model against which to set the supposedly debased European culture that he abhorred."[25] And Rosenblum says that although Gauguin's art

was also closely interwoven with the values of his life and [he] . . . constantly tried to evoke symbolist mysteries beneath the surface of

things, ... the quasi-religious questions he meant to pose in his master-piece of 1897—*Where do we come from? What are we? Where are we going?*—are posed almost more in the title than in the luxuriant, decorative splendor of the picture itself.[26]

The spiritual was only one area in which common interests and goals made Strindberg's relationships with Munch and Gauguin useful to him. Though he was older than Munch and in some ways better known than either Munch or Gauguin (he was certainly more notorious in Germany and France than either of them), he was in a position of having at least as much to learn from them as they from him when he first met them—Munch in 1892 and Gauguin in 1894. By then, they were already embarked on a course of radical changes in their styles. Though he was still several years away from making such a decision, they had, by example, charted the way for him on a journey that he too would make. To understand the nature of that journey and what it would mean to him artistically, we need to explore where Munch and Gauguin were artistically when he met them. One point of departure is an event that the two painters experienced some years earlier (at a time when Strindberg was much preoccupied in Denmark and Sweden with the problems of trying to keep his marriage, career, and even life from falling apart): the 1889 World's Fair in Paris.

Munch and Gauguin at the 1889 World's Fair: The Emergence of Synthetism

More than thirty million visitors—an unprecedented number at that time for world expositions—attended one of the climactic events of the age of progress. Its bold symbol was the newly erected Eiffel Tower (which Gauguin admired as a "triumph of iron"),[27] proudly dominating a 72-acre fairgrounds stocked with examples from around the world of technological advances, commercial innovations, and art exhibitions and popular entertainments (including the Buffalo Bill Wild West Show, which attracted both Munch and Gauguin).[28] It is unlikely that Munch

and Gauguin met among the masses of visitors at the fair, but each spent considerable time wandering the fairgrounds, though not primarily to admire the technological progress that most exhibits celebrated.[29] Indeed, their goals, like those of many of their contemporaries at the time, were to search for ways to express opposition to the positivism and materialism that were the philosophical bulwarks of the age of progress. In the process, each artist eventually evolved different symbolic approaches, Munch from the point of view of an intensely subjective psychological exploration of the most basic human fears and desires—love, sex, jealousy, despair, loneliness—and Gauguin out of an archetypal, Rousseauistic nostalgia for a lost paradise that was implied for him in the land, people, and mythologies of the Buddhist East. Strindberg already shared Munch's interest in the psychological, and the strong enthusiasm he voiced for Buddhism and Buddhist mythological images a year after he met Gauguin was probably due in part to the influence of the French painter.

At the time of the fair, the twenty-six-year-old Munch was an art student studying on a Norwegian state fellowship, and Gauguin, at forty-one, was a contributor to what might be called one of the fair's sideshows: an exhibition called the "Groupe impressioniste et synthétiste," a collection of paintings rejected by establishment critics and hung on the walls of one of the fair restaurants, the Café Volpini. Though the works failed to attract the kind of respect and admiration lavished on conservative academy artists in the officially approved French art exhibit, Gauguin's work in particular excited and stimulated disaffected young academy students. His radically flattened forms and exaggerated colors prompted G.-Albert Aurier to write: "I seem to have noticed a marked tendency towards a synthesis of drawing, composition and color, as well as an effort to simplify the means of expression."[30] Describing this new style as "Synthetist," Aurier insisted, with reference to Gauguin's eloquent paintings as examples, that "the usual and ultimate goal of painting . . . cannot be the direct representation of objects. Its finality is to express ideas by translating them into a special language."[31]

Munch probably saw the Volpini exhibition,[32] but it would be several years before evidence appeared in his work of its influence. When it did, the resemblances to Synthetism were obvious: bold simplification and an emphasis on ideas. If Munch was not ready to be influenced by Synthetism when he arrived in Paris in 1889, it was because he was more interested at the time in finding his own Impressionistic route away from the radical Naturalism he had been practicing, which specialized in depicting what Reinhold Heller describes as "intense sunlight illuminating a proletarian interior."[33] Moreover, though a popular theme in Norwegian painting in the 1880s was the depiction of the lives of peasants, there is no evidence that Munch was impressed one way or another at the Café Volpini by Gauguin's apparently apolitical, sometimes semireligious, canvases of pious, hardworking Breton women laboring in the fields.

In these Breton works was a goal that tied in with Gauguin's own wanderings at the fairgrounds: a quest for *primitif* (see chapter 7) forms of expression, forms somehow more simply and authentically human than those associated with modern, technological, "cultural" man. At the fair, he found the forms he was looking for in the colonial section, an elaborate demonstration of the vitality of French imperialist acquisitiveness, including artifacts from the latest conquest, Indo-China. Among the separate buildings representing almost every major colony were several in which Gauguin took special interest: a copy of the Angkor Wat temple and a reconstructed Javanese village where he watched native dancing. A related fascination in the *primitif* three years earlier had led him to abandon his solid bourgeois life as a stockbroker and his Danish wife and children and to travel abroad to Panama and Martinique before returning to France and Pont-Aven in Brittany. Two years after the fair would come his first trip to Tahiti. A large number of the Breton drawings, watercolors, and paintings show women piously working at tasks that made their lives seem more natural, more organic than those of city dwellers. "Washing clothes," says William Rubin of this motif in the Breton works, "becomes for Gauguin less a casual, anecdotal activity than

a ritual which attaches the women performing it to the cycle of life."[34] Whether they were washing clothes, working in the fields, dancing, or praying at roadside crucifixes, the ritualistic atmosphere in the paintings is enhanced by their native dress: somber black dresses and large, white, winged caps. If they often seem like figures out of a medieval stained-glass window, the effect was intentional. Gauguin roamed Breton churches for ideas on form and color, and in 1889 he wrote to van Gogh: "There is something medieval looking about the peasants here in Brittany; they don't look as though they suspect for a moment that Paris exists or that it's 1889. . . . Look at how the bodice forms a cross in back, how they wrap their heads in black headscarves, like nuns. It makes their faces look almost Asiatic—sallow, triangular, dour."[35] The heart of Gauguin's synthetic approach was this attempt to suggest a blend of the medieval and the Asian, the two currents that would so fascinate Strindberg in his post-Inferno works (see chapter 7).

Though at the World's Fair Munch failed to respond immediately to Gauguin's radical style, evidence in his own paintings over the next four years demonstrates that he was very sensitive to other images at the fair. In fact, one in particular came to echo again and again not only in his work but in Gauguin's: an ethnographic exhibit featuring a thousand-year-old Peruvian mummy (fig. 10), its body tied in a fetal position, hands positioned on each side of the head, and with hollow sockets for eyes and a toothless mouth agape, as if in shock or surprise.[36] The mummy image appeared in 1896 in two Munch paintings, The Storm and, most notably, The Scream (also called The Shriek in English; fig. 11), as well as in numerous Gauguin drawings, watercolors, paintings, and wooden carvings—from the watercolor Eve (fig. 12) in 1889 to the massive 1897 painting Where Are We Going?—in each instance demonstrating its power to stamp an indelible mark on artists' imaginations. Images used by the artist were no longer to serve limited narrative or political functions in the context of a Naturalistic imitation of nature: they were to speak directly to the viewer's imagination in their own Symbolistic or Synthetistic language. For Munch, the mummy image became in The Scream a symbol

of stark, existential anguish and, says Robert Hughes, "the most famous image of neurosis in Western art."[37] For Gauguin, it was an expression of existential sorrow—the kind of wail over life's pain and suffering that is best understood by the old and the wise.

There are no specific references to the fair's mummy exhibit in any of Strindberg's later writings, as far as I can tell. But mummy images do appear. They are prominent in an 1896 essay, as we shall see, and in one of his greatest plays—*The Ghost Sonata*—where a haunting character, called the Mummy, evokes not only the anxiety of Munch's use of the image and the sorrow of Gauguin's but also a strange, melancholy form of hope. During Strindberg's visits to Gauguin's atelier during the winter of 1894–95, he certainly could have noticed the use of the image in one or more of the watercolors and woodcuts on display, and by that time he had been made well aware of the effect it could produce in a Munch painting.

Munch and Strindberg in Berlin

In the years between the World's Fair and his meeting with Strindberg in 1892, Munch steadily assimilated the lessons he had learned in Paris. He also brooded a great deal about the purpose of art and his own role as an artist—proper subjects for a young man about to embark on a new approach in his work. A sympathetic fellow brooder was a young Danish poet and enthusiast of French Symbolism, Emanuel Goldstein, who transmitted his enthusiasm to Munch. Feeling that the artist's primary goal was shifting from imitations of the world of nature to renderings of the landscape of his own soul, Goldstein viewed spiritual enlightenment and salvation as the new anti-Naturalist goal, and Symbolism would show the way to that salvation. This is the art, Goldstein wrote in an 1892 essay, "that values moods and thoughts over all else, and uses reality only as a symbol."[38] Instead of "plastic images of conventional reality," the artist was to produce "a plastic image of the reality alive in one's mind."[39]

By late 1892, when Munch arrived in Berlin for a November

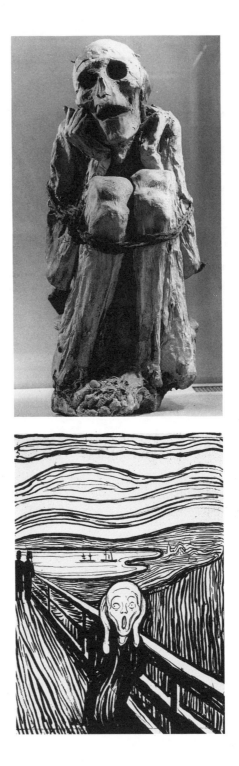

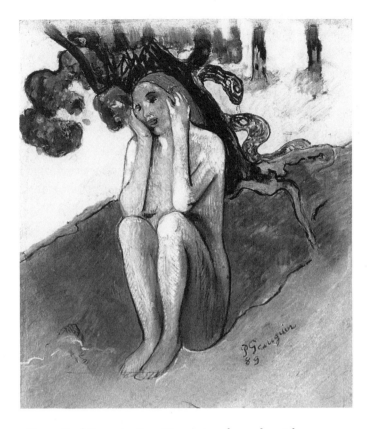

Fig. 12. Paul Gauguin, *Eve*, 1889, watercolor and pastel on paper,
13¼ × 12¼ inches. *The McNay Art Museum, San Antonio, bequest of
Marion Koogler McNay, 1950.45.*

Fig. 10. Peruvian mummy, *Musée de l'homme, Paris.*

Fig. 11. Edvard Munch, *The Shriek*, 1896, lithograph, printed in black,
13$\frac{15}{16}$ × 10 inches. *The Museum of Modern Art, New York, Matthew T. Mellon Fund.
Photograph © 1995, The Museum of Modern Art, New York.*

exhibition of his paintings, he had experimented regularly with producing the kind of plastic images of subjective moods and thoughts that Goldstein mentioned. Strindberg had been there for some weeks and had already become the center of the radical, bohemian circle of artists, writers, and intellectuals for which the Schwarzen Ferkel tavern was to become famous. Among them was Stanislaw Przybyszewski, a young Polish writer fascinated by mysticism and satanism and destined to become another important aesthetic soulmate for Munch. Stach's (Przybyszewski's) mystical faith, however, was not in some vague spiritual force but in a more carnal mythological deity—Eros. "In the beginning," he wrote, "was sex. Nothing outside it. Everything contained in it. . . . Sexuality is the primal substance of life . . . the eternally creative, the transformatory and destructive force."[40]

The conflict Stach perceived in sexuality between the creative and the destructive (suggestively illustrated by a Munch lithograph, *Madonna*, and a Munch etching, *Vampire*; figs. 13 and 14) was more than one of his preoccupations—it was an article of faith of the times. The Munch works mentioned are described by Strindberg in his essay in terms that harmonize with Stach's ideas. *Madonna* (which Strindberg called *Conception*) represents orgasmic climax: "immaculate or not, same thing; the red or golden halo crowns the completion of the act, the only raison d'être for a creature who lacks an independent existence." And *Vampire* (which Strindberg called *Red Hair*) is a depiction of "the golden rain which falls over the unfortunate one, on his knees before his lesser self, pleading to have his life taken by a needle sting. The golden rope which binds him to the earth and to suffering."[41]

In the public imagination, the embodiment of the ambivalent nature of sexuality was the allure and danger posed by the femme fatale, a theme that "was all-pervasive, appealing to men of opposing artistic creeds, symbolists and realists, rebels and reactionaries, and penetrating deeply into the popular consciousness."[42] In keeping with the fashion, the Schwarzen Ferkel tavern devotees even believed they had their own resident femme fatale: Norwe-

gian writer Dagny Juel. She had affairs with Munch and Strind-
berg and later married Przybyszewski, and her charms, powers,
and genuine talents as a writer made her something of a legend.
One of Munch's lithographs, *Jealousy* (fig. 15), purportedly depicts
Przybyszewski's face close up, with Dagny and Strindberg in the
background, as if haunting Stach's imagination. In Strindberg's
essay dialogue is provided for the scene: "the jealous person says
to his rival: 'Go, you incomplete one; you shall warm yourself
by the fire you have ignited, you shall inhale my breath from her
mouth; you suck in my blood and remain my slave; my spirit
rules you through this woman who has become your master.' "[43]

Mary Kay Norseng says that Dagny Juel Przybyszewska "seemed
to her contemporaries to speak a mute language pregnant with
mysteries from beyond the grave. She gave them the electrifying
feeling that she had something to reveal to them, if they could
only understand her." [44] Both Munch and Strindberg tried to solve
the riddle that was Dagny Juel, and her presence haunts a variety
of Munch paintings [45] and Strindberg writings.

In the intoxicating atmosphere of aesthetic stimulation spiced
by eroticism at the Schwarzen Ferkel it is easy to see why Strind-
berg, already established as a significant chronicler of the battle of
the sexes, should become a celebrity. His arrival in Berlin had been
preceded by his reputation (for performances there of *The Father*
in 1890 and *Miss Julie* in early 1892) as "a Swedish sensationalist
writer" ("*ein schwedischer Sensationsschriftsteller*").[46] To the progressive-
minded artists and intellectuals at the Schwarzen Ferkel he was a
pioneer in exploring the darker sides of love, sex, and marriage,
taking issue with the bourgeois glorification of woman and the
family, and exposing candidly the deep frictions and complexities
in sexual relationships. The Captain's complaints in *The Father* that
these complexities evoked emotions akin to "race hatred," and
that man and woman must be descended from different species
(ss 23:69), were later echoed by Stach in an 1897 article on Munch,
in which he asserted that "the man and the woman are two com-
pletely differently organized creatures who feel differently, think

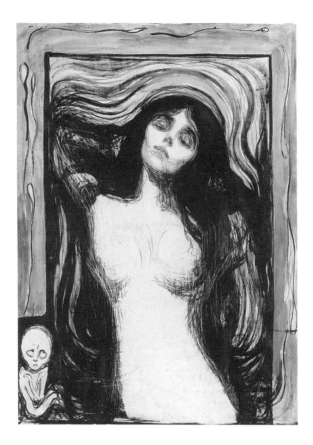

Fig. 13. Edvard Munch, *Madonna*, 1895, lithograph,
printed in black and colored by hand, 59.8 × 44 cm.
The Art Institute of Chicago, Print and Drawing Purchase Fund, 1945.229.
Photograph © 1994, *The Art Institute of Chicago, all rights reserved.*

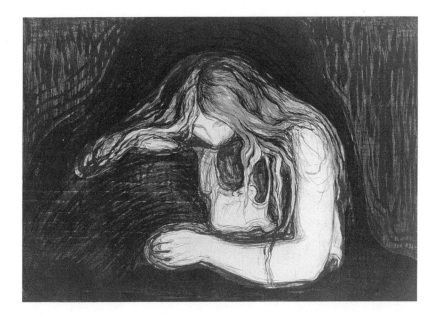

Fig. 14. Edvard Munch, *The Vampire*, 1895–1902, etching.
The Art Institute of Chicago, John H. Wrenn Memorial Collection, 1941.1066.
Photograph © 1994, *The Art Institute of Chicago, all rights reserved.*

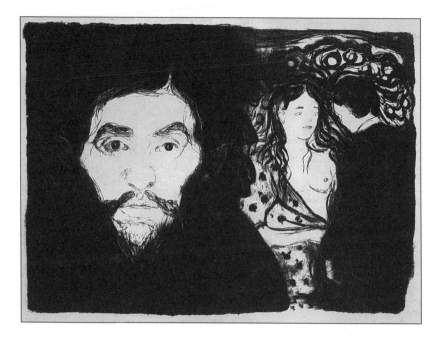

Fig. 15. Edvard Munch, *Jealousy*, 1896, lithograph, printed in black, $13\frac{3}{8}$ × $18\frac{3}{8}$ inches. *The Museum of Modern Art, New York, the William B. Jaffe and Evelyn A. J. Hall Collection. Photograph* © *1995, The Museum of Modern Art, New York.*

differently, that *never* can understand each other, and where this seemingly happens, the one or the other must have been raped or overpowered."[47]

Przybyszewski was an influential figure aesthetically for Strindberg as well as for Munch, but in different ways. For Munch, Stach verbalized the archetypal tensions that the painter struggled to express visually and helped him transform his view of sex and sexual relations. Both he and Munch saw the battle of the sexes, says Reinhold Heller, as "the basic content of the relationship . . . , with all other aspects subordinated to it."[48] So highly did Munch regard Stach's opinions that he occasionally changed the title of a painting to conform to his interpretation. In the process, the title became bolder, more provocative, with greater emphasis on violence and drama. What was first called *Despair*, for example, became *The Scream*.[49] Stach called the approach that they were practicing Psychic Naturalism, which contained, says Reinhold Heller, "virtually all the characteristics associated a decade later in Germany with Expressionism."[50]

Strindberg's reactions to Stach were more complicated. Though he was flattered by the hero worship that Stach lavished on him when they first met, the man's reputation for satanism must have disturbed him, given what we know of Strindberg's lingering faith in Christian ideals (which would become much stronger in Paris after his discovery of Swedenborg). But more pointedly, though he shared with both Munch and Przybyszewski a conviction that relations between the sexes were primarily adversarial, he did not share his colleagues' virtually fanatical belief in a primarily biological interpretation of the conflict. For him, there was an important metaphysical dimension as well, and by 1896, he was tempering his acknowledgment of the power of sexual attraction with a professed leaning toward Buddhist asceticism and a commitment to Swedenborgian spiritual goals over purely carnal ones.

Evidence of Munch's impact on his Swedish compatriot can be detected only after Strindberg resumed writing plays—but it is unmistakable, like Gauguin's impact on Munch. In Munch's paintings, Strindberg could find reminders of the fundamental

themes and images that had dominated his own imagination in the past. What was new was that the paintings presented him with examples of bolder, more-concentrated forms of expression for the kinds of archetypal actions and mythic figures that we have discussed in his works throughout this study, not only for the sexual-metaphysical image of Eve and the Fall but for all the literary archetypal roles—from madonnas to femmes fatales to vampires—played by women in Strindberg's imagination in images of mothers, sisters, and wives/lovers. These images would ferment in his imagination with kindred ones over the next three or four years and emerge clearly in his post-Inferno plays in such figures as the woman in To Damascus whom the Stranger names Eve (suggesting that their relationship becomes a replay of all the trials and tribulations of the first couple), the femme fatale sculptress in Crime and Crime, and the vampire mother in Pelican. But long before then, he had also been influenced by another powerful imagination: Gauguin's.

Gauguin and Strindberg in Paris

In late 1894 and early 1895, Gauguin, like Strindberg, was passing through an important transition in his art and life. While Strindberg was approaching the end of his years of exile, Gauguin was about to return to Tahiti to definitive exile for the last decade of his life. Both men were living near the Montparnasse cemetery, and Strindberg visited the French painter's studio on the rue Vercingétorix a number of times, to judge from their correspondence. They talked and sang together (with the Swede on the guitar and the Frenchman on the mandolin), and Strindberg had numerous chances to see and examine his colleague's radical paintings. The possibility that one artist influenced the other has been advanced by Gunnar Brandell, who asserted that Strindberg eventually succeeded in creating in words "a truly striking counterpart to Gauguin's expressionistic symbolism." Brandell also speculated that Strindberg could have become aware in the winter of 1894–95 "of the distinction made by Mallarmé and Gauguin between

figurative, ideological, and unconscious symbolism."[51] But it was more than an awareness of new trends that Strindberg absorbed from his acquaintance with Gauguin. Though very different from him in a number of ways, Strindberg was to employ some of the same strategies and borrow from the same sources as his French colleague, even as each artist worked out his own separate, revolutionary destiny.

Early in 1895, Gauguin invited Strindberg to write a preface to a catalogue for an auction of his paintings. It proved to be a difficult request to satisfy, at least partly because psychic and physical problems had reached a crucial stage for Strindberg. When he arrived in Paris the previous August, it marked the second time in two years that he had moved to a new city in hopes of finding a way out of a crisis situation. Berlin had been the first port in a storm after the collapse of his marriage and career in Sweden, but the new environment yielded mixed results, as we have seen (see chapter 5). Off he went to a second port in France. Here, too, he found new and exciting ideas, particularly in occult circles (see chapter 6). But the years of mounting stress were exacting their toll. In *Inferno*, Strindberg himself dates the beginning of the most difficult period of his Inferno years—the Crisis—in November 1894, after he and Frida Uhl were separated, and two months later he was hospitalized for three weeks with psoriasis, possibly as a result of the stress. Three more traumatic episodes took place before the Crisis climaxed in a July 1896 breakdown, which did not subside completely until after his Swedenborgian revelations in the spring of 1897.

After some soul-searching, Strindberg declined Gauguin's request and tried to explain his reasons in a letter. The refusal was quite understandable, and not just because of health problems. Temperamentally, they seemed literally polar opposites: Strindberg was identified in the public imagination with the dark chill of northern Europe and Gauguin with the bright warmth and passion of the south of France or of Tahiti. Moreover, Gauguin, proud to call himself a barbarian or savage (his grandmother was half Peruvian), regarded Strindberg as a sympathetic but ultimately

typical example of the other overcivilized and desensitized Euro-
peans who had rejected his art because they lacked a feel for the
primitif. Though Strindberg may have been much more fastidious
than his colleague (one can hardly picture him plunging into the
jungles of Tahiti), in many ways he was as authentic a primitif as
Gauguin. He, too, was a Rousseauist skeptic who valued "natural"
man over "cultural" man (see chapter 1), ranking natural instincts
and impulses in importance above conventional, so-called civi-
lized values. And he, too, was an inveterate borrower as an artist,
having in the past used the images he felt he needed from a variety
of primitif sources, including Asian philosophy (via Schopenhauer)
and Judeo-Christian mythology.

Despite Strindberg's reluctance to provide a preface, Gauguin
chose to publish his letter of refusal in its place. Perhaps he was
hoping to trade on the literary prominence Strindberg's name had
acquired as the result of the successful French premiere of The
Father at Théâtre de l'Oeuvre in December 1894 (which Gauguin
attended). He added a letter of his own in response and both were
published; today they are often cited as representative of different
avant-garde attitudes at the time.[52] In the context of our discus-
sion, however, there was a special significance to Strindberg's let-
ter: it heralded profound changes about to take place in his views
on art, changes provoked, in part, by being forced to describe
his reactions to what must have seemed stunning and disturbing
images in the paintings.

The contents of the two letters indicate that among the weight-
ier topics the two men had discussed were fundamental philo-
sophical questions involving the artist and the choices he must
make. A number of these questions were couched in mythological
or metaphysical terms, which is not surprising, considering that
Strindberg had long been interested in myth and metaphysics, and
that Gauguin, familiar with the mythologies of South America as
well as the South Pacific, took considerable care in his paintings
to evoke the presence of a separate world, with its own heaven
and hell, its own gods and devils. Strindberg was skeptical about
the validity of that separate world, partly because his response to

virtually all recent trends in art was hostile. In an 1895 essay he said he had studied carefully and ultimately rejected all modernist trends: Impressionism, Symbolism, and Synthetism. His reasoning was that rather than being new, they were retrogressive: "backward-leaning novelties that bring back already vanquished forms, novelties that are usually contrary to contemporary needs" (ss 27:526).

Implicit in the idea of artistic novelties that were "contrary to contemporary needs" is a reminder of Strindberg's old faith in the importance of social relevance in art, a faith unquestionably out of fashion in Symbolist Paris. He had to learn (as he did) that it was possible to reconcile the conflicting demands of the imagination and of social relevance. Nevertheless, just how hostile Strindberg really was to modernism is difficult to ascertain, despite his plainly derogatory remarks. Their tone is similar to that of a number of statements he had made in the last years of the 1880s and the first years of the 1890s when, feeling bypassed, he resented the fact that unqualified younger artists had usurped the leadership position he had held in the arts in Scandinavia in the early 1880s. Moreover, at the time he wrote the essay, he had yet to be sufficiently exposed to the influence of the very "backward" ideas that he would later champion, especially ideas associated with the Oriental Renaissance and with medievalism. They were not unknown among the habitués of the Schwarzen Ferkel in Berlin, thanks to renewed interest in German Romanticism, but Strindberg appears to have focused on them seriously only after he arrived in the French capital.

What sort of world was Strindberg reacting to in the many paintings, ceramics, and prints in Gauguin's atelier? Among the paintings listed in the auction catalogue were several that contained a theme common to Synthetism and theosophy: a syncretistic mixing of images from different religions or mythologies. In Delightful Drowsiness (Nave nave moe; also rendered as Delicious Water), for example, a seated native woman in the foreground of a jungle clearing has a Christian symbol, a halo, around her head, while in the distance at the right several other women dance before a

pair of Oceanic mythological statues. A similar statue, set in an enclosure surrounded by an ornately carved fence, appears in *The Sacred Mountain (Parahi te marae)*, which has been described by Robert Goldwater as a

strange composition, put together out of Maori legends (or [Gauguin's] interpretation of them), his notion of primitive religion and the cult of the dead, decorative motifs from the East, and a synthesis of the luxuriant nature that surrounded him. . . . These motifs have never been seen together. But here they belong together, because together they create the sacred enclosure, an Olympus bathed in light and somewhere above the world of men.[53]

Gauguin was not the first European painter to borrow motifs from the East: Delacroix and Alexandre Decamps had preceded him. But he was unique in a way that made Strindberg privileged to be exposed to his work, since the Frenchman, says Bengt Danielsson, "was the first painter in the West who ascribed artistic value to the cult and domestic articles of native people and consciously attempted to use 'primitive' stylistic touches and methods of composition in his own work."[54] Consequently, Strindberg's exposure to Gauguin's paintings was an unparalleled opportunity for him to view the work of an artist who was battling positivism and materialism by rejecting many Western values and was consciously borrowing themes and forms from Asian art and mythology to recycle in his own art. In 1890 Gauguin had written to Émile Bernard: "The entire East—the lofty thoughts inscribed in golden letters in all their art—all of that is worth studying and I feel I can revitalize myself out there. The West is effete at present, and even a [man with the strength of] Hercules can, like Antaeus, gain new vigor just by touching the ground [of the Orient]."[55]

The Eastern sources that Gauguin absorbed into his Synthetism included Japanese, Egyptian, Persian, and Cambodian images, and he was eclectic in his use of them. One Western source became virtually synonymous with Synthetism: *cloisonnisme*, a term Gauguin and his colleagues borrowed from the practice in medieval enamelwork of sharply dividing a surface into areas of flat, almost

unmodulated color. Sharp outlines and flat colors were also fea-
tures of prints by the Japanese master Hokusai, examples of which
Gauguin hung on a wall of his house in Tahiti. Nearby was a
photograph obtained as early as 1887–88 of formally posed carved
figures in a frieze from the Javanese Buddhist temple of Borobudur
(fig. 16).[56] The poses appear repeatedly in Gauguin's depictions of
Tahitian women, reflecting his deep admiration for the temple
and the abstract quality of its decorations. In fact, in one painting,
Ia Orana Maria (pl. 4), he provided a syncretistic mix of Borobudur
poses and Christian halos for the Madonna and Son figures.

Michael Sullivan says that Gauguin was "the first European
painter of any importance to admire Buddhist art," and "nowhere
more successfully than in Buddhist Mahayana art have abstract
ideas been given visible form."[57] How much of this admiration
for Mahayana Buddhism rubbed off on Strindberg at the time is
difficult to judge, but the admiration is certainly evident in the
heavily marked books on the subject in his post-Inferno library
and in the imagery of *A Dream Play*.[58]

In Gauguin's later books about life on Tahiti, he tried to suggest
that he had absorbed his feeling for Tahitian mythology naturally,
through his contacts with the natives. Despite the claim in *Noa
Noa*, however, that the primary source for his mythological stat-
ues (which were no longer found on Tahiti) was his new young
Tahitian wife, Tehura,[59] the actual authorities were two borrowed
studies of Oceanic life, published half a century earlier, works he
could have read in Paris without ever journeying to Tahiti.[60]

For Gauguin, as for Strindberg and other turn-of-the-century
artists, what was vital about *primitif* images, no matter how they
were obtained (whether from books, museums, or real-life ex-
periences), was their evocative power for the imagination. A cen-
tury before the present attacks on what is viewed as Western
culture's excessive emphasis on the primacy and implied superi-
ority of Eurocentric sources, Gauguin and Strindberg managed
with their eclectic borrowings to be both multicultural *and* Euro-
centric. Of course, they did so unwittingly; they were ignorant of
the origins and complexities of the cultures whose images they

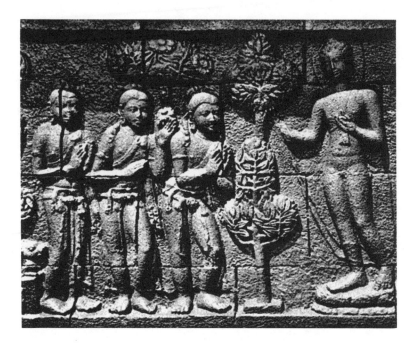

Fig. 16. Detail of temple frieze, Borobudur, Java.

appropriated. And by many of the standards of the 1990s, they were hopelessly reactionary on the issues of ethnicity and gender: Gauguin's patronizing attitudes toward Tahitians bordered on racism, and Strindberg's polemical essays against the women's movement were outrageously sexist. But in their historical context, each man's emphasis on the primitif led to sincere responses, in the prevalent syncretistic spirit of the time, to powerful aesthetic stimuli from diverse cultures. However naïve they were about the notion of the primitif (Gauguin, for example, admired Buffalo Bill as "a half-savage, half-civilized man of action"),[61] they believed that a search for that primitif would somehow bring them closer to the "urhuman" in themselves.

A major philosophical question that divided Strindberg and Gauguin in their letters was mythological: not whether mythology had a place in the creative process, but whether Gauguin's choices in mythic images were appropriate. Not surprisingly, perhaps, Strindberg tells Gauguin: "in your paradise there dwells an Eve who is not my ideal—for I, myself, really have an ideal of a woman or two!" (ss 54:328) (see pl. 3 and fig. 12). Then, in one of his anti-Christian moods, Strindberg says he also objects to all allusions to Christ, which are plentiful in Gauguin's paintings: "I am striking against the crown of thorns, Monsieur, which I hate, as you must know! I will have none of this pitiful God who accepts blows. My God is rather that Vitsliputsli, who in the sun devours the hearts of men" (328). This pointed reference to the Aztec war god indicates that they probably discussed the subject in which Gauguin took such pride: his South American Indian ancestry.[62]

Another mythological image implicit in the letters is the paradisial Golden Age. On this point, Gauguin was plainly a utopian in his symbolism. Strindberg, as we have seen (chapter 4), was also a utopian, but of a more skeptical variety, as his criticism of Gauguin's visions indicates:

I saw trees that no botanist would be able to recognize, animals that Cuvier never dreamt of, and people that only you could create, . . . a heaven in which no God could live. . . .

. . . You've created a new earth and a new heaven, but I don't feel at home in your creation. It's too sun-drenched for me; I prefer chiaroscuro. (SS 54:325–26, 328)[63]

Gauguin responded, defending his half-real, half-imaginary Tahiti: "This world, to which a Cuvier or a botanist would be unknown, would be a paradise which I alone would have portrayed."[64] The early-nineteenth-century naturalist Cuvier's "catastrophe theory" to explain the appearance and disappearance of so many different species of life on earth—sudden, overwhelmingly drastic changes like volcano eruptions or biblical-scale floods— had long nourished lively Romantic imaginations hungry for evidence of life's power to spawn fabulous new creations of all kinds. When Strindberg charged that not even Cuvier could have imagined the strange world one encounters in Gauguin's paintings, the painter responded, in essence, that he as an artist had as much right as Cuvier to extend his imagination and go beyond a simple imitation of nature. Cuvier had opened the door; he was simply walking through it.

In the utopia Gauguin thought he found in the South Seas he seemed to realize a freedom that had been denied to him by the restrictive conventions of Western art. Perhaps because there was no European artist or critic at hand to check on how far he departed from a realistic imitation of nature or from the laws of perspective, he felt free to follow his true bent as an artist, free to make skies red and trees purple if the passion moved him. In a 1900 letter to his wife, Gauguin admits: "I am not a painter who works from nature. With me, everything happens in my wild imagination."[65] But as with so many other Western artists at the turn of the century—Kandinsky and Mondrian, for example (see chapter 5)—he needed a special justification to be able to break with realistic conventions and move toward abstraction. Isolation on Tahiti probably provided that justification. Strindberg, as we have seen (chapters 5–7), found his freedom to break with realistic conventions at least in part in the occult, which was justified by the "scientific" status and respectability it enjoyed at the time.

The final lines of Strindberg's letter indicate that he was not quite as negative as his earlier sharp words might have suggested. Gauguin's art had affected him after all. "Really," he concludes, "it seems to me that since I have warmed up as I write, I am beginning to have a certain understanding of the art of Gauguin. . . . I, too, am beginning to feel an immense need to become a savage and create a new world" (ss 54:329).[66] The admission reveals one of the lessons Strindberg absorbed from his acquaintance with Gauguin and his art. He had been discovering on his own, especially through his woodnymphism experiments (see chapter 5), the importance of allowing the imagination to pursue its own course, quite independent of the old Naturalistic goals. The vital thing was to "create a new world." Gauguin insisted he was proceeding from a different point of departure, the "Oriental Renaissance" (see chapter 7): "Is not a glimpse of happiness a foretaste of Nirvana?"[67]

A foretaste of Nirvana defines very well Gauguin's own synthetic blend of what might be called Naturalistic Symbolism: realistic touches—such as the first reasonably accurate portraits of the Tahitian people in Western art—set in mythological contexts that were re-created and filtered through the artist's imagination. Nirvana carries a promise of liberation from the prison of time and space and so does the mood of many of Gauguin's paintings. In fact, this was a key objection to his art by some critics. In 1893 a critic of an exhibit of Gauguin's paintings complained that "not a single landscape recedes, not a single figure exists in space." There was an "absence of atmosphere," which, if looked at too long, caused one to feel "an indefinable malaise."[68] For other critics, it was precisely Gauguin's disregard for the tyranny of laws of perspective that made his work especially appealing. Here was a revolutionary gesture against the realistic conventions governing the treatment of time and space that had caused many painters (and dramatists, too, of course) to curb their imaginations since the Renaissance. Though "it was the fashion at the time," wrote Achille Delaroche in *L'Ermitage* in 1894, "to split one's sides with laughter . . . before those vertical landscapes that are not given sufficient breath by perspective," it did not matter to him "whether or

not there is exact reproduction in the name of exotic reality. Gauguin used this unprecedented framework to localize his dream, and what setting could be more favorable than one yet unpolluted by our civilized lies!"[69]

Years later, Matisse said that Eastern art (he was referring to Persian miniatures) "showed me all the possibilities of my sensations. I could find again in nature what they should be. By its properties this art suggests a larger and truly plastic space. That helped me to get away from intimate painting." John Elderfield says that Matisse's phrase for this freedom—*véritable éspace plastique*— "describes a true plastic space, a space authentically his own."[70] A comparable Eastern plastic treatment of objects and space appears in Gauguin's paintings, and his reaction to an Assyrian relief of lion images he saw in the Louvre reveals how important this plasticity was: "I believe it required great genius to create flowers which are really muscles on these animals, or conversely muscles which are flowers. There we have the entire mystical dream world of the Orient."[71] In the Asian dream world, the spirit of metamorphic imagination creates an ambiguous landscape in which muscles readily become flowers and vice versa. A little more than a year after Strindberg wrote his letter to Gauguin, he would react almost the same way as the French painter in describing the evocative plasticity of objects suggested by Chevrillon's description of the vase in Benares (see chapter 6): "What do these chasings represent? At first one knows nothing: one sees only a thicket of entwined lines, twisted together at random. Gradually, the skein untangles and shadowy figures emerge: gods, genies, fish, dogs, gazelles, flowers, herbs" (Brev 11:151–52).

Plasticity in the treatment of time was also characteristic of Gauguin's paintings. Although individual portraits of Tahitians display a detailed realism in the treatment of faces, skin tones, and clothing cuts and colors, the figures are often suspended in a mythic landscape that seems to defy historical definition. Even scenes of ordinary daily life were yanked out of their mundane contexts, says Danielsson, and given "a mystical, secretive character that they did not possess in reality."[72] The freedoms Gauguin's

paintings seemed to provide—through the plastic treatment of time and space and the recycling of earlier, primitif forms—may well be the most important lessons Strindberg absorbed in Gauguin's atelier, for experiments with the same devices characterize most of his most-significant post-Inferno works, from To Damascus to A Dream Play to The Ghost Sonata.

The most-immediate evidence of Gauguin's possible impact on Strindberg can be found in Strindberg's essay on Notre Dame Cathedral in mid-1895: "The Barbarian in Paris." Gauguin (with his strong identification with the "barbarian" spirit)[73] had chided him for being insufficiently savage. Now Strindberg discusses with pride the signs he detects of Viking barbarianism in the cathedral's architecture:

The Romanesque cathedral is the oak forest, with its tunnel vaults, its Druids' grove, whereas the Gothic is the northern forest, the spruce grove, with its sharp angles. It is also the Viking ship turned upside down, its keel in the air and its ribs extracted so that they lie bare; there are even the dragon heads that decorated the bold Nordic seafarers' prows: look at the rooftop gutter downspouts.

Yes, it truly has the flavor of northern Europe and it is a charming barbarism, which has abandoned cold geometric figures for the overflowing and disjointed fullness of life of northern flora and fauna. (SS 27:559)

The "charming barbarism" Strindberg found in the Gothic style with its supposed direct links to the Vikings became a means for Strindberg to declare his own Nordic "barbarism" as well as to forge a link to the primitif purity of the Middle Ages, and both sources supplied energies to his post-Inferno works. But perhaps more importantly, the reference to rooftop downspouts resembling ships' prows underscores the long continuity in the vibrant, wood-nymph aspect of Strindberg's visual imagination. We recall, for example (see chapter 4), that in The Romantic Organist Alrik Lundstedt stares at night at a rooftop chimney visible from the window of his room and fantasizes that its "great metal cap took on the form of a witch wearing a black hood" (SS 21:193).

Gauguin's taunting charge that his Swedish visitor was over-civilized had struck a nerve, but it is evident in Strindberg's letter that Gauguin's paintings had already set him thinking about style in a new way. His critical comments on Gauguin's art are reminiscent of another essay, one he wrote in 1884 on his painter friend Carl Larsson (see chapter 2). In each case, the tone Strindberg uses to describe his subject is more revealing than he may have realized. When he now talks about Gauguin, he frequently ascribes to him traits of his own, as we can read in the following account of one feisty, defiant Romantic rebel attempting to define another:

[Y]ou seem to me primarily strengthened by the hatred of others. Your personality delights in the antipathy it arouses, anxious as it is to keep its own integrity. And this may be a good thing, for the moment you were approved of and admired and had supporters, they would classify you, put you in your place, and give your art a name which, five years later, the younger generation would be using as a tag for designating a superannuated art, an art they would do everything to render still more out of date. (ss 54:326).[74]

It is not difficult to read "I" behind the references to "you." The feelings described are nearly identical to Strindberg's in the 1880s: wanting to be a leader, to be "in the vanguard," as he put it, yet reluctant to carry a banner for others to follow, afraid his fierce independence would be compromised. When he goes on in his letter to attempt to capture Gauguin's essential quality as an artist, the self-portrait he creates is even more obvious. Writing in the same Rousseauistic spirit that he detects in the Frenchman's paintings, Strindberg asserts that Gauguin is

the savage, who hates a whimpering civilization, a sort of Titan who, jealous of the Creator, makes in his leisure hours his own little creation, the child who takes his toys to pieces so as to make new ones, who denies and defies, preferring to see the heavens red rather than blue with the crowd. (ss 54:328–29)[75]

Titan, as we have seen (chapter 2), was a title Strindberg himself accepted, and he, too, was capable—if not in his paintings, then

metaphorically in his plays—of seeing the heavens as red rather than blue. In *Inferno* in 1897, he singled out Gauguin in a description of the artistic social gatherings at the home of the Scandinavian couple where he first met the painter in late 1894. Among all the intelligent and witty people present was one who "has a truly brilliant natural talent and has acquired a respected name" (ss 28:21). Strindberg had not only begun to understand the kind of pioneering role Gauguin was playing in modern painting but was rapidly approaching the time when he would be ready to assume that role himself in modern drama.

Creating a New World:
Turning Images into Drama

Unquestionably, the interests in Asian aesthetics and comparative mythology that Strindberg shared with Gauguin were instrumental in his decision to set about creating his own artistic world. But the two men had very different ideas about how to utilize these interests because they had different needs to satisfy in their art. One of Gauguin's principal maxims was: "Let everything you do be marked by repose and peace of mind. Therefore avoid depicting movement. Every figure should be static."[76] This explains why he was drawn to what he felt were the fixed, eternal qualities in Buddhist art. But Strindberg was drawn to Indic philosophy and art for the reverse reasons: instead of stasis, he found turbulence; instead of fixed, eternal qualities, he found unending metamorphoses. While Gauguin favored the images of static elegance he saw in Egyptian wall paintings and the frieze at the temple of Borobudur, Strindberg preferred the sinuous, dramatic movement and dynamic, unrestrained handling of time and space he found implied in Chevrillon's descriptions of Benares in his travel book. The fact that it was Indic metaphysics rather than Indic art that inspired Strindberg enabled him to anticipate a very modern way of thinking about both nature and art. Michael Sullivan, writing about the relationships between Western and Eastern scientific as

well as aesthetic concepts, describes clearly the importance of this
way of thinking:

Space and time, we have come to feel, are infinite, and our knowl-
edge of them can be but partial and relative. Solid matter has dissolved
into an accretion of particles in an eternal state of agitation. Such a
view would seem the natural one to any thinker in the Hindu-Buddhist
world. For the basic ambiguity of our concept of matter, and particu-
larly for the illusory nature of sense data, the Buddhist philosopher
would use the term Māyā (illusion), while, when referring to the idea
of continuous change, he would speak of Sunyata (the Void) or Samsāra
(the chain of existence in which all things are forever coming together,
dissolving and coalescing again into new transient patterns).[77]

A world created by the deceptive illusion of Māyā and the
endless dissolving and coalescings of Samsāra was precisely what
Strindberg tried to indicate that Indra's daughter experiences on
her journey to Earth in *A Dream Play*. The Daughter explains Māyā's
origin and meaning to the Poet at the end of her earthly journey
by relating an aphorism that echoes a passage marked in the mar-
gin of a book owned by Strindberg after 1895:[78]

In the dawn of time, before the sun shone, Brahman, the divine pri-
mal force, allowed itself to be seduced by Māyā, the world mother,
into propagating. This contact between divine and earthly substances
was heaven's original sin. And so the world, life, and human beings are
only an illusion, a phantom, a dream image. . . . (SV 46:115)

Strindberg's ready receptiveness in the mid-1890s to such East-
ern metaphysical concepts as Māyā, the organic power of *natura
naturans* (see chapters 1 and 5), and the illusoriness of time and
space had probably been primed (as we have seen about many
of his philosophical ideas throughout this study) by his readings
twenty years earlier in Schopenhauer's *World as Will*, where we
find passages like the following:

[T]he ancient wisdom of the Indians declares that "it is Māyā, the veil
of deception, which covers the eyes of mortals, and causes them to see

a world of which one cannot say either that it is or that it is not; for it is like a dream, like the sunshine on the sand which the traveller from a distance takes to be water, or like the piece of rope on the ground which he regards as a snake."

[N]atura naturans ["Creative nature"], as such and in itself, knows nothing of space and time. . . . [Consequently,] space and time, on which rests the possibility of all plurality, are mere forms of our perception or intuition.[79]

Space and time are also illusory in mythology, which both Gauguin and Strindberg used extensively in their work, but mythic images serve different purposes in Gauguin's paintings and Strindberg's plays. For Gauguin, they functioned both as reminders of the genuinely *primitif* and as means of suggesting the presence of a utopian atmosphere, frozen in time. Strindberg, recognizing that the tensions and conflicts implicit in myth's metamorphic nature made it a seedbed of drama, borrowed not only its *primitif* authenticity but its turbulent energies. These energies were the basic ingredients of his art—before *and* after the Inferno years—because through them, says Johan Cullberg, "he externalized his conflicts and let his deepest contradictions take on a life outside himself."[80]

A good example of an encounter that shows Strindberg in the process of borrowing from the energies of myth is in a passage in the 1895 essay "Extraordinary Sensations" ("Sensations détraqués").[81] The essay's narrator describes how during a visit to Versailles, he reacted to a mysterious, irresistible force, enticing but frightening: "I rebel against this blind, brutal power, and in order better to combat it, I personify it, turn it into a god" (SS 27: 535). Psychologically, inner turmoil has prompted the narrator to fantasize about the source of his anxiety, as other of Strindberg's narrators had done in the past. For example, in *Son of a Servant Woman* the narrator relates how "Johan" (Strindberg's alter ego) had dealt with an anxiety-producing episode as a young man on a wooded island outside Stockholm:

Distress magnified his sense of self; the impression that he struggled against an evil power provoked his power of resistance to the point of

defiance. The desire to battle fate was aroused, and, without thinking about it, he pulled a long, sharp stick from a pile of fencing materials. It became a spear in his hand and a club. He tore into the woods, knocking down the branches around him as if he were fighting with these dark giants. (ss 19:93)

In both of the instances cited, fantasizing does more than help the narrator personally to deal with the anxiety: it carries artistic potential.[82] Turning "brutal" or "evil powers" into supernatural or mythic personifications—gods or "dark giants"—invests the battles against them with stormy emotional energies. Mythic metamorphoses make drama possible.

The decision to transform a mysterious power by personifying and then deifying it—a typical device of the Romantics[83]—also offers a valuable insight into the psychology of Strindberg's frequent post-Inferno use of mythological allusions.[84] Through them, the presence of an "other" or of something supernatural could be suggested even in a naturalistic setting, creating a context in which a character could experience his contact with the world around him as life confronting life, a context in which all his senses develop intimate, reciprocal relationships with Nature and/or with God. This is as true of a nonrealistic play like To Damascus—in which the Stranger's encounter with strange people in the Asylum (see chapter 6) suggests a mythic hero's underground journey to the realm of shades—as of the more realistic Dance of Death, in which the guilt-ridden Captain has a sudden, brief, mysterious late-night visit from an old woman. Afterward, he asks his wife:

CAPTAIN: Who was that at the door? Was that anyone?
ALICE: Yes, old Maia from the poorhouse went by.
CAPTAIN: Are you sure?
ALICE: Are you frightened?
CAPTAIN: I, frightened? Of course not! (ss 34:64)

The Captain's bravado is not convincing. We recognize that he has encountered a mythopoeic embodiment of his own innermost fears.

Mythopoesis is also characteristic of Munch's paintings, as his characters' feelings spill over into the worlds around them. In contrast to Gauguin's paintings, however, Munch's are filled with overt dramatic tensions, and Strindberg understood their dynamics well. This is evident in his essay on Munch in 1896 for the Symbolists' and Nabis' journal *Revue Blanche*. The essay's primary purpose may have been to help introduce Munch to esoteric circles when he arrived in Paris for a stay that year, but Strindberg's comments are as revealing about himself as they are about Munch, or as they were about Gauguin. As in his earlier essay on Carl Larsson (see chapter 2), his interpretations, even when they accurately describe the painter's intentions, are probably also indicative of the changes taking place in his own aesthetic attitudes. More importantly, in the case of Munch, we find seeds planted for future plays.

To Strindberg, Munch's *Scream* conveyed precisely the kind of dramatic mythopoeic setting — life confronting life — that we have been discussing. Reflecting Munch's own description of the hallucination that inspired the painting — "I felt a loud, unending scream piercing nature" [85] — Strindberg writes of "a scream of terror before a Nature reddening with fury and preparing with storm and lightning to address the small confused ones who imagine themselves to be gods without resembling gods." [86] A very different mythopoeic view was presented by Przybyszewski, who interpreted the pathetic figure in *Scream* as terrorized because "his sexuality has crawled out of him and now it screams through all of nature for a new means of manifestation in order to do more than live through the same torture, the same battle all over again." [87] Where Strindberg saw an expression of primal existential angst in the humbling of a mortal by the gods, Przybyszewski also pictured a victim, not of divine beings, but of the forces of sexuality: "The mind has been destroyed, and sex, the primevally eternal, screams out for new victims." [88] Strindberg's broader, more metaphysical view of the situation foreshadows both his reworking in 1897 of his little creation play *Coram Populo* (with its cynical final line: "Thus goes the world: when the gods are amused, mortals are abused") [89]

and his return to drama in *To Damascus*, in which the protagonist suspects he is being persecuted by supernatural forces.[90]

Personification is also present in Munch's *Mystique of a Summer Night*, which Reinhold Heller portrays as "a view of the seashore in a nocturnal mystical summer vision that seems to transform stones and trees into living creatures."[91] Strindberg's assessment of the painting (which he calls *The Shore*) contains an even stronger sense of empathy with a mythopoeic Nature: "The wave has broken the branches, but the roots, the subterranean, revive, creeping over the barren sand to drink at the eternal spring of Mother Ocean! And the moon rises, like the dot of the 'I' completing the gloom and the infinite devastation."[92]

In Strindberg's portrayal of Munch's *Evening on Karl Johan Street*, the subject is not how characters' feelings are reflected in nature, but how they modify people's physical appearances. Munch's deathly pale, masklike faces, says Strindberg, turn strollers on Kristiania's (Oslo's) main thoroughfare into the living dead, as metaphor threatens to become real: "The sun is fading, night falling, and twilight is transforming the living into ghosts and corpses at the moment that they are going home to wrap themselves in the shrouds of their beds and surrender to sleep. This apparent death which restores life, this ability to endure which originates in heaven or hell."[93]

The passage reads like a theosophical description of the living death of the astral plane (see chapter 6) in which the characters in *The Ghost Sonata* (written more than a decade after the essay) reside. This is the state of "apparent death which restores life" in which the Mummy exists in the beginning of the play. And here, too, metaphor threatens to become real. From one of the servants we learn that the Mummy "thinks she's a parrot, and who knows? Maybe she is" (SS 45:176). Strindberg, working close to the boundary between the metaphorical and the literal, anticipated the later, broader distortions of Expressionistic drama, just as his working close to the boundary between dream and reality would anticipate Surrealism. More radically, Strindberg's tensions suggest, in

a very modern way, that not only the integrity of reality is threat-
ened but so is the ability of language to portray that reality.

"Cemetery Sketches": From the Cocoon to the Butterfly

Visual images that prompt the imagination to explore esoteric
meaning, visual images that have the power to generate drama—
these become talismans in Strindberg's post-Inferno drama and
are foreshadowed by elements in yet another Inferno period essay,
"Cemetery Sketches," published in *Revue des Revues* in July 1896, a
month after the Munch essay appeared in *Revue Blanche*. This short
but important piece, very much in the Romantic graveyard tradi-
tion,[94] was the direct result of Strindberg's musings during walks
in the summer and fall of 1895 through Paris's Montparnasse
cemetery and marks the first time he experimented comprehen-
sively with the problems of incorporating his Inferno years' im-
pressions and discoveries into his work. Throughout are signs of
the conscious artist stirring: a passionate commitment to a new
style, a daring to advance boldly across boundaries that he had
earlier investigated only tentatively. Almost effortlessly, his prose
moves into poetic suggestion, and his sharp attention to realistic
detail shifts into literary allusion and then into mythopoeic reso-
nance. And yet, despite the apparently new boldness, the essay
also evokes feelings of déjà vu, as if we were watching a painter
pick up his palette after long neglect and brush old, trusted hues
onto his canvas.

Though ostensibly a report of impressions gathered during a
series of wanderings, the essay is cast in the form of a single jour-
ney, broken in time, a quest toward a particular goal. The narrator
seeks nothing less than a return of a sense of purpose in his life,
and this makes him anxious, right from the start of his journey,
as though he were expecting something important to happen. At
one point he confesses: "I would gladly become a believer again,
but cannot, for I crave a miracle" (ss 27:598). Only a few years

later, this would become the explicit or implicit craving of a num-
ber of Strindberg protagonists in novels like *Inferno* and plays like
To Damascus.

The atmosphere throughout the essay is one of mutability and
change, expressed in various ways, from references to illustrious
names on the headstones and memorials to the falling of autumn
leaves. At one point, theosophical themes resound in the remark
by the essay's narrator that people had warned him against visit-
ing the cemetery "because of the unhealthy vapors" there, vapors
that bear a strong resemblance to disembodied spirits wandering
restlessly in the astral plane. For example, when he returns to his
apartment after his cemetery visit, a bad taste lingers in his mouth
for hours, because "there were souls, that is to say, dematerialized
bodies, hovering in the air" (ss 27:595).

A companion on his wanderings is a mocking blackbird, who
takes a special interest in the narrator, flying over him along the
well-kept paths between graves like a worldly-wise escort and
occasionally pointing out lessons to be learned: "my guide lifts
his wings and leads me further into the cemetery labyrinth, all
the while whistling an unusual call that I would dearly love to
understand." Foreshadowed by this avian guide is the character
of the Beggar in *To Damascus*, who carries a linden twig (a tradi-
tional bait for luring wild birds) and a starling in a cage (ss 29:
113), and who pops into the protagonist's life from time to time
like some mysterious messenger in a fairy tale, puzzling and dis-
turbing the Stranger but persistently urging him—a tired writer
whose career and personal life are in tatters—to seek wholeness
and reconciliation.

The craving for a miracle is almost satisfied in a solemn
confrontation scene that is brought to life in the narrator's
imagination in a vision that resembles one of Strindberg's wood-
nymphistic exercises. In the sky the horizontal line of a cloud is
transformed as it suddenly rises up in the sky,

resembling the [statue of the] Belfort lion supported on its hind legs,
and become vertical. I've never seen anything like this, except in paint-

ings representing the Last Judgment. The black lines of the figure drift apart, and the heavens assume the form of Moses' Sinai tablet, immeasurably large, but sharply drawn. And on this slate panel of sheet-metal gray is now written by lightning, which cleaves the firmament, in clear, readable strokes: "Yahweh," the God of vengeance!

But there is also a skeptical note: "The atmospheric pressure caused me to bend my knees; but since I heard no response from the heavens except thunder, I went home" (SS 27:598). A similar reference to a protagonist reluctant to bend his knee as a sign of acknowledging the authority of the divine appears in To Damascus. There it represents a Promethean defiance in the Stranger that smacks of hubris. He is found unconscious after a mysterious wrestling match at the top of a mountain, and only after he finally does bend his knee, does he realize a measure of peace.[95]

The visual catalyst for the reference in the play, the image that Strindberg translated into dramatic action, was a visit to Delacroix's mural of Jacob Wrestling with the Angel in the Saint-Sulpice Church in Paris in the fall of 1897, significantly, after Strindberg had learned from Swedenborg to read images allegorically (see chapter 7). Here, in a single dramatic scene, were the themes that dominate the play as they earlier dominated the cemetery essay: the anguished tension between human longing and apparent divine silence, between skeptical questioning of the meaning of divine will and reluctant yielding to that will. In the novel fragment Jacob Wrestles the narrator says that the mural "constantly gives me something to think about" (SS 28:329). When he exits the church amid kneeling worshipers, he retains the memory of the wrestler who is injured while struggling with the angel of the Lord even as he earned the angel's respect for his defiance: "he holds himself upright despite his injured hip tendon" (329).

In the cemetery essay the narrator's matter-of-fact reaction— he goes home after hearing no clear divine response—introduces a note of ironic humor that undercuts some of the solemnity of the piece, almost as if the author were reminding us that he was both an impassioned witness and a dispassionate literary observer

of the event. The Lord may have spoken, but the wanderer was waiting for more tangible evidence of a miracle.

One July morning, the narrator's attention is drawn to a woman who is apparently waiting for someone among the graves. After a five-week trip abroad, he sees her again and is surprised by the visual transformation in her appearance:

> [H]er emaciated body was outlined against the cross behind her, as if she had been crucified—above was the inscription O Crux, ave spes unica! [O Cross, our only hope!]
>
> I approached and observed more closely the devastation her face had undergone within so short a time. It was like seeing a corpse in a crematory under its asbestos mantle. Everything that resembled a human form was there but burnt to ashes, lifeless. . . . Sun and rain had bleached the colors from her coat; the flowers in her hat had yellowed like the linden trees; even her hair had paled. . . . She waits here, constantly, day after day. Mentally disturbed?
>
> Yes, someone seized by the great madness of love! (ss 27:597)

The depiction of the woman is striking, not only because of its graphic vividness, but because no visual image in Strindberg's Inferno years' writings demonstrates more clearly and unmistakably both the continuity with his earlier work and some of the future choices he would make as a dramatist in the post-Inferno period. First, there is an echo of 1880s' works like "Pangs of Conscience" and Development (see chapters 1 and 2) in the linking of the woman's plight with Christ's Passion. Christian iconography would once again assume the powerfully suggestive role it had in Strindberg's earlier writings, and he would later select the inscription mentioned—"O Cross, our only hope!"—for the simple wooden cross that marks his grave today in Stockholm. Second, it became one of the visual catalysts for the play Crime and Crime: while Jeanne, Maurice's lover, waits for him with their child in the Montparnasse cemetery, a woman in mourning kneels in prayer at a nearby grave. When Maurice finally shows up, only to abandon Jeanne and their child, the kneeling woman is like a visual echo of the despairing Jeanne, who says "O Cross, our only hope." Third,

as in the Munch essay, there is the visual description of a character's appearance transforming to correspond to her feelings. And finally, there is a plastic handling of time: the woman and her clothes have become timeworn and deteriorated over an unusually short period. This is not unlike the visual metamorphosis of the pathetic Officer in *A Dream Play*, who waits in vain outside the theatre for his beloved Victoria. Although the actual time that elapses during his waiting is only a few minutes, he, too, ages visibly, his clothing turns shabby, and the flowers he carries for Victoria wither and fade. He, too, is a victim of the great madness of love.

The essay's narrator, meditating on the evidence around him of life's transience, wonders about the usefulness or purpose of encouraging children to dream about fanciful ideals: "Why do we tell children . . . fairy tales about a Promised Land, about trolls and goblins and giants, without telling them that it's all lies?" (ss 27:604). His answer reflects the renewed faith in the mission and purpose of the teller of fairy tales that became one of Strindberg's prime motivations for returning to belles lettres: "To let the child through images undergo his phylogenesis, in other words, live through past phases of his existence, just as the fetus in the womb passes through the entire chain of its evolution as an animal" (604).[96] Science would admit this, says the narrator, "if it were honest." An implication is that perhaps only in the imaginative play of myth and fairy tale and their natural expression in literature are we able to be simply and honestly human in a way that is true to our nature. Maybe the Golden Age never existed, but the narrator insists that we are "the corrupted heirs of its blissful ones, whom we can never forget, lamenting their loss like a child crying on its arrival in a world in which it feels a stranger" (604).

Once again, a Strindberg passage is dense with suggestive imagery that echoes his past work as well as foreshadows future work. In the references to lamenting the loss of a Golden Age and feeling like an anxious child in an alien world, he never expressed more eloquently that special tension that exists in all his work between a sadly nostalgic dream of impossible utopian ideals and a candid, often brutally realistic appraisal of the cruel dystopian

world within which his characters always feel like strangers. Significantly, the protagonist in *To Damascus* is referred to simply as the Stranger, and his story is told with resonances from many mythological sources.[97] These literary—or preliterary—sources have the capacity to bridge the gap between utopian dream and dystopian reality, because through their power to reconcile the impossible contradictions of this life, even if only temporarily, they activate the energies of the imagination. In a 1902 letter to his German translator, he explains sending an enclosed volume of stories, written while he was preparing to write about the concept of God in history (see chapter 3): "my imagination wants refreshing through fairy tales. Be that as it may, here come fairy tales" (Brev 14:237). Before his intellect and understanding could come to grips with the problem of expressing a complex idea, he needed fairy tales to stretch the limits of his imagination.

The miracle for which the narrator in the essay has so long waited arrives, one might say, in stages. The first stage is a sign that something portentous is on the way: "The night breeze has shaken the linden trees, and—a miracle!—the buds, held in safekeeping until next year, have unfolded, so that the black skeleton of the tree bears new green, like Aaron's rod" (SS 27:599). This is not the last time in Strindberg's late works that we find a reminder of the suddenly blooming grapevine in "Pangs of Conscience," where we began our exploration of Strindberg's image worlds. And in each instance, the witnessing of a sudden surge of life—Dylan Thomas's "force that through the green fuse drives the flower"— is like an extraordinary largess that triggers a burst of imaginative energy in response. A similar situation (and a reminder of the continuing legacy of Strindberg's woodnymphistic experiments) was the later incident that would become the visual catalyst for the chamber play *The Burned Site* (1907). During a morning promenade with Strindberg, according to his companion, August Falck, they passed the site of a building that had burned the night before:

A large quantity of household goods was assembled in the courtyard. We stopped. Strindberg put his hand on my arm and pointed past the

yard. In an instant he had seized upon the theatrical effect of an apple tree, iced over, that had bloomed under the heat of the fire and stood there like a revelation in the midst of the soot and the homelessness.

That burned site had given him his "gift"—as he always said.[98]

In the cemetery essay is another "gift": the delivery, at long last, of the miracle, carried in the beak of the blackbird, the special messenger, and it turns out to be an even more eloquent symbol of transformation than blooming linden or apple trees:

a butterfly cocoon, with that unique form, unlike any other in the animal kingdom. A frightening image, a monster, a troll's cap, neither animal, vegetable, nor mineral. A shroud, a grave, a mummy, which has not been born, since it has no ancestors on earth, but has been made, created by someone.

The great Artist-Creator has amused himself by creating for the sake of creating—like any ordinary artist—perhaps a symbol. I know quite well that this mummy contains only animal slime, formless, without any structure at all, and with the stench of a fresh corpse. And yet this splendid thing is endowed with life, with the instinct for self-preservation, since it squirms on the cold iron and is prepared to attach itself with threads if it feels in danger of being shaken loose.

A living corpse, which will surely be resurrected! (ss 27:605)

There was a doubly prophetic quality to this mummy image, clinging to self-preservation. First, it foreshadowed the Mummy in *Ghost Sonata*. Second, the essay was published the same month—July 1896—that Strindberg suffered his breakdown, which began the final, most difficult phase of all the Inferno years. But as was true of the mummy-cocoon, there was life within the artist, and it was awakened in the spring of 1897 with his discovery in Swedenborg of the power of images as revelations and as renewers of the imagination.

Poetic Imagination and Ethical Imagination

Strindberg's definitive return to belles lettres with the novel *Inferno* in late 1897 detonated an explosion of creative activity for him.

The cocoon had burst and the butterfly emerged. In one four-year period alone, 1898–1902, he wrote twenty-one full-length plays, three or four of which—*A Dream Play, Dance of Death, Easter, Erik XIV*—remain standard parts of the international repertoire, and still to come were the masterly chamber plays, five years later. By the time he died in 1912, the full listing of post-Inferno writings alone included thirty-seven plays, a dozen collections of fiction, essays, or poems, eight novels or novellas, and some three thousand letters.

The artist's long, off-and-on affair with the imagination—now hostile, now friendly—had become a settled relationship, but an ambivalence was still present. Though a member of a generation of artists and writers who, like their Romantic predecessors, redeemed the imagination from the abuse of rationalist philosophers or skeptical critics, he differed from some of his more-extreme contemporaries by maintaining a balance in his approach to its power. Rather than allowing the *poetic-fantastic* aspects of imagination to dominate, as did so many Decadents, Symbolists, and, later, Surrealists, he fused these aspects to his already well-rooted *ethical* imagination, the driving force behind his interest in and enthusiasm for art's sociopolitical and historical dimensions (see chapter 3). Consequently, even as he probed nature for mystical universal correspondences, he continued, as he had done earlier, to probe society for contradictions and injustices, contemporary as well as historical. However much he allowed chance or imaginative impulse to direct his creative activities, he never severed his roots in the sociopolitical implications of the historical imagination, and a number of post-Inferno historical dramas—particularly *Gustav Vasa* and *Erik XIV*, with their incisive examinings of the democratic, egalitarian responsibilities of those in power—are among his most-accomplished works.

In Strindberg's later history plays, historical patterns demonstrate through correspondences the visible workings of God's invisible plan for the universe, with individual monarchs serving as instruments of that plan. If there was a new urgency on the playwright's part to acknowledge that plan, it may be because the

general emphasis on spirit over matter by the Occultists reminded him of the appeal that he had Gert Bookprinter make in *Master Olof*, thirty years earlier. Trying to goad Olof to action against royal and clerical tyranny on a Pentecost—the time of the coming of the Holy Spirit—Gert tells him not to listen to "the death cry that everything is fine, because then the Millennium, the kingdom of freedom, will never come to pass, and that's exactly what's beginning now!" (ss 2:23). Echoed is the belief, first voiced in speculations by the medieval monk Joachim of Fiore (see chapter 3), that a new Millennium implied the coming of a third age, the Age of the Holy Spirit, which would succeed the Age of the Father (the Old Testament) and the Age of the Son (the New Testament).

As we have seen (chapter 6), many artists and intellectuals throughout Europe at the turn of the century shared Strindberg's sense that a new spiritual age was dawning, and their hopes were expressed in much the same terms. For Kandinsky, says Sixten Ringbom, "art and nature form two different realms but they are both subject to laws and in the last resort parts of the great realm of the Third Revelation, the revelation of the spirit in art as well as in nature."[99] Kandinsky viewed abstract art as the most meaningful form of that revelation. In Strindberg's post-Inferno histories, the revelation is expressed in sociopolitical terms similar to those that in the 1870s allowed him to use Gert Bookprinter as symbol of both Holy Spirit and revolution. It is this symbolic function—suggesting the possibility of radical change to a new, more just, more equitable form of human society—that informs the dialogue at the end of the little 1905 story about the last days of the French Revolution, "Days of Judgment" (see chapter 3). When François, the young aristocrat, expresses his sense of relief at the realization that Napoleon has assumed power, "The Revolution is over," and the old rebel replies, "*That* Revolution," the implication is that no individual revolutionary idea or party can ever be sole proprietor of the promise of freedom and equality that drives the theme. "It is possible," said Northrop Frye, "that social, political, or religious revolution always and necessarily betrays a revolutionary ideal of which the imagination alone preserves the secret."[100]

From our vantage point eighty years after Strindberg's death, we can see that the cycle of devaluation and revaluation of the imagination that he witnessed during his career has been repeated several times, the last occurring within the last quarter of the twentieth century. Across the whole spectrum of contemporary criticism today—structuralism, poststructuralism, deconstructionism—says Richard Kearney, the imagination is regarded "as an outdated humanist illusion spawned by the modern movements of romantic idealism and existentialism." [101] Except for the reference to humanism, the condemnation is remarkably similar to criticism made by Georg Brandes more than a century ago (see chapter 2). Taking an ethical position with an emphasis on social relevance, Brandes also considered the imagination outdated, insisting that the view that it was the only thing that mattered in poetry "applies only to a certain kind of poet and poetry: the Romantic. In our day it is not the gift for invention that we expect of a poet and search for in his works, it is a sense of reality." [102] Yet, by the 1890s, another pendulum swing in the arts had restored the poetic imagination to a position of honor and dominance. Imagination is dead—Long live imagination!

Postscript

In the long, continuing, tragic-comic history of the effort to understand the role of imagination in art, the uniqueness of Strindberg's contributions lies in the range and balance of attitudes he maintained toward it: from profound skepticism and even hostility to mystical faith, from a historical perspective with an ethical dimension to pure fantasy. One character in his post-Inferno drama epitomizes this range and balance: the Poet in *A Dream Play.* Like Strindberg himself in the final Inferno years, he is trying to resolve a tangle of contradictions within himself: an artist who has lost confidence both in art and in his own artistic talents, a skeptical believer who is searching to regain his faith, a politically sophisticated writer with extraordinary gifts of creative hallucination.

But there is irony in the way the Poet is handled. The central character is Agnes, the daughter of Indra, whose descent to Earth provides the journey structure for *A Dream Play,* and he is only a supporting player. He is almost abstractly drawn; we know virtually nothing about the details of his life. Though his relationship with Agnes is probably the most important one she has during her journey, the character is much less developed than the other men, the Officer and Lawyer, with whom she also has personal relationships. Moreover, his first appearance is late in the action, and Strindberg does not give him a great deal to do. Indeed, of all the male-female relationships in Strindberg's plays this one is undoubtedly the most tantalizingly sketchy. Ingmar Bergman, in his brilliant 1970 production of *A Dream Play,* successfully prevailed over the sketchiness by placing the character onstage for most of the action, thus turning him into a kind of godlike stage manager or fellow witness with Agnes of the imaginative play of metamorphoses that take place. While in the text proper the Poet does gradually occupy more and more of her attention, the development of the character has an improvised quality, as if Strindberg added it after he began writing the play, the result not of conscious planning but of an imaginative impulse—a woodnymphistic whim. Perhaps Strindberg, freed at last from the baggage of autobiographical detail he had unloaded on the character of the Stranger in part I of *To Damascus* (finished only several months before he began writing *A Dream Play*), had found another way to reveal his deepest feelings about what mattered most to him as an artist.

The Poet (like the play's author) has a rich poetic imagination, but his ethical imagination has pinched and repressed its creative outbursts. His social conscience makes it difficult for him to dream or fantasize, just as the Lawyer's imagination is hobbled by his social conscience. In the course of the action of *A Dream Play,* Agnes becomes a muse, another kind of Beatrice to the Poet's Dante, reintroducing him to the importance of art and eventually reconciling him with his calling. In this way, she fulfills the same role played by the Indic god Agni, who initiated men "into the art of

poetry and gave them inspiration," according to a source much admired by Strindberg in 1896: Viktor Rydberg's *Teutonic Mythology*.[103]

But Agnes has little luck breaking through the Poet's skeptical attitude toward the world in general and art in particular until she takes him to the place to which she had earlier taken the Lawyer on a similar journey of revelation: Fingal's Cave on Staffa Island. We have seen the special role played by caves in Strindberg's works (see chapters 1 and 4)—a place of magical transformations, the very wellspring of the imagination. The Romantic Organist had seen a picture of Fingal's Cave in a book and it became a visual catalyst for his fantasies: "from that day on, the [Jacob's Church] organ was a great basalt grotto and the organ bellows was Aeolus, King of the Winds" (ss 21:232). And Lieutenant Bleichroden in "Pangs of Conscience" found a similar stimulating catalyst in the cavelike hall in the Swiss hospital.

Horace Engdahl, writing about Swedish Romanticism, described such a location in an artist's work as an "imaginational space with unlimited transformational potential; a space in which visions and voices can crisscross without the need of satisfying the demands of space, time, causality, and reality." [104] Fingal's Cave served the same purpose in Strindberg's imagination, a place of visions and voices outside ordinary time and space. In *A Dream Play* the evocative atmosphere of the shadowy place causes the Daughter to remember the many things she has experienced. As she recites them, the Poet begins to understand the vital role the imagination has to play as mediator between art and nature, dreams and reality:

DAUGHTER: . . . all these things I have dreamed . . .
POET: All these things I have written . . .
DAUGHTER: Then you know what poetry is . . .
POET: Then I know what dreams are . . . What is poetry?
DAUGHTER: Not reality, but more than reality . . . not dreams, but waking dreams . . .
POET: And the children of man think we poets only play . . . only make-believe! (sv 46:91)

But in the end, no matter how vibrantly visual catalysts or waking dreams set the artist's imagination in motion, he must eventually translate them into images of his own, images eloquent enough to express his own truths, and in that search he knows he is doomed to fall short. A century before *A Dream Play*, in Shelley's *Prometheus Unbound*, the Demogorgon regrets that the "abysm" cannot "vomit forth its secrets" because "the deep truth is imageless" (II.iv.114–16).[105] In the same spirit, Agnes has a message of caution when the Poet asks her to relate her sorrows:

DAUGHTER: Poet, could you tell me yours so completely that every word counted? Have you ever found words equal to the moment?
POET: No, you're right. I've always thought of myself as a deaf-mute. Whenever my songs were admired, they seemed only noise to me. (SS 46:325–26)

Despite the shortcomings of art and imagination—the frustration that inevitably accompanies the act of creation, the gap that must inevitably remain between the real and the ideal, and the pain that creation can cause to the artist and his subject alike— the Poet in *A Dream Play* sees, as Strindberg himself must have seen after the Inferno years, that the artist's mission remains an honorable one. The "deep truth" may be "imageless," but the paradox of the Poet, as Paul Cantor says of Shelley, is that he "can only work through images to convey that truth."[106] When his soaring vision is modulated by an earthy realism, his instinct for fantasy tempered by an ethical awareness, he has an unusual and advantageous perspective, as Agnes reminds him:

Farewell, child of man, you dreamer,
You poet, who understands best how to live.
Hovering on your wings above the world,
You plunge to earth from time to time,
But just to brush against it, not be trapped by it! (SS 46:121)

Appendix 1

Strindberg's Plays

A Name Day Gift	En namnsdagsgåva (1869)
The Freethinker	Fritänkaren (1869)
Hermione	Hermione (1870)
In Rome	I Rom (1870)
The Outlaw	Den fredlöse (1871)
Master Olof	Mäster Olof
The Prose Version	Prosaupplagan (1872)
The Middle Version	Mellandramat (1874)
The Verse Version	Versupplagan (1876)
The Epilogue (Creation Play)	Efterspelet (ca. 1877)
In the Year '48	Anno fyrtioåtta (ca. 1876−77)
The Secret of the Guild	Gillets hemlighet (1880)
Lucky Per's Journey	Lycko-Pers resa (1882)
Herr Bengt's Wife	Herr Bengts hustru (1882)
Comrades	Kamraterna (1886−87)
The Father	Fadren (1887)
Miss Julie	Fröken Julie (1888)
Creditors	Fordringsägare (1888)
The Stronger	Den starkare (1888−89)
Pariah	Paria (1889)
The People of Hemsö	Hemsöborna (1889)
Samum	Samum (1889)
The Keys of Heaven	Himmelrikets nycklar (1892)
Debit and Credit	Debet och kredit (1892)
The First Warning	Första varningen (1892)
Facing Death	Inför döden (1892)
Mother Love	Moderskärlek (1892)
Playing with Fire	Leka med elden (1892)
The Bond	Bandet (1892)
To Damascus I	Till Damaskus I (1898)

To Damascus II	Till Damaskus II (1898)
Advent*	Advent (1898)
Crime and Crime	Brott och brott (1899)
The Saga of the Folkungs	Folkungasagan (1899)
Gustav Vasa	Gustav Vasa (1899)
Erik XIV	Erik XIV (1899)
Gustaf Adolf	Gustav Adolf (1900)
Midsummer	Midsommar (1900)
Kasper's Shrove Tuesday**	Kaspers fettisdag (1900)
Easter	Påsk (1900)
The Dance of Death I	Dödsdansen I (1900)
The Dance of Death II	Dödsdansen II (1900)
The Crown Bride	Kronbruden (1901)
Swanwhite	Svanevit (1901)
Charles XII	Karl XII (1901)
To Damascus III	Till Damaskus III (1901)
Engelbrekt	Engelbrekt (1901)
Christina	Kristina (1901)
A Dream Play	Ett drömspel (1901)
Gustav III	Gustav III (1902)
The Flying Dutchman	Holländarn (1902)
The Nightingale in Wittenberg	Näktergalen i Wittenberg (1903)
Dramas of World History	Världshistoriska dramer (1903)
Moses	Moses
Socrates	Sokrates
Christ	Kristus
Summer Storm	Oväder (1907)
The Burned Site	Brända tomten (1907)
The Ghost Sonata	Spöksonaten (1907)
The Isle of the Dead	Toten-Insel (1907)
The Pelican	Pelikanen (1907)
The Last of the Knights	Siste riddaren (1908)

*Advent is the fourth Sunday before Christmas, a time of penitence.
**Shrove Tuesday is the day before Ash Wednesday.

Strindberg's Plays

Abu Casem's Slippers	*Abu Casems tofflor* (1908)
The Regent	*Riksföreståndaren* (1908)
The Earl of Bjälbo	*Bjälbo-Jarlen* (1909)
The Black Glove	*Svarta handsken* (1909)
The Great Highway	*Stora landsvägen* (1909)

Appendix 2

Nondramatic Strindberg Texts Mentioned in Book

"The Visit"	"Besöket" (1868)
The Red Room	Röda rummet (1879)
The New Kingdom	Det nya riket (1882)
Swedish Destinies and Adventures	Svenska öden och äventyr (1882–1904)
The Swedish People	Svenska folket i helg och söcken (1882)
"Biographically"	"Biografiskt" (1883)
Development	Utveckling (1883)
The Isle of Bliss	Lycksalighetens ö (1884)
"Pangs of Conscience"	"Samvetskval" (1884)
"The Universal Discontent: Its Causes and Cures"	"Om det allmänna missnöjet, dess orsaker och botemedel" (1884)
Getting Married	Giftas (vol. 1: 1884; vol. 2: 1885)
"Above the Clouds"	"Över molnen" (1885)
"The Familistère in Guise"	"Familistèren i Guise" (1885)
"For Payment"	"Mot betalning" (1885)
"Relapse"	"Återfall" (1885)
Utopias in Reality	Utopier i verkligheten (1885)
The Son of a Servant Woman	Tjänstekvinnans son (1886–1909)
The People of Hemsö	Hemsöborna (1887)
Men of the Skerries	Skärkarlsliv (1888)
The Romantic Organist on Rånö	Den romantiske klockaren på Rånö (1888)
"About Modern Drama and Modern Theatre"	"Om modernt drama och modern teater" (1889)
By the Open Sea	I havsbandet (1890)
"A Witch"	"En häxa" (1890)
Vivisections	Vivisektioner (1890–91)

A Madman's Defense	En dåres försvarstal (1893/1895)
"Extraordinary Sensations"	"Sensations détraqué" (Sw.: Förvirrade sinnesintryck) (1894)
"The New Arts! The Role of Chance in Art"	Strindberg's manuscript title was "Des arts nouveaux! Ou le hasard dans la production artistique"; the published title was "Du Hasard dans la production artistique" (1894)
"The Barbarian in Paris"	"Barbaren i Paris" (1895)
"Cemetery Sketches"	"På kyrkogården" (1896)
Jardin des plantes	Jardin des plantes (1896)
"The Sunflower"	"Solrosen" (1896)
Inferno	Inferno (1897)
"A Look into Space"	"En blick mot rymden" (1897)
Jacob Wrestles	Jakob brottas (1898)
Legender	Legends (1898)
Fairy Tales	Sagor (1904)
Gothic Rooms	Götiska rummen (1904)
"Days of Judgment"	"Domedagar" (1905)
Historical Miniatures	Historiska miniatyrer (1905)
Black Banners	Svarta fanor (1907)
"The Doppelgänger"	"Dubbelgångaren" (1907)
Blue Books	En blå bok (vol. 1: 1907; vol. 2: 1908; vol. 3: 1908; vol. 4: 1912)
Open Letters to the Intimate Theatre	Öppna brev till Intima teatern (1909)
Talks to the Swedish Nation	Tal till svenska nationen (1910)
The Occult Diary	Ockulta dagboken (written in 1896–1908; facsimile edition published 1977)

Notes

Introduction

1. Though Strindberg adopted the Swedish terms Överklass (Overclass) and Underklass (Underclass) from polemical writer Nils Quiding's The Settling of Accounts with Swedish Law (Slutliqvid med Sveriges lag), he is generally credited with giving them the currency they still enjoy in the Swedish language.

2. Alfred de Vigny, Réflexions sur la vérité l'art, in Cinq-mars. Cited by Levin, Gates of Horn, p. 26.

3. Gustave Flaubert, Correspondance, 2:243. Cited by Levin, Gates of Horn, p. 218.

4. Jean-Paul Sartre, The Words. Cited by Tom Bishop, "Superstar of the Mind," New York Times Book Review, 7 June 1987, p. 11.

5. Abrams, Natural Supernaturalism, p. 13.

6. Nilsson, Svensk romantik.

7. Brandell points out that the Symbolists' elaboration of the Romantic enthusiasm for Swedenborg's theory of correspondences "led to little more than an abstract manner of speaking with a broadly mystical ring. Strindberg, in contrast, filled his new picture of the world with a multitude of concrete analogies from many different spheres of activity" (Strindberg in Inferno, p. 239; Strindbergs Infernokris, p. 219). There are references throughout my study to Brandell's pioneering monograph on Strindberg's Inferno years. For this particular passage, I have used Jacobs's English translation, but in other instances I have turned directly to the original, especially concerning passages which were excised in the translation.

8. Rosenblum, Modern Painting and the Northern Romantic Tradition.

9. Maurice Tuchman points out that "the Nazi theory of Aryan supremacy, for example, was indebted to various versions of Theosophy, such as theozoology, which pertains to birth by electric shock into the astral ether, and arisophy, which fuses ideas of karma, the ether, and sun worship with idolatry of Aryan ancestry." See his "Hidden Meanings in Abstract Art," p. 18.

10. Reprinted in Danto, Encounters and Reflections, p. 81.

11. Linde, Efter hand, p. 299.

12. See Feuk, August Strindberg, p. 88. On Book's acknowledgment of Strindberg's influence, see August Strindberg—Carl Kylberg—Max Book, p. 5.

13. Johann Wolfgang von Goethe, Autobiography, 2:278. Strindberg's

German edition (Strindberg Library, catalogue no. 97): *Werke, Auswohl* in sechzehn Bänden (Leipzig: n.d.), 3:138.

1 / The Nature of the Artist:
Romantic Legacies and Archetypal Images

1. Émile Zola, *Les romanciers naturalistes* (Paris, 1881), p. 340. Elsewhere, Zola refers to "the Romantic gangrene" (*L'oeuvre*, ed. Maurice Le Blond [Paris, 1928], p. 66).

2. Cited by Nolin, *Den gode europén*, p. 64.

3. Kärnell says that "[K. E.] Lundevall confirmed that personification, despite outspoken suspicion of the concept, is a common feature in the works of Swedish writers in the 1880s and concludes that Strindberg probably served as a model in this regard" (*Strindbergs bildspråk*, p. 122).

4. The term *Doppelgänger* was invented and first exploited by German Romantic Jean Paul (pseud. for Friedrich Richter) and he defined it as "what people are called who see themselves" ("So heissen Leute, die sich selber sehen"). Cited in "Introduction," *Tales of E. T. A. Hoffmann*, ed. and trans. Leonard J. Kent and Elizabeth C. Knight (Chicago: University of Chicago Press, Phoenix Books, 1972), p. xvi.

One of the sources that may have influenced Strindberg's ideas on character doubling was French association psychologist Théodule Ribot (1839–1916). Ribot's *Les maladies de la volonté* (1883) and *Les maladies de la personnalité* (1885) were owned by Strindberg. Lindström, in *Hjärnornas kamp*, p. 82, notes that though there is no certainty that Strindberg was aware of Ribot's ideas until 1886—that is, after he wrote "Pangs of Conscience"—he might have become familiar with hallucinatory phenomena from other sources. One source named by Lindström is the very Schopenhauer volume that Bleichroden has by his bedside: *Parerga und Paralipomena*. In the essay "Versuch über Geistersehn," Schopenhauer analyzes several instances of "Sichselbstsehen," pointing out that "die nicht seltene Thatsache, dass Kranke, wann dem Tode nahe, sich im Bette doppelt vorhanden wähnen" ("it is not unusual for sick people, when death approaches, to imagine the presence of a double in their beds").

5. Responding to a request from Count Maurice Prozor in 1891 to translate the stories, Strindberg wrote that they were "too cosmopolitan, programmatic, schematically contrived to represent Swedish literature" in France. "Frenchmen will probably say: 'Oh, we knew about all that before: socialism, world peace . . . , old familiar things from 1830 and 1840'" (Eklund, "Efterslåtter bland Strindbergs brev," p. 32).

6. Thorslev, Romantic Contraries, p. 114.

7. For analyses of Strindberg's antifeminism see Lagercrantz, August Strindberg; Lamm, August Strindberg; Meyer, Strindberg; and Sprinchorn, Strindberg as Dramatist.

8. Dijkstra, Idols of Perversity, p. viii.

9. Ollén, Strindbergs dramatik, p. 125.

10. Thorslev, Romantic Contraries, p. 127.

11. See Johannesson, Novels of August Strindberg, p. 71: "Having read Schiller's Die Räuber he identifies with Karl Moor in his revolt against the law, society, customs, religion (ss 18:276). In Byron's Manfred he discovers a kindred spirit, a rebel against heaven and the divine order (ss 18:285)."

Another admirer of Byron's play was Nietzsche: "Mit Byrons Manfred muss ich tief verwandt sein: ich fand alle diese Abgründe in mir—mit dreizehn Jahren war ich für dies Werk reif. Ich habe kein Wort, bloss einen Blick für die, welche in Gegenwart des Manfred das Wort Faust auszusprechen wagen." Cited in Nolin, Den gode europén, p. 197 n. 6.

12. Häggqvist, "Strindbergs 'Samvetskval'"; Lamm, August Strindberg, pp. 166–67; and Edqvist, Samhällets fiende, pp. 257–65.

13. Barzun, Classic, Romantic, and Modern, p. 21.

14. "The strength and originality of [Rousseau's] thought lies in the clarity with which he perceived fundamental contradictions in man's condition: the tension between nature and civilization, the tension between reason and passion, the tension between the extraordinary man and the ordinary community. . . . [C]ontrary to the popular view of Rousseau, he does not advocate simply rejecting civilization and returning to the state of nature. He makes this point explicitly [in The Second Discourse]: 'What! must we destroy societies, annihilate thine and mine, and go back to live in forests with bears? A conclusion in the manner of my adversaries, which I prefer to anticipate rather than leave them the shame of drawing it'" (Cantor, Creature and Creator, pp. xv, 14–15).

15. The term "la multiplicité du moi" is associated with the work of French association psychologist Théodule Ribot (see n. 4, above). The Nietzsche statement was cited by Le Bris, Romantics and Romanticism, p. 193.

16. Cited by Bowman, "Illuminism, Utopia, Mythology," p. 76.

17. "Die Welt selbst mitten entzwei gerissen ist. Denn da das Herz des Dichters der Mittelpunkt der Welt ist, so musste es wohl jetziger Zeit jämmerlich zerrissen werden" (Heinrich Heine, Sämtliche Werke, ed. Oskar Walzel, 10 vols. [Leipzig, 1912–15], 4:333; cited by Wellek, A History of Modern Criticism, 3:199).

18. Thorslev, The Byronic Hero, pp. 88–89.

19. "As a mode of the imagination, mythopoesis became for the nineteenth-century writer a common activity, or at least a frequent goal. From Goethe and Friedrich Schlegel to Thoreau and Whitman, writers called for and got new myths for modern man and heroic literature for the modern adventure. Myth is a major concern of romantic literature, as René Wellek and M. H. Abrams have insisted; it has even been described as one of the distinguishing characteristics of romantic writing" (Feldman and Richardson, *Rise of Modern Mythology*, pp. 297–98).

20. A virtually identical passage appears in Schopenhauer's *World as Will*, another Strindberg favorite. See *The World as Will and Representation*, 1: 275–76.

21. Brandes, *Samlede skrifter*, 5:350, 352.

22. Engell, *The Creative Imagination*, p 138.

23. Ibid., p. 83.

24. Ibid., p. 358.

25. Karsten Harries, "Our Analgesic Culture," *New York Times Book Review*, 14 January 1990, p. 24.

26. Brandell, *Strindberg in Inferno*, p. 33. See also Brandell, *Strindbergs Infernokris*, p. 35.

27. Boëthius, "Stjuttitalets Strindberg," p. 285.

28. Examples of full-length critical studies that include archetypal or mythopoeic approaches to interpretation of Strindberg's work are Fraenkel's *Strindbergs dramatiske fantasi i Spöksonaten*; Johannesson's *Novels of August Strindberg*; Delblanc's *Stormhatten*; Sprinchorn's *Strindberg as Dramatist*; my own *Strindberg and the Poetry of Myth*; and Bellquist's *Strindberg as a Modern Poet*.

29. Engdahl, "Myten i texten," p. 102.

30. Feldman and Richardson, *Rise of Modern Mythology*, p. 310.

31. John Eric Bellquist points out that "a similar vision is evoked in Strindberg's 1883 poem 'Biographically.'" "In a hospital, the poet's wound fever prepares him for his concluding vision. At first he finds solace in dreams of flowery meadows and the sea, just as Loke looks forward to a new paradise on earth" (*Strindberg as a Modern Poet*, p. 39).

32. Cited by Ziolkowski, "Some Features of Religious Figuralism in Twentieth-Century Literature," p. 367.

33. Strindberg's final library in Stockholm contains three dozen different editions or language versions of the Testaments and several dozen more books of biblical commentary or interpretation. His familiarity with the Bible as a young man is attested to by his confession that when he first read a draft of *Master Olof* aloud to his university literary society, "one of the more awake [members] thought he noticed

that there were too many of God's words in the piece and that this was not suitable for the stage" (ss 19:55).

34. For a discussion of the relationship between Strindberg's socialistic and religious attitudes after the turn of the century, see Meidal, Från profet till folktribun.

35. Cf. a similar sentiment by Arno Holz, the leading theoretician of German Naturalism, in the dedicatory epistle to his *Book of the Times* (Buch der Zeit, 1885):

> Für mich ist jener Rabbi Jesus Christ
> nichts weiter als der erste Sozialist.
> (As far as I am concerned, that rabbi Jesus Christ
> is nothing more than the first socialist.)

Cited by Ziolkowski, *Fictional Transfigurations of Jesus*, p. 58.

36. Strindberg could have found some support for his position in John 7:12, where Jesus is accused of "leading the crowd astray."

37. Bowman, "Illuminism, Utopia, Mythology," p. 105.

38. *The Origin and Stability of the French Revolution: A Sermon Preached at St. Paul's Chapel, Norwich, July 14, 1791*, p. 5; quoted by Mark Schorer, *William Blake: The Politics of Vision* (New York: Henry Holt, 1946), p. 205; and Abrams, "English Romanticism: The Spirit of the Age," p. 34.

39. In their historical, biblical sense "chronos is 'passing time' or 'waiting time'—that which, according to Revelation, 'shall be no more'—and kairos is the season, a point in time filled with significance, charged with a meaning derived from its relation to the end." See Kermode, *The Sense of an Ending*, p. 47.

40. Ibid., p. 48.

41. Bakhtin, *Rabelais*, p. 31.

42. Ibid.

43. Except for Schopenhauer, German Romantics generally were not an influence on Strindberg at the time he wrote "Pangs of Conscience." In this regard he was like most other young Scandinavian writers, heeding the advice of Georg Brandes, who disapproved strongly of the decadent Germans. Less than a decade after Strindberg completed the story, however, readings in E. T. A. Hoffmann's disciple Edgar Allan Poe sent him back to the original, and then the influence became real. After the turn of the century, he found stimulation in other German Romantics, particularly Novalis.

44. Cited by Törnqvist, *Bergman och Strindberg*, p. 107.

45. Olivier's own remarks about the character make clear the extent of his misunderstanding. "I found *The Dance of Death* a pretty claustro-

phobic piece in which you can't open out too much, unlike Miss Julie. Strindberg is veritas, perfectly straightforward, no undercurrent, no subtext, no sneaky, subconscious underneath thought that he is either unaware of or hiding from himself. Quite unlike his fellow Scandinavian Ibsen, who has a subtext of pure filth and a very strong undercurrent which can have an extremely bad effect on the actor. The subtext is so dirty, really; well, if not dirty, then salacious" (Laurence Olivier, On Acting [New York: Simon & Schuster, 1986], p. 325).

46. Bakhtin, Rabelais, p. 50.

47. Goethe, Faust, Part One, p. 221.

48. Once actually called the Cave of Staffa, it was renamed for the mythic figure in Macpherson's great 1762 literary hoax, Fingal, an Ancient Epic Poem, in Six Books.

49. See, e.g., Wordsworth's "Cave of Staffa":

> . . . The pillared vestibule,
> Expanding yet precise, the roof embowed,
> Might seem designed to humble man, when proud
> Of his best workmanship by plan and tool.
> Down-bearing with his whole Atlantic weight
> Of tide and tempest on the Structure's base
> And flashing to the Structure's topmost height,
> Ocean has proved its strength, and of its grace
> In calms is conscious, finding for his freight
> Of softest music some responsive place.

From "Itinerary Poems of 1833," in Wordsworth: Poetical Works, p. 371.

50. The resemblance of the pillars of Fingal's Cave to organ pipes is noted in the most popular family encyclopedia of the day, Nordisk familjebok (Stockholm: Gernandts, 1881–88), to which Strindberg himself contributed material.

51. For a distinctly Freudian slant on the cave's sexual implications in A Dream Play, see Sprinchorn, Strindberg as Dramatist, pp. 162: "When seen in a drawing where there is no sense of scale, [Fingal's Cave] is an excellent representation of the vulva."

52. Dahlbäck, "Hugo och Strindberg," p. 17.

53. Hartman, Wordsworth's Poetry, p. xii.

2 / Imitation and Imagination

1. Strindberg, Före röda rummet, p. 139. This statement was made before Strindberg understood the relationship between Romanticism and the

French Revolution, a relationship we shall examine later in connection with his interest in history.

2. McKeon, "Literary Criticism and the Concept of Imitation in Antiquity," pp. 130, 131.

3. Hawkes, Metaphor, p. 34.

4. Eric Partridge, Origins (New York: Macmillan, 1958), p. 305.

5. Keats uses "fantasy" positively, but, as we shall see (see epigraph, chap. 4), he was aware as well of the negative aspects of the imagination.

6. "Coleridge . . . distinguished sharply between fancy, 'the aggregative and associative power,' and imagination, the 'shaping spirit.' This 'vital' faculty dissolves and dissipates in order to re-create, whereas fancy is a mode of memory that finds its materials by the law of association. Fancy accounts for allegory and metaphor, imagination for symbol" (Tindall, The Literary Symbol, p. 38).

7. Plato, The Republic, trans. Desmond Lee, 2d rev. ed. (Harmondsworth, Middlesex, England: Penguin Books, 1974), p. 432.

8. The historical development that led to the Romantics' positive view of the imagination is described well by James Engell in his Creative Imagination.

9. Cited in ibid., p. 304.

10. Nilsson, Svensk romantik, p. 76.

11. Ibid., p. 79.

12. Ibid., p. 181.

13. Cited in ibid.

14. Cited by Olsson, Idealism och klassicism, p. 59.

15. Cited by Brandell, "Åttiotalet" (The 1880s), p. 146.

16. Ibid.

17. Wellek, History of Modern Criticism, 4:357.

18. Levin, Gates of Horn, p. 13.

19. Nolin, Den gode europén, p. 63.

20. Brandes and Brandes, Brevveksling, 6:300.

21. Brandes, Samlede skrifter, 5:275.

22. Cited by Lindström, Hjärnornas kamp, p. 21.

23. Brandes, Samlede skrifter, 4:5.

24. Cited by Lindström, Hjärnornas kamp, pp. 20–21.

25. Cited by Wellek, History of Modern Criticism, 4:357.

26. Brandes and Brandes, Brevveksling, 4:212.

27. Brandes, Samlede skrifter, 3:337.

28. Brandes and Brandes, Brevveksling, 7:236–37.

29. Ibid., 6:158. Cited in Lindström, Hjärnornas kamp, p. 21.

30. Brandes, Samlede skrifter, 5:340.

31. Letter to Carl Snoilsky, 3 December 1881. Cited by Söderström, *Strindberg och bildkonsten*, p. 15.

32. From the title of their first publication, *Songs and Tales by Nine Signatures (Sånger och berättelser av nio signaturerna)*.

33. Plato, *The Republic*, trans. Desmond Lee, 2d rev. ed. (Harmondsworth, Middlesex, England: Penguin Books, 1974), p. 437.

34. On Brandes's Romanticism, see Thure Stenström, *Den ensamme: En motivstudie i det moderna genombrottets litteratur* (Stockholm: Natur och Kultur, 1961), p. 96; Brandell, "Bakgrund till sekelslutet," p. 24; and Bellquist, *Strindberg as a Modern Poet*, pp. 27–28. Brandes's opposition to Romanticism was far from consistent. When he uses the term "naturalist" to describe Byron, he sounds suspiciously Rousseauistic, and of course this was before he became acquainted with Zola, whose works gave the term another meaning (Nolin, *Den gode europén*, p. 365). We learn, for instance, that Byron the naturalist "preferred the forest to the garden, natural man to cultural man, the original expression of passion to its artificial language" (Brandes, *Samlede skrifter*, 5:560: "foretrak Skoven for Haven, Naturmennesket for Selskabsmennesket og Lidenskabens oprindelige Udtryk for dens tillærte Sprog. . . ."). As contradictions in *Main Currents* make clear, the particular brand of Romanticism that Brandes opposed was conservative—as he saw it practiced in Germany. But one of the writers he admired most was Heine, a transitional and ambivalent figure who was Romantic *and* liberal, aesthetic *and* didactic (see Wellek, *History of Modern Criticism*, 3:199). Since Brandes approved of English liberalism, he carefully refrained from associating it with Romanticism, and so he spoke of English "naturalism." And while he attacked the German emphasis on egoistic individualism, his hero, Byron, was its epitome. (See Gunnar Ahlström, *Brandes' Hovedstrømninger*, p. 97.)

35. Brandes, *Samlede skrifter*, 5:391–92.

36. Wirsén, *Kritiker*, p. 216.

37. See Nolin, *Den gode europén*, p. 189.

38. According to associationist Alexander Gerard, the sensation experienced "operates on the imaginations of both by *resemblance;* on the poet, by the resemblance of its general appearance, or of some of its particular qualities, to a distant subject; on the botanist, by the exact resemblance of its parts to individuals of the same kind" ("Of the Influence of Habit on Association," in *Essay on Genius* [London, 1774], pp. 138–39; cited by Bate, *From Classic to Romantic*, p. 96).

39. Abrams, *The Mirror and the Lamp*, p. 177.

40. Brandes, *Samlede skrifter*, 9:542.

41. See, e.g., ibid., 4:344: "The thoughts and images we had previ-

ously in life we compare with each other merely through the associations between them, in other words, with the help of the characteristic feature they have, through the power of certain laws, to call up each other."

42. Ibid., 4:346.

43. Ibid., 8:423.

44. Ibid., 5:355.

45. Ibid., 5:303.

46. Ibid., 5:463.

47. "Balzac's greatness, according to Brandes, is in the domain of the creative imagination" (Gunnar Ahlström, Brandes' Hovedstrømninger, p. 241).

48. From an essay in 1879 cited by Nolin, Den gode europén, p. 366.

49. Hawkes, Metaphor, p. 14.

50. Johnson defined metaphor as "the application of a word to an use to which, in its original import, it cannot be put" (ibid., p. 32).

51. Ibid., pp. 34, 39.

52. To be sure, Strindberg was not alone in this regard. Swedish poet Verner von Heidenstam, in an antinaturalistic broadside in 1889, noted how the notorious Zola complained that he could not free his style from metaphor. See von Heidenstam, "Renässans," p. 24.

53. Goethe, Autobiography, 2:59–60.

54. Luke 1:28.

55. Clark, The Nude, pp. 233–34.

56. Goethes Gespräche, in a conversation reported by J. D. Falk, 14 June 1809. Cited by Read, "The Dynamics of Art," p. 325.

57. "Far too impetuous to proceed by . . . unobtrusive means, the divine impulse to form often hurls itself directly upon present-day reality, and upon the life of action, and undertakes to fashion anew the formless material presented by the moral world" (cited by Engell, Creative Imagination, p. 219).

58. Söderström, "Strindbergs måleri," p. 222.

59. Carlson, Introduction, in Strindberg: Five Plays, p. ix.

3 / Masters, Servants, and the Drama of History

1. Poggioli, Theory of the Avant-Garde, p. 66.

2. Göran Printz-Påhlson, "Allegories of Trivialization," pp. 221–36.

3. A translation by Michael Robinson of a condensed form of "The Mysticism of World History" appears in Comparative Criticism, ed. E. S. Slaffer, 3:237–56.

4. Wordsworth, Poetical Works, p. 532.

5. Lindström, Strindberg och böckerna, p. 31.

6. Carlyle, French Revolution, pp. 266, 273.

7. During the Saturnalia (17–24 December) "the customary restraints of law and morality [were] thrown aside" in favor of an orgiastic, carnival atmosphere. Mardi Gras is one of the descendents of the festival. One remarkable feature of the Saturnalia was a reversal of social roles. Slaves were permitted to drink as much as their masters and even rail at them, while "masters actually changed places with their slaves and waited on them at table" (Sir James George Frazer, The New Golden Bough: A New Abridgment of the Classic Work [New York: Criterion Books, 1959], pp. 559–60).

8. Carlyle, French Revolution, pp. 270, 274.

9. Ibid., p. 268.

10. Scott, Sweden, p. 385.

11. Cantor, Creature and Creator, p. 182.

12. Cited by Strindberg in SS 8:372.

13. Cited by Abrams, Natural Supernaturalism, p. 338.

14. Lamm, August Strindberg, p. 68.

15. Barber, Shakespeare's Festive Comedy, p. 51.

16. Holquist, prologue to Bakhtin's Rabelais, p. xviii.

17. Bakhtin, Rabelais, p. 88.

18. Ibid., p. 439.

19. Ibid., p. 109.

20. Ibid., p. 21.

21. "The French Revolution everywhere stresses the movement of history from palaces and parliaments down onto the streets and into the consciousness of the people. . . . [T]he protagonist of his historical drama is clearly the people; the central lines are always spoken in Carlyle's collective voice—'the voice of all France' (2:117)—as he presides over the narrative in his composite role of biblical prophet and Greek chorus. Seen in this light, The French Revolution is the chronicle of the new national consciousness created by the Revolution itself" (Rosenberg, Carlyle and the Burden of History, p. 34).

22. Bakhtin, Rabelais, p. 40.

23. Ibid.

24. Frye, The Great Code, p. 43.

25. John L. McKenzie, Dictionary of the Bible (New York: Macmillan, 1965), p. 421.

26. For Carlyle myth was not "the antithesis of history but . . . its inevitable accompaniment, . . . the necessary modality by which the

human imagination figures and interprets its past" (Rosenberg, *Carlyle and the Burden of History*, p. 42).

27. Wirsén, *Kritiker*, p. 295.

28. See my discussion of the character in *Strindberg and the Poetry of Myth*, pp. 45–48.

29. Cohn, *Pursuit of the Millennium*, p. 108.

30. Ibid., p. 109.

31. See Brian Johnston's *The Ibsen Cycle* (Boston: Twayne/G. K. Hall & Co., 1975), and his *To the Third Empire*.

32. "In his drama *Emperor and Galilean* of 1873 Henrik Ibsen revived the mystical significance of the idea which since Lessing had dried into a philosophical or political abstraction. The doctrine preached by the mystic Maximos in Ibsen's play is Joachite throughout: the first reign was founded on the Tree of Knowledge and the second on the Tree of the Cross, while the third will be founded on both trees together. Over and over again Ibsen returned to the theme of the Third Age" (Ringbom, *The Sounding Cosmos*, p. 174). Ringbom also cites an early study of Ibsen and Joachism: R. Engert's *Henrik Ibsen als Verkünder des dritten Reichs* (Leipzig, 1921).

33. Brian Johnston, "The Corpse and the Cargo: The Hegelian Past in Ibsen's Naturalistic Cycle," *Drama Review* 13, no. 2 (T42) (winter 1968): 49.

34. Ibsen, *Ibsens samlede verker i billigutgave: Nutidsdramaer*, p. 380.

35. Brandes and Brandes, *Brevveksling*, 4:204.

36. Ibid., 4:212.

37. *SV* 37:382. *Inferno* was first written in French during the spring of 1897. The new bilingual French/Swedish version (*SV* 37), edited and with commentary by Ann-Charlotte Gavel Adams, was published in 1994.

38. Promethean "chiliasm, regardless of its contemporary political implications or its prior religious background, . . . marks one essence of Strindberg's Romantic affinities" (Bellquist, *Strindberg as a Modern Poet*, p. 35). Frank Bowman points out that "Hugo associated Prometheus and Eve, the bearers of gifts of fire and knowledge to man. He [Prometheus] is also associated with Job and Cain, the victims of divine injustice who complain about God defined as the symbol of evil fate." See Bowman's "Illuminism, Utopia, Mythology," p. 101.

39. Cited by Löwith, *Meaning in History*, p. 47.

40. Camus, *The Rebel*, p. 26.

41. Letter to John Murray, 15 February 1817. Cited in *Poetical Works of Lord Byron*, p. 209.

42. Ibid., p. 213.

43. Schiller, "*The Robbers*" and "*Wallenstein*," p. 35. The citation of the passage by Strindberg occurs in SS 18:275.

44. *Poetical Works of Lord Byron*, pp. 217, 218, 223.

45. Ibid., p. 217.

46. Ibid., p. 220.

47. All line references from *Cain* are taken from Steffan's edition: *Lord Byron's "Cain."*

48. Cited by Cantor, *Creature and Creator*, p. 140.

49. Ibid., p. 140.

50. Romantic poet Esaias Tegnér's translation of Goethe's *Prometheus* was reprinted in Strindberg's favorite literary encyclopedia, Arvid Ahnfeldt's *Verldslitteraturens historia* (Stockholm, 1875), 1:339.

51. Goethe, *Autobiography*, p. 277. The edition in Strindberg's library is *Werke, Auswahl in sechzehn Bänden* (Leipzig, n.d.), 3:138 (Strindberg Library, catalogue no. 97).

52. Feldman and Richardson, *Rise of Modern Mythology*, p. 264.

53. Brandes, *Samlede skrifter*, 5:482.

54. *Poetical Works of Lord Byron*, p. 676.

55. Schopenhauer, *World as Will*, 2:442.

56. For a discussion of Agnes, the Daughter, as an enlightened one (i.e., a bodhisattva), see my *Strindberg and the Poetry of Myth*, pp. 172–78.

57. Zimmer, *Myths and Symbols in Indian Art and Civilization*, p. 152.

58. "[Carlyle's] first text was the Bible, and although it lost its unique authority, it never lost its primacy. In *Sartor Resartus* he discovered in God's 'second book,' Nature, the Divinity that had grown faint in His 'first book,' Scripture. But the text which more than any other he made his own was God's 'third book,' His writing in time, or History" (Rosenberg, *Carlyle and the Burden of History*, pp. 8–9).

4 / Naturalism: Evolution and Devolution

1. *Svenska Dagbladet*, 13 March 1901. Cited in Brev 14:51 n. 6.

2. Lindström, *Hjärnornas kamp*, p. 135.

3. Goldman, *Social Significance of the Modern Drama*, p. 27. Almost forgotten today, *The Social Significance of the Modern Drama* carried a powerful message about the purpose and usefulness of ideas in art to a parochial audience in pre–World War I America. Author Henry Miller said Goldman "opened up the whole world of European culture for me and gave a new impetus to my life, as well as direction" (cited by Alice Wexler, *Emma Goldman in America* [Boston: Beacon Press, 1984], p. 205).

4. Zola, "From Naturalism in the Theatre," p. 362.

5. Levin, *Gates of Horn*, p. 72.

6. See Gillian Beer's important study of the impact of Darwin's ideas and language on English Victorian literature: *Darwin's Plots*.

7. For a discussion of the implications of this theory, see my *Strindberg and the Poetry of Myth*, pp. 29–30.

8. Beer, *Darwin's Plots*, p. 7.

9. *The Autobiography of Charles Darwin and Selected Letters*, ed. F. Darwin (New York, 1892; reprint, 1958), p. 32. Cited by Beer, *Darwin's Plots*, p. 275.

10. Beer, *Darwin's Plots*, pp. 7, 110.

11. Cited in ibid., pp. 138–39.

12. Ibid., p. 7.

13. Book 15, lines 252–58; Ovid, *Metamorphoses*, trans. Innes, p. 371.

14. Ibid., lines 259–62.

15. Ovid, *Metamorphoses*, trans. Innes, p. 35.

16. Cited by Levin, *The Myth of the Golden Age in the Renaissance*, p. 159.

17. Cervantes Saavedra, *The Adventures of Don Quixote*, p. 149.

18. Coleridge, *Table Talk*, 1 May 1830. Cited by States, *The Shape of Paradox*, p. 2.

19. Cantor, *Creature and Creator*, pp. 22–23.

20. Ibid., p. 156.

21. Frye, *Secular Scripture*, pp. 97–98.

22. This passage is from the revised, longer version of the play that Strindberg wrote in 1897 for the French version of his novel *Inferno* (Paris: Mercure de France, 1966), p. 20 (see also *SV* 37:388).

23. Ibid. (French version, 1966), p. 21; *SV* 37:390.

24. See, particularly, Lindberg, *Tillkomsten af Strindbergs "Mäster Olof"*; Eklund, *Tjänstekvinnans son: En psykologisk Strindbergsstudie*; Lindström, *Hjärnornas kamp*; and Smedmark, *"Mäster Olof" och Röda rummet*.

25. Driver, *Romantic Quest*, p. xii.

26. "Invokation," a manuscript in the Birger Mörner Collection, Örebro stads- och länsbibliotek. Cited by Brandell, *Strindberg—ett författarliv*, 2:21. It is interesting that Strindberg uses the same word, "disentangle," that Dr. Samuel Johnson used in the 1826 edition of his dictionary as the definition for "evolve." See Beer, *Darwin's Plots*, p. 23.

27. Schopenhauer, *World as Will*, 2:585.

28. Schopenhauer, *Essays and Aphorisms*, p. 49.

29. Pierrot, *The Decadent Imagination*, p. 56.

30. See *SS* 19:157 and 26:33.

31. Schopenhauer, *World as Will*, 2:587.

32. See Lamm, *August Strindberg*, p. 118.

33. Brandes, *Samlede skrifter*, 7:153.

34. Ibid.

35. Ibid., 7:218.

36. Zola, The Sin of Father Mouret, p. 182.

37. Brandes, Samlede skrifter, 7:155.

38. Levin, Gates of Horn, p. 331. Levin misses the point, I believe, about the Rousseauistic doppelgänger effect intended when he terms this abrupt change in the abbé's behavior as inexplicable on Zola's part, "with complete discontinuity, and no introspection at all. . . ."

39. Ortega y Gasset, Meditations on Quixote, p. 164.

40. Smedmark, August Strindbergs dramer, 3:343. This passage was excised by an early publisher and does not appear in the standard edition of the collected works.

41. Zola, The Sin of Father Mouret, p. 186.

42. Ibid.

43. Sandy Petrey, afterword to Zola's The Sin of Father Mouret, p. 307.

44. Ibid., p. 306.

45. The letter to Maurice Prozor, dated 24 February 1891, is not included in the standard edition of Strindberg's letters. It was first published in Meddelanden från Strindbergssällskapet, nos. 59–60, May 1978, p. 32.

46. Smedmark, August Strindbergs "Mäster Olof," 2:678. It is interesting, and indicative of Strindberg's mixed feelings about the imagination, that he first wrote fantasiens, then crossed it out in favor of inbillningens.

47. Lindström, Hjärnornas kamp, p. 53.

48. Ibid., p. 82.

49. Smedmark, "Mäster Olof" och Röda rummet, p. 276.

50. Buckle, History of Civilization in England, 1:vii.

51. Ibid., 95–96.

52. Ibid., 104–5.

53. Lindström, Hjärnornas kamp, pp. 204–305 passim.

54. Richet, L'homme et l'intelligence, p. 268. Cited by Lindström, Hjärnornas kamp, p. 154.

55. Printz-Påhlson, "Tankens genvägar II," p. 603.

56. Den romantiske klockaren på Rånö was included by Strindberg in a collection of short stories, Men of the Skerries (Skärkarlsliv), about the arduous life on the beautiful but rugged islands of Stockholm's archipelago, and was first published in 1888. The word klockaren has been arbitrarily rendered as "organist," although playing the organ was only one of the duties of this factotum to the local minister, who represented the State Lutheran Church; other duties ranged from running errands to school-teaching.

57. Lamm, August Strindberg, p. 248.

58. Johannesson, Novels of Strindberg, p. 109.
59. Printz-Påhlson, "Tankens genvägar II," p. 601.
60. "Omkring 1890: Omvärderingar," reprinted in Järv, Strindbergs-fejden, 1:91.
61. Wirsén, Kritiker, p. 336.
62. Ibid.
63. Kärnell, Strindbergs bildspråk, p. 243.
64. Printz-Påhlson, "Tankens genvägar II," p. 603.
65. See Lamm, August Strindberg, p. 251. Printz-Påhlson, "Tankens gen-vägar II," notes (p. 601) that the last section faithfully follows the model of a Neoromantic fantasy, with themes drawn from folklore and legend.
66. Wirsén, Kritiker, p. 335.
67. Kärnell, Strindbergs bildspråk, p. 244.
68. Cited by Beer, Darwin's Plots, p. 267 n. 12.
69. The identity of this piece of music and of the ones following is discussed by Gunvor Blomquist, "Kring den Romantiske klockaren på Rånö," Meddelanden från Strindbergssällskapet 51–52 (May 1973): 34.
70. Hoffmann's influence on Strindberg has been noted and dis-cussed by several scholars. See Lamm, August Strindberg, pp. 251, 258; and Mortensen and Downs, Strindberg, p. 184. Not unlike Alrik Lundstedt, An-selmus, the hero of Hoffmann's "The Golden Pot," chooses to join his beloved, Serpentina, in the land of fantasy rather than marry Veronica in the real world. See Tales of Hoffmann, ed. and trans. Leonard J. Kent and Elizabeth C. Knight (Chicago: University of Chicago Press, 1972), pp. 14–92.
71. Rinman, "Strindberg," 4:81.
72. Lamm, August Strindberg, p. 252.

5 / The Visual Imagination and the Challenge of Nature

1. Ollén, Strindbergs dramatik, p. 130.
2. The "interview" was intended for, but never used as, an introduc-tion to Son of a Servant Woman. It was first published as an addendum to volume 18 (pp. 452–58) in the collected works.
3. Heidenstam, "Renässans," p. 30.
4. Ibid., p. 11.
5. Ibid., p. 13.
6. Ibid., pp. 20, 22, 23.
7. Fröding, "Naturalism och romantik," pp. 44, 58.
8. Ollén, Strindbergs dramatik, p. 144.
9. Strömbom, Konstnärsförbundets historia, 1:43.

10. Söderström, *Strindberg och bildkonsten*, pp. 61, 331.

11. Ibid., p. 219.

12. Söderström, "Phantasies of a Visual Poet," p. 32.

13. I am obliged to artist Suzanne Mason for pointing this out to me.

14. Meyer, *Strindberg*, pp. 69, 46.

15. Mitchell, "Visible Language: Blake's Wond'rous Art of Writing," p. 48.

16. I am obliged to Björn Meidal for pointing out this reference in Falck, *Fem år med Strindberg*, p. 190.

17. Linde, *Efter hand*, p. 469.

18. Cited by Honour, *Romanticism*, p. 32.

19. Cited by Rosen and Zerner, *Romanticism and Realism*, p. 67.

20. Ibid.

21. Ibid.

22. Söderström, "Phantasies of a Visual Poet," p. 32.

23. Ibid.

24. See the description of *The Solitary Toadstool* when it was shown in a 1986 exhibition of modern Scandinavian painting: "Diese [Friedrich's paintings] konnte Strindberg in Berlin studieren (besonders *Mönch am Meer*)" (*Im Lichte des Nordens Skandinavische Malerei um die Jahrhundertwende*, p. 266).

25. Reinhold Heller says "the possibility that Munch knew of Friedrich's ideas and work as early as the 1880s cannot be dismissed, although it is also unverifiable" (*Munch*, p. 228 n. 14). For further discussions of Munch's relationship to German Romanticism, see Reinhold Heller, "Edvard Munch and the Clarification of Life," *Allen Memorial Art Museum Bulletin* 29, no. 3 (spring 1972): 121–29; Reinhold Heller, *Edvard Munch: The Scream* (New York: Viking, 1973), pp. 23–25, 72–73; and Rosenblum, *Modern Painting and the Northern Romantic Tradition*, pp. 101 ff.

26. Rosenblum, *Modern Painting and the Northern Romantic Tradition*, p. 14.

27. Cited by William Feaver, "Walls Plastered with Blankness," *Observer Review*, 8 April 1990, p. 54.

28. See Hedenberg, *Strindberg i skärselden*, and particularly Cullberg's *Skapar kriser*, about which we shall have more to say in the final chapter.

29. Bowman, "Illuminism, Utopia, Mythology," p. 76.

30. Cited by Imanse, "Occult Literature in France," p. 355.

31. Kandinsky, *Über das Geistige in der Kunst*, 5th ed. (Berne, 1956).

32. *The Complete Works of Oscar Wilde*, p. 909.

33. Letter cited by Pierrot, *Decadent Imagination*, p. 21.

34. When Wilde was criticized because the characters in *The Picture of Dorian Gray* were "mere catchpenny revelations of the non-existent,"

he replied: "Quite so. If they existed they would not be worth writing about. The function of the artist is to invent, not to chronicle. . . . The supreme pleasure in literature is to realise the non-existent" (*Letters of Oscar Wilde*, ed. Rupert Hart-Davis [London, 1962], p. 258; cited by Pierrot, *Decadent Imagination*, p. 23).

35. Strindberg's essay "The New Arts" was first published as "Du Hasard dans la production artistique" in *Revue des Revues* 11 (15 November 1894): 19–27.

36. Strindberg, *Vivisektioner*, p. 65.

37. Ibid.

38. Ibid., pp. 65, 67.

39. Ibid., p. 57.

40. Ibid., pp. 57, 59.

41. Lipsey, *An Art of Our Own*, p. 118.

42. Kandinsky, "Reminiscences," p. 34.

43. Strindberg, *Vivisektioner*, p. 73.

44. Goethe, "Über Wahrheit und Wahrscheinlichkeit der Kunstwerke," in *Sämtliche Werke*, 33:90. Cited by Abrams, *Mirror and the Lamp*, p. 207.

45. *The Compact Edition of the Oxford English Dictionary*, vol. 3, s.v. "natura naturans."

46. Cited by Engell, *Creative Imagination*, p. 358.

47. See Coomaraswamy, *Selected Papers*, 1:54.

48. Cited by Clay, *Romanticism*, p. 174. Similar advice to artists is cited by Göran Söderström and given by Max Ernst. Söderström: "As our friend Botticelli observed, a mushroom, impregnated with different colors and thrown against a wall, leaves stains which can look like a landscape; one can distinguish a mass of images in such stains—a man's head, different animals, pitched battles, cliff scenes, seas, clouds, woods, and so forth—all depending on the disposition of one's soul" ("Strindbergs måleri," pp. 221–22). Max Ernst: "It is not to be despised, in my opinion, if, after gazing fixedly at the spot on the wall, the coals in the grate, the clouds, the flowing stream, if one remembers some quite admirable inventions. Of these the genius of the painter may take full advantage, to compose battles of animals and of men, of landscapes or monsters, of devils and other fantastic things which bring you honor. In these confused things genius becomes aware of new inventions" ("On Frottage," in Chipp, *Theories of Modern Art*, p. 429).

49. Cited in Sprengel, *De nya poeterna (80-talet)*, p. 225.

50. A reproduction of Strindberg's rubbing of a crab shell appears in Söderström, "Strindbergs måleri," p. 146.

51. From a film documentary series, *The Surreal Eye*, broadcast on Public Television in 1987.

52. Ibid.

53. Max Ernst, "On Frottage," in Chipp, *Theories of Modern Art*, p. 431.

54. Rosenblum, *Modern Painting and the Northern Romantic Tradition*, p. 170.

6 / The Romance of the Occult

1. Lamm, *Strindberg och makterna*.

2. Stockenström, *Ismael i öknen*.

3. Brandell, *Strindbergs Infernokris*, p. 109.

4. Cited in Pierrot, *Decadent Imagination*, p. 109.

5. Cited in ibid., p. 87.

6. Ibid., p. 191.

7. Édouard Schuré, *Les grandes légendes de France* (Paris: Perrin, 1892), pp. ii–iv. Cited in Pierrot, *Decadent Imagination*, pp. 193–94.

8. Feldman and Richardson, *Rise of Modern Mythology*, p. 298.

9. Brandell, *Strindbergs Infernokris*, p. 106.

10. Cited in Pierrot, *Decadent Imagination*, pp. 113–14, from an excerpt of Guaita's *Serpent de la Genèse* in the February 1890 number of *L'Initiation*.

11. Research in art history over the past twenty-five years has explored the important connections between artists and occult movements like Theosophy, and I am indebted to this literature in the preparation of the last three chapters. Especially valuable were Sixten Ringbom, "Art in the 'Epoch of the Great Spiritual,' " and his pioneering *Sounding Cosmos*; Rosenblum, *Modern Painting and the Northern Romantic Tradition*; Lipsey, *An Art of Our Own*; and Weisberger, *The Spiritual in Art*, particularly Imanse's essay "Occult Literature in France."

12. Brandell, *Strindbergs Infernokris*, pp. 40–41.

13. See especially Lindström, *Hjärnornas kamp*, pp. 83, 297.

14. Gerould and Kosicka, "The Drama of the Unseen—Turn-of-the-Century Paradigms for Occult Drama," p. 5.

15. Ibid.

16. See John P. Frayne, introduction to *The Uncollected Prose by W. B. Yeats*, 1:48; and Welsh, "Mondrian and Theosophy," pp. 35–51.

17. See Brandell, *Strindbergs Infernokris*, p. 138; and Stockenström, *Ismael i öknen*, p. 506.

18. Yeats was another turn-of-the-century artist with ambivalent feelings about Mme. Blavatsky. At first both her disciple and friend, they eventually quarreled and broke off relations. See Ellman, *The Identity of Yeats*, p. xvi.

19. Quoted by Allen, "Introduction: Édouard Schuré and *The Great Initiates*," p. 19.

20. Schuré, *The Great Initiates*, pp. 124–25.

21. Strindberg's 1892 library contained two books on Theosophy by Alfred Percy Sinnett: *Den dolda verlden* (*The Occult World*) and *De invigdes lära* (*Esoteric Buddhism*), both published in 1887. His 1912 library on Theosophy and related subjects included Blavatsky's *Nyckel till teosofien* (*Key to Theosophy*), Swedish trans. 1890 (now lost); Besant's *Den uråldriga visdomen* (*The Ancient Wisdom*), Swedish trans. 1900 (now lost); Besant's *Esoterisches Christentum; oder, Die kleineren Mysterien* (*Esoteric Christianity*), trans. from German by Mathilde Scholl (Leipzig: Th. Grieben, 1903); anthroposophist Rudolf Steiner's *Die Stufen der höheren Erkenntnis* in a 1908 Danish translation; a copy of Steiner's German magazine, *Luzifer-Gnosis*; and dozens of copies of Swedish Theosophist periodicals, dating from 1895 through 1906. See Lindström's important inventory of Strindberg's private libraries, *Strindberg och böckerna*, pp. 51, 94, 96, 104, and 105–6.

22. Unfortunately, Besant's *The Ancient Wisdom* was one of a number of volumes that disappeared before Strindberg's final library was moved in the 1980s from the Nordic Museum to the Strindberg Museum.

23. Besant, *The Ancient Wisdom*, pp. 3–4.

24. Ellman, *Identity of Yeats*, p. xvi.

25. Carlyle, *Heroes and Hero Worship*, pp. 94–95.

26. Novalis, *Schriften*, 1:281 (Strindberg Library, catalogue no. 1688).

27. "The Auguries of Innocence," in *The Complete Poetry and Prose of William Blake*, p. 493.

28. Papus [Gérard Encausse], *L'occultisme* (Paris, 1890), p. 5. Cited by Imanse, "Occult Literature in France," p. 356.

29. Stanislas de Guaita, *Essais de sciences maudites, I, Au seuil du mystère* (1886; Paris: Durville, 1915), pp. 15–17. Cited by Imanse, "Occult Literature in France," p. 356.

30. Imanse, "Occult Literature in France," p. 356.

31. Cited from *Pensées de Joseph Delorme* by Bowman in his "Illuminism, Utopia, Mythology," p. 84.

32. Gérard Nerval, *Aurélia*, trans. Richard Aldington (London, 1932), pp. 51–52. Cited in Wellek, *Concepts of Criticism*, p. 177.

33. Arthur E. Waite, introduction to *Transcendental Magic*, by Éliphas Lévi, p. 12 n. 1.

34. Besant, *The Ancient Wisdom*, pp. 63–64.

35. Ibid., p. 72.

36. Ibid., p. 79.

37. Lévi, *The Key of the Mysteries*, p. 83.

38. Besant, *The Ancient Wisdom*, p. 65.

39. Lévi, *The Key of the Mysteries*, p. 83.

40. Cited by Tindall, *Literary Symbol*, p. 48.

41. *Uncollected Prose by W. B. Yeats*, 1:247.

42. Pierrot, *Decadent Imagination*, p. 115.

43. Cited in ibid. from Papus's *Sciences occultes*.

44. Notes on the third cover page of the *Occult Diary* indicate that the explanation of everything there could be found not only in Strindberg's correspondence with Theosophist Torsten Hedlund but in his conversations with a friend, Axel Herrlin. See Strindberg, *Ockulta Dagboken*.

45. Lévi, *The Key of the Mysteries*, pp. 155–56.

46. "Homunculus"—a manikin produced in a distillation flask—is evidence of Strindberg's alchemical interests.

47. Strindberg uses the English word here.

48. Besant, *The Ancient Wisdom*, p. 68.

49. Besant and Leadbeater, *Thought-Forms*, p. 39.

50. See Ringbom's "Art in the 'Epoch of the Great Spiritual'" and *The Sounding Cosmos*.

51. Kandinsky, "Reminiscences," p. 32.

52. Ringbom, *The Sounding Cosmos*, p. 88.

53. Strindberg, *Vivisektioner*, p. 65.

54. I am obliged to Sophie Grimal for bringing this reference to my attention.

55. Mitchell, *Iconology*, p. 37.

56. De Man, *The Rhetoric of Romanticism*, p. 16.

57. Mitchell, *Iconology*, p. 37.

58. Cited by Lamm, *Strindberg och makterna*, p. 94.

59. Besant and Leadbeater, *Thought-Forms*, p. 15.

60. Wellek, *Concepts of Criticism*, p. 176.

61. See Stockenström, *Ismael i öknen*, p. 506 n. 128; and Torsten Eklund's editor's note, *Brev* 15:354.

62. Besant, *The Ancient Wisdom*, p. 91.

63. Ibid., pp. 91, 101.

64. Ibid., p. 59.

65. Ibid., p. 104.

66. Ibid., pp. 91–92.

67. Rosenblum, *Modern Painting and the Northern Romantic Tradition*, p. 85.

68. Ibid., p. 47.

69. Klee, "Creative Credo," p. 186.

70. Rosenblum, *Modern Painting and the Northern Romantic Tradition*, p. 152.

71. Brandell, *Strindberg in Inferno*, p. 164; Brandell, *Strindbergs Infernokris*, p. 152.

72. See Welsh's stimulating discussion of Darwinism and Theosophy in Piet Mondrian's career: "Mondrian and Theosophy," p. 43.

73. Sprinchorn, *Strindberg as Dramatist*, p. 55.

74. Frye, "New Directions from Old," p. 116.

75. Strindberg's version: Ralph Waldo Emerson, *Essays*, trans. Dr. Karl Federn (Halle, Germany: Otto Hendel, n.d.), p. 89 (Strindberg Library, catalogue no. 3498). See also Emerson, *Selected Essays, Lectures, and Poems*, p. 24. The passage was probably marked sometime after Strindberg discovered Emerson in 1904.

76. Yeats, *Collected Poems*, p. 399.

77. Lamm, *Strindberg och makterna*, p. 95.

78. Brandell, *Strindbergs Infernokris*, p. 130.

79. Stockenström, *Ismael i öknen*, p. 78.

80. Berendsohn, *Strindbergsproblem*, p. 94.

81. Wallace, *The World of Van Gogh*, p. 69.

7 / Oriental Renaissance and Medieval Nostalgia

1. Cited by Schwab, *Oriental Renaissance*, p. 12.

2. Schlegel, "Talk on Mythology." Cited by Schwab, *Oriental Renaissance*, p. 13.

3. Varnedoe, "Primitivism in Modern Art: Gauguin," p. 181.

4. Schwab, *Oriental Renaissance*, pp. 12, 13.

5. Cited in ibid., p. 214.

6. Imanse, "Occult Literature in France," p. 357.

7. Balzac, *Louis Lambert*, pp. 201–2.

8. See Brandell, *Strindberg in Inferno*, and Stockenström, *Ismael i öknen*.

9. Inge Jonsson observed that "Swedenborg makes innumerable . . . references to Oriental and Greek mythology, emblematics, and hieroglyphics" (*Emanuel Swedenborg*, p. 109).

10. Buckle, *History of Civilization in England*, 1:104–5.

11. Ibid., pp. 95–96.

12. Schwab, *Oriental Renaissance*, p. 4.

13. Cited by Le Bris, *Romantics and Romanticism*, p. 170.

14. Ibid., p. 164.

15. Cited by Curtius, *European Literature and the Latin Middle Ages*, p. 303.

16. *The Complete Works of Oscar Wilde*, p. 918.

17. Inscription in the Carl Larsson room of the Gothenburg Municipal Museum in Sweden.

18. Rydberg, *Den siste atenaren*, 2:12–13.

19. Strindberg apparently never understood why Jewish friends and colleagues like Georg Brandes's brother, Edvard, took offense at some of his anti-Semitic remarks. Michael Meyer, in his 1985 *Strindberg: A Biography*, makes much of the remarks. Nowhere does he suggest, however, that Strindberg's prejudices oblige us to reconsider the meaning or importance of his plays. In fact, in a review seven years later (*New York Review* 39, no. 11 [11 June 1992]: 15), he acknowledged that "racism does not appear in his plays and [Strindberg] mellowed in the final decade of his life." Racial or ethnic slurs should be labeled as such and criticized wherever they occur, but they were unfortunately all too common in nineteenth-century Scandinavia, as Meyer himself noted in his earlier biography of Ibsen. There he cites the report of a trip to Denmark in the 1870s by British critic Edmund Gosse: "it was difficult to account for the repulsion and even terror of Georg Brandes which I heard expressed around me whenever his name came up in the course of general conversation. . . . Brandes was a Jew, an illuminated specimen of a race little known at that time in Scandinavia, and much dreaded and suspected" (*Ibsen: A Biography*, pp. 345–46). Brandes himself, in fact, despite his cosmopolitanism, was also capable of crude ethnic slurs. He reported in a letter that Zola was losing his educated audience in France and now pleased only the Italians, the Russians, "and other barbarian peoples" (cited by Nolin, *Den gode europén*, p. 369).

20. Cited by Honour, *Neo-classicism*, p. 60.

21. Chevrillon, *Dans l'Inde*.

22. Brandell, *Strindbergs Infernokris*, p. 223.

23. Schwab, *Oriental Renaissance*, p. 59.

24. See also my discussion of Agnes's identity in *Strindberg and the Poetry of Myth*, pp. 146–47.

25. Lindberger, "Strindberg and Péladan," p. 251; Ollén, *Strindbergs dramatik*, p. 436.

26. Chevrillon, *Dans l'Inde*, pp. 184–85, 186.

27. Strindberg, "Nya konstriktningar! eller Slumpen i det konstnärliga skapandet," p. 29. Originally published as "Du Hasard dans la production artistique."

28. Cited by Schwab, *Oriental Renaissance*, p. 106.

29. Furst, *European Romanticism*, p. 5.

30. Lévi, *Key of the Mysteries*, p. 26.

31. Ahnfeldt, *Verldslitteraturens historia*, 2:3–4.

32. "Editors' Introduction," in Coleridge, *Biographia Literaria*, 1:xci.

33. Carlson, *Strindberg and the Poetry of Myth*, pp. 147, 181.

34. Schwab, *Oriental Renaissance*, p. 480. Goethe, in his *Epigrams*, was finally at best ambiguous about the value of the Oriental Renaissance: "Whoever knows others as well as himself must also recognize that East and West are now inseparable. I admit that while dreaming between these two worlds, one can waver; but such coming and going may be best done between going to bed and rising" (cited in Schwab, *Oriental Renaissance*, p. 60).

35. Wilson, "See the Text and Hear the Pictures," pp. 61–62.

36. Cited by Pierre Schneider, *Matisse* (Paris: Flammarion, 1984), p. 155.

37. Birgitta Steene described Strindberg's *The Saga of the Folkungs* as the whole medieval "morality pattern . . . compressed into a single play"; Margareta Wirmark examined the connections between medieval themes and Strindberg's *Dance of Death*; and Barry Jacobs discussed Strindberg's medieval-like mixing of the comic and the serious. See Steene, "Shakespearean Elements in Historical Plays of Strindberg," p. 126; Wirmark, *Kampen med döden*; and Jacobs, "Strindberg's *Advent* and *Brott och Brott*."

38. Uddgren, *Andra boken om Strindberg*, pp. 82–83.

39. Ljunggren, *Svenska dramat intill slutet af sjuttonde århundradet*, p. 65. See also Lindström, *Strindberg och böckerna*, p. 25.

40. Hardison, *Christian Rite and Christian Drama in the Middle Ages*, pp. 16–17.

41. Lagerkvist, *Modern Theatre*, p. 25.

42. Benjamin, "What Is Epic Theater?" p. 148.

43. Potter, *The English Morality Play*, p. 6.

44. Auerbach, *Mimesis*, p. 158.

45. See my *Strindberg and the Poetry of Myth* for a discussion of the biblical allusions in *Miss Julie*.

46. Widman, "Konsthantverk, konstindustri, design: 1895–1975," pp. 468, 480.

47. Frye, *Secular Scripture*, p. 177.

48. Fuchs, "The Mysterium," p. 76.

49. Ibid., p. 73.

50. In his "Epistle Dedicatory" to *Man and Superman* Shaw explains how *Everyman* influenced him in the creation of his heroine: "Ann was suggested to me by the fifteenth century Dutch morality called *Everyman*, which Mr. William Poel has lately resuscitated so triumphantly. I trust he will work that vein further. . . . As I sat watching *Everyman* at the Charterhouse, I said to myself Why not Everywoman? Ann was the

result: every woman is not Ann; but Ann is Everywoman" (*Prefaces by Bernard Shaw* [London: Constable, 1934], p. 161).

51. Stevens, "Medieval Drama," p. 38. See also Stevens's "The Reshaping of *Everyman*," *Germanic Review* 48 (1973): 118; and his "Illusion and Reality in the Medieval Drama," *College English* 32 (1971): 450.

52. *Meyerhold on Theatre*, pp. 60, 120.

53. Hanna Rydh has pointed out that it was "hardly likely" that *Tobiae comedia* could have been performed at the time Strindberg suggests, 1524, since the play was not written until 1550. That Strindberg probably knew better (see note below on Strindberg's early knowledge of the medieval theatre) and could have avoided such an anachronism says a great deal about the important example he wanted to make of the play. See Rydh's *De historiska källorna till Strindbergs "Master Olof,"* p. 16.

54. Strindberg's early knowledge of the medieval theatre was probably acquired through reading Gustaf Ljunggren's 1864 survey of Swedish drama and through association with Gustaf Klemming, the head of the Royal Library, who was admired by Strindberg when he worked there in 1875–76. Klemming published a volume of medieval prose and poetry in the same period as the publication of Strindberg's *The Swedish People*. See Ljunggren, *Det svenska dramat*, and the inventory list of Strindberg's 1883 library in Lindström, *Strindberg och böckerna*, p. 25, catalogue no. 74. Strindberg's appreciation of the medieval after the Inferno period was probably enhanced by his friend Johan Mortensen, who in 1899 published a study of medieval drama in France. See Richard Bark, *Strindbergs drömspelsteknik*, p. 38; and Mortensen, *Medeltids dramat i Frankrike*.

55. Ljunggren, *Det svenska dramat*, p. 76.

56. Ring, *Teaterns historia från äldsta till nyaste tid*, p. 122. Björn Meidal told me that he discovered the importance to Strindberg of Ring's book in the early 1900s during his editing of the continued publication of Strindberg's letters.

57. Ibid., p. 123.

58. In *Open Letters to the Intimate Theatre* (ss 50:12), written in 1908 and 1909, Strindberg stated his new views of the problems of form slightly differently: "The writer shall not be bound by any form, for the motif determines the form. Consequently, a freedom of treatment, bound only by a unity of concept and an artistic sense."

59. For a discussion of the Ahasuerus imagery in *To Damascus* see my *Strindberg and the Poetry of Myth*, esp. pp. 99–103.

60. Reprinted in Strindberg, *Före Röda rummet*, p. 24.

61. Fletcher, *Allegory*, pp. 4, 7.

62. Luke 24:44–45. *Bibeln, eller Den Heliga skrift innehållande Gamla och Nya*

Testamentets kanoniska böcker (Öfvers. Af Kongl. Bibelkommissionen, 1898) (Strindberg Library, catalogue no. 2203).

63. Potter, *The English Morality Play*, p. 8.

64. Fuchs, "The Mysterium," p. 77.

65. Sokel, introduction to *Anthology of German Expressionist Drama*, p. x.

8 / The New Seer: Putting It All Together

1. Psychiatrist Johan Cullberg has persuasively analyzed the stages in this breakdown in his *Skapar kriser*.

2. Cited in ibid., p. 13.

3. Lagercrantz, *August Strindberg*; and Sprinchorn, *Strindberg as Dramatist*.

4. Cullberg, *Skapar kriser*, p. 33.

5. Ibid., p. 32.

6. Ibid., pp. 119, 86.

7. Ibid., p. 86.

8. On the importance of Strindberg's discovery of Swedenborg's philosophy in March 1897, see Brandell, *Strindbergs Infernokris*, pp. 88–100 passim; Stockenström, *Ismael i öknen*, pp. 86–108; and Cullberg, *Skapar kriser*, pp. 88–91.

9. Cited by Stockenström, *Ismael i öknen*, p. 96.

10. Ibid., pp. 100–103.

11. Jonsson, *Emanuel Swedenborg*, p. 108.

12. Matter, *Emanuel Swedenborg*, p. 101 (Strindberg Library, catalogue no. 2073).

13. Another well-marked book in his library, an illustrated edition of the Egyptian *Book of the Dead*, suggests that Strindberg may have intended to follow Swedenborg's lead and explore the symbolism of hieroglyphics on his own (*The Egyptian Book of the Dead*; Strindberg Library, catalogue no. 2226).

14. Engell, *Creative Imagination*, p. 357.

15. Atterbom, *Svenska siare och skalder*, pp. 115–16 (Strindberg Library, catalogue no. 3604).

16. Ibid., p. 117.

17. Ibid., p. 116.

18. I am obliged to Freddy Rokem for drawing my attention to this *Blue Book* image.

19. Block, "Strindberg and the Symbolist Drama," p. 322.

20. "In Berlin Munch associated almost exclusively with a group of occultists, believers in mesmerism and Theosophy, a group that regularly attended spiritualist sessions and séances and was interested

in physiological psychology. Przybyszewski, writing in 1894, labeled Munch's art 'psychic naturalism,' explaining that Munch, 'the naturalist of the phenomena of soul,' aimed at projecting a 'psychical, naked process . . . directly in his color equivalents,' identifying his tradition in the line of Stéphane Mallarmé and Maurice Maeterlinck" (Tuchman, "Hidden Meanings in Abstract Art," p. 33; as the source of the Przybyszewski quotation, Tuchman names Carla Lathe, "Edvard Munch and the Concept of 'Psychic Naturalism,'" *Gazette des Beaux-Arts*, 6th ser., 93 [1979]: 136).

21. "Both [Paul-Élie] Ranson and [Paul] Sérusier were interested in theosophy, and like many poets and artists of the period (including Gauguin) searched for common ground in Eastern and Western religions" (Goldwater, *Symbolism*, p. 105). "[A]mbitious splicings of foreign religious motifs with native figures leave no doubt that Gauguin connected the Polynesians not just with innocence but with ancient wisdom, in the spirit of theosophy" (Varnedoe, "Primitivism in Modern Art: Gauguin," p. 191).

22. Cited by Hodin, *Edvard Munch*, p. 50. Originally translated in Frederick B. Deknatel, *Edvard Munch* (New York, 1950), p. 18.

23. Aurier, "Symbolism in Painting," p. 152. Essay originally published in *Mercure de France* 2 (December 1891).

24. Rosenblum, *Modern Painting and the Northern Romantic Tradition*, p. 71.

25. William Rubin and Matthew Armstrong, *The William S. Paley Collection* (New York: Museum of Modern Art, 1992), p. 53.

26. Rosenblum, *Modern Painting and the Northern Romantic Tradition*, p. 71.

27. Howard, *Gauguin*, p. 28.

28. Reinhold Heller notes that the serious artistic exhibitions at the fair were not mentioned in Munch's letters and sketchbooks: "It was Buffalo Bill's Wild West Show that he wrote about in the last letter home his father was to answer" (*Munch*, p. 50). Gauguin "went repeatedly to watch the stunts of Buffalo Bill" (Thomson, *Gauguin*, p. 97).

29. "Gauguin found it hard to get interested in all the wonderful factory products and ingenious machines which filled most of the glass palaces and iron halls. What fascinated him more were the representations of Far Eastern sculpture, originals and replicas, which he saw for the first time in the French colonial section" (Danielsson, *Gauguin in the South Seas*, p. 23).

30. G.-Albert Aurier, "Concurrence," *Le Moderniste* 10 (27 June 1889), as cited by John Rewald, in *Post-Impressionism: From Van Gogh to Gauguin*, 3d ed. (New York: Museum of Modern Art, 1979), p. 261; and Heller, *Munch*, p. 50.

31. Aurier, "Symbolism in Painting," p. 153.

32. "Circumstantial evidence—Gauguin's relationship by marriage to [Norwegian painter] Fritz Thaulow, his association with other Scandinavian painters, his earlier insistence that 'all the Norwegians' visited one of his other exhibitions—suggests that Munch would have seen Gauguin's Café Volpini exhibition" (Heller, Munch, p. 229 n. 13).

33. Ibid., p. 29.

34. Rubin and Armstrong, William S. Paley Collection, p. 48.

35. Cited in Cachin, Gauguin, p. 142.

36. See Hughes, Shock of the New, p. 282; and Thomson, Gauguin, p. 86.

37. Hughes, Shock of the New, p. 285.

38. Emanuel Goldstein, "Kammeratkunst," København, 8 February 1892. Cited by Heller, Munch, p. 60.

39. Goldstein, "Kammeratkunst." Cited by Heller, Munch, p. 66.

40. Przybyszewski, Totenmesse (Berlin, 1893), p. 7. Cited by Heller, Munch, p. 106.

41. August Strindberg, "L'exposition d'Edward Munch," reprinted in Söderström, Strindberg och bildkonsten, p. 304.

42. Bade, Femme Fatale, p. 6.

43. Strindberg, "L'exposition d'Edward Munch," p. 304.

44. Norseng, Dagny, p. 83.

45. Norseng (ibid., p. 8) identifies Dagny Juel as the woman in Munch's Madonna, Vampyr (Vampire), Jalousi (Jealousy), The Kiss, and Ashe (Ashes). Other scholars have speculated that the men in Jealousy are Strindberg, at the left, and Stanislaw Przybyszewski, at the right.

46. Ollén, Strindbergs dramatik, p. 109.

47. Stanislaw Przybyszewski, "Edvard Munch," Moderní Revue 5 (1897). Norwegian translation in the Munch-Museet, Oslo. Cited and translated by Norseng, in Dagny, p. 149.

48. Heller, Munch, p. 106.

49. Ibid., p. 130.

50. Ibid., p. 105.

51. Brandell, Strindbergs Infernokris, p. 222. This passage was omitted from the English version of Brandell's book.

52. Complete translations of the Strindberg and Gauguin letters can be found in Chipp, Theories of Modern Art, pp. 80–83.

53. Goldwater, Gauguin, p. 92.

54. Danielsson, "De exotiska källorna för Gauguins konst," p. 39.

55. Cited by Cachin, Gauguin: The Quest for Paradise, p. 144.

56. Danielsson, "De exotiska källorna för Gauguins konst," p. 42.

57. Sullivan, The Meeting of Eastern and Western Art, pp. 234, 237.

58. See my discussions of the books on Buddhism owned by Strindberg and the use he made of Buddhist imagery in *A Dream Play* in *Strindberg and the Poetry of Myth*, esp. pp. 137–90.

59. "Tehura [Gauguin's wife] goes regularly to the temple, and offers lip-service to the official religion. But she knows by heart, and that is no small task, the names of all the gods of the Maori Olympus. . . . As chance has come she has given me a complete course in Tahitian theology" (Gauguin, *Noa Noa*, pp. 40–41).

60. The studies on Tahitian life borrowed by Gauguin in the Tahitian town of Papeete were J. A. Moerenhout, *Voyages aux Iles du Grand océan* (Paris, 1837), and Edmond de Bovis's "Etat de la société tahitienne à l'arrivée des Européans," *Revue Coloniale* 14 (Paris, 1855). See Danielsson, *Gauguin in the South Seas*, pp. 100–101.

61. Howard, *Gauguin*, p. 28.

62. According to Bengt Danielsson, Gauguin "was the only European artist at the time to appreciate pre-Columbian ceramics" (Danielsson, "De exotiska källor för Gauguins konst," p. 41).

63. *Paul Gauguin's Intimate Journals*, p. 46.

64. Ibid., p. 49.

65. Cited by Goldwater, *Gauguin*, p. 92.

66. *Gauguin's Intimate Journals*, p. 49.

67. Ibid.

68. François Thiébault-Sisson, "Les petits salons," originally published in *Le Temps*, 2 December 1893, and reprinted in Prather and Stuckey, eds., *Gauguin: A Retrospective*, p. 218.

69. Achille Delaroche, "Concerning the Painting of Paul Gauguin," reprinted in *Gauguin: A Retrospective*, p. 228.

70. Elderfield, *Henri Matisse: A Retrospective*, p. 61.

71. Cited in Danielsson, "De exotiska källorna för Gauguins konst," p. 42.

72. Ibid., p. 46.

73. Gauguin "never tired of extolling the value of everything 'barbaric' or primitive and running down the decadence and corruption of civilization. Two of his most important paintings are entitled *Poèmes barbares* . . . and *Contes barbares*" (Leymarie, *Watercolors, Pastels, Drawings*, p. 57).

74. The translation of this excerpt from Strindberg's letter to Gauguin is my own revised version of the translation printed in *Gauguin's Intimate Journals*, trans. Van Wyck Brooks, p. 45.

75. Ibid., p. 48.

76. Cited by Danielsson, "De exotiska källorna för Gauguins konst," p. 46.

77. Sullivan, *The Meeting of Eastern and Western Art*, p. 259.

78. A passage marked in the margin of a book on Buddhism in Strindberg's final library asks the question, "how is Brahmā, the active masculine principle, able to emerge from Brahman, the neutral principle? The Vedantic school resolved the problem through means of the principle called Māyā, illusion, otherwise described as matter, the significance of which is that of measurement and space. Much later, Plato must have developed this same theory, to which he gave the name . . . the universal mother . . ." (Lafont, *Le Buddhisme*, pp. 81–82; Strindberg Library, catalogue no. 2847).

79. Cited by Schopenhauer in *World as Will*, 1:7–8 and 2:322.

80. Cullberg, *Skapar kriser*, pp. 119, 86.

81. *Détraqués*: "Normally distracted, half-mad, but as used in Parisian fin-de-siècle literary circles an accolade, denoting extreme sensitivity and intellectual refinement" (*Strindberg's Letters*, 2:846 n. 3).

82. The positive aspects of fantasizing are underscored by modern psychology. A report of a survey of extreme fantasizers in *American Psychologist* states that "the studies showed that, with a few exceptions, the fantasizer's capacity to imagine contributed to their psychological well-being" (Daniel Coleman, "For Some People, Half of Day Is Spent in Fantasy," *New York Times*, 15 December 1987).

83. For the French Romantics, "myth could be defined as a treatment of the symbol . . . in which that symbol is first personified or concretised, and then set in dramatic conflict with other symbols" (Bowman, "Illuminism, Utopia, Mythology," p. 100).

84. For examples of Strindberg's frequent and expressive use of mythological allusions, see index to my *Strindberg and the Poetry of Myth*.

85. Heller, *Munch*, p. 76.

86. August Strindberg, "L'exposition d'Edward Munch," reprinted in Söderström, *Strindberg och bildkonsten*, pp. 304–5.

87. Cited by Heller, *Munch*, p. 131.

88. Ibid.

89. Strindberg, *Inferno* (French version, 1966), p. 26; SV 37:397.

90. Munch's own description (cited in Heller, *Munch*, p. 76) of the genesis of *The Scream* is closer to Strindberg's, giving the protagonist's imagination the power to project his despair into nature:

I was walking along the road with two friends. The sun set. I felt a tinge of melancholy. Suddenly the sky became a bloody red.

I stopped, leaned against the railing, dead tired. And I looked at the flaming clouds that hung like blood and a sword over the blue-black fjord and city.

My friends walked on. I stood there, trembling with fright. And I felt a loud, unending scream piercing nature.

As model for the utterer of that "unending scream" what could be more appropriate than the image of the gaping mummy at the World's Fair, which, as we have seen, served more than one artist searching for symbolic vehicles of expression?

91. Heller, Munch, p. 97.

92. Strindberg, "L'exposition d'Edward Munch," in Söderström, Strindberg och bildkonsten, p. 305.

93. Ibid., p. 304.

94. The Romantic graveyard tradition had its roots in works like pre-Romantic Thomas Gray's Elegy written in a Country Church-Yard (1751) in England, and influenced the Swedish Romantic poets Franz Michael Franzén, Johan Gabriel Oxenstierna, and Esias Tegnér, all writers familiar to Strindberg since his youth. In keeping with this tradition, the overriding tone is melancholic and nostalgic about the past, and Nature is personified throughout (like the blackbird in the essay), so that Nature's moods interact with the moods of the narrator.

95. For an analysis of the purging of the Stranger's hubris in To Damascus, see my Strindberg and the Poetry of Myth, pp. 114–15.

96. Psychiatrist Bruno Bettelheim would have agreed with the importance Strindberg attaches in the passage to fairy tales. In fact, he stated their continuing psychological validity and relevance in terms almost identical to Strindberg's: "Historically, fairy tales anticipate by centuries our knowledge of embryology, which tells how the human fetus undergoes various stages of development before birth, as the frog undergoes a metamorphosis in its development" (Bettelheim, Uses of Enchantment, p. 289).

97. For a discussion of the mythic references in To Damascus, see my Strindberg and the Poetry of Myth, pp. 92–123.

98. Falck, Fem år med Strindberg, p. 84.

99. Ringbom, Sounding Cosmos, p. 177.

100. Frye, Secular Scripture, p. 165.

101. Kearney, Wake of the Imagination, p. 251.

102. From an essay in 1879 cited by Nolin, Den gode europén, p. 366.

103. Rydberg, Undersökningar i germansk mythologi, 1:143. Strindberg noted in August 1896: "In [Rydberg's Teutonic Mythology] is everything I have been groping for" (Brev 11:295).

104. Engdahl, Den romantiska texten, p. 124.

105. The Complete Poetical Works of Percy Bysshe Shelley, p. 238.

106. Cantor, Creature and Creator, p. 94.

Bibliography

Abrams, M. H. "English Romanticism: The Spirit of the Age." In *Romanticism Reconsidered*, ed. Northrop Frye, pp. 26–72. New York: Columbia University Press, 1963.

————. *The Mirror and the Lamp: Romantic Theory and the Critical Tradition.* Oxford: Oxford University Press, 1953. Reprint, Oxford: Oxford University Press paperback, 1971.

————. *Natural Supernaturalism: Tradition and Revolution in Romantic Literature.* New York: W. W. Norton, 1971. Reprint, Norton Library, 1973.

Ahlström, Gunnar. *Georg Brandes' Hovedstrømninger.* Lund, Sweden: C. W. K. Gleerup, 1937.

Ahlström, Stellan. *Strindbergs erövring av Paris: Strindberg och Frankrike, 1884–1895.* Stockholm Studies in History of Literature, no. 2; Acta Universitatis Stockholmiensis. Stockholm: Almqvist & Wiksell, 1956.

Allen, Paul M. "Édouard Schuré and *The Great Initiates.*" In *The Great Initiates,* by Édouard Schuré, trans. Gloria Rasberry, pp. 11–31. San Francisco: Harper & Row, 1961.

Atterbom, P. D. A. *Svenska siare och skalder.* 2d ed. Örebro, Sweden: N. M. Lindh, 1862. Strindberg Library, catalogue no. 3604.

Auerbach, Erich. *Mimesis: The Representation of Reality in Western Literature.* Trans. Willard R. Trask. Princeton: Princeton University Press, 1953. Reprint, Princeton: Princeton Paperbacks, 1968.

August Strindberg—Carl Kylberg—Max Book. Exhibition catalogue. Stockholm: Liljevach Konsthall, 1992.

Aurier, G.-Albert. "Symbolism in Painting: Paul Gauguin." In *Gauguin: A Retrospective,* ed. Marla Prather and Charles F. Stuckey, trans. Alexandra Bonfante-Warren, Chester Burnett, and Thomas Spear, pp. 150–56. New York: Park Lane, 1989. Essay originally published in *Mercure de France* 2 (December 1891).

Bade, Patrick. *The Femme Fatale.* New York: Mayflower Books, 1979.

Bakhtin, Mikhail. *Rabelais and His World.* Trans. Helene Iswolsky. Bloomington: Indiana University Press, Midland Books, 1984.

Balzac, Honoré de. *Louis Lambert.* In *The Works of Honoré de Balzac,* 4:145–258. Society of English and French Literature. New York: Thomas Crowell, 1900. No translator listed.

Bibliography

Barber, C. L. *Shakespeare's Festive Comedy: A Study of Dramatic Form and Its Relation to Social Custom.* Princeton: Princeton University Press, 1959. Reprint, Princeton: Princeton Paperbacks, 1972.

Bark, Richard. *Strindbergs drömspelsteknik — i drama och teater.* Lund: Studentlitteratur, 1981.

Barzun, Jacques. *Classic, Romantic, and Modern.* Garden City, N.Y.: Doubleday, Anchor, 1961.

Bate, Walter Jackson. *From Classic to Romantic: Premises of Taste in Eighteenth-Century England.* Cambridge: Harvard University Press, 1946. Reprint, New York: Harper Torchbooks, 1961.

Beer, Gillian. *Darwin's Plots: Evolutionary Narrative in Darwin, George Eliot, and Nineteenth-Century Fiction.* London: Routledge & Kegan Paul, 1983. Reprint, Ark Paperbacks, 1985.

Bellquist, John Eric. *Strindberg as a Modern Poet.* University of California Publications in Modern Philology, vol. 117. Berkeley and Los Angeles: University of California Press, 1986.

Benjamin, Walter. "What Is Epic Theater?" In *Illuminations,* ed. Hannah Arendt, trans. Harry Zohn, pp. 147–54. New York: Schocken, 1968.

Berendsohn, Walter A. *Strindbergsproblem.* Stockholm: Kooperative förbundet, 1946.

Besant, Annie. *The Ancient Wisdom.* London, Wheaton, Ill., and Adyar, Madras, India: Theosophical Publishing House, 1897; 1st Adyar ed., 1939.

Besant, Annie, and C. W. Leadbeater. *Thought-Forms.* Wheaton, Ill.: Theosophical Publishing House, 1969. Abridged paperback ed. of 1901 original.

Bettelheim, Bruno. *The Uses of Enchantment.* New York: Knopf, 1976.

Blake, William. *The Complete Poetry and Prose of William Blake.* Ed. David V. Erdman. Garden City, N.Y.: Doubleday, Anchor Books, 1982.

Blavatsky, Helena P. *The Key to Theosophy.* Pasadena, Calif.: Theosophical University Press, 1987. Reprint of 1889 1st ed., with Glossary from 2d ed.

Block, Haskell M. "Strindberg and the Symbolist Drama." *Modern Drama* 5 (1962): 314–22.

Boëthius, Ulf. "Sjuttitalets Strindberg." *BLM* 48, no. 4 (1979): 284–85.

Bowman, Frank. "Illuminism, Utopia, Mythology." In *The French Romantics,* 2 vols., ed. D. G. Charlton, 1:76–112. Cambridge: Cambridge University Press, 1984.

Brandell, Gunnar. *Strindbergs Infernokris.* Stockholm: Bonniers, 1950.

354

Bibliography

————. "Åttiotalet." In Ny illustrerad svensk litteraturhistoria, ed. E. N. Tiger-stedt, 4:144–94. 2d rev. ed. Stockholm: Natur och Kultur, 1967.

————. "Bakgrund till sekelslutet." In Ny illustrerad svensk litteraturhistoria, ed. E. N. Tigerstedt, 4:3–29. 2d rev. ed. Stockholm: Natur och Kultur, 1967.

————. Strindberg in Inferno. Trans. Barry Jacobs. Cambridge: Harvard University Press, 1974.

————. Strindberg—ett författarliv. 3 vols. Stockholm: Alba, 1983–.

Brandes, Georg. Samlede skrifter. 12 vols. Copenhagen: Gyldendalske Boghandels forlag, 1899–1902.

————. "Inaugural Lecture, 1871." Trans. Evert Sprinchorn. In The Theory of the Modern Stage, ed. Eric Bentley, pp. 383–97. Baltimore: Penguin Books, 1968.

Brandes, Georg, and Edvard Brandes. Brevveksling med nordiske Forfattere og Videnskabsmaend. 8 vols. Ed. Morten Borup, Francis Bull, and John Landquist. Copenhagen: Gyldendal, 1939–42.

Buckle, Henry Thomas. History of Civilization in England. 2 vols. New York: D. Appleton & Co., 1861.

Byron, Lord. The Poetical Works of Lord Byron. Philadelphia: Porter & Coates, n.d.

Cachin, Françoise. Gauguin: The Quest for Paradise. Trans. I. Mark Paris. New York: Harry N. Abrams, 1992.

Camus, Albert. The Rebel. Trans. Anthony Bower. New York: Vintage Books, 1956.

Cantor, Paul A. Creature and Creator: Myth-Making and English Romanticism. Cambridge: Cambridge University Press, 1984.

Carlson, Harry G. "Problems in Play Translation." Educational Theatre Journal 16 (March 1964): 55–58.

————. "Several Unknown Strindbergs." Scandinavian Review 64 (September 1976): 5–6.

————. Strindberg and the Poetry of Myth. Berkeley and Los Angeles: University of California Press, 1982.

————. "In Search of the Dionysian Actor." In Strindberg, O'Neill, and the Modern Theatre, ed. Claes Englund and Gunnel Bergström, pp. 48–56. Nobel Foundation Symposium, no. 72. Stockholm: Nobel Foundation and entré/Riksteatern, 1990.

Carlyle, Thomas. Heroes and Hero Worship. New York: A. L. Burt, [1907 or earlier].

————. The French Revolution. New York: Modern Library, n.d.

Cervantes Saavedra, Miguel de. The Adventures of Don Quixote. Trans. J. M.

Bibliography

Cohen. Harmondsworth, Middlesex, England: Penguin Books, 1950.

Chevrillon, A. *Dans l'Inde.* Paris: Librairie Hachette, 1891, 1908.

Chipp, Herschel B., ed. *Theories of Modern Art.* Berkeley and Los Angeles: University of California Press, 1968.

Clark, Kenneth. *The Nude: A Study in Ideal Form.* Bollingen Series 35.2. Princeton: Princeton University Press, 1956. Reprint, Princeton: Bollingen Deluxe Paperbacks, 1972.

Clay, Jean. *Romanticism.* Trans. Daniel Wheeler and Craig Owen. New York: Vendome, 1981.

Cohn, Norman. *The Pursuit of the Millennium.* New York: Oxford University Press, 1957. Rev. and enl. paper ed., Oxford: Oxford University Press, 1970.

Coleridge, Samuel Taylor. *Biographia Literaria; or, Biographical Sketches of My Literary Life and Opinions.* Ed. James Engell and W. Jackson Bate. Bollingen Series 75. Princeton: Princeton University Press, 1983. Paperback ed., no. 7 of *The Collected Works,* 1984.

Coomaraswamy. *Selected Papers.* 3 vols. Ed. Roger Lipsey. Bollingen Series 89. Princeton: Princeton University Press, 1977.

Cullberg, Johan. *Skapar kriser: Strindbergs Inferno och Dagermans.* Stockholm: Natur och Kultur, 1992.

Curtius, Ernst Robert. *European Literature and the Latin Middle Ages.* Trans. Willard R. Trask. Bollingen Series 36. Princeton: Princeton University Press, 1953. Reprint, Princeton: Bollingen Paperback, 1973.

Dahlbäck, Bengt. "Hugo och Strindberg." In *Goethe, Hugo, Strindberg: Diktare, bildkonstnärer,* pp. 14–18. National Museum Catalogue 382. Stockholm, 1974.

Danielsson, Bengt. *Gauguin in the South Seas.* Trans. Reginald Spink. Garden City, N.Y.: Doubleday, 1966.

———. "De exotiska källorna för Gauguins konst." In *Gauguin i söderhavet,* pp. 38–50. Catalogue. Stockholm: Etnografiska Museet and National Museum, 1970.

Danto, Arthur C. *Encounters and Reflections: Art in the Historical Present.* New York: Farrar Straus Giroux, 1990.

Delblanc, Sven. *Stormhatten.* Stockholm: Bonniers, 1979.

Dijkstra, Bram. *Idols of Perversity: Fantasies of Feminine Evil in Fin de Siècle Culture.* New York and Oxford: Oxford University Press, 1986.

Driver, Tom F. *Romantic Quest and Modern Query: A History of the Modern Theater.* New York: Dell, 1971.

Edqvist, Sven-Gustaf. *Samhällets fiende: En Strindbergsstudie.* Stockholm: Tidens förlag, 1961.

Bibliography

The Egyptian Book of the Dead: An English Translation of the Chapters, Hymns, etc., of the *Theban Recension*. Ed. E. A. Wallis. 3 vols. London: 1901. Strindberg Library, catalogue no. 2226.

Eklund, Torsten. *Tjänstekvinnans son: En psykologisk Strindbergsstudie.* Stockholm: Bonniers, 1948.

———. "Efterslåtter bland Strindbergs brev." *Meddelanden från Strindbergssällskapet*, nos. 59–60 (May 1978): 15–35.

Elderfield, John. *Henri Matisse: A Retrospective.* New York: Museum of Modern Art, 1992.

Ellman, Richard. *The Identity of Yeats.* London: Macmillan, 1954. 2d ed., paper, London: Faber & Faber, 1964.

Emerson, Ralph Waldo. *Essays.* Trans. into German by Dr. Karl Federn. Halle, Germany: Otto Hendel, n.d. Strindberg Library, catalogue no. 3498.

———. *Selected Essays, Lectures, and Poems.* Ed. Robert E. Spiller. New York: Washington Square Press, Pocket Books, 1965.

Engdahl, Horace. "Myten i texten." *BLM* 51, no. 2 (April 1982): 99–103.

———. *Den romantiska texten.* Stockholm: Bonniers, 1986.

Engell, James. *The Creative Imagination.* Cambridge: Harvard University Press, 1981.

Falck, August. *Fem år med Strindberg.* 2d ed. Stockholm: Wahlström & Widstrand, 1935.

Feldman, Burton, and Robert D. Richardson, eds. *The Rise of Modern Mythology, 1680–1860.* Bloomington: Indiana University Press, 1972. Reprint, Bloomington: Midland Books, 1975.

Feuk, Douglas. *August Strindberg: Inferno Painting; Pictures of Paradise.* Trans. Kjersti Board. Format, A Series of Art in the Nordic Countries, vol. 4. Hellerup, Denmark: Edition Bløndal, 1991.

Fletcher, Angus. *Allegory: The Theory of a Symbolic Mode.* Ithaca: Cornell University Press, 1964. Reprint, Ithaca: Cornell Paperbacks, 1970; reissued 1982.

Fraenkel, Pavel. *Strindbergs dramatiske fantasi i Spöksonaten.* Oslo: Universitetsforlaget, 1966.

Fröding, Gustaf. "Naturalism och romantik." In *Efterskörd*, 2:44–59. Stockholm: Bonniers, 1910.

Frye, Northrop. "New Directions from Old." In *Myth and Mythmaking*, ed. Henry A. Murray, pp. 115–31. Boston: Beacon Paperbacks, 1968.

———. *Secular Scripture: A Study of the Structure of Romance.* Cambridge: Harvard University Press, 1976.

Bibliography

————. *The Great Code: The Bible and Literature*. New York: Harcourt Brace Jovanovich, 1981.

Fuchs, Elinor. "The Mysterium: A Modern Dramatic Genre." *Theatre Three* 1 (fall 1986): 73–88.

Furst, Lilian, comp. *European Romanticism*. London: Methuen, 1980.

Gauguin, Paul. *Noa Noa: The Tahitian Journal*. Trans. O. F. Theis. New York: Nicholas L. Brown, 1919. Reprint, New York: Dover Publications, 1985.

————. *Paul Gauguin's Intimate Journals*. Trans. Van Wyck Brooks. Preface by Emil Gauguin. Bloomington: Indiana University Press, Midland Books, 1958.

Gerould, Daniel, and Jadwiga Kosicka. "The Drama of the Unseen— Turn-of-the-Century Paradigms for Occult Drama." In *The Occult in Language and Literature*, ed. Hermine Riffaterre, pp. 3–42. New York: New York Literary Forum, 1980.

Goethe, Johann Wolfgang von. *Dichtung und Wahrheit*. In *Werke. Auswohl in sechzehn Bänden*. Leipzig, n.d. Strindberg Library, catalogue no. 97.

————. *The Autobiography of Johann Wolfgang von Goethe*. Vol. 2. Trans. John Oxenford. Chicago: University of Chicago Press, Phoenix Books, 1974.

————. *Faust, Part One*. Trans. Peter Salm. Rev. ed. New York: Bantam, 1985.

Goldman, Emma. *Social Significance of the Modern Drama*. Boston: Richard G. Badger, 1914. Reprint, New York: Applause Books, 1987.

Goldwater, Robert. *Symbolism*. New York: Harper & Row, 1979.

————. *Paul Gauguin*. New York: Harry N. Abrams, 1983.

Häggqvist, Arne. "Strindbergs 'Samvetskval.'" *Edda* 39 (1939): 284–94.

Hardison, O. B., Jr. *Christian Rite and Christian Drama in the Middle Ages*. Baltimore: Johns Hopkins Press, 1965.

Hartman, Geoffrey. *Wordsworth's Poetry, 1787–1814*. New Haven: Yale University Press, 1964. Reprint, with the essay "Retrospect 1971," New Haven: Yale University Press, 1971.

Hawkes, Terence. *Metaphor*. London: Methuen, 1972.

Hedenberg, Sven. *Strindberg i skärselden*. Göteborg: Akademiförlaget-Gumperts, 1961.

Heidenstam, Verner von. "Renässans." In *Stridsskrifter*, pp. 7–37. Stockholm: Bonniers, 1912.

Heller, Reinhold. *Munch: His Life and Work*. Chicago: University of Chicago Press, 1984.

Hodin, J. P. *Edvard Munch*. New York: Praeger, 1972.

Bibliography

Holquist, Michael. Prologue to *Rabelais and His World*, by Mikhail Bakhtin, pp. xiii–xxiii. Bloomington: Indiana University Press, Midland Books, 1984.

Honour, Hugh. *Neo-classicism*. Rev. ed. New York: Viking, Penguin, 1977.

————. *Romanticism*. New York: Harper & Row, 1979.

Howard, Michael. *Gauguin*. Eyewitness Art Series. London and New York: Dorling Kindersley, 1992.

Hughes, Robert. *The Shock of the New*. New York: Knopf, 1980. Rev. ed., New York: Borzoi, 1991.

The Hymns of the Ṛgveda. Rev. ed. Trans. Ralph T. H. Griffith. Ed. J. L. Shastri. Delhi: Motilal Banarsidass, 1973.

Ibsen, Henrik. *Ibsens samlede verker i billigutgave*. 3 vols. Oslo: Gyldendal Norsk forlag, 1972.

Imanse, Geurt. "Occult Literature in France." In *The Spiritual in Art: Abstract Painting, 1890–1985*, ed. Edward Weisberger, pp. 355–60. Los Angeles: Los Angeles County Museum of Art; New York: Abbeville Press, 1986.

Im Lichte des Nordens Skandinavische Malerei um die Jahrhundertwende. Düsseldorf: Düsseldorf Kunstmuseum, 1986.

Jacobs, Barry. "Strindberg's *Advent* and *Brott och Brott*: Sagospel and Comedy in a Higher Court." In *Strindberg and Genre*, ed. Michael Robinson, pp. 167–87. Norwich, England: Norvik Press, 1991.

Järv, Harry, ed. *Strindbergsfejden*. 2 vols. Uddevalla, Sweden: Bo Cavefors, 1968.

Johannesson, Eric O. *The Novels of August Strindberg*. Berkeley and Los Angeles: University of California Press, 1968.

Johnston, Brian. *To the Third Empire*. Minneapolis: University of Minnesota Press, 1980.

Jonsson, Inge. *Emanuel Swedenborg*. Trans. Catherine Djurklou. New York: Twayne Publishers, 1971.

Kandinsky, Wassily. "Reminiscences." In *Modern Artists on Art*, ed. Robert L. Herbert, pp. 19–44. Englewood Cliffs, N.J.: Prentice Hall, 1964.

Kärnell, Karl-Åke. *Strindbergs bildspråk: En studie i prosastil*. Stockholm: Almqvist & Wiksell, 1962.

Kearney, Richard. *The Wake of the Imagination*. London: Hutchinson, 1988.

Kermode, Frank. *The Sense of an Ending*. New York: Oxford University Press, 1966, 1967. Paperback ed., 1968.

Klee, Paul. "Creative Credo." In *Theories of Modern Art*, ed. Herschel B. Chipp, pp. 182–86. Berkeley and Los Angeles: University of California Press, 1968.

Bibliography

Lafont, G. de. *Le Buddhisme*. Paris: Chamuel, 1895. Strindberg Library, catalogue no. 2847.

Lagercrantz, Olof. *August Strindberg*. Trans. Anselm Hollo. New York: Farrar Straus Giroux, 1984.

Lagerkvist, Pär. *Modern Theatre: Seven Plays and an Essay*. Trans. with intro. by Thomas R. Buckman. Lincoln: University of Nebraska Press, 1966.

Lamm, Martin. *Strindberg och makterna*. Stockholm: Svenska kyrkans diakonistyrelses bokförlag, 1936.

———. *August Strindberg*. Trans. Harry G. Carlson. New York: Benjamin Blom, 1971.

Le Bris, Michel. *Romantics and Romanticism*. Trans. Barbara Bray and Bernard C. Swift. New York: Rizzoli, 1981.

Lévi, Éliphas. *The Key of the Mysteries*. Trans. Aleister Crowley. London: Rider & Co., 1959. New York: Samuel Weiser, 1970.

———. *Transcendental Magic*. Trans. Aleister Crowley. London: Rider & Co., 1896, 1968. New York: Samuel Weiser, 1970.

Levin, Harry. *The Gates of Horn: A Study of Five French Realists*. New York: Oxford University Press, 1963. Reprint, Galaxy Books, 1966.

———. *The Myth of the Golden Age in the Renaissance*. Bloomington: Indiana University Press, 1969. New York: Oxford University Press, 1972.

Leymarie, Jean. *Gauguin: Watercolors, Pastels, Drawings*. Trans. Robert Allen. New York: Rizzoli International, 1989.

Lindberg, Per. *Tillkomsten af Strindbergs "Mäster Olof."* Skrifter från Stockholms högskolas litteraturhistoriska seminarium, ed. Karl Warburg, no. 1. Stockholm: Bonniers, 1915.

Lindberger, Örjan. "Strindberg and Péladan." In *Structures of Influence: A Comparative Approach to August Strindberg*, ed. Marilyn Johns Blackwell, pp. 245–55. Chapel Hill: University of North Carolina Press, 1981.

Linde, Ulf. *Efter hand: Texter, 1950–1985*. Ed. Lars Nygren. Stockholm: Bonniers, 1985.

Lindström, Hans. *Hjärnornas kamp: Psykologiska idéer och motiv i Strindbergs åttiotalsdiktning*. Uppsala: Appelbergs boktryckeri, 1952.

———. *Strindberg och böckerna*. Skrifter utgivna av svenska litteratursällskapet, no. 36. Uppsala, 1977.

Lipsey, Roger. *An Art of Our Own: The Spiritual in Twentieth-Century Art*. Boston and Shaftesbury: Shambhala, 1989.

Ljunggren, Gustaf. *Svenska dramat intill slutet af sjuttonde århundradet*. Lund, Sweden: C. W. K. Gleerup; Copenhagen: Christian Falkenberg, 1864. Strindberg's 1883 library inventory.

Löwith, Karl. *Meaning in History*. Chicago: University of Chicago, 1949.

Bibliography

Man, Paul de. *The Rhetoric of Romanticism.* New York: Columbia University Press, 1984.

Matter, M. *Emanuel Swedenborg: Hans lefnad, hans skrifter och hans lära.* 1864. Strindberg Library, catalogue no. 2073.

McKeon, Richard. "Literary Criticism and the Concept of Imitation in Antiquity." In *Critics and Criticism,* ed. R. S. Crane, pp. 117–45. Chicago: University of Chicago Press, 1952. Abridged ed., Chicago: Phoenix Books, 1957.

————. "The Philosophic Bases of Art and Criticism." In *Critics and Criticism,* ed. R. S. Crane, pp. 191–273. Chicago: University of Chicago Press, 1952. Abridged ed., Chicago: Phoenix Books, 1957.

Meidal, Björn. *Från profet till folktribun.* Stockholm: Tidens förlag, 1982.

Meyer, Michael. *Ibsen: A Biography.* Garden City, N.Y.: Doubleday, 1971.

————. *Strindberg: A Biography.* New York: Random House, 1985.

Meyerhold, Vsevolod. *Meyerhold on Theatre.* Trans. and ed. Edward Braun. New York: Hill & Wang, 1969.

Mitchell, W. J. T. *Iconology: Image, Text, Ideology.* Chicago: University of Chicago Press, 1986.

————. "Visible Language: Blake's Wond'rous Art of Writing." In *Romanticism and Contemporary Criticism,* ed. Morris Eaves and Michael Fischer, pp. 15–45. Ithaca: Cornell University Press, 1986.

Mortensen, Brita, and Brian Downs. *Strindberg: An Introduction to His Life and Work.* 1949. Reprint, paper ed., Cambridge: Cambridge University Press, 1965.

Mortensen, Johan. *Medeltids dramat i Frankrike.* Göteborg: Wettergren & Kerber, 1899. Reprint, Lund, 1967.

Nilsson, Albert. *Svensk romantik: Den Platonska Strömningen.* Lund: Gleerups, 1916.

Nolin, Bertil. *Den gode europén: Studier i Georg Brandes' idéutveckling 1871–1893 med speciell hänsyn till hans förhållande till tysk, engelsk, slavisk och fransk litteratur.* Stockholm: Norstedts, 1965.

Norseng, Mary Kay. *Dagny: Dagny Juel Przybyszewska, the Woman and the Myth.* Seattle: University of Washington Press, 1991.

Novalis. *Schriften.* 3 vols. in 1. Ed. Ludwig Tieck and Friedrich Schlegel. Berlin: G. Reimer, 1837–46. Strindberg Library, catalogue no. 1688.

Ollén, Gunnar. *Strindbergs dramatik.* 4th ed. Kristianstad, Sweden: Sveriges Radios förlag, 1982.

Olsson, Thomas. *Idealism och klassicism.* Skrifter utgivna av Litteraturvetenskapliga institutionen vid Göteborgs universitet, no. 4. Göteborg, 1981.

Bibliography

Ortega y Gasset, José. *Meditations on Quixote*. Trans. Evelyn Rugg and Diego Marín. New York: W. W. Norton, 1961.

Ovid. *Metamorphoses*. Trans. Mary M. Innes. Baltimore: Penguin Books, 1955.

Partridge, Eric. *Origins*. New York: Macmillan, 1958.

Petrey, Sandy. Afterword to *The Sin of Father Mouret* by Émile Zola. Trans. Sandy Petrey. Lincoln: University of Nebraska Press, Bison Books, 1983.

Pierrot, Jean. *The Decadent Imagination: 1880–1900*. Trans. Derek Coltman. Chicago: University of Chicago Press, 1981.

Poggioli, Renato. *The Theory of the Avant-Garde*. Cambridge: Belknap Press of Harvard University Press, 1968.

Potter, Robert. *The English Morality Play: Origins, History and Influence of a Dramatic Tradition*. London: Routledge & Kegan Paul, 1975.

Prather, Marla, and Charles F. Stuckey, eds. *Gauguin: A Retrospective*. Trans. Alexandra Bonfante-Warren, Chester Burnett, and Thomas Spear. New York: Park Lane, 1989.

Princeton Encyclopedia of Poetry and Poetics. Ed. Alex Preminger with Frank J. Warnke and O. B. Hardison, Jr. Enl. paper ed. Princeton: Princeton University Press, 1974.

Printz-Påhlson, Göran. "Tankens genvägar II." *Bonniers litterära magasin* 38 (October 1969): 594–610.

———. "Allegories of Trivialization: Strindberg's View of History." In *Comparative Criticism*, ed. E. S. Slaffer, 3:221–36. Cambridge: Cambridge University Press, 1981.

Read, Herbert. "The Dynamics of Art." In *Aesthetics Today*, ed. Morris Philipson, pp. 324–48. Cleveland and New York: World Publishing Co., 1961.

Reinert, Otto, ed. *Strindberg: A Collection of Critical Essays*. Englewood Cliffs, N.J.: Prentice-Hall, 1971.

Rewald, John. *Post-Impressionism: From Van Gogh to Gauguin*. 3d ed. New York: Museum of Modern Art, 1979.

Richet, Charles. *L'homme et l'intelligence*. 2d ed. Paris, 1887.

Ring, Herman A. *Teaterns historia från äldsta till nyaste tid: En skildring af antikens, medeltidens och den nyare tidens skådebanor*. Stockholm: C. E. Gernandts, 1898. Strindberg Library, catalogue nos. 444 and 2483.

Ringbom, Sixten. "Art in the 'Epoch of the Great Spiritual.'" *Journal of the Warburg and Courtauld Institutes* 29 (1966): 386–418.

———. *The Sounding Cosmos: A Study of the Spiritualism of Kandinsky and the*

Bibliography

Genesis of Abstract Painting. Acta Academiae Aboensis, Ser. A., vol. 38. Åbo, Finland, 1970.

Rinman, Sven. "Strindberg." In *Ny illustrerad svensk litteraturhistoria,* 4:30–143. 2d rev. ed. 4 vols. Stockholm: Natur och Kultur, 1967.

Robinson, Michael, ed. *Strindberg and Genre.* Norwich, England: Norvik Press, 1991.

Rosen, Charles, and Henri Zerner. *Romanticism and Realism.* London: Faber & Faber, 1984.

Rosenberg, John D. *Carlyle and the Burden of History.* Cambridge: Harvard University Press, 1985.

Rosenblum, Robert. *Modern Painting and the Northern Romantic Tradition: Friedrich to Rothko.* New York: Harper & Row, Icon Editions, 1975. Reprint, 1988.

Roth, Philip. "This Butcher, Imagination: Beware of Your Life When a Writer's at Work." *New York Times Book Review,* 14 February 1988.

Rubin, William, and Matthew Armstrong. *The William S. Paley Collection.* Catalogue. New York: Museum of Modern Art, 1992.

Rydberg, Viktor. *Den siste atenaren.* 2 vols. 1859. Reprint, Stockholm: Bonniers, 1945.

———. *Undersökningar i germansk mythologi.* 2 vols. Stockholm: Bonniers, 1886.

Rydh, Hanna. *De historiska källorna till Strindbergs "Master Olof."* Skrifter från Stockholms högskolas litteraturhistoriska seminarium, ed. Karl Warburg, no. 2. Stockholm: Bonniers, 1915.

Schiller, Friedrich. *"The Robbers" and "Wallenstein."* Trans. F. J. Lamport. Middlesex, England: Penguin Books, 1979.

Schopenhauer, Arthur. *The World as Will and Representation.* 2 vols. Trans. E. F. J. Payne. Indian Hills, Colo.: Falcon's Wing Press, 1958. New ed., New York: Dover Publications, 1969.

———. *Essays and Aphorisms.* Trans. R. J. Hollingdale. Baltimore: Penguin Books, 1970.

Schuré, Édouard. *The Great Initiates: A Study of the Secret History of Religions.* Trans. Gloria Rasberry. San Francisco: Harper & Row, 1961.

Schwab, Raymond. *The Oriental Renaissance.* Trans. Gene Patterson-Black and Victor Reinking. New York: Columbia University Press, 1984.

Scott, Franklin D. *Sweden: The Nation's History.* Minneapolis: University of Minnesota Press, 1977.

Shelley, Percy Bysshe. *The Complete Poetical Works of Percy Bysshe Shelley.* Oxford: Oxford University Press, 1945, 1960.

Smedmark, Carl Reinhold, ed. *August Strindbergs "Mäster Olof."* 2 vols. Sven-

ska författare; utgivna av Svenska vitterhetssamfundet, no. 19. Stockholm: Bonniers, 1948.

———. *"Mäster Olof" och Röda rummet.* Stockholm: Almqvist & Wiksell, 1952.

———. *August Strindbergs dramer.* 4 vols. Stockholm: Bonniers, 1964.

Söderström, Göran. *Strindberg och bildkonsten.* Uddevalla, Sweden: Forum, 1972.

———. "Strindbergs måleri." In *Strindbergs måleri,* ed. Torsten Måtte Schmidt, pp. 33–254. Malmö: Allhems förlag, 1972.

———. "Phantasies of a Visual Poet." Trans. Patrick Hort. In *August Strindberg,* ed. Louis van Tilborgh and Sjraar van Heugten, pp. 27–35. Zwolle: Uitgeverij Waanders; Amsterdam: Riijksmuseum Vincent van Gogh, 1987.

———. "Edvard Munchs utställning." In *August Strindberg: Malmö Konsthall,* pp. 59–61. Catalogue no. 135. Catalogue of exhibition, Malmö, Sweden, 26 December 1989–4 February 1990. Malmö: Malmö Konsthall, 1989.

Sokel, Walter H. Introduction to *Anthology of German Expressionist Drama,* pp. ix–xxxii. Garden City, N.Y.: Doubleday, Anchor, 1963.

Spender, Stephen. *The Struggle of the Modern.* Berkeley and Los Angeles: University of California Press, 1963, 1965.

Sprengel, David. *De nya poeterna (80-talet).* Stockholm: C & E Gernandts, 1902.

Sprinchorn, Evert. *Strindberg as Dramatist.* New Haven: Yale University Press, 1982.

States, Bert O. *The Shape of Paradox: An Essay on "Waiting for Godot."* Berkeley and Los Angeles: University of California Press, 1978.

Steene, Birgitta. "Shakespearean Elements in Historical Plays of Strindberg." In *Strindberg: A Collection of Critical Essays,* ed. Otto Reinert, pp. 125–36. Englewood Cliffs, N.J.: Prentice Hall, 1971. Originally published in *Comparative Literature* 11 (1959): 209–20.

———, ed. *Strindberg and History.* Stockholm: Almqvist & Wiksell International, 1992.

Steffan, Truman Guy. *Lord Byron's "Cain."* Austin: University of Texas Press, 1968.

Stevens, Martin. "Medieval Drama: Genres, Misconceptions, and Approaches." In *Approaches to Teaching Medieval English Drama,* ed. Richard Emmerson, pp. 36–49. New York: Modern Language Association of America, 1990.

Stockenström, Göran. *Ismael i öknen: Strindberg som mystiker.* Acta Universi-

tatis upsaliensis, historia litterarum, no. 5. Uppsala, Sweden, 1972.

—————, ed. *Strindberg's Dramaturgy*. Minneapolis: University of Minnesota Press, 1988.

Strindberg, August. "Du Hasard dans la production artistique." *La Revue des Revues* 11 (15 November 1894): 19–27. Translated as "Nya konstriktningar! eller Slumpen i det konstnärliga skapandet" by Torsten Måtte Schmidt, in *Strindbergs måleri*, ed. Torsten Måtte Schmidt, pp. 25–30 (Malmö: Allhems förlag, 1972). Also translated as "The New Arts, or The Role of Chance in Artistic Creation" by Albert Bermel in *"Inferno," "Alone," and Other Writings*, ed. Evert Sprinchorn, pp. 97–103 (Garden City, N.Y.: Doubleday Anchor, 1968).

—————. *Före Röda rummet: Strindbergs ungdomsjournalistik*. Ed. Torsten Eklund. Stockholm: Bonniers, 1946.

—————. *Vivisektioner*. Strindbergssällskapets skrifter. French/Swedish ed. Stockholm: Bonniers, 1958.

—————. *Ockulta dagboken*. Facsimile ed. Stockholm: Gidlunds, 1977.

—————. "The Mysticism of World History." Trans. Michael Robinson. In *Comparative Criticism*, 3, ed. E. S. Slaffer, pp. 237–56. Cambridge: Cambridge University Press, 1981.

—————. *Strindberg: Five Plays*. Trans. Harry G. Carlson. New York: New American Library, Signet Classic, 1984.

—————. *Strindberg's Letters*. Trans. and ed. Michael Robinson, 2 vols. Chicago: University of Chicago Press; London: Athlone Press, 1992.

—————. *Inferno*. In *August Strindbergs samlade verk*, vol. 37. Bilingual French/ Swedish ed.; ed., with commentary, by Ann-Charlotte Gavel Adams. Stockholm: Norstedts, 1994.

Strindberg, Auguste [sic]. *Inferno*. French version produced with the assistance of Marcel Réja. New, rev. ed. Paris: Mercure de France, 1966.

Strömbom, Sixten. *Konstnärsförbundets historia*. 2 vols. Stockholm: Bonniers, 1945, 1965.

Sullivan, Michael. *The Meeting of Eastern and Western Art*. Rev. and exp. ed. Berkeley and Los Angeles: University of California Press, 1989.

Thomson, Belinda. *Gauguin*. London: Thames & Hudson, 1987, 1990.

Thorslev, Peter L., Jr. *The Byronic Hero*. Minneapolis: University of Minnesota Press, 1962.

—————. *Romantic Contraries: Freedom versus Destiny*. New Haven: Yale University Press, 1984.

Tindall, William York. *The Literary Symbol*. New York: Columbia University Press, 1955. Reprint, paper ed., Bloomington: Indiana University Press, 1960.

Bibliography

Törnqvist, Egil. *Bergman och Strindberg*. Stockholm: Prisma, 1973.

Tuchman, Maurice. "Hidden Meanings in Abstract Art." In *The Spiritual in Art: Abstract Painting, 1890–1985*, ed. Edward Weisberger, pp. 17–61. Los Angeles: Los Angeles County Museum of Art; New York: Abbeville Press, 1986.

Uddgren, Gustaf. *Andra boken om Strindberg*. Göteborg, Sweden: Åhlén & Åkerlunds förlag, 1912.

Varnedoe, Kirk. "Primitivism in Modern Art: Gauguin." In *"Primitivism" in 20th Century Art: Affinity of the Tribal and the Modern*, ed. William Rubin, 1:179–209. New York: Museum of Modern Art, 1984.

Wallace, Robert. *The World of Van Gogh: 1853–1890*. New York: Time-Life Books, 1969.

Wellek, René. *Concepts of Criticism*. Ed. Stephen G. Nichols, Jr. New Haven and London: Yale University Press, 1963.

———. *A History of Modern Criticism, 1750–1950*. 4 vols. Paper ed. Cambridge: Cambridge University Press, 1983.

Welsh, Robert P. "Mondrian and Theosophy." In *Piet Mondrian: 1872–1944, Centennial Exhibition*, pp. 35–51. New York: Solomon R. Guggenheim Museum, 1971.

Widman, Dag. "Konsthantverk, konstindustri, design: 1895–1975." In *Konsten i Sverige*, ed. Sven Sandström, 2:463–612. Stockholm: Norstedts, 1974, 1988.

Wilde, Oscar. *The Complete Works of Oscar Wilde*. Leicester, England: Galley Press, 1987.

Wilson, Robert. "See the Text and Hear the Pictures." In *Strindberg, O'Neill, and the Modern Theatre*, ed. Claes Englund and Gunnel Bergström, pp. 57–62. Nobel Foundation Symposium, no. 72. Stockholm: Nobel Foundation and entré/Riksteatern, 1990.

Wirmark, Margareta. *Kampen med döden: En studie över Strindbergs Dödsdansen*. Skrifter utgivna av svenska littatursällskapet, no. 41. Stockholm: Almqvist & Wiksell International, 1989.

Wirsén, Carl David af. *Kritiker*. Stockholm: Norstedt & söners förlag, 1901.

Wordsworth, William. *Wordsworth: Poetical Works*. Ed. Thomas Hutchinson. Rev. Ernest de Selincourt. London: Oxford University Press, 1969.

Yeats, W. B. *Collected Poems*. 2d ed. London: Macmillan, 1969.

———. *The Uncollected Prose by W. B. Yeats*. 2 vols. Ed. John P. Frayne. New York: Columbia University Press, 1970.

Zimmer, Heinrich. *Myths and Symbols in Indian Art and Civilization*. Ed. Joseph Campbell. Princeton: Princeton University Press, 1972.

Bibliography

Ziolkowski, Theodore. "Some Features of Religious Figuralism in Twentieth-Century Literature." In *Literary Uses of Typology from the Late Middle Ages to the Present*, ed. Earl Miner, pp. 345–69. Princeton: Princeton University Press, 1977.

————. *Fictional Transfigurations of Jesus*. Princeton: Princeton University Press, 1972. Reprint, paper ed., Princeton: Princeton University Press, 1978.

Zola, Émile. "From *Naturalism in the Theatre*." Trans. Albert Bermel. In *The Theory of the Modern Stage*, ed. Eric Bentley, pp. 351–67. Baltimore: Penguin Books, 1968. Originally published in French in 1881.

————. *The Sin of Father Mouret*. Trans. Sandy Petrey. Lincoln: University of Nebraska Press, Bison Books, 1983.

Index

Index

Index

Index

Index

Index

Index

Index

Index

Index

necrobiosis, 263

Neoplatonism, 57, 139, 197

Nerval, Gérard du, 198

 on imagination, 206

New Kingdom, The, 16, 174

Nietzsche, Friedrich Wilhelm, 25, 60, 61

 admired as Buddhist by Strindberg, 194

 Birth of Tragedy, 231

 on figurative nature of language, 70

Nilsson, Albert, 8, 57

Nolin, Bertil, 59

Nordau, Max, 174

Norseng, Mary Kay, 279

Notre Dame Cathedral, Paris, 83

Novalis (pseud. for Friedrich Leopold von Hardenberg), 196

Nyblom, Carl Rupert, 57–59, 62

Oberammergau, Germany, Passion play, 253

occult, 5, 6, 8, 47, 170, 174, 176, 189, 212–15, 217, 219, 223, 233, 235–37, 254, 260, 262, 264

 attempt to reconcile religion and science, 190

 fin de siècle popularity of, 188

 hostility toward Naturalism, 193

 L'Occultisme, 196

 "primordial light" (urljuset), 197

 scientific credentials of Occultists, 190

 Strindberg's ambition to be "Zola of the occult," 213

 view of Creation, 236

 view of Nature, 238

 Western and Eastern schools of, 192

 See also correspondences; mysticism; Papus; Theosophy

Occult Diary, The, 201, 219, 264

Odin Theatre, 250

Oehlenschläger, Adam, 6, 61, 66

Olivier, Laurence, 45, 325n45

Ollén, Gunnar, 234

omphalos, 51, 149

Open Theater, 250

Orientales (Hugo), Les, 225

Orientalism and Hellenism

 Hellenism

 definition of, 230–31

 hostility toward, 230–31

 support from Rydberg, 230

 Orientalism, 5, 32, 66, 138, 222, 223, 260

 ambivalence toward, 228

 hostility toward, 239

 mythopoeic nature of Arabic, 229

 naiveté associated with, 221

 support for, 227, 229–30, 232

 and racism, 230

Oriental Renaissance, 32, 33, 223, 239, 287, 293

 attraction for Romantics, 225

 popularity of Indic texts, 226

Ortega y Gasset, José, 133

Overclass and Underclass, 6, 22, 40, 90, 116, 139, 140

 definition of, 321n1

Ovid, 119, 149, 150, 177, 213

 Metamorphoses, 120, 121

 linking of History and Nature in, 123

 as model for scientific concepts, 122

Paley, William, 122

"Pangs of Conscience," 16–19, 23, 25, 26, 28, 29, 34, 35, 37, 39, 42, 45, 46, 51, 68, 75, 112, 130, 132, 143, 146, 149, 180, 194, 205, 209, 221, 224, 241, 266, 306, 308, 314

pantheism, 219

Papus (pseud. for Gérard Encausse), 188, 196

 on astral body, 201

 physician and public health officer, 190

Paris Commune, 36, 87

Parliament, Swedish

Index

Index

Index

Index

Index

Index

Index